PARIS in 3D

From stereoscopy to virtual reality 1850-2000

In association with the Musée Carnavalet,
Museum of the History of Paris

Edited by Françoise Reynaud, Catherine Tambrun and Kim Timby

PARIS musées

Booth-Clibborn
Editions

Front cover:
Trimaran, **The Eiffel Tower**, 2000
Lenticular image, 3-D effect and lenticular master
by Patrick Garret, printed by Imprimerie Smic,
Montbrison (see p. 226)

This catalogue is published on the occasion of the
'Paris en 3D' exhibition held at the Musée Carnavalet
from 4 October to 31 December 2000.

This exhibition is part of the 'Mois de la Photographie'
festival and comes under the aegis of Mission Paris 2000.

The following people made this project possible through their generous support:

Jean Tiberi
Mayor of Paris

Hélène Macé de Lépinay
Deputy Mayor responsible for Cultural Affairs

Jean Gautier
Director of Cultural Affairs for the City of Paris

Édouard de Ribes
President of Paris-Musées

André Pichery
Assistant Director responsible for the Artistic Heritage

Isabelle Secrétan
Head of the Museums Department

Jean-Marc Léri
Director of the Musée Carnavalet

Aimée Fontaine
Director of Paris-Musées

Front cover:
Trimaran, **The Eiffel Tower**, 2000
Lenticular image, 3-D effect and lenticular master
by Patrick Garret, printed by Imprimerie Smic,
Montbrison (see p. 226)
Eiffel Tower lighting effect © Société nouvelle
d'exploitation de la tour Eiffel, conception Pierre Bidault.

This catalogue is published on the occasion of the
'Paris en 3D' exhibition held at the Musée Carnavalet
from 4 October to 31 December 2000.

This exhibition is part of the 'Mois de la Photographie'
festival and comes under the aegis of Mission Paris 2000.

The following people made this project possible through their generous support:

Jean Tiberi
Mayor of Paris

Hélène Macé de Lépinay
Deputy Mayor responsible for Cultural Affairs

Jean Gautier
Director of Cultural Affairs for the City of Paris

Édouard de Ribes
President of Paris-Musées

André Pichery
Assistant Director responsible for the Artistic Heritage

Isabelle Secrétan
Head of the Museums Department

Jean-Marc Léri
Director of the Musée Carnavalet

Aimée Fontaine
Director of Paris-Musées

This book and the 'Paris en 3D' exhibition at the Musée Carnavalet would not have been possible without generous loans from the following organizations, libraries, museums, institutes and private individuals:

Archives photographiques, médiathèque de l'Architecture et du Patrimoine
Archives de la préfecture de police de Paris
Bibliothèque de l'Arsenal, Paris
Bibliothèque historique de la Ville de Paris
Bibliothèque municipale de Lyon
Bibliothèque nationale de France, Paris
Centre national d'art Georges-Pompidou, Paris
Cinémathèque française, Paris
Gernsheim Collection, Harry Ranson Humanities
Research Center, University of Texas at Austin
The J. Paul Getty Museum, Los Angeles
Hachette Livre, Paris
Institut Lumière, Lyon
Institut national de la propriété industrielle, Paris
International Museum of Photography and Film,
Georges Eastman House, Rochester, NY
Maison de Victor Hugo, Paris
Musée des Arts et Métiers, Paris
Musée de l'hôpital Saint-Louis, Paris
Musée Nicéphore Niepce, Chalon-sur-Saône
Musée d'Orsay, Paris
Musée français de la photographie, Bièvres
Musée de la Publicité, Paris
Société française de photographie, Paris
Université de Gand - Musée pour l'histoire
des sciences

Olivier Auboin-Vermorel, Paris
Robert Blake, Paris
Joachim Bonnemaison, Paris
Michèle Bonnet, Saint-Sulpice
Francis Chantret, Châtenay-Malabry
Roxane Debuisson, Paris
Jacques Delamarre, Paris
Françoise Doërr, Paris
Michel Frizot, Paris
Marie-Thérèse et André Jammes, Paris
Serge Kakou, Paris
Roger Karampournis, Barbizon
Christian Kempf, Colmar
Micheline Kerzoncuf, Arpajon
Wim van Keulen, Amsterdam
Patrick Lamothe, Paris
Lapidus Haute Couture, Paris
Les Amis de J. H. Lartigue, Paris
Galerie Le Fell, Paris
Gérard Lévy, Paris
Emmanuelle Michaud, Paris
Moulinex
Russell Norton, New Haven, CT
Françoise Paviot, Paris
Denis Pellerin, Mondoubleau
Jacques Périn, Paris
Pierre-Marc Richard, Paris
B. J. Roedema-Van Loon, Amsterdam
André Tambrun, Sèvres
Tex Treadwell, Bryan, TX

Artists who created projects and works reflecting this theme:

Alexander
Patrick Bailly-Maître-Grand
Sylvie Blocher
Gérard Boisard
Blanca Casas Brullet
Anne Deguelle
François Delebecque
Alain Dufour
Louis Fléri
Jean-Marc Fournier
Jeanine Front
Síocháin Hughes
Catherine Ikam
Kamran Kavoussi
Hans Knuchel
Martha Laugs
Marie-Hélène Le Ny
François Mazzero
Bruce McKaig
Hélène Mugot
Raphaël O'Byrne
Alain Paiement
Guillaume Paris
Catherine Poncin
Jacques Robin
Stephen Sack
Ellen Sandor
Jacques Simonetti
Dagmar Sippel
Michael Snow
Pierrick Sorin
Gilbert Tribillon
Jean-Louis Tribillon
Aiyoung Yun
Fernand Zacot

In partnership with:
Architecture Vidéo
Association nationale pour l'amélioration de la vue
Barco France SA
CANAL⁺ multimédia
Centre national de la recherche scientifique : Unité mixte
de recherche : « Modèles et simulations pour l'architecture,
l'urbanisme et le paysage », et l'équipe nancéienne
de l'École d'architecture
Direction des parcs, jardins et espaces verts
de la Ville de Paris
École d'architecture de Paris-La Villette
ESME-Sudria
Espaces 3D - P. Garret
Fondation Florence Gould
Foundation for French Museums
France Télécom
Hewlett-Packard, Division grand public
Imprimerie Kheops, Pulversheim
Imprimerie Smic, Montbrison
Institut de France
Institut géographique national
ISTAR, Sophia-Antipolis
Maison européenne de la photographie
Ministère de la Culture et de la Communication, Patrimoine
photographique, Direction de l'architecture et du patrimoine
Minolta
Nemo
Oktal
Ondim
Préfecture de police de Paris
Renault Design
17ᵉ rencontres Image et Science
Groupe SECA
Silicon Graphics Computer Systems
Simteam
Le Stéréo-Club français
Trimaran

With the support of:
ACD Girardet et associés
AJN architecture Jean Nouvel
Alias et Wavefront
Artefactory
Atelier Christian de Portzamparc
Atelier holographique de Paris
Atelier parisien d'urbanisme
Bergger
Centre culturel canadien, Paris
La Cité des sciences et de l'industrie
La Cité internationale des arts
CNRS Images Femis-Cict
Commissariat à l'énergie atomique
Pierre Corman
École nationale des sciences géographiques
École nationale supérieure Louis Lumière
Électricité de France
Exmachina
L'hebdomadaire *L'Express*
Fédération française de tennis
Feichtinger Architectes
Fondation Électricité de France
Fondation Patino
Fondation Pro Helvetia
Fricout-Cassignol Architectes
Etat et Ville de Genève
H3D
Initial Labo Photo
Institut d'études supérieures des arts
Institut et centre d'optométrie de Bures-sur-Yvette
Institut national de la propriété industrielle, Paris
Jakob et Macfarlane
JMG Graphics et le CIRAD de Montpellier
Kodak
L'Autre Image
Media Relief
Médialab
Le Métafort d'Aubervilliers
Marc Mimram
Ministère des Affaires étrangères et du Commerce
international, Canada

Musée de l'Holographie
Musée Roland-Garros
Palais de la Découverte, département physique
Gérard Perron
Publimod'photo
Philippe Pumain
Push-Tac
RATP
Reichen et Robert
Sarea Alain Sarfati
Jean-Louis Schulmann
Société d'exploitation de la tour Eiffel
Société française de photographie
Soval
Spéos
Studio Gui
Nadir Tazdaït
TDLK Thierry Deschaumes
Thomson
3Dx Laboratory
Vendôme Rome
Dina Vierny
Eddie Young

We would also like to express our gratitude for the invaluable support given by all the departments of the City of Paris, including the Photothèque des Musées for the reproduction of documents, the Atelier de Restauration et de Conservation des Photographies for the restoration of the photographs on show, the Département des Arts Plastiques for its contribution to artistic projects and the Ateliers d'œuvres d'Art d'Ivry for preparing the prototype of this exhibition, by all the administrative, scientific, security and technical staff at the Musée Carnavalet and by everyone who assisted the team during the exhibition and book preparation: Alice Barzilay, Laurence Bellot, Carol Bergami, Christiane Dole, Elisa Gabriel, Sophie Hedtmann, Julie Mauclert, Armelle Maugin, Gilles Menegaux and Bruno Tessari. We should also like to thank Michel Imbert who helped us gain a better understanding of the neurological implications of three-dimensional vision, and all those whom we could not mention here but whose support, expertise and efficiency enabled us to bring this project to fruition.

Our thanks also to Maryvonne Deleau and, last but not least, at Paris-Musées, Pascale Brun d'Arre, Denis Caget, Sophie Kuntz, Karin Maucotel, Claire Nenert, Arnaud Pontier, Virginie Perreau, Judith Vincent, as well as their collaborators.

The 'Paris en 3D' exhibition was produced by Paris-Musées and designed by Architecture Studio.

Contents

Introduction

Life on the Level — Michel Tournier — 11

Paris and 3-D photography — Françoise Reynaud, Catherine Tambrun and Kim Timby — 13

Three-dimensional perception — Jacques Ninio — 17

Realism and its detractors — Anne McCauley — 23

Surface space. Instrumental depth — Michel Frizot — 31

The magic of 3-D — Hubert Damisch — 37

1 The golden age of stereoscopy 1850-1880
Haussmann's Paris. Banks of the Seine. Napoleon III and Empress Eugénie. 'Bal Bullier' dance hall.
A House in Paris. World Fairs. The Commune. Photosculpture. Models and eroticism

The origins and development of stereoscopy — Denis Pellerin — 43

Photosculpture – the fortunes of a sculptural process based on photography — Philippe Sorel — 81

File BB3 and the erotic image in the Second Empire — Denis Pellerin — 91

Stereoscopic devices — Jacques Périn — 100

Chronology 1830-1880 — 102

2 New ways of creating 3-D images 1880-1940
Stereoscopic explorations. Jacques Henri Lartigue's beginnings, 3-D printing.
Louis Lumière and 'photostéréosynthèse'. Anaglyphic advertisements. Inventors and patents.

Amateur stereoscopic photography: the example of the Stéréo-Club Français — Clément Chéroux — 107

The anaglyph, a new form of stereoscopy — Denis Pellerin — 121

The 'feeling of life': the birth of stereoscopic film — Laurent Mannoni — 137

Photostéréosynthèse: a new approach to 3-D photography — Michel Frizot — 145

Line screen systems — Michel Frizot — 153

The inventors of 3-D photography in France: patents 1852-1922 — Kim Timby — 159

Chronology 1880-1940 — 166

3 The modern age 1940-2000
3-D in colour. Portraits and postcards. Holograms. Computer imagery. Architects and 3-D.
Modern town-planning. Contemporary creation using 3-D. Paris from the sky.

Lenticular screen systems and Maurice Bonnet's process — Michel Frizot — 171

Holography in Paris — Jean-Marc Fournier — 193

Stereo-reality and other dimensions — Odile Fillion — 213

Three-dimensional relief — Anne-Marie Duguet — 225

Artists and contemporary art — Françoise Reynaud — 234

Stereoscopy and aerial views — 264

Chronology 1940-2000 — 276

Sources and bibliography — 278

Glossary, index, photographic credits — 282

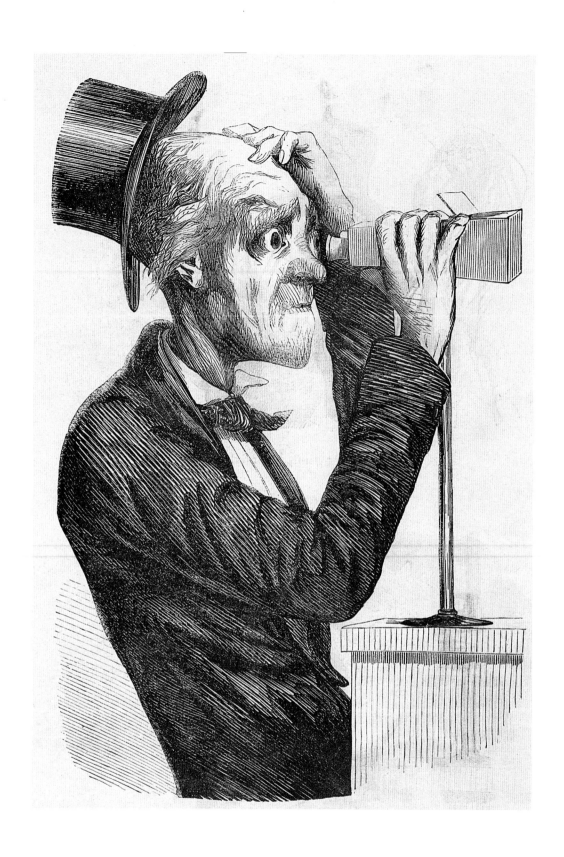

Life on the Level

Michel Tournier

The optician put down his ophthalmoscope and, watching me with unmistakable curiosity to gauge the effect of his words, said:
– 'Well, there you have it! It's quite simple, you're blind in one eye.'
– 'Blind in one eye? But I've got two eyes and I can see with both of them!'
– 'You may be able to see with two eyes, but not with both of them at the same time. You're short-sighted in the right eye and long-sighted in the left. And because of these defects, your eyes take turns to see. Suppose there is an object twenty centimetres from your face.'
From the table he picked up a small frame with some letters written on it.
– 'You can see this perfectly. But only with your right eye. The object is much too close for your left eye, which is taking a rest for the time being. If I move the object further away, like so, it's now fifty centimetres from you. Your right eye begins to strain, but your left eye – the long-sighted eye – wakes up. Another ten centimetres and the deed is done. Your right eye gives up and allows its neighbour to take over, which it does so promptly that you don't notice a thing.'
– 'Amazing! How highly developed I am! How clever my eyes are! Indeed, since we have two eyes, why not allow them to specialize and to share their work?'
– 'Don't gloat too much,' said the optician.
– 'Everything's fine, in fact, so long as you don't place too much importance on three-dimensional vision.'
– 'Is that because I don't see things in three dimensions?'
– 'Of course you don't. If you want to see things in three dimensions, you have to see them with both eyes at the same time. The impression of three-dimensionality is created by the slight discrepancy between the two images – which are similar but not identical.'
– 'So I'm living in a two-dimensional world?'
– 'Yes, you're looking at a flat world. You can see right and left, top and bottom, but absolutely no depth. You have the vision of a man who's blind in one eye.'
– 'Incredible! So what can I do?'
– 'I'll make you a pair of glasses that will enable you to see with both eyes at the same time,' promised the optician.

Three days later, I came out of his shop wearing this contraption designed to make my eyes cooperate perfectly with each other. I immediately had to step to one side to allow a woman to enter. Did I say a woman? A nose, more like it; a nose with a woman behind it. I'd never seen a nose like it in my life. Immense, interminable, sharp, pointing at me like a stork's beak.

Then I was out in the street. Did I say street? It was more like a stampede, it was hell on earth. Fangs bared, sabres upraised, lances deployed, angry bulls on the rampage. The cars bore down on me like a pack of rabid dogs, passers-by converged on me, missing me by a whisker at the last possible moment. Objects reared up in my face like cobras. I was the focus of a unanimous, widespread and ubiquitous hatred.

Finally, I performed a life-saving manoeuvre. My folded glasses disappeared into my pocket. Such sweet relief! The paper-thin passers-by and cars glided past, like ghosts on a canvas. The buildings merged into a harmless backdrop. Once more tender and graceful, the women paraded across the page of a fashion magazine. This was how I discovered the secret truth about four universal and antithetical human gestures. Firstly, the flat of the hand outstretched for a friendly handshake as opposed to the tightly balled fist ready to strike a blow or at least add weight to a curse. But, most importantly, a smile, which is the flattest of all gestures and the one best suited to two dimensions: the mouth splits widthways, the eyes crinkle. It is the glorious symbol of two-dimensional life. Children are only too aware that when they stick out their tongue, they are, on the contrary, rediscovering the third dimension with a grimace that is the opposite of a smile.

Francis Bacon and Raoul Dufy. The glasses had plunged me into Bacon's absurd, aggressive and distorted universe. By taking them off, I had rediscovered the graceful floral patterns, cheerful motifs and flat birds of a painting by Dufy.

*Des clefs et des serrures
(Keys and Locks)
Chêne/Hachette, Paris, 1979*

Man looking into a stereoscope, 1859
Illustration in *Le Petit journal pour rire*.

Coll. Denis Pellerin.

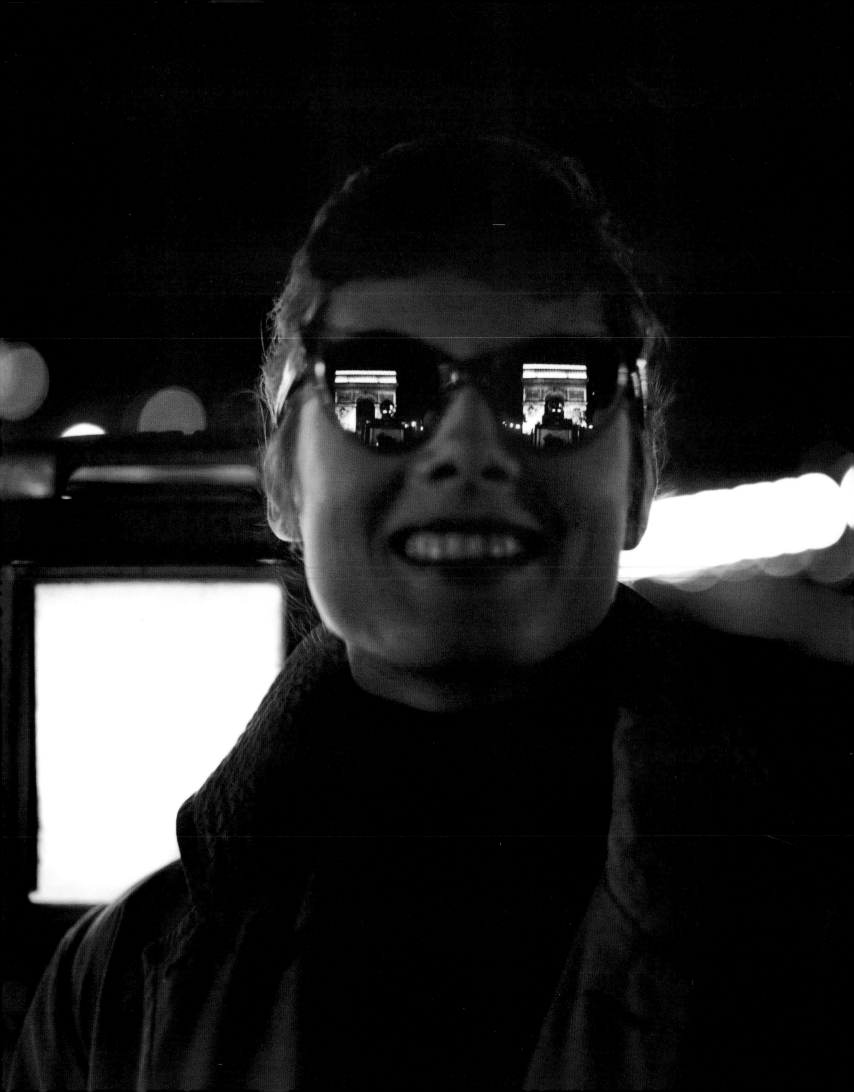

Paris and 3-D photography

Françoise Reynaud, Catherine Tambrun and Kim Timby

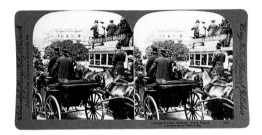

Berry, Kelley & Chadwick, **Traffic jam
on the Champs-Élysées**, before 1904
Stereoscopic view, gelatin silver print. Inscription
in English: 'Champs-Élysées, Blocked. Paris, France. 1802
Copyright 1904, by William H. [...]'; mount 17.7 x 8.7 cm.

Coll. Wim van Keulen.

Robert Doisneau, **Paris monuments**, 1955
Modern gelatin silver print; 23.8 x 17.8 cm.

Coll. Agence Rapho.

The double reflection of the Arc de Triomphe in the young
woman's glasses can be viewed in three dimensions. When
taking this and several other similar photographs, Doisneau
probably did not know he was creating 3-D images.

The fascination of three-dimensionality

Carriages driving up and down the Champs-Élysées, a colourful crowd milling around
the buildings of the Great Exhibition of 1900: the viewer gazes deep into these scenes,
examining their every nook and cranny. The three-dimensional effects of these images
exercise extraordinary fascination. Various figures jump out at us – this time in colour –
holding out shiny objects which seem within easy reach.

We are fascinated by these images because they create an impression of depth and
presence that no other type of representation – paintings, drawings, engravings, posters
or even video or cinematographic sequences – has ever equalled. How are they
produced? How can motifs which at first sight are invisible, stand out from or fall back
into a flat surface, taking shape within three-dimensional space?

To create an impression of three-dimensionality, at least two slightly different
photographs combining two points of view are needed. As a result, 3-D images,
whether stereoscopic, anaglyphic, line screen, lenticular, holographic or virtual, are
plural images – in other words, groups of images. In certain techniques, the points of
view comprising the three-dimensional image are immediately discernible by the viewer;
in other cases, they are not visible at first sight and can only be perceived with the aid
of a special viewing device.

A wide variety of techniques

Invented in the nineteenth century, around the same time as colour and motion
photography, the technique of producing three-dimensional images was the logical
outcome of the great advances made in photography. This invention generated such
keen interest that hundreds of thousands of images were produced on all types of
media (daguerreotypes, glass, paper, film). For a time, these images were even more
popular than ordinary photographs. Stereoscopy, which was simpler and less
expensive, was the first technique to attract attention. Later, more sophisticated or
experimental techniques such as lenticular systems or holography – often too expensive
or overly complicated for widespread application – gave rise to a smaller number of
works which were sometimes even more highly sought after because of their very rarity.
In the end, the success of these different processes depended less on the quality
of the three-dimensional effect created than on the cost of production.

Many scientists carrying out research into photographic representation made it
their goal to improve this new form of iconography and introduce it to a wider audience.
In this climate of often fierce economic competition, some of them succeeded in
presenting their invention at the Académie des Sciences, the institution where Arago
had announced the discovery of photography, while others, with a greater or lesser
degree of success, endeavoured to promote and sell their processes unaided.
This period saw the registration of many patents, the formulation of many inspired
improvements by unknown inventors and the development of many systems by
leading scientific figures or enthusiastic amateurs. Countless prefixes and suffixes
were combined endlessly to describe these inventions which sometimes proved to
be largely linguistic. It might be thought surprising, in fact, that no one ever produced
an 'auto-holo-photo-stereo-anabio-glyphogram'!

However, after this resounding success, 3-D images gradually sank into almost

14 complete oblivion. Consigned to cellars and attics and stored in laboratory archives, they were largely forgotten by their owners. This loss of interest was due to an accumulating number of constraints: high production costs, special lighting conditions, almost systematic recourse to specialized accessories (lenses, red and green glasses, etc.), as well as some people's inability to see 3-D images or, on the other hand, their ability to see them too clearly: it was not unusual for the extremely lifelike lenticular portraits dominating drawing rooms to be relegated to less prominent places because of their rather unsettling hyperrealism.

The utopia of the 'total image'
'Imagination is so insatiable that it needs very little assistance'.[1]

The concretization of objects in three-dimensional space was not necessary for photography or the animated image to become immensely popular, because the imagination is usually sufficient for the recreation of the impression of depth unaided. However, 3-D images possess an intrinsic richness. Initially in great demand for their dramatic impact, they have also been progressively developed in a more scientific manner.

Present-day techniques for producing computer-generated 3-D images have aroused new interest in this field. Extensive investment has been made in the simulation of different aspects of reality (such as flight, architecture or medical operations). 3-D is widely used in computer games, advertising and Internet websites and, with virtual reality, we have entered a world without gravity: we can stroll down the streets of Paris, take a walk around the Place de la Concorde or fly over the banks of the Seine with the greatest of ease. These new images may well be allowing us to continue our pursuit of the age-old – and unrealizable – utopian dream of creating an identical facsimile of physical life, the ancient fantasy of obtaining an integral and dematerialized image.

We have already entered the era of virtual reality. But how many of us remember that, in nineteenth-century Paris, one could have a 3-D portrait taken and that stereoscopic photographs were as popular as television is today?

Paris and the 3-D image
In fact, the first process for creating 3-D images, the stereoscopic photograph, was launched in Paris in the 1850s. *La Marseillaise*, Rude's famous bas-relief sculpture on the Arc de Triomphe, is probably the oldest Parisian motif viewed in a stereoscope. About ten years later, in the middle of the Second Empire, these images were so popular that a guide for international visitors to the capital, published in 1863, made

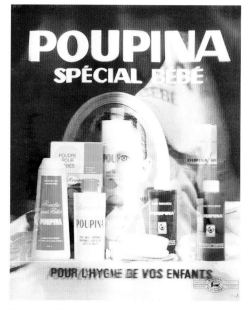

Michel Sarret/Relieforama, **Advertisement for Poupina toiletries**, after 1967
Lenticular photograph, transparency glued to thick screen. Transparent label with inscription in French: 'RELIEFORAMA/ DE LA VASSELAIS/ maurice bonnet process/ C.N.R.S. licence/EXCLUSIVE RIGHTS 4 rue CIMAROSA/75 Paris 16'; 30.0 x 3.9 cm.

Coll. Michel Frizot.

Viewed from a different angle, this three-dimensional image shows a baby's face, also in 3-D.

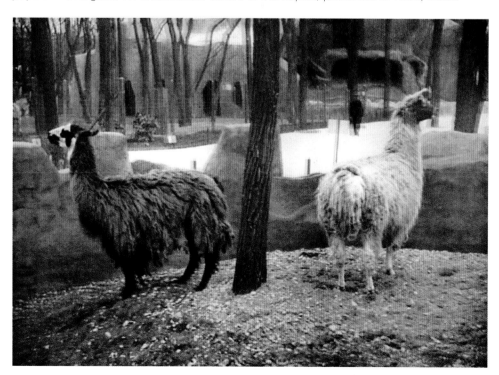

Anonymous, **Llamas at the Vincennes zoo**, c. 1937
Printed anaglyph, plate from the album: *Zoo de Paris en relief par les anaglyphes*, Les Editions en anaglyphes; 21 x 27 cm.

Coll. Musée Carnavalet.

Anonymous, **Carnival float**, early twentieth century
Stereoscopic view, modern print from a gelatin silver
negative on flexible film; images 7.7 x 17.2 cm.

*Coll. Société Française de Photographie, catalogue
no. 1070/99.*

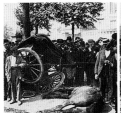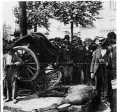

Société Industrielle de Photographie,
Carriage accident, c. 1900
Stereoscopic view, gelatin silver print. Inscription: no. '23';
printed on reverse: 'Société industrielle de photographie,
Rueil (Seine-&-Oise)'; mount 8.8 x 18.0 cm.

Coll. Pierre-Marc Richard.

special mention of them under the heading of 'Photography', and provided valuable information for travellers wanting to buy 3-D souvenirs of their visit to Paris[2]. In 1864, after a visit to Europe, Oliver Wendell Holmes (1809–1894), a Boston doctor and avid collector of stereoscopic views, commented 'Views of Paris are everywhere to be had, good and cheap'.[3]

The body of 3-D photographs produced in Paris, from the mid-nineteenth century to the present day, somewhat resembles a surrealist inventory: zinc palm-trees on a barge-bathhouse on the Seine, a llama at the Vincennes zoo, skeletons wearing crinolines, a woman sticking out her tongue, a stuffed fox, a giant fish, a chrysomelid beetle, a bottle of champagne, a ham market and a competition for flying bicycles!

These incredible photographs, taken both by professional and amateur photographers and by artists, allow us to reconstruct the history of the capital or illustrate certain aspects of it in a highly original way. This is true, for example, of the nineteenth-century stereoscopic views which, unlike other photographs of the same period, whose large negatives required long exposure times, used smaller negatives and were therefore able to take much faster photographs. Moving subjects, like passers-by and vehicles – usually non-existent in other photographs – could therefore be recorded. To underline this quality, some of these series of stereo images were actually labelled 'Instantaneous Views'.

As a result, chronicling the birth and development of 3-D photography in Paris provides the ideal opportunity to rediscover entire sections of the city's past, whether architectural (the construction of Les Halles and the wide modern boulevards), social (a visit to the dentist, a satire on crinolines) or historical (the Great Exhibitions, the wars).

The story which unfolds in the pages that follow is an invitation to a journey through space and time, in which Paris can be seen as both backdrop and protagonist in a play written by a poet whose main theme is the exploration of the third dimension. 3-D images plunge us into strange and unexpected worlds, helping us to understand individual creative processes. They also prompt us to examine our own ways of viewing the world around us.

Never before published, these images await discovery. As we gaze at people strolling across the windswept Pont des Arts bridge or along the streets of Paris, each picture is a window onto an entire world.

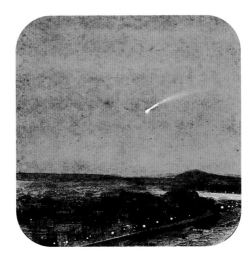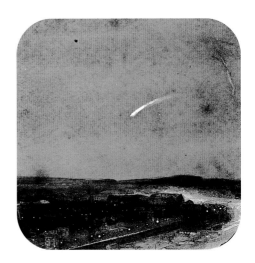

Anonymous, **Comet of 1858**, c. 1858
Stereoscopic tissue view, albumen print with cut-outs,
coloured on reverse; mount 8.5 x 17.2 cm.

*Coll. Harry Ransom Humanities Research Center,
University of Texas at Austin, catalogue no. S1957.*

1. Georges Didi-Huberman, *Ce Que Nous Voyons, Ce Qui Nous Regarde*, Editions de Minuit, Paris, 1992.
2. Adolphe Joanne, *Le Guide Parisien*, Hachette, Paris, 1863, pp. 38–39.
3. Holmes, co-inventor of the Holmes-Bates stereoscope, wrote for the *Atlantic Monthly* magazine from 1859 to 1864.

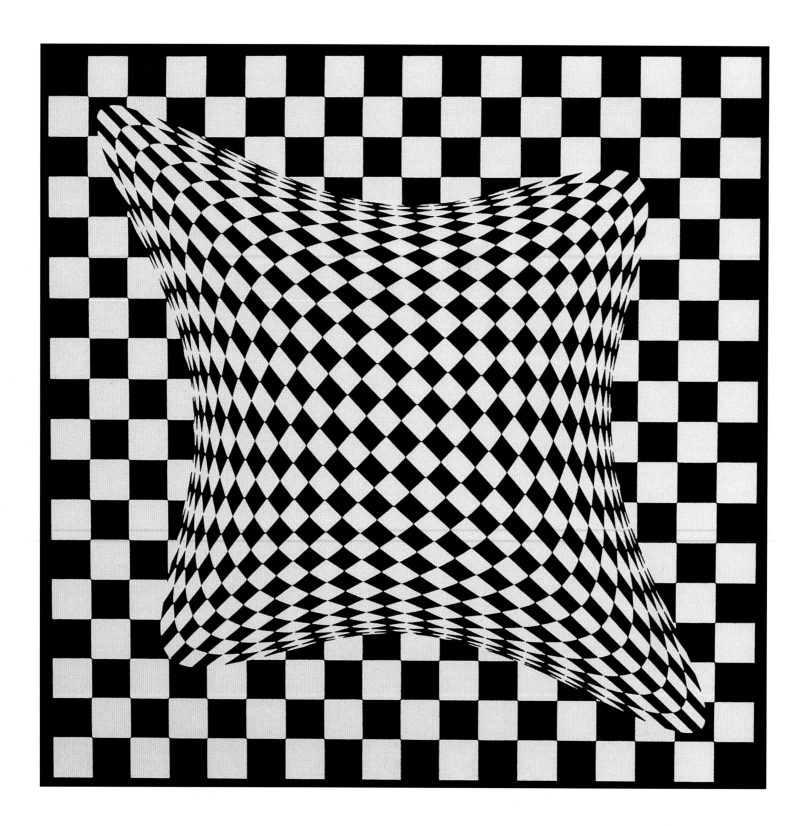

Figure 1, **The Claparède effect**
Look at this image through a narrow tube, for example
through a rolled up piece of paper or a curled hand, placed
against one eye. The texture will acquire a relief similar to
stereoscopic relief.

Jacques Ninio

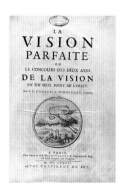

Chérubin d'Orléans, **Title page and illustration from**
La Vision parfaite ou le Concours des deux axes
de la vision en un seul point de l'objet, Paris,
Sébastien Marie Chamoisy, 1677

Coll. Société Française de Photographie.

A brief historical overview

People need both of their legs to walk, but are two eyes really necessary to see? In normal circumstances we can get by with just one eye to orientate ourselves in space, recognize objects, read or perceive colours. For a long time the fact that we see with two eyes at once – binocular vision – remained a puzzle. Why, wondered the eighteenth-century naturalist Buffon, do we not see double?

The images received by each eye are slightly different and these differences are accentuated when we look at something very close. If an object is held close to the eyes and at an equal distance between them, each eye will see a side of the object not seen by the other. With both eyes we see both sides simultaneously, as Euclid observed around 300 BC. This kind of representation does not accord with Western perspective and is closer to the inverted perspective of the East.

In the fifteenth century Leonardo da Vinci provided an even more curious example of the difference between *monocular* (one-eyed) and *binocular* (two-eyed) vision. An object in a painting covers all the space behind it. Yet in reality we can see past a small object, since what is hidden from the left eye is visible to the right and vice versa. Painting thus reflects reality only as it is seen with one eye, and only in this sense can it be said to create an illusion.

Around 1600 Kepler explained the geometrical aspect of the formation of images on the retina and people began to think that using both eyes together provided a way of gauging the distance of objects through a process of triangulation. Descartes suggested the metaphor of a blind man who locates an object by touching it with the tip of a stick held in each hand. This theory was widely adopted.

Between Euclid and Descartes the focus shifted from the relation of binocular vision to the *shape* of objects to its relation to their *distance*, and the aspect of distance dominated from the seventeenth century until recent years. In this tradition, vision was thought to function like a camera's telemeter: the distance to the object viewed would be gauged by making the two images formed at the end of two different optical paths coincide. The eyes would converge on the area being looked at, so that the two images would be brought to 'corresponding points' on the two retinas. The area would then be seen in focus. Everything in the nearer or further distance would be seen double.

In practice, although some people do naturally see double outside a given area, others almost never experience double vision. According to Helmholtz,[1] 'people whose attention is drawn to binocular double images for the first time are very surprised never to have noticed them before'.

The modern version of the other tradition (that of 'shape') may have originated in descriptive geometry, which appeared in the second half of the eighteenth century. This branch of geometry shows how to infer the three-dimensional form of curves in space from two projections on two perpendicular planes. For decades engineers represented machines in this way, using drawings showing views projected on different planes: front view, top view and side view. The three projections in conjunction could be interpreted to give the three-dimensional shape.

In 1832 Wheatstone invented the stereoscope or, one should say, stereoscopic imagery. The instrument itself is nothing extraordinary; the real discovery was conceptual. The stereoscopic images developed by Wheatstone were pairs of drawings representing

18 two projections of a figure on a single frontal plane, as they would be seen by two eyes (or two photographs taken with cameras in the place of two eyes)[2]. In terms of angle of vision, seeing these two projections or two photographs was the same as seeing the object in space (Fig. 2, left). Wheatstone thought that the ability to infer relief resulted from the comparison of the two retinal images, and particularly from the 'horizontal disparities' or the discrepancies in the position of the same points in the two images (Fig. 2, right). It isn't necessary to use a stereoscope to view stereoscopic images, at least where small images are concerned. Wheatstone invented the instrument as a teaching tool, to show others what he himself could see quite clearly without it. A little training enables people to interpret stereoscopic images with the naked eye (Fig. 3), using either crossed vision (where the left eye looks at the right image while the right eye looks at the left image) or parallel vision (where each eye looks at the image on its own side), the latter being a more difficult method in which the images must be closer together than the eyes.

 Seeing in three dimensions was no longer thought of in terms of calculating

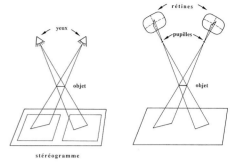

Figure 2, **Stereograms and retinal images**
A stereogram is formed by two projections on the same plane of an object in space, the projections being produced from the optical centres of the two eyes (left-hand figure). In principle both eyes receive the same information, whether this comes from the object itself or from a stereogram. Leaving aside any deviations made by the rays as they pass through the optics of the eye, the two retinal images are also projections, but on different surfaces (right-hand figure).

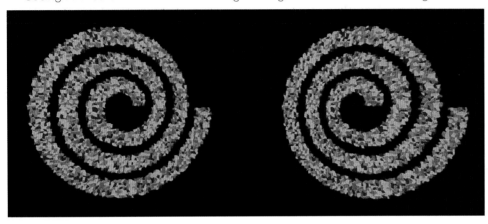

distances from point to point, like Descartes's blind man with his sticks; it had become a question of comparing two images treated as two complementary projections, as in descriptive geometry, and exploiting their differences in order to deduce their three-dimensional shapes. These comparisons (Figs 4 and 5) seemed to be based on the 'horizontal disparities' – in other words, the small differences in the relative positions of near and distant objects – and the 'orientational disparities' – the effects of perspective that modify the orientation of plunging lines.

 Today some people still speak of the 'illusion of three dimensions' provided by stereoscopic images. Others, including scientists, err on the other side and talk as if three dimensions are created only by stereoscopy, so that the world flattens out as soon as we close one eye, an illusion few of us experience in practice.

Ordinary clues of relief

We can infer volume even with a single eye, using what are known as monocular indicators. In a method systematically exploited by the chiaroscuro painters, effects of light and shadow, reflections, gradations of light on the surface of objects and the stretching and compression of textures are used to give an idea of shape.

 Where distance is concerned, several indicators have long been recognized, including the effects of aerial perspective (distant objects look more blue and their texture is seen in less detail), interposition (if one object partially hides another, it is because it is in front of it) and apparent size (if we have an idea of the object's real size, its apparent size gives us an idea of its distance). Distance can also be judged more rigorously by the effect of parallax. Instead of comparing the images seen by each eye, the head is moved from left to right, thereby changing the point of view. Distant elements are in turn hidden and revealed as a result of the relative displacement of nearer objects, and this helps us get a sense of the overall depth of the scene.

 To infer relief in a photograph, as we regularly do, is one thing, to experience it as a physical reality coming out towards us is quite another.[3] The sensation of a three-dimensional presence can nevertheless be felt without stereoscopy, using only one eye (Fig. 1). Any method that makes the image's support less obvious and, in particular, that causes its frame to disappear, will help create a three-dimensional effect. Such methods

Figure 3, **Seeing in three dimensions**
People with stereoscopic vision can use several techniques to see a pair of stereoscopic images in relief without the use of an instrument. Initially the two images (here two spirals) must be 'fused'.

 An effective method by which beginners can achieve this is to place the two images very close to the eyes, and then gradually move them away. There comes a point when an image of the spiral is seen in the centre, either alone or accompanied by spirals to the left and right. At this point the observer should try to retain the image of the central spiral for as long as possible and wait for it to become three-dimensional. Another method is to hold the tip of a pencil at an equal distance from the spirals and to keep looking at the tip as you bring it closer to your nose, holding it still when the central image appears. You can also hold your head still and run your eyes backwards and forwards across the image in a sweeping motion.

 When the spiral appears in three dimensions, note how the coil is orientated so that it appears to rest on a cone. In fact what we are observing is a 'peeled cone', whose tip points away from those looking at it with the cross-viewing technique (using the right eye to see the left-hand image and the left eye to see the right-hand image) and towards those observing it using the parallel viewing technique (each eye seeing the image on its own side).

 Like intelligence, stereoscopic vision cannot be measured on a single scale. People who do not do well in tests using certain types of stereograms may do very well with other types.

Figure 4, **Stereoscopic indicators**

These photographs of two obelisks were taken from points 6 metres apart, a distance about a hundred times greater than that between the eyes. Three things are immediately apparent:

1) The respective displacement of the two obelisks to the left or right: in the right-hand image the standing obelisk, in the background, is further to the right of the obelisk on the ground than it is in the left-hand image. This relative displacement is known as 'horizontal disparity'.

2) A comparison of the points of the fallen obelisks reveals that the corresponding edges in the two images do not have exactly the same orientation. The difference in the angle of the corresponding orientations is known as 'orientational disparity'.

3) Finally, by observing the square formed by the base of the point of the fallen obelisk, it can be seen that the length of the vertical sides appears to be different. In the photograph on the right, the right-hand side of the square appears longer than the left-hand side, and vice versa in the photograph on the left. This is linked to the fact that the camera was turned toward the point of the obelisk when the pictures were taken. This effect is known as 'vertical disparity'.

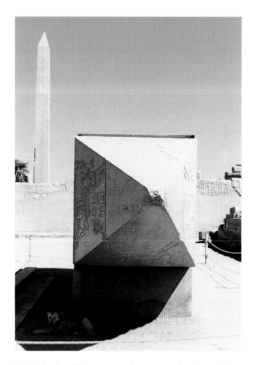 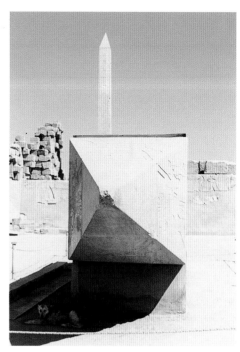

include looking at a photograph through a narrow tube placed against one eye, seeing it reflected in a mirror and looking at it using binocular vision but with the image in focus for one eye only. An excellent three-dimensional effect can be obtained by looking at transparencies through an enlarger. The magnifying lens reduces awareness of the frame and the transparency of the image makes its support seem less present.

Stereoscopic relief

When we examine a pair of stereoscopic photographs, purely stereoscopic relief combines with monocular clues of three-dimensionality. How can this stereoscopic effect be recognized? In principle, by a simple test: look at a three-dimensional image through the stereoscope, then close one eye. The difference between the two perceptions gives an idea of the contribution made by stereoscopy. When the left- and right-hand images in a stereoscopic pair are inverted (pseudoscopy), all the monocular indicators remain, but the stereoscopic indicators suggest the inverse relief. As long as we are looking at a regular continuous surface, this front-to-back inversion poses no problems. The hollows turn into humps and vice versa. But when one surface is in front of or behind another, such interposition gives rise to 'monocular' areas, shown on only one image of the pair. The arrangement of these areas provides clues that contradict the horizontal disparities and the brain finds it very hard to construct a coherent interpretation of the pair. At first one sees the usual relief, then a surface that was formerly convex starts to hollow out; this effect spreads from one part of the picture to another until the whole interpretation is reorganized to account for the inverted distances.

A photographer fascinated by stereoscopy is sorely tempted to depict scenes involving striking relief. Too often in such cases the monocular clues of three-dimensionality are sufficient and stereoscopy becomes a kind of pleonasm, adding little to the image. In my view it is better to find subjects whose relief is hard to discern using the usual indicators. In such images the emergence of an unsuspected three-dimensionality through the effects of stereoscopy alone is very gratifying (Fig. 5).

Old stereoscopic photographs often depict distant buildings. As the two views are taken from points six or seven centimetres apart, the geometrical differences between the left- and right-hand images of the buildings cannot be exploited. However, the photographer often included an object in the near foreground – such as a wall or the branch of a tree – and at once we sense a great separating depth between the anecdotal foreground and the building being photographed.

The operations the brain performs to calculate relief by comparing the two parts of a stereoscopic image are fairly slow. It takes at least fifty milliseconds to tell whether one surface in the image is behind or in front of another. From this it can be estimated that the brain acquires information about relief at a rate of around twenty units per second.

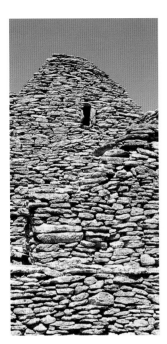

Figure 5, **Stone cabins near Gordes in Provence.**
Their structure becomes clearer in stereoscopic vision.
Cover the right image for cross-viewing, and the left image
for parallel viewing.

Stereoscopic photographs in which exploitable geometrical differences exist on all surfaces are very rare. The brain calculates the relative depths of a small number of reference points on each image and constructs a three-dimensional representation in which these reference points are positioned in depth in accordance with the result of the calculations. At first, the rest of what is perceived in three dimensions is most probably inferred from the usual monocular indicators; but little by little the relief that is calculated using stereoscopy gradually adds detail to – and corrects if needed – the relief obtained by other methods (see, for example, Fig. 5). If the viewer lacks skill,[4] three dimensions will form in specific areas only and will dissolve as the eye moves, while the more skilful viewer will create a complete three-dimensional interpretation in which the acquired elements gradually come together in a harmonious way.

The contribution of stereoscopic vision

It is primarily through laboratory experiments, particularly those using camouflaged stereograms, that it has been possible to identify precisely what stereoscopy contributes to vision.

When appropriate reference points are available, stereoscopy initially provides the direction of curvature of the surfaces: are they flat, convex, concave or a combination

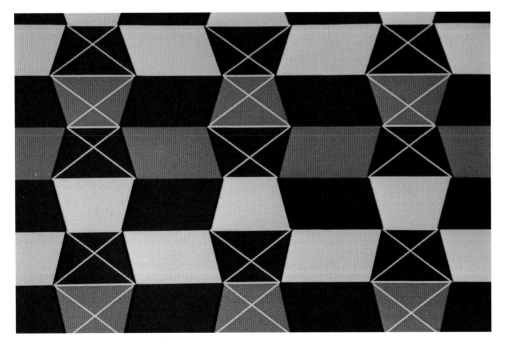

Figure 6, **Quadrilaterals**
Stereoscopic vision clearly tells us whether or not four
points in space are on the same plane. When the
central column with Xs is fused with the corresponding
column on the right or left, it becomes apparent that the
two branches of an X are not on the same plane and
form the sides of a tetrahedron. In the same column,
even when the Xs are not present, it can be seen that
the quadrilaterals are not flat.

of convex and concave? In this it is more successful than telemetry. Let us imagine four points in space, A, B, C and D, and let us suppose that we know both their directions and distances. Are these points on the same plane? We would have to make some exact calculations using their coordinates to find out. Most viewers can 'see' at once if a surface represented in a stereogram consists of flat sections or not (Fig. 6), whereas other people can identify only the distance relations ('some parts are in front, others behind'), with no certain sense of flatness.

With only a few precise reference points and in the absence of monocular indicators, stereoscopic vision can make us see complete well-formed surfaces in a way not dissimilar to that by which a skilled artist can suggest a complex three-dimensional shape with only a few separate lines.

Stereoscopic vision also provides the orientation of lines and surfaces, but with a degree of relativism. We should not forget that in natural sight, the further away an object is, the more compressed it is in terms of depth (for instance, as witnessed in the flattening effect in photographs taken with a telephoto lens). For the same reason a slope looks steeper as we move further away from it. So a three-dimensional shape changes depending on how far away it is. Does stereoscopy calibrate the third dimension and how does it convey depth in relation to the two frontal dimensions? The specialists continue to argue over the indicators (particularly 'vertical disparity' – see Fig. 4) used in the calibration of distance. Here we should note that the same observer may, at different times, see the same stimulus with more or less depth. Furthermore, stereoscopic vision seems to place objects within a given volume, accommodating them – even making them turn if need be – so that their depth is not too great.

One remarkable property of human stereoscopic vision, compared to the sight with which robot designers are trying to endow their machines, is its extreme flexibility and tolerance where distortions of the image are concerned. While a robot programme needs to have fairly detailed knowledge of the way the cameras were configured when the images were taken, the human brain can do its work of stereoscopic interpretation even if it has no access to data concerning the exact position of the eyes.

Specialists also argue about monocular regions – those areas that are present on only one of the two images due to the interposition of one surface in front of another. Some people are sensitive to these and identify them as areas where the image is not clearly defined. This does not always prevent them from seeing these areas in three dimensions. Some see them as flat, others as continuing the surface in front or behind them, while yet others see them as links between these two surfaces. Specialists believe that these areas, which are a little harder to see, probably – and paradoxically – provide great assistance to the brain, since they help it define which parts of the two images it must match up.

Neurophysiologists have naturally wanted to find out which neurones are involved in stereoscopic vision and to understand how they work. However, there are currently very few studies linking stereoscopy as it is described by the neurophysiologists, which is mainly based on the detection of segments orientated in space, and stereoscopy as it is studied in experimental psychology using stereograms, which do not generally contain oriented segments. Most neurophysiologists believe that there is a system of fixed correspondence between the neurones of the two retinas that receive the image of a particular point in space. Such a system does not seem very compatible with the fact that the eyes move the one with respect to the other, so that the configuration in which visual information is acquired is highly variable.

1. Hermann von Helmholtz (1821–1894), the great German physiologist and physician.
2. Photography officially came into being in 1839. This new technique enabled Wheatstone to prove his theory completely. (See the article on stereoscopy by Denis Pellerin in Chapter 1.)
3. All people do not have the same degree of binocular vision. There are all kinds of differences, although deficiency can sometimes be improved with training. It is generally accepted that between 10 and 15% of the population do not use stereoscopic vision (although they can identify relief using other means than binocular vision). There are different reasons for this such as, for example, lack of sight in one eye. Up to 30% of the population have some difficulty seeing stereoscopically (Editor's note).
4. Someone with poor stereoscopic vision.

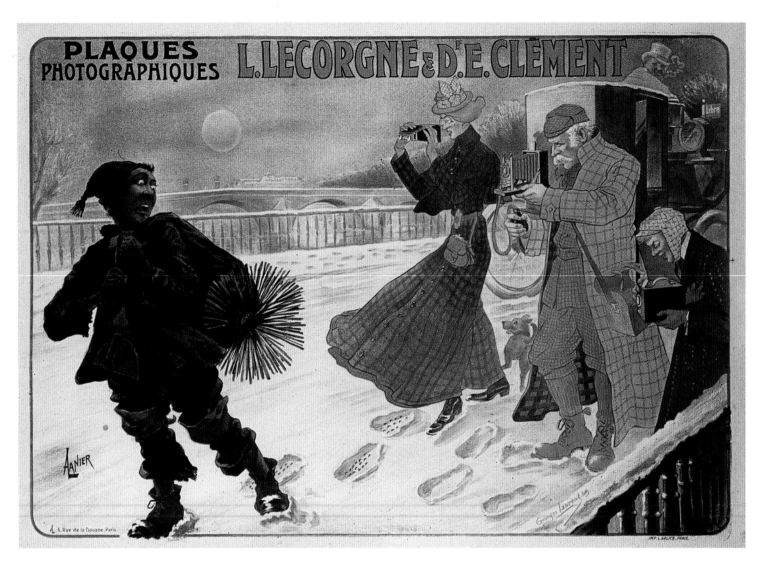

A. Lanier, **A chimney sweep being photographed on the Pont du Carrousel**, c. 1900

Poster for L. Lecorgne & d'E. Clément photographic products; 100 x 140 cm.

Coll. Musée de la Publicité, catalogue no. 14393.

Anne McCauley

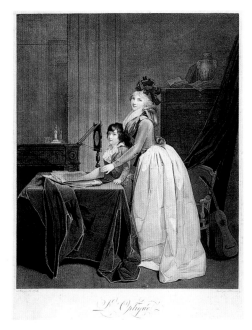

J.-F. Casenave after Louis Léopold Boilly, **Optics**, 1790
Engraving with coloured aquatint; 66.0 x 49.9 cm.

Coll. Musée Carnavalet, catalogue no. G13076.

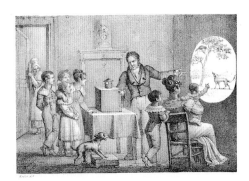

Jean Henri Marlet, **The Magic Lantern**, 1827
Lithograph; 21.3 x 26.8 cm.

Coll. Musée Carnavalet, catalogue no. 'Mœurs' 103/3.

*The deception inherent in [the painter's] work is pleasurable and involves no reproach,
for to confront objects which do not exist as though they existed and to be influenced
by them, to believe that they do exist, is not this, since no harm can come of it,
a suitable and irreproachable means of providing entertainment?*
Philostratus the Younger, 'Proemium', Imagines (c. AD 300).

*The alienation of the spectator vis-à-vis the object being contemplated (which is the
result of his own subconscious activity) takes the following form: the more he
contemplates, the less he lives; the more he is content to recognize himself in the
dominant images of the need, the less he understands his own existence and his
own desire.*
Guy Debord, La Société du Spectacle (1967).

The contemplation of images, particularly those that seem to dissolve their mode of
creation into the transparency of nature when it is confronted directly, has always been
fraught with danger: the danger of mistaking inferior human craftsmanship for the work
of God, the danger of confounding the icon with its unknowable referent, the danger
of desiring things of the world, the danger of being fooled into thinking that the illusory
is the real. And yet, at the same time, the production of images that go further and
further in recreating the effects of lived experience reveals how widespread is the
public's willingness to succumb to phantoms, dreams, simulacra, where the body
vaporizes into pure visuality and effortlessly travels in space and time.

Nowhere can this conflict between the popular craving for visual thrills and
the condemnation of such desires be better observed than in the responses to
stereoscopic photography. The undeniable commercial success of stereoscopic
views was met by charges that the small images appealed to the young and ignorant,
enticed the masses with objects beyond their means, undermined the taste for the
ideal, and encouraged idleness. Set against a 'high culture' that was defined
as permanent, transcendent, moral, and uplifting, stereoscopic imagery was cheap,
frivolous, and painfully tied to the here-and-now.

Within a larger historical framework, the arguments raised against stereoscopy have
a long lineage, which begins with the earliest recorded attacks on mimesis and popular
culture. The Promethean march of technology, the ingenious development of devices
founded on greater understanding of the laws of optics, perception, and neurology –
from linear perspective through panorama, photography, stereography, lenticular images
and cinema, to the helmets and gauntlets of 1980s virtual reality – has been met with
a remarkably consistent chorus of complaints, warnings, and apocalyptic predictions
of the end of human free will, creativity, and political stability. While to a certain extent
these decriers of the new optical devices echo Luddite fears that technological progress
is a threat to employment, they reveal a level of anxiety that goes beyond mere
economic self-interest. We perhaps need to ask ourselves, what is wrong with wanting
to immerse oneself in optical fantasies? Who are the people who have condemned
such illusionistic scenes, and what is really at stake in these attacks?

If we start with the quotation in the epigraph from the Greek sophist rhetorician
Philostratus the Younger, in a book describing various paintings of his time, we can

24 see that already in the classical world there were factions regarding the appropriate limits of imitation in the visual arts. Philostratus, by using such words as 'deception' and 'reproach', and by asserting that 'no harm' can come of looking at paintings, is defensively responding to Plato and his idealist followers, who famously scorned not only the lowly copies of ephemeral nature produced by artists, but the perceived world itself.[1] For Plato, the kinds of mimetic paintings by Zeuxis that Pliny later described and which can only be imagined, based on the style of surviving Roman wall paintings, were cheap tricks that interested the lower classes, children, and the ignorant: 'It is this debility of our nature which perspective-painting exploits by using every sort of magic, just as in conjuring and other tricks of the kind.'[2] Like a joke that is no longer of interest after one hears the punchline, such paintings of grapes, transparent vases and curtains, carefully modelled in light and shadow, caused the viewer to marvel over the skill of the artist and to laugh at his own deception, but failed to engage the higher faculties of reason. Plato dismisses such works as 'entertainment', a term that Philostratus defends as a source of pleasure.

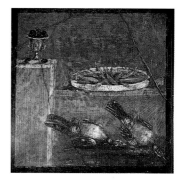

Anonymous, **Still-life**, mid-first century AD
Roman wall painting from a villa in Pompeii.

Coll. Museo Archeologico Nazionale di Napoli.

Plato's writings contained the seeds of thoughts about the imitative arts that continued to resonate into the modern period. As artists in the sixteenth and seventeenth centuries tried to distinguish themselves from artisans, and established academies to encourage the public to think of them as practitioners of the liberal arts, they increasingly defined nature as raw material to be corrected. Paintings were ranked in importance based on their subjects, starting with those closest to everyday observation (still-lifes, portraits, genre painting) and culminating in idealized scenes from classical history and the Bible.[3] A writer such as Abbé Dubos in the eighteenth century could distinguish between two kinds of 'vraisemblance' in painting: 'mécanique', in which depictions followed the laws of mechanics, statics and optics; and 'poétique', in which painted figures behaved in accordance with the meaning of the narrative.[4] The mastery of the mechanical aspects of painting, while an important part of artistic training, was only the foundation upon which a great artist built historical figure compositions that could move and inspire the viewer.

The Platonic identification of children, the ignorant masses and, by inference, women as those duped by mimetic arts, persisted in later attacks on trompe-l'œil painting and the new technologies of illusionism. The panorama, a horizontal painting visible from a central vantage point, with overhead lighting and a canopy to hide the top edge of the canvas, was often dismissed by critics in the early nineteenth century as 'an expensive daub to entertain children young and old, whose entire merit consisted solely in the well-observed perspective, and in a faithful imitation of the objects depicted'.[5] Popular magazines recounted women fainting and suffering from vertigo on viewing Charles Langlois's Panorama de Navarin in 1831.[6] The audience for another eighteenth-century entertainment, the peep-show or 'boîte d'optique', which consisted of a closed box with a single or double viewing lens in which painted scenes were revealed, was similarly stereotyped in popular prints as being primarily for children and young women.[7]

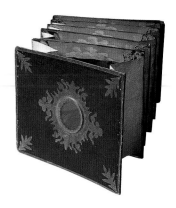

The shift in the concept of the artist from an often anonymous, artisanal transcriber of the world to an intellectual creator and genius culminated in the eighteenth century, when the terms 'originality' and 'imitation' began to assume a new importance as the poles between which creative works were measured. Not only should a painter no longer copy earlier art (a fundamental practice for the medieval scribe and an accepted part of the educational process), but he should not try to remake nature as seen by the eye. Physiologists such as Berkeley and Malebranche, inspired by the writings of Descartes and by seventeenth-century discoveries made with the telescope and microscope, had shown that the eye itself was but an imperfect instrument that made visually knowing nature impossible: 'Our senses, our imagination and our passions are of absolutely no use to us when it comes to discovering the truth and a sense of well-being'[8] If the real world were unknowable through the senses, then any attempt to transcribe it with tiny brush strokes was in vain.[9]

Anonymous, **Peep-show**, c. 1800
Cardboard, paper and lens; 14.5 x 18.0 x 30.0 cm.

Coll. Institut Lumière.

This type of peep-show predates the first stereoscopic photographs. The images in this 'concertina' box are on five different planes, which creates the impression of a three-dimensional image as the observer looks through the lens.

In the face of challenges by philosophers and men of science to the phenomenological stability of the world, and by academicians to the desirability of representing it, some artists (and a large mass of the public)[10] persisted in praising highly finished, illusionistic paintings. The Dutch school's adherence to materialistic painting (albeit one in which the physical was read symbolically) has been analysed by Svetlana Alpers in *The Art of Describing: Dutch Art in the Seventeenth Century*

25

(Chicago, 1983). The still-life and genre painter Samuel van Hoogstraten in his 1678 treatise, *Introduction to the Academy of Painting*, claimed that 'a perfect painting is like a mirror of nature which makes things that do not actually exist appear to exist, and thus deceives in a permissible, pleasurable and praiseworthy manner.'[11] Embracing the new optical instruments, Hoogstraten concluded that 'I remain firm in my initial feeling that one must, through the habit of attentive observation, aim to make the eye into a compass.'[12] Hoogstraten justified such exact copying by emphasizing the painting as a source of knowledge, and nature as a more fruitful inspiration than previous artworks.[13]

Hoogstraten's likening of his work to that of a compass is, however, unusual, since the spread of machinery increasingly inspired artists to assert the difference between their activity and mechanical action. Critic Terry Eagleton has posited that the construction of the artist (or writer) as a creative genius occurred just when he 'is becoming debased to a petty commodity producer' through the proliferation of commercial galleries, print sellers, and reproductive techniques.[14] The 'Mechanick', a new type of worker who designed and repaired machines, became the metaphorical representative of lower-class labour, which threatened handcrafted goods, including the precariously (and recently) defined 'fine arts'. The encroachment of mechanical reproductive and printing techniques also fuelled the legal concept of copyright (for both literary and visual artists), which hinged on the concept that man-made works were private property, embodying not merely labour, but 'originality' and the personality of their maker.[15] Thus, for British writers such as Henry Fielding in 1752, the mass of popular authors could be dismissed as 'mere Mechanics',[16] and poet Edward Young, in his *Conjectures on Original Composition* (1759), could qualify imitative composition as a 'sort of manufacture wrought up by those mechanics, art, and labour, out of pre-existent materials not their own.'[17]

By the time of the invention of photography and the public announcement in 1839 of the discovery of various processes, the rhetorical structure was firmly in place for the entire medium to be dismissed as uncreative, mechanical, mindless and having nothing to do with art. The daguerreotype outdid even miniatures and seventeenth-century still-lifes in its fine, grainless detail, and its devotees boasted how rapidly and easily the image could be formed (despite the difficulties amateurs experienced in getting good results). Thus, the camera image combined two qualities that placed it outside praiseworthy art: it had overall and unedited dense visual information and yet it was produced with no labour. Its value as a commodity had to be defined in a new way: it took something that was free and evident (the observable world) and reproduced it using a machine and chemicals. John Locke's famous definition of private property as the removal of materials from the state of nature through the use of labour therefore seemed no longer to apply,[18] but the exact status of the photograph as a product of man or a product of nature remained unclear.

Just as the invention of the microscope had called into question the way we see the world with our unaided eyes, the invention of photography challenged any lingering belief that an aesthetic goal of painting was imitation. Painters and connoisseurs defensively asserted that the human and machine were different and that the photograph was a document, not art. To cite just three responses from 1839, a writer for *Le Charivari* noted that 'machines can replace arms but not the head', and that mathematical exactitude belonged to science.[19] Similarly, the young Charles Blanc complained the same year: 'Who will stop Mr Daguerre from making this mirror into an engraving? Oh! if chemistry takes over, I fear that all mystery will vanish, and poetry with it. Dear God, do not let art merge with science.'[20] Repeating the charge that the new medium lacked the spiritual, the sculptor David d'Angers, upon looking at the daguerreotype, cried: 'The soul is mute, it is a mathematical positive of art.'[21]

The materialism of photography placed it firmly in the camp of science and mathematics, which were seen as threats to a universe governed by divine power. While the 'facture' of traditional paintings, no matter how detailed, caused viewers to respond to them as objects among other man-made things, the successful transparency of the photographic medium resulted in the uncanny feeling of looking at an oddly familiar environment drained of colour and motion – like the body after death. The philosopher Jean Baudrillard, in a recent essay on trompe l'œil, experienced the same malaise when studying the highly polished studies of flowers, letters and fruit by artists such as Boilly, Vaillant or de la Motte: 'The pleasure they [trompe-l'œil

Anonymous, **Polyorama and stereoscope**, c. 1853
Stereoscopic view, coloured lithograph; 8.4 x 16.4 cm.

Coll. Wim van Keulen.

Anonymous, **Children's stereoscope, polyorama**, c. 1853
Stereoscopic view, coloured lithograph; 8.4 x 16.4 cm.

Coll. Wim van Keulen.

26

paintings] procure is thus not the aesthetic one of familiar reality [...] it is the acute and negative pleasure found in the abolition of the real. Haunted objects, metaphysical objects, they are opposed in their unreal reversion to the whole representative space elaborated by the Renaissance [...] The enjoyment of trompe l'œil comes from an intense sensation of déjà vu and of the eternally forgotten, of a life that is pre-existent to the mode of production of the real world.'[22] By depicting forms that seemed proximate to the space of the viewer and yet preternaturally still, illusionistic painting prompted the observer to consider what distinguished the living from the dead.

With the discovery of the principles of stereoscopic vision in the 1830s and the development of double-lensed stereoscopic cameras in the early 1850s, the transport of an observer, seated in an interior, into deep imaginary spaces made older visual illusionism seem quaint and contrived. The men who perfected and sold stereoscopic photographs and stereoscopes proclaimed that this latest technology would allow the sun to become the 'historiographer of the future'. As David Brewster, one of the inventors of stereoscopy, wrote: 'In the fidelity of his [the sun's] pencil and the accuracy of his chronicle, truth itself will be embalmed and history cease to be fabulous.'[23] But Brewster's slip in using the term 'embalmed' recalled the deathlike stasis that was even more obvious in stereoscopic imagery as other impediments to 'realistic' representation dropped away. Even a stereo enthusiast such as the American doctor and writer Oliver Wendell Holmes (1809–1894) noted the absence of colour and motion in the stereoscopic view, and compared the experience of viewing to 'some half magnetic effect in the fixing of the eyes on the twin images – something like Mr. Braid's hypnotism'.[24] The effects of concentrated looking, of substituting a purely optical for a haptic experience of space, recalled to the physiologist Holmes the recent experiments of the Scottish doctor James Braid (1795–1860), who was able to induce a hypnotic state by staring at a small bright circular object.[25]

Holmes's clever observation that merely looking at a fixed object might result in a loss of rational consciousness may be the earliest case in which mechanical imaging technologies were criticized on this score. He therefore anticipates Guy Debord's neo-Marxist polemic against the reduction of life to a spectacle in which the public is politically disempowered and reduced to passive recipients of artificial (and therefore false) messages, quoted in the epigraph at the beginning of this essay. This idea that looking replaces doing and causes a failure to live in the real world has also become a cliché in criticisms of television, ranging from Jerry Mander's *Four Arguments for the Elimination of Television* (1978) and Marie Winn's *The Plug-in Drug* (1978) to Neil Postman's *Amusing Ourselves to Death* (1986). The debate on the dangers of the process of viewing electronic media, and not just their vapid or violent content, has persisted into contemporary appraisals of virtual reality, whose origins in military and industrial uses has made it even more suspicious to leftist social critics.[26]

The potential political dangers of a loss of consciousness brought on by hypnotic viewing overlay another danger that perhaps Holmes sensed but couldn't actualize when he compared stereo viewing to hypnotism: the potential for sexual arousal. New optical instruments developed to enhance 'natural' vision, from the telescope, microscope, and *camera obscura* to the seventeenth-century Dutch and subsequent peep-show boxes, had often been associated with voyeurism. The act of looking through a darkened tube or lens into a surprising illuminated foreign world that could not interact with the viewer recalled the primal forbidden vision (through a keyhole or cracked door) of parental sexual intercourse that was later described by Freud. Not only did the viewing device reveal potentially scabrous subjects, but the momentary distraction of the person looking could result in further sexual misconduct taking place in the real world surrounding the engaged viewer. As is revealed in stereotypical cartoons of cuckolded husbands looking through a camera (or at a peep-show or, later, a stereoscope) while their wives embrace lovers,[27] eager absorbed viewing was often repaid by sexual betrayal at home. Similarly, young girls distracted by optical devices could themselves be fondled by avid suitors, just as hypnotized (or sleeping) subjects might be sexually assaulted.

The erotic potential of images seen through viewing devices was fulfilled when stereo photography was invented. Whereas double-lensed opera glasses exposed the details of dancers' legs or courtesans' make-up and were used in public spaces,[28] the stereoscope, focused on a hand-tinted daguerreotype, confronted the solitary

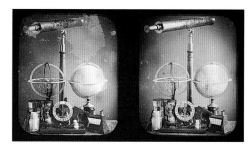

Duboscq-Soleil, **Scientific instruments**, 1851
Stereoscopic daguerreotype. Inscription in French on reverse: 'Photograph by Duboscq-Soleil. One of their very first stereoscopic views: selection of the instruments manufactured (including a stereoscope). Extremely rare by Gab. Cromer double' (label handwritten by Gabriel Cromer appearing on another copy of this daguerreotype, no. 70.012.1); mount 8.5 x 17.8 cm.

Coll. International Museum of Photography and Film, George Eastman House, Rochester, NY, catalogue no. 76.168.100.

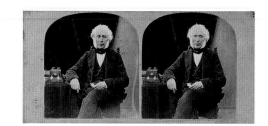

Anonymous, **Stereoscopic portrait of Sir David Brewster**, c. 1856
Stereoscopic view, coloured albumen print; mount 8.5 x 17.5 cm.

Coll. Tex Treadwell.

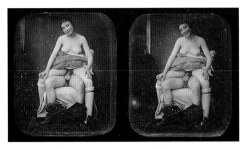

Anonymous, **Pornographic scene**, 1850s
Coloured stereoscopic daguerreotype; mount 8.5 x 17.0 cm.

Coll. Gérard Lévy.

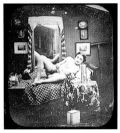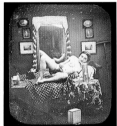

Anonymous, **Nude with stereoscope and other objects**, 1850s
Stereoscopic daguerreotype. Inscription in French on label on reverse: 'Photography Richebourg Portraits, Lessons, Prints, MANUFACTURE & SUPPLY of Instruments & Accessories, Paris, Quai de l'Horloge, 29'; mount 17.5 x 8.5 cm.

Coll. Wim van Keulen.

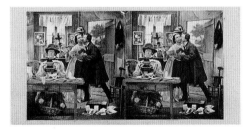

Anonymous, **Conjugal scene**, 1860s
Stereoscopic view, coloured albumen print; mount 8.4 x 16.7 cm.

Coll. Pierre-Marc Richard.

viewer with a palpably real, astonishingly detailed female nude often smiling and aggressively jutting her secret charms into the foreground. The commercial success of pornographic stereo daguerreotypists (confirmed by Second Empire police reports and the numbers of such images that still survive)[29] justifies the suspicions of the opponents of stereoscopy that the medium was potentially immoral and induced bad habits. For example, an anonymous chronicler in the 1851 *Gazette des Tribunaux* (police gazette) noted that coloured daguerreotypes showing 'the most licentious subjects, reproduced with all the precision, all the accuracy that only the daguerreotype can achieve,' were flooding shop windows.[30] At the peak of the stereo craze in 1865, petitions to the French Senate complained that pornographic photographs (as well as books, prints and theatrical performances) were corrupting the masses; the government responded that 172 individuals had been arrested and that the police had seized 300 negatives and 15,000 microphotographs (visible through a viewing tube with a lens at one end) in a single day.[31] Whether such images contributed to (or substituted for) immoral behaviour is impossible to determine, but that they were extremely popular and triggered widespread public criticism cannot be denied.

Trompe-l'œil still-lifes, panoramas, photographs, stereographs, early cinema, television, and VR have all been attacked by defenders of religion and very centralized governments as non-art, mindless entertainment, dangerous distractions from work and political action, and breeders of false consciousness and unrealistic social aspirations. Oliver Wendell Holmes puzzled in 1861 that there was 'a strange indifference' to the stereograph 'among persons of cultivation and taste', and such indifference has marked most art critics' attacks on mass culture and various realist schools of painting up until the present.[32] However, Holmes became a staunch defender of stereoscopic views and can be taken to represent that segment of the intelligentsia that appreciated photography (and would have probably enjoyed video and VR technology). Teacher at Harvard Medical School, popular writer of poems and novels, amateur photographer, owner of over 1,000 stereographs and viewer of an estimated 100,000, Holmes was enthralled by the spectacle of nature that God had placed before his eyes and saw stereoscopic photography as a way of bringing that bounty to a huge public: 'Oh, infinite volumes of poems that I treasure in this small library of glass and pasteboard. I creep over the vast features of Rameses, on the face of his rock-hewn Nubian temple; I scale the huge mountain-crystal that calls itself the Pyramid of Cheops [...] I sit under Roman arches, I walk the streets on once buried cities, I look into the chasms of Alpine glaciers.'[33]

Whereas man-made images that tried to simulate the 'real' might be attacked as artificial trickery, the stereoscopic photograph for Holmes and many others was the real. It had nothing to do with art (Holmes wrote that 'the very things which an artist would leave out, or render imperfectly, the photograph takes infinite care with'[34]) and everything to do with nature. So long as nature was perceived as good and a reflection of God's ingenuity and imagination, looking at it through the invisible medium of photography could be nothing but instructive.[35] The inexpensive stereoscopic view made possible the amassing of enormous archives so that every household (and not just the wealthy tourist) could experience the world's treasures.[36] It was a democratic art that held great promise to persons like Holmes, who believed in the potential good judgement of the educated common man.

The scopophobia[37] that we have found from Plato to Debord has proven to be unwarranted: humans have not confused the virtual with the real, dictators have not long swayed the masses, highbrow culture has not vanished into a morass of infantile visual pabulum. However, the utopian claims that each new visual medium will educate the masses have also not been realized: people persist in reading images as they wish and ignoring those that don't reinforce what they already know. What both critics and advocates have overestimated is the power of those who create and disseminate images to control their reception, and the power of commercially fabricated representations to shape lived experience.[38] The medium, *pace* MacLuhan, is not the message; it only sharpens our awareness of the buzzing static of our own innate hard-wiring.

1. On Greek aesthetics, see J.J. Pollitt, *The Ancient View of Greek Art: Criticism, History and Terminology* (New Haven, Conn., 1974).

2. Plato, *The Republic*, trans. S. Halliwell (Warminster, 1988) p. 57.

3. It is beyond the scope of this essay to detail the history of aesthetic theory and the changing professional status of the artist. For basic introductions, see André Fontaine, *Les Doctrines d'art en France* (Paris, 1909); Anthony Blunt, *Art Theory in Italy*, 1450–1600 (Oxford, 1956); Nikolaus Pevsner, *Academies of art, past and present* (Cambridge, 1940); and Albert Boime, *The Academy and French Painting in the Nineteenth Century* (New Haven, Conn., 1986).

4. Abbé Dubos, *Réflexions critiques sur la poésie et sur la peinture*, Vol. I (Paris, 1719), p. 242.

5. A.L. Millin, *Dictionnaire des Beaux-Arts* (1806), quoted in Bernard Comment, *Le XIX® siècle des panoramas* (Paris, 1993), p. 59.

6. *Le Cabinet de lecture* (24 January 1831), quoted by B. Comment, op. cit., pp. 116–17.

7. On the history of the peep-show, see Richard Balzer, *Peepshow: A Visual History* (New York, 1998). For an excellent assessment of the meaning of optical and physical amusements during the Enlightenment, see Barbara Stafford, *Artful Science: Enlightenment Entertainment and the Eclipse of Visual Education* (Cambridge, Mass., 1994). The use of the feminine as a mode of disparagement also carried over into criticisms of finish in painting. Highly polished, detailed works were classified by Sir Joshua Reynolds, among others, as feminine. Naomi Schor has analysed negative attitudes to what she calls 'detailism' in art and literature and its identification with the feminine in her *Reading in Detail: Aesthetics and the Feminine* (New York, 1987). Her book touches on photography as the exemplary art of detail in a discussion of Realist critic Francis Wey in Chapter 3. Richard Sha has pointed out further that a double standard regarding finish applied during the romantic period in which quickness of paint application represented genius and energy in a male artist and sloth in a female. Richard C. Sha, *The Visual and Verbal Sketch in British Romanticism* (Philadelphia, 1998), p. 19.

8. *Nicolas Malebranche, De la recherche de la verité* (1674), *Œuvres* (Paris, 1979), p. 11. For a survey of anti-ocularism in European thought which briefly summarizes the pre-nineteenth-century period, see Martin Jay, *Downcast Eyes: The Denigration of Vision in Twentieth-Century Thought* (Berkeley, 1993).

9. Early microscopists revealed a paradoxical attitude towards the validity of observing nature. The microscope itself demonstrated that there was an enormous unseen world beyond the limits of the eye (thereby highlighting the eye's deficiencies); however, the supposedly 'true' world seen through the lens was also filtered through that same deficient eye. For a fascinating discussion of the cultural impact of seventeenth-century microscopy, see Catherine Wilson, *The Invisible World: Early Modern Philosophy and the Invention of the Microscope* (Princeton, N.J., 1995).

10. The high prices received for seventeenth-century still-life and genre paintings attest to the public's appreciation of these works. Svetlana Alpers has cited Gerard Dou and Vermeer as painters who received high prices for very finished paintings. According to Alpers, the tradition of paying artists by the hour was a survival from guild practices. See her *The Art of Describing: Dutch Art in the Seventeenth Century* (Chicago, 1983), pp. 115ff., and *Rembrandt's Enterprise: The Studio and the Market* (Chicago, 1988), pp. 19ff. However, John Michael Montias, using quantitative analyses of notarial documents, found that average prices for still-life paintings in seventeenth-century Holland were lower than those for genre and history paintings. Montias, *Le Marché de l'art aux Pays-Bas*

(XVe–XVIIe siècles) (Paris, 1996).

11. Celeste Brusati, *Artifice and Illusion: The Art and Writing of Samuel van Hoogstraten* (Chicago, 1995), p. 159.

12. *Ibid.*, p. 225.

13. Hoogstraten thus defined himself as believing in the superiority of the 'moderns' as opposed to the 'ancients' in the famous seventeenth-century debate over the importance of classical art and civilization for contemporary painting.

14. Terry Eagleton, *The Ideology of the Aesthetic* (Oxford, 1990), pp. 64–65. Richard Sha has argued that the eighteenth-century gentry began to denigrate reproductions (largely in the form of prints) in order to solidify its class position. They placed more importance on original paintings, which were still located in private houses unavailable to the public. R. Sha, *op. cit.*, pp. 32ff.

15. On the evolution of copyright in eighteenth-century England and its relationship to concepts of imitation and originality, see Mark Rose, *Authors and Owners: The Invention of Copyright* (Cambridge, Mass., 1993), particularly Chapter 7.

16. Quoted in M. Rose, *op. cit.*, p. 119.

17. Edward Young, Conjectures on Original Composition (Manchester, 1918, Edith J. Morley, ed.), p. 7. There is extensive literature on the origins of the concepts of genius and imagination in romantic literature. See, for example, Thomas McFarland, *Originality and Imagination* (Baltimore, 1985) and James Engell, *The Creative Imagination – Enlightenment to Romanticism* (Cambridge, Mass., 1981).

18. 'Whatsoever then he removes out of the state that nature hath provided, and left it in, he hath mixed his labour with, and joined to it something that is his own, and thereby makes it his property.' John Locke, 'An Essay concerning the True Original, Extent, and End of Civil Government', *Two Treatises on Government* (1690) (Cambridge, 1988), section 27, p. 288.

19. Writers for *Le Charivari* in 1839–40 were consistently opposed to photography and all mechanical inventions that threatened artists. For example, in an article on mechanical sculpture, a writer complained that 'L'inspiration est remplacée par la vapeur, la pensée par une roue à cylindre, le génie de l'artiste par une machine de la force de plusieurs ânes.' 'La sculpteur mécanique', *Le Charivari*, 9 April 1840, p. 2. See also 'Une machine trouve toujours de plus grands machines qui l'admirent', 30 August 1839, pp. 1–2; 'De deux nouveaux partis politiques – les daguerréotypophiles et les daguerréotypophobes', 10 September 1839, p. 1; 'Rapport de l'Académie des Sciences relativement à l'invention de la serinette pour faire suite au daguerréotype', 19 September 1839, p. 1; 'Tout n'est pas rose dans la peinture en noir', 22 September 1839, p. 1.

20. Charles Blanc, 'Beaux-Arts. Gravure. La Madone de l'Arc et les moissonneurs', *Revue du progrès*, 15 February 1839, p. 14.

21. David d'Angers, *Les Carnets de David d'Angers* (Paris, 1958), Vol. II, p. 50, carnet 34 (1839). For more early criticisms of photography and their relationship to the debates on machinery, see McCauley, *Industrial Madness: Commercial Photography in Paris, 1848–1871* (New Haven, Conn., 1994), pp. 223–32.

22. Jean Baudrillard, 'The Trompe l'Œil,' in Norman Bryson, ed., *Calligram: Essays in New Art History from France* (Cambridge, 1988), pp. 54 & 58. Baudrillard's comments echo scattered comments by romantic artists who were experimenting with looking at a landscape reflected in a mirror. For example, C.G. Carus wrote to Caspar David Friedrich that 'le reflet en revanche n'apparaît éternellement que comme fragment, comme une partie de la nature infinie, détachée de ses liens organiques et cantonnée dans les limites contre nature' (cited in Comment, p. 65). The use of optical

Paul Intini, **Trompe-l'œil: the Pont-Neuf and Ile de la Cité**, 1991
Oil on canvas; 60 x 81 cm.

Coll. Musée Carnavalet, catalogue no. P2473.

Anonymous, **The Paris Opéra**, late 1930s
Printed photographic image, cut out and placed on separate planes; frame 15.0 x 18.7 cm.

Coll. François Paviot.

devices such as mirrors, Claude glasses, or frames to objectify nature or make it look like a picture is discussed in artist's manuals particularly after the seventeenth century, when these devices became more prevalent. Carus's observation on the oddness of such fragmentary and seemingly frozen images is, however, unusual.

23. David Brewster, *The Stereoscope – Its History, Theory and Construction* (London, 1856), p. 181.

24. Oliver Wendell Holmes, 'Sun-Painting and Sun-Sculpture; with a stereoscopic trip across the Atlantic', *Atlantic Monthly*, July 1861, p. 14.

25. On the history of hypnotism and the importance of Mesmer and his followers, see Alan Gauld, *A history of hypnotism* (Cambridge, 1992).

26. For example, see Ralph Schroeder, *Possible Worlds – The Social Dynamic of VR Technology* (Boulder, Colorado, 1996); Robert Markley, *Virtual Realities and their Discontents* (Baltimore, 1996); Neil Postman, *Technopoly: The Surrender of Culture to Technology* (New York, 1992).

27. Such images appear as early as the seventeenth century when, according to Celeste Brusati, the Dutch perspective box was already recognized as being potentially erotic. (Brusati, *op.cit.*, pp. 198–201, 204ff.).

28. Much has been written recently by feminist critics on the meaning of Impressionist paintings by Manet, Cassatt, and Degas that feature figures looking through lorgnettes. See Griselda Pollock, 'The gaze and the look: women with binoculars – a question of difference', in R. Kendall and G. Pollock, eds., *Dealing with Degas: Representation of Women and the Politics of Vision* (London, 1992), pp. 106–30.

29. On the Second Empire pornographic photo market, see McCauley, *Industrial Madness: Commercial Photography in Paris, 1848–1871*, Chapter 4, and the article by Denis Pellerin in this work.

30. 'Chronique', *La Gazette des Tribunaux* (25 July 1851), p. 724.

31. Procès-verbaux des séances du Sénat, 22 June 1865, pp. 360–62.

32. Holmes, *op. cit.*, p. 16. Perhaps the best example of this aversion to realistic styles and the popular appreciation of them is Clement Greenberg, who lambasted figurative painters, from the social realists of the 1930s to pop art, and considered photography to be appropriate only for documentation. See his *Avant-Garde and Kitsch* (1939) or *The Camera's Glass Eye: Review of an Exhibition of Edward Weston* (1946).

33. Holmes, 'The Stereoscope and the Stereograph', *Atlantic Monthly*, June 1859, pp. 745–46.

34. Holmes, *ibid.*, p. 746.

35. In his reconciliation of scientific observation of nature with a belief in God, Holmes continues a long tradition of natural philosophy that saw the world as a mirror, book, or theatre of nature. On the history of this metaphorical image, see Ann Blair, *The Theater of Nature: Jean Bodin and Renaissance Science* (Princeton, N.J., 1997) and Edward Peter Nolan, *Now Through a Glass Darkly: Specular Images of Being and Knowing from Virgil to Chaucer* (1990). A proper genealogy for the stereographic craze must include books such as Jean Bodin's *Universae Naturae Theatrum* (1597), Guilio Camillo Delminio's memory theatre (1530s), and Renaissance and baroque Wunderkämmer in which the marvels of the world were physically displayed for edifying contemplation.

36. Holmes in 1859 called for the development of huge systematically arranged stereo libraries. He predicted that, instead of being toys, the stereos were initiating 'a new epoch in the history of human progress'. (*The Stereoscope and the Stereograph*, p. 748).

37. 'Scopophilia' is the psychoanalytical term used to describe the obsessive love of looking at primarily erotic scenes (voyeurism). 'Scopophobia' normally refers to the fear of being seen, but I am adapting it here to stand for the opposite of scopophilia, which would be a fear of seeing (and, more particularly, a fear of feeling pleasure from seeing). For a summary of Freud's attitude towards the visual and seeing, see Martin Jay, *Downcast Eyes*, pp. 331ff. It is certainly possible that many critics of illusionistic imagery not only feared the masses and their access to education and visual culture (as suggested in this essay), but may have experienced discomfort with all visual (and other) pleasure. For a study of psychological conditions involved with seeing and being seen, see David W. Allen, *The Fear of Looking: On Scopophilic-Exhibitional Conflicts* (Charlottesville, Va., 1974).

38. This is not to deny that images contribute to the construction of reality and do have strong psychological influences, as outlined in David Freedberg's *The Power of Images: Studies in the History and Theory of Response* (Chicago, 1989). However, one of the indicators of sanity remains the ability to distinguish the real from the phantasmagoric.

Une fenêtre qui s'ouvre sur le monde !

8 VUES EN RELIEF
ET EN COULEURS

STEREOCARTE
BRUGUIERE
PARIS

Surface space
Instrumental depth

Michel Frizot

Stéréofilms Bruguière, **The 'Stéréoclic'**, c. 1960
Plastic and metal; 8.5 x 12.0 x 7.0 cm.

Coll. Christian Kempf.

Born (1877) in the village of Mazamet, in the Tarn, Aimé
Bruguière specialized in the manufacture of stereoscopes.
On 1 January 1946, his son Georges took over the
business and moved to Paris where he founded the
company 'Stéréofilms Bruguière' at 5, Boulevard de Clichy.
He opened a studio at no. 2, Square Trudaine and
developed the large-scale distribution of stereoscopes and
the accompanying stereoscopic images. It was from this
point that the Bruguière company really established its
reputation before being merged, in 1974, with Lestrade.

Advertisement for Bruguière, c. 1960
Packaging for stereoscopic cards; 18.7 x 11.4 cm.

Coll. Michel Frizot.

'What would the stereoscope be without photography?' asked Louis Figuier in 1869, when the viewing of three-dimensional objects was becoming increasingly popular: 'an instrument that could be used to prove a somewhat abstract proposition in the field of optics [...] Without the help of photography, the stereoscope would never have managed to produce these incredible views of nature, which allow us to see objects in all their three-dimensionality, complete with all their hollows and projections.'[1]

In fact, Wheatstone's announcement about the stereoscope (1838) preceded the description of the daguerreotype (1839) by a year and it was not until the Great Exhibition of 1851 in London that photography (on metal, glass and paper) and stereoscopy were successfully married. From the first, the spectacular achievement of these magic windows, which captivated a bourgeoisie avid for these technical feats, shifted the emphasis from the artificiality of the instrumental preparations necessary for such an off-putting piece of optical equipment and focused squarely on the admirable naturalistic testimony of photography: the latter was still not highly rated in 1851 and stereoscopy provided it, in mimetic fashion, with a welcome boost.

However, it should be noted that both the principle and the effect of stereoscopy[2] existed 'in their own right', independently from photography, although the latter provided them with a playful and illusionist foundation which occasionally causes us to confuse or invert 'physics' and 'nature'. Stereoscopy is a perfect illustration of the dichotomy between artificialia and naturalia: nature can only be 'imitated' by using a device and this one, as it happens, is the twin of the camera obscura (the two lenses of Brewster's stereoscope correspond to the lens-eye of the camera). But this is a double twin, being 'twinned' itself; the stereoscopic camera has two lenses, two 'eyes', which seems preposterous, even for a machine intended to imitate human binocular vision: how – we might ask – can photography, with a single eye, the lens, imitate eyesight so accurately that it can occasionally be even more precise? We actually have to make a concerted effort to distinguish, in stereoscopic illusion – and since then in any other artificial manifestation of three-dimensionality – between what emerges from the photographic analogy on one hand and from the analogy of perceived space on the other: the preservation of the homologous relationships between forms and the apparent reconstruction of depth of the tiered arrangement of forms. Although the achievement of the latter is dependent on the former, it does not necessarily follow that they have to be linked together. Stereoscopy, invented by Wheatstone, worked very well with drawings, even with geometric figures, but it was seen as a curiosity, an amusing experiment in physics. It did not 'need' photography, but the latter raised it to the status of a brilliant and 'miraculous'[3] illusion: people believed that Nature itself had been recreated.

Nevertheless, from the time when the stereoscope began exploiting the effects of the photographic image, what was actually seen? Essentially *photography* in 3-D, and subsequent processes, until holography, were to adhere to this principle. The eye is only too happy to allow itself to be deceived (even in the case of natural vision); it is vital to deconstruct this illusion of three-dimensional space into its two component parts: the dual illusion is made up of photography on the one hand and an illusion of space on the other. And in both cases, this illusion is created by devices, because these have been designed in such a way as to transform presumed 'reality', while preserving a few

Stereoscopic view of a left eye, c. 1923
Figure 72 in E. Colardeau's *Traité général de stéréoscopie*,
Editions J. de Francia, Paris, c. 1923.

elements which are enough to keep the observer happy. This is because several tell-tale clues are enough to satisfy the eye: how else can one explain the fact that painting, from any period, could have been regarded as a 'representation' acceptable to the senses and justifiable by some illusion or other? How can we be satisfied by the illusion produced by the stereoscope, all the while knowing it is merely photography?

These representations, generated by altering various clues, involve *a fortiori* a loss, in painting and photography, as well as in stereoscopy. From the time of its invention, photography was universally praised for its precision and its delineation of space, but when it came to recording light, the images retained only values, gradations of shadow, a stopgap measure which, however, soon became the standard mode of perceiving images. Even when the images were coloured to give them a semblance of realism (widely practised under the Second Empire), it was obvious and accepted that these were photographs and people liked these pictures precisely because they were photographs. Far from objecting to them because of their secondary status, people gladly attributed to them the huge success of an ambitious technological development, forgetting that they could expect increasingly better things from any technical process. And when we examine an Ektachrome produced with Maurice Bonnet's lenticular screen system, we also know that we are looking at examples of photography and photographic colours in varying degrees of naturalness or artificiality. The device, because of its mode of operation, is responsible for this discrepancy between what has been recorded and what is visible on a surface. The image is derived from a loss; a loss of the natural contrasts between the different types of light flowing from each point in the space, a loss of the naturalness of these objects which no longer radiate their own light: surfaces have taken their place and the different intensities of light are compressed, re-coded in a system of values (gradients of grey or another tonality) specific to each period and photographic process. In the same way, the stereoscope recreates an impression of depth for an image that does not have any by pairing it with an almost identical image, taken from a nearby standpoint. This dual system, that of taking pictures and reproducing the image from the two shots, combines two surfaces in an arrangement which is able to make the observer believe he or she is seeing the original space, the one to which the two photographs related. But this space is also merely an illusion, an approximation which satisfies the mind; it is an exaggerated space, an optical space devoid of reality and atmosphere, a uniform swollen image which is reminiscent of looking through the magnifying lens of a peep-show. Imposing, certainly, but still artificial: it is a space that exists via a device, not a natural space.

When talking, in relation to these techniques, about 3-D vision, or about viewing things in 'relief' or 'three dimensions', we are still falling into a linguistic trap because we are actually unable to see things in any other way. This at least allows us to conceal a certain confusion: the three dimensions are only recreated, but we talk 'as if' they were the same as the three-dimensional reality perceived by the visual system. Stereoscopy, holography and lenticular systems only operate as perceptual illusions and not as perception. 'Analysing' optical devices (reduced to incident light for holography) are placed between correctly programmed photographic recordings and the observer's eyes; but these methods cannot replace the scope and characteristics of direct natural vision. Beyond the transparent optical systems, the gaze comes up against a (photographic) surface-medium. The fact that our eyes see a non-existent space in this way is what they are supposed to do, in a manner of speaking; it is a mental function

Anonymous, **Stereoscopic acuity test**, 1926
Stereoscopic view, gelatin silver on glass. Inscription in French: 'Paris: 24 February 1926 – Given by Commandant Hurault, Head of the Optics Laboratory in the Army's geographic department'; mount 8 x 16 cm.

Coll. Société Française de Photographie.

Diagram of accommodation on two points A and B, at a fixed focal distance, c. 1923

Figure 33 in E. Colardeau's *Traité général de stéréoscopie*, Editions J. de Francia, Paris, c. 1923, p. 68.

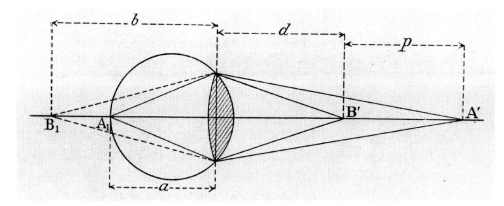

that we cannot control and that eludes us. Why not accept we are being fooled if the stratagem provides advantages and improvements?

However, the fact remains that the space presented in stereoscopy (in lenticular systems or in holography) is a false space and that the eyes are taken in by the illusion of depth which they think they recognize, when they are only seeing a surface which is very close to them. In stereoscopy, for example, both eyes have to focus on their respective image which is not very far away, a position to which they are not accustomed and which forces them to make a particular effort to converge or diverge, often causing them to experience difficulties or to give up the attempt. On the other hand, accommodation has to occur on the perceived surface (the focal plane of the lens), whereas the observer is already expecting to accommodate on a faraway object, imagining that it will soon appear. The illusionist space in stereoscopy is a faraway image that takes shape and is perceived at very close quarters – another disconcerting effect. 'In other words, with binocular vision, we analyse the object first, whereas with

Anonymous, **Wall at the Jules Richard company, 25, Rue Mélingue**, c. 1909

Modern print after a gelatin silver negative on glass; 4.5 x 10.7 cm.

Coll. Musée Carnavalet, catalogue no. Ph 11554.

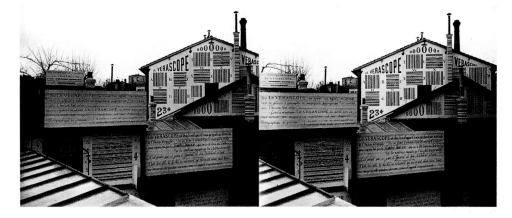

stereoscopic vision, we synthesize two images of the object.'[4]

The artificially-created three-dimensional effect obtained with 3-D processes results from two optical and therefore physical operations (photography or analysis, followed by reconstruction or synthesis), which enable an individual to see various images which have their own characteristic features and which appear extremely simplistic compared with real space and real objects. The system's analogical aim is therefore dependent on certain technical constraints whose deleterious effects the observer tolerates while appreciating the improved view (in comparison with the potential of traditional images).

The photographic device for taking pictures uses an angle of field (to which the angle of vision is then submitted); it proceeds, from each point in the space, by central projection (the centre of the lens) onto the sensitive surface and, if the photographer has taken certain precautions (diaphragm), the projected forms are equally sharp wherever they are in the space (depth of field when the photo is taken). But all this information is artificial, compared with the individual's direct binocular vision.

When the two photographs are combined in the stereoscopic device, this information serves as a basis for the mental reconstruction of a space and of objects which can only be true to what has been recorded and not to what actually exists. In the stereoscopic illusion, all the planes are sharp, whatever their position in the space and their apparent distance from the subject. 'So a stereoscopic pair is as uniformly

'Method for taking stereoscopic prints of close objects', attachment for a tripod, 1869

Figure 129 in Louis Figuier's *Les Merveilles de la science*, Editions Furne, Jouvet & Cie, Vol III, Paris, 1869, p. 207.

34

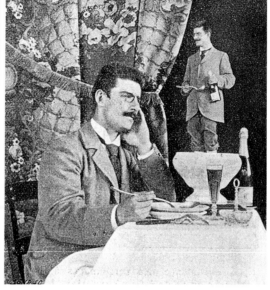

Raoul Ellie, **Optical illusion**, 1903
Stereoscopic view. Illustration from Raoul Ellie's
'Stéréoscopie combinée' in *Bulletin de la
Société Française de Photographie*,
1903, p. 406.

Coll. Société Française de Photographie.

sharp in the foreground as it is in the background. This is not the case however with
binocular vision because when we look hard at an object we see it clearly but, on the
other hand, objects close by, whether near or far, although they continue to form an
image on the retina, do not appear sharply in focus. Therefore, to sharpen the image,
we have to accommodate, to change the shape of our crystalline lens, which we
actually do very easily, almost unconsciously.'[5] All in all, our perception of space using
a mechanical device is not corroborated by the ocular physiological sensation – more
or less unconscious, but taken into account by our powers of perception – caused by
accommodation. The space we think we are perceiving actually lacks the depth that
is perceived by means of our unconscious accommodation.

Similarly, when certain processes (such as lenticular systems) present blurred areas
in the image, this blurredness, which is specifically photographic and caused by
movement or focusing, is grasped perfectly by the perceptual system but cannot be
compared to the real sensation of movement or distance.

As a result, whether we like it or not, perceived spaces display a certain artificiality,
like constructed spaces, instrumental spaces – artificially created spaces. But the only
three-dimensionality here exists via the device, a particularized three-dimensionality,
constructed by the brain from signs encoded by the device.[6]

To all appearances, three-dimensional viewing processes (based on the
pre-eminence of photographic analysis) suggest the possibility of reversing the
procedure: at an analytical level, the device used to produce images takes into
consideration a natural space – or at least the light emissions that characterize this
space – and transforms it into an image (one or two) or an 'informed' flat surface; at
a synthetic level, the viewing device (stereoscope, anaglyphic filters, lenticular system)
only takes into consideration these surfaces and their information to reconstruct a
completely different space, a completely different light and a completely different
sensation. The illusion of three-dimensionality is therefore based on filtered information,
which is reoriented linearly in the same way as a polarizer would do. Before it is
reconstructed, the three-dimensional reality is reduced and its space and information
compressed.

Any technological procedure irreversibly changes the nature of the information it
processes. The dual procedure used here (analysis and synthesis) is therefore itself
irreversible. It is only by making a deliberate effort that we accept 'seeing' the
stereoscope's three-dimensional image as a reality which, incidentally, we have not
seen in its original three-dimensionality; we only have access to substitutes. The space
produced is a false space, which cannot be understood by the ocular system in
accordance with the same criteria as natural space.

Movement, for example, plays a key role in our perception of space: both by the
movement of the eyeballs and the trajectory of various components in the surrounding
area. The 'gaze' in particular (if this is how we describe the directivity of our acquisition
of information) is continually changing direction to 'read' the surface of things in a type of

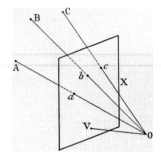

**Diagram, perspective projection of three points A,
B and C onto a surface (central projection onto
a focal point O)**, 1923
Figure 18 in E. Colardeau's *Traité général de stéréoscopie*,
Editions J. de Francia, Paris, c. 1923, p. 22.

Brownian motion,[7] or to estimate the distance of objects; and the two eyes alter their angle of convergence to accommodate on a variety of perceived points. On the other hand, it has been established that certain pathologies preventing the perception of movement (and reducing it to successive static states) also impede the perception of three-dimensionality. The mental awareness of three natural dimensions is linked both to the movement of things in space and to the shifting gaze as it alights on different things.

When the perceived surfaces, which the gaze wants to synthesize, cannot provide these same sensations, the reconstructed three-dimensional image consists only of 'unnatural' space subject to other spatial criteria which the perceptual system uses simply to deceive itself.

Even less than painting, and no more than photography, stereoscopy, or any other three-dimensional viewing process, is not at all like a window giving onto the outside world – no matter what the perspectivist speculation of the Renaissance or the advertising for '3-D vision' might have said. This is because the window is merely a frame, situated in space, surrounding and delimiting the pyramid of visual acquisition; it has no surface and has nothing in common with an artificially created surface, such as a photograph in the stereoscopic device.

The pseudo-reversibility of a return to three-dimensional perception as a result of viewing a surface is, in fact, comparable to an inversion which in turn can be likened to turning a glove inside out; it is as if the eye had been removed from its socket, had left the observer's body to be projected out in front and had become part of the enlarged space which is under scrutiny. However, it has nothing before it except the visual obstacle of a surface-boundary. The process to which it lends itself is preceded, literally, by a loss of vision, in so far as the awareness of natural sight becomes lost, within the surface. And paradoxically, this is followed by the opposite impression, that the distances have been expanded and magnified, comparable to the effect of a magnifying lens which enlarges the three dimensions.

The sensation of three-dimensionality, which some people occasionally find hard because it involves making a visual – as well as what might be called a mental – effort, often creates the impression of projecting the eyes from the head, of adopting a somewhat unnatural way of looking at things. The impression is one of muscular contraction which is, however, contradicted by the impression that the perceived space has been enlarged. Although the mind knows very well that the observed space is, in this case, restricted to the box of the stereoscope, or to the frame of an image, the senses indulge in the contemplation of an unusual world which they believe to be extendible although compartmentalized; but perhaps it is because this space is compartmentalized, reduced to a small angle and limited to a frontal surface, that our senses feel the need to enlarge it, to recreate the lost vision in our head?

1. Louis Figuier, *Les Merveilles de la Science*, Furne, Jouvet et Cie, Paris, 1869, p. 189.
2. In this text, the term 'stereoscopy' refers to the principle and effect of the stereoscope and not to a collection of 3-D viewing effects; on the other hand, the ideas revolving around a surface-depth dialectic are not applicable to 'photostereosynthesis', which is comprised of several surfaces forming a succession of layers.
3. François Napoléon Marie Moigno, *Le Stéréoscope, ses effets merveilleux. Le Pseudoscope, ses effets étranges*, Paris, 1852.
4. E. Estanave, *Relief photographique à vision directe. Photographies animées et autres applications des réseaux lignés ou quadrillés*, F. Meiller, Vitry-sur-Seine, 1930, p. 7.
5. *Ibid.*, p. 8.
6. This is to be compared with the position upheld by Bergson who posited that in cinematographic synthesis, which makes us think we are perceiving movement, there is actually no movement other than in the instrument.
7. This refers to the jerky disordered motion of ocular directionality, as the eyes alight on certain particular points of the surface, which is similar to the Brownian movement of gas molecules.

DEUXIÈME ANNÉE. N° 2.

DIMANCHE, 30 NOVEMBRE 1851.

LA LUMIÈRE

REVUE DE LA PHOTOGRAPHIE.

BEAUX-ARTS — HÉLIOGRAPHIE — SCIENCES.

JOURNAL NON POLITIQUE

PARAISSANT LES 15 ET 30 DE CHAQUE MOIS.

BUREAUX, A PARIS, RUE DE LA PERLE, 7 (au Marais).

ABONNEMENTS.—PRIX. — *Paris*, UN AN, 10 FR.; 6 MOIS, 6 FR.; — *Départements*, UN AN, 12 FR.; 6 MOIS, 8 FR.; — *Etranger*, UN AN, 14 FR.; 6 MOIS, 10 FR.

AVIS AUX ABONNÉS.

A dater du 17 novembre, les bureaux du journal *La Lumière* ont été transférés de la rue de l'Arcade, n° 15, au n° 7 de la rue de la Perle (au Marais).

L'administration prie les anciens abonnés qui ne se seraient pas fait rembourser les différences qui sont dues sur leur précédent abonnement, de vouloir bien hâter cette démarche, en accompagnant la demande *affranchie* de leur quittance. Cela est nécessaire, même pour les personnes qui continuent leur abonnement.

SOMMAIRE.

ACADÉMIE DES SCIENCES, par M. GOVI. Pierres précieuses artificielles. Expériences avec le pendule à Colombo et à Rio-Janeiro. Portraits de crétins daguerréotypés. Epreuves positives sur papier. — Application du stéréoscope, par M. A. GAUDIN. — La photographie rendue facile par M. N. WHITLOCK. — Souscription Niépce et Daguerre. — CORRESPONDANCE.

ACADÉMIE DES SCIENCES.

—

Pierres précieuses artificielles. — Expériences avec le pendule à Colombo et à Rio-Janeiro. — Portraits de crétins daguerréotypés. — Epreuves positives sur papier.

Plusieurs chimistes avaient déjà essayé de tirer parti de l'analyse des pierres fines pour les reconstituer artificiellement, par voie de fusion, par voie humide, en dissolvant leurs principes constituants, par des actions lentes, par décomposition de vapeurs et même par voie de sublimation. Mais il y avait un nouveau mode de production à essayer, et voilà M. Ebelmen qui, l'ayant découvert, s'est présenté aux savants avec des produits qui ont dépassé de beaucoup les espérances des chimistes. L'habile directeur de la manufacture de Sèvres est parti du principe que, comme les sels en dissolution cristallisent toutes les fois que le menstrue dissolvant vient à diminuer par rapport aux substances dissoutes, il serait possible qu'en remplaçant l'eau ou les autres corps liquides aux températures ordinaires, par des liquides incandescents, on réussit à obtenir, dans des corps fondus et vaporisables, des sels cristallisés de matières insolubles et presque infusibles. C'est, en effet, ce qu'il a pu réaliser en dissolvant l'alumine, la silice, la magnésie, la glucine, la chaux, etc., dans de l'acide borique, dans de l'acide phosphorique ou dans de l'acide silicique en fusion. Les terres se dissolvaient dans ces liquides embrasés, comme le sucre dans l'eau, et de même que celui-ci, quand son eau s'évapore, ils se prenaient en masses cristallines quand l'acide dissolvant s'en allait en vapeurs. Plus tard, M. Ebelmen substitua la potasse, la soude, les alcalis en un mot, aux acides précédemment employés; les résultats furent différents pour les substances, mais identiques pour la forme. Enfin, le même chimiste a songé, ces jours derniers, à l'emploi d'une méthode différente qui lui a aussi donné d'admirables produits. Voici en quoi consiste cette méthode. On sait que par des oxydes, on arrive à en précipiter d'autres dans des solutions froides, et l'on sait aussi que l'oxyde précipité entraîne souvent une partie de la matière qui a servi à produire la précipitation. M. Ebelmen a fait dissoudre des oxydes dans des acides fusibles; puis, à l'aide d'oxydes alcalins plus puissants que les premiers, il a soustrait ceux-ci à l'action de l'acide qui les tenait en dissolution. C'est toujours le même procédé que celui par voie humide; seulement, les températures sont changées, et ce qui a lieu pour les sels ordinaires ou pour les oxydes à 0°, à 12°, ou à 100° tout au plus, s'opère ici à des degrés de beaucoup supérieurs, et qui montent quelquefois au delà du 1000e de l'échelle centigrade. Il serait inutile d'indiquer maintenant quels sont les cristaux obtenus par cette voie toute nouvelle. Nous nous contenterons d'avoir signalé ces méthodes, afin que ceux qui voudraient les essayer les connaissent, et qu'ils puissent attaquer cette mine non encore exploitée, qui promet pourtant déjà des résultats magnifiques.

Il a été beaucoup parlé, et on parlera beaucoup encore de l'admirable expérience à l'aide de laquelle M. Foucault a réussi à faire voir, aux yeux du corps, la rotation de la terre, que les yeux de l'esprit pouvaient seuls apercevoir. On vient de répéter cette expérience en deux endroits fort éloignés de nous et placés dans des conditions particulières. L'un, c'est Colombo, dans l'île de Ceylan, très-près de l'équateur, au sud de l'empire indo-britannique, par 6°56'6" de latitude boréale. Le pendule de 20m,269 de longueur, formé par un fil métallique de 1mm,016 de diamètre, suspendu à un faisceau de fils de cocon non tordus, et portant une boule en plomb, du poids de 15k,854, a donné, comme moyenne de plusieurs expériences, une déviation horaire de 1°,825; la théorie donnait pour cette latitude 1°,811, ce qui peut être considéré comme identique avec le résultat de l'observation. L'autre endroit où l'on a fait osciller le pendule, c'est la ville de Rio-Janeiro, dans le Brésil, au sud de l'équateur, par une latitude australe de 22°,54'. M. d'Oliveira, qui faisait l'expérience, s'est servi d'un pendule qui, certes, ne pouvait pas être fort exact dans ses mouvements. Sa longueur était de 4m,565; il était en fil de lin sans torsion, et supportait une sphère creuse en métal du poids de 10,5 kilogrammes. Presque toujours l'oscillation a été elliptique, au lieu d'être linéaire, ce qui tient, de l'aveu même de M. d'Oliveira, au mode de suspension du pendule. On a trouvé une différence notable, et même une opposition complète entre le mode d'oscillation dans le plan méridien et dans le plan perpendiculaire. M. d'Oliveira prétend, en outre, avoir constaté l'existence de deux plans invariables d'oscillation inclinés de 78°,44' 20" sur le plan du méridien. Il est bien possible que toutes ces inégalités et ces plans invariables ne soient que le résultat des actions mécaniques particulières, attribuables au faisceau de fils qui servait de moyen de suspension à l'appareil. La déviation en 30m a été entre 5°,9' et 5°,12'; la théorie aurait donné 2°,918 dans le même temps, ce qui n'est que la moitié environ du résultat observé.

Nous avons à indiquer ici une application heureuse de la photographie à la médecine. C'est M. le docteur Baillarger qui en a eu l'idée, pour transmettre aux savants les images fidèles de quelques malheureux crétins, qu'il a pu étudier dans ses voyages. Nous avons examiné ces portraits, et nous les avons trouvés fort remarquables au point de vue de la daguerréotypie, mais d'une telle difformité, par rapport à la nature humaine, que nous avons failli désirer le rétablissement de la loi des Spartiates ou de celle des Douze Tables : *Insigni deformitate puerum, cito necato*.

M. Gustave Legray a déposé à l'Académie un paquet cacheté contenant la description d'un procédé nouveau pour avoir des images positives sur papier. Espérons que l'auteur voudra sortir bientôt des cartons académiques.

G. GOVI.

APPLICATION DU STÉRÉOSCOPE

A LA PHOTOGRAPHIE

Le stéréoscope, imaginé par M. Brewster, et construit par M. Dubosc, est représenté en perspective et dans ses détails par les figures ci-jointes. On voit qu'il consiste en une boîte en carton ou bois d'acajou, *fig.* 1, susceptible de recevoir deux épreuves daguerriennes. Etablies,

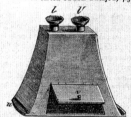

côte à côte, sur une même planchette, qui est placée sur le fond de la boîte, ces épreuves reçoivent la lumière à travers une ouverture rectangulaire munie d'une trappe à paroi réfléchissante *v*, qui est tournée vers la lumière, tandis que les yeux sont appliqués aux tubes *ll'*, garnis des pièces optiques. Ces tubes ou lunettes sont perpendiculaires au plan des images, et peuvent se mouvoir séparément, en avant ou en arrière, afin d'être amenés à la vision distincte.

Les verres qui garnissent les deux lunettes d'un stéréoscope sont les deux moitiés d'un même objectif achromatique *ll'*, *fig.* 2, dont les biseaux se regardent, et

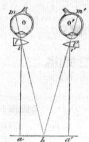

sont maintenus dans cette position relative par un tenon fixé aux oculaires, et glissant dans une fente pratiquée dans les tubes enveloppants. La *fig.* 2 montre que tout rayon *a i*, *a' i'*, arrivant aux demi-objectifs, en sort dans une direction oblique *l m*, *l' m'*, pour pénétrer dans les yeux *o o'*, de sorte que la vision simultanée de ces points les fait paraître en *b* jonction de ces lignes prolongées.

Le résultat serait le même pour les deux pyramides *a a*,

fig. 3. Au moyen du stéréoscope, ces deux figures seraient superposées, et les pans ombrés qui portent une teinte uniforme donneraient lieu à une ombre finement dégradée, qui produirait l'illusion d'une arête en saillie, et par conséquent d'une pyramide en relief.

The magic of 3-D

Hubert Damisch

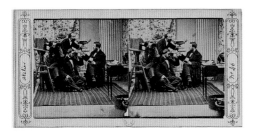

Alexandre, **Men looking at stereoscopic views**,
before 1860
Stereoscopic view, albumen print. Inscriptions in French:
'Workshop no. 46'; copyright stamp on reverse '1859',
and stamp 'ALEXANDRE/PHOTOGRAPHY, 18 RUE DE LA PEPINIERE';
mount 8.8 x 17.1 cm.

Coll. Bibliothèque Nationale de France, catalogue no. EK5.

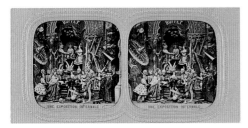

Adolphe Block, **'An infernal exhibition'**, c. 1868
Coloured stereoscopic tissue view, albumen print;
mount 8.6 x 17.5 cm.

Coll. Pierre-Marc Richard.

The sculpted plaster figures were the work of Louis Alfred
Habert. This is a satirical image of the World Fair of 1867.

Gaudin, **'Application du stéréoscope
à la photographie'**
Article in *La Lumière*, 30 November 1851; 36.6 x 26.6 cm.

Coll. Société Française de Photographie.

This was the first illustrated article on stereoscopy to appear
in *La Lumière*, a French photographic journal published
between 1851 and 1867.

Just how great is the curiosity that today impels us to peer through the twin lenses of a stereoscope so that we can each repeat our individual experience of three-dimensional photography? What excessive care or attention do we give it, by what desire to know and learn, by what inquisitiveness about trifles that do not concern us, by what taste for things that are novel and strange are we driven (these being the terms used to define the word 'curiosity') ?

Perhaps three-dimensional photography itself has become no more than an object of curiosity, a thing of the past. Maybe this is why we now question its importance, not to say its attraction for us, an attraction that is at once anachronistic and strangely immediate. To come under the spell of a stereoscopic device is to slip, however briefly, into the empirical position that so enthralled the nineteenth-century enthusiasts, so much so that three-dimensional imagery became immensely popular.

Today we may find it hard to identify the reasons for such enthusiasm simply by looking at the images; if so, this is largely the fault of cinema. From the outset photography had been inhabited by the fantasy of grasping reality and reproducing it in all its aspects and in all its spatial and temporal dimensions. In comparison to the stereoscopic image, the reproduction of movement by means of a succession of frames projected on a screen offered an indisputably more effective response to that fantasy. What we now see in these three-dimensional images is different from what was sought by the 'thousands of avid eyes' described by Baudelaire as they peered into 'the holes of the stereoscope which were like skylights onto infinity' at the Salon of 1859.[1] Yet the fact that we see different things in them and look at them in a different way is no longer due to the influence of cinema alone. It is directly related to the possibilities created by photography's current role, whether 'virtual' or not.

The stereoscope caught Baudelaire's attention at a time when the vogue for this device was still in its infancy. He included it among what he regarded as the ever growing number of 'scientific playthings' whose importance he refused to discuss either approvingly or disapprovingly.[2] Certainly the stereoscope was a toy, although intended for adults. Its uses and content ranged from contemporary reality, in all its aspects, to pornography, via archaeology, tourism and tableaux vivants. But what justified it as 'scientific'? Was it the 'sculptural rendering of a flat image', as Baudelaire writes in *La Morale du joujou*, which can be likened to the recording of movement using a succession of static figures by the phenakistoscope, which was older and lesser-known (though apparently better able to hold the poet's attention)? As Baudelaire predicted, the three-dimensional effect long continued to amuse: interest in stereoscopic images did not diminish until the invention of instant photography, which allowed movement to be captured, and that of cinema, which restored the illusion of movement. The cinematic illusion eventually became more successful than that of three-dimensional photography, but did not supplant it altogether.

The fact that we can still be surprised by and marvel at this trick without its magic being dispelled by its 'objective' explanation clearly reveals that this effect should be understood in terms more intentional than demonstrative, borrowed from the phenomenology of perception and the experience of life rather than from optics or the theory of sight. Bergson criticized cinema for portraying movement by using fixed images, as the phenakistoscope had already done. Yet how does the stereoscope

38 make three dimensions if not from flat images? As Deleuze emphasizes, we cannot conclude that the artificiality of the means is reflected in the artificiality of the result.[3] Yet it is important to understand the practical extent of the artifice.

Whereas the construction of perspective required the existence of a single eye, corresponding to its point of origin, the two eyepieces of the stereoscope mobilize both eyes, the better to deceive binocular vision. Whether each eye looks at a different image, what is seen being unified only at the expense of a forced synthesis, or whether this synthesis is brought about in the apparatus itself, in virtual form, by means of prisms through which the two images are refracted, the observer's binocular vision is diverted from its natural course and, so to speak, objectivized, confronted with its own operation. Any manipulation involved is less the work of the observer who holds the stereoscope or peers into it with both eyes, than that of the apparatus itself. For the stereoscope holds its operators so completely in its power that they forget that (as Leonardo da Vinci said of the image in the mirror) both the image it contains and that image's three dimensions are present only to the beholder. Paradoxically, and herein lies the artifice, the indisputable illusion of three dimensions procured by stereoscopic vision can be given an objective causal explanation in terms of optics. It results from the superimposition of two images, whose only difference lies in a slight displacement of the vanishing lines of their perspectives, which emanate from two viewpoints separated by a distance corresponding to the space between two eyes. (This remains true whatever discussions there may have been concerning the distance that should be set between the two camera lenses. Such disputes are a direct echo of the arguments about the limits within which perspective should be contained in painting to avoid any unwanted distortion). The artifice lies in the fact that the impression or sensation of three dimensions is generated by the conjunction of two *flat* images, reinforcing or emphasizing the overall effect of depth and volume created by perspective.

Maurice Merleau-Ponty said of depth that of all the dimensions it is the most 'existential', since it cannot be seen on the object itself, being a matter of perspective rather than of things.[4] The perspective is that of the person looking. This was demonstrated by Brunelleschi's absolutely fundamental experiment in which an observer was asked to look through a hole in a small panel at a view of the Florence Baptistry seen from the central door of the Duomo. This view was painted on the panel's other side and reflected in a mirror. The hole was placed exactly at the vanishing point of the image, which is so aptly named in Italian the *punto dell'occhio* or 'eye point'.[5] This experiment was intended to demonstrate the coincidence of viewpoint and vanishing point. However, it can justly be said to have revealed less about the illusion of depth than about the volumetric effect which can arise from the portrayal in perspective of a regular geometric body, such as the octagon of the San Giovanni Baptistry with its pyramid-shaped roof. This was an effect of volume rather than of relief. It had none of the *saillie* or projection later defined by Delacroix, when the vogue for the stereoscope was at its height.

Projection in painting is created using not only graphic but also pictorial means such as chiaroscuro, colour, thickness of paint, etc. To Delacroix it was, like 'thickness', the mark of a great artist.[6] 'One could make a great joke', he wrote, 'about the search for flatness, which is so esteemed by the fashionable arts, including architecture'.[7] At the time the stereoscopic industry seemed to be winning out over such a reduction of the art of painting to 'flatness' or platitude – to the two-dimensional surface – which was later to become an integral part of the modernist credo. In the three-dimensional image the synthesis of two flat images through interference or superimposition lends the plane the equivalent of the thickness linked to projection in painting.

Yet this process is only partly successful since, for the most part, the impression of three dimensions does not proceed from the stereoscopic image as a whole. It is linked more to the fixing of the observer's attention on a particular object, bringing it forward or making it stand out from the background. But, as Merleau-Ponty asked, what is meant by 'fixing'? Where the object is concerned, it means separating the area in question from the rest of the field (a condition satisfied by the enclosed mechanism of the stereoscope). From the point of view of the person looking, it means replacing the vision of the whole with observation, a localized sight governed by looking. 'The quality apprehended by the senses, far from being coextensive to perception, is the particular product of an attitude of curiosity or observation. It appears when, instead of giving my

Marinier, **Box for 12 stereoscopic views illustrating La Juive**, before 1868
Inscription in French on the lid: 'OPERA LA JUIVE, 12 STEREOSCOPIC TABLEAUX, LITH. DUBOIS PARIS'; on the box: 'REGISTERED', 'E.L.' [Ernest Legendre, card manufacturer]; 9.0 x 18.0 x 2.5 cm.

Coll. Musée Carnavalet, catalogue no. Ph 15110 to Ph 15121.

In the 1860s major plays and operas were often the subject of series of six or twelve stereoscopic views. They were small-scale compositions which faithfully reproduced the main scenes of the production (scenery, costumes, staging).

Anonymous, **Daguerreotype of a sculpted bust of François Arago (1786–1853)**, 1850s
Stereoscopic daguerreotype in a viewing case: folding panel with stereoscopic lenses; velvet lining with gold motifs, leather case with embossed motifs. Inscription: 'BIRANVI KORNIS' in gold letters below the images and on the lens panel; round label with '3.958', bottom right, in brown ink; closed case 12.4 x 15.5 x 2.0 cm; images 9.0 x 12.8 cm.

Coll. Musée Carnavalet, catalogue no. Ph 14427.

The astronomer and physician François Arago presented the daguerreotype process to the Académie des Sciences in 1839. Director of the Paris Observatory, he was also a member of the provisional government of 1848 and played a key role in the abolition of slavery in the French colonies. His brother Étienne Arago (1802–92) became mayor of Paris in 1870 and his son, Emmanuel Arago (1812–96) was a member of the government of the Défense Nationale after 4 September 1870.

Moulin, **The workshop of the sculptor Dantan Jeune (1800–69)**, between 1857 and 1859
Stereoscopic view, albumen print. Inscriptions: oval embossed stamp 'ML'; label printed in French on reverse, on the right: 'STUDIO OF THE SCULPTOR DANTAN JEUNE. JOURNAL LE STEREOSCPE, 5, Rue Neuve-Saint-Augustin. December 1.'; mount 8.7 x 17.4 cm.

Coll. Pierre-Marc Richard.

Jean-Pierre Dantan (Dantan Jeune) was famous for his busts and caricatural statuettes. He exhibited his work in his 'museum' on the Square d'Orléans, a cast-iron gallery lit by a skylight.
Moulin also photographed Dantan's caricatures for the journal *Le Stéréoscope*.

E. Bloch, **The 'Bouquin', a stereoscopic camera in the form of a book**, 1904
Wood, cardboard and various metals; drop shutter; 6.0 x 11.5 x 14.5 cm.

Coll. Musée Française de Photographie, Bièvres, catalogue no. 95.9052.

This very typical example of Bloch's concealed cameras takes photographs (4.5 x 10.7 cm) using lenses located on the edge of the book.

entire gaze over to the world, I turn to this gaze itself and ask myself exactly what it is I am seeing; it does not enter into my sight's natural commerce with the world, it is a response to a particular question from my gaze, the result of secondary or critical sight.'[8]

Three-dimensional photography should certainly be discussed as a quality apprehended by the senses, even if it is only illusory or virtual. What do we see, exactly, in the stereoscope? If the power its magic exerts is sometimes surprising (so much so that a reference to sculpture is in order, and indeed stereoscopic imagery has not failed to pay tribute to this art), it is because the normal conditions of visual perception have been disturbed and the gaze that falls on the image raises questions about itself. These questions cannot be answered by any optical, physiological or neurological explanation, since they cannot but refer back to a phenomenal order in which the 'three dimensions' appear in a quite different form from the one they adopt when we put our two eyes to the stereoscope. In what Merleau-Ponty calls sight's natural commerce with the world, we do not, properly speaking, see in three dimensions. If, in the depth of the world as it forms in the beholder's gaze ('one must look to see', said one of the authors cited by Merleau-Ponty),[9] objects appear in three dimensions, this is the effect of a type of attention which is retrospectively illuminated, if not actually shaped, by the experience of looking into a stereoscope. The same can be said of the experience of photography, if we are to believe, as its devotees suggest, that without photography stereoscopy would never have been able to create 'the striking views of nature which place three-dimensional objects before us, with their anfractuosities and their projections'.[10] Others before Delacroix had observed that the proportions of rocks on the seashore were such as to give the impression on paper of an immense cliff. However, the description in Delacroix's *Journal* of the way that waves divide into smaller waves, which then subdivide in turn, showing the same lines and planes of light,[11] anticipates the theory of fractals. By analogy, it almost certainly owes something to the experience of photography, if not to the stereoscope.

Yet all this would still be nothing if three-dimensional photography did not deserve our attention today for other reasons. As with any sensation, any quality that can be apprehended by the senses – again, however illusory – the sensation offered by stereoscopic vision is motivated by physiognomy and is accompanied by imperceptible movements which can be called 'virtual'. As Rosalind Krauss observes, stereoscopic images are concrete invitations to let our gaze enter the depth of field of the image over which it wanders. On a kinaesthetic level the microscopic efforts of our muscles correspond to the purely optical illusion of the stereoscopic image.[12] One cannot possibly walk round the object, however clear its three dimensions. To attain this end, we have had to wait for a different type of imagery, itself called virtual, which invites different kinds of active manipulation on the part of the beholder. But the fact that the observer is allowed to penetrate the image, to open up a way into it, to go round obstacles and look at objects from behind does not imply that the site of the manipulation itself has moved so that it is now produced by those observers alone. In fact, they themselves are strictly programmed in terms of the operations available to them. Hence the outmoded and rather nostalgic charm of the images we see in the stereoscope, born of a magic whose principle is altogether singular and individualized, unlike the collective magic of the cinema. This magic is all the more effective because it offers the gaze the freedom to contemplate relationships other than the supposed mastery it has over objects, living things and the world as a whole.

1. Cf. Denis Pellerin, 'Les lucarnes de l'infini', *Etudes photographiques*, no. 4, May 1998, pp. 27–43.
2. Charles Baudelaire, *Morale du joujou*, 1853.
3. Gilles Deleuze, *Cinéma I. L'image-mouvement*, Paris, 1983, p. 10.
4. Maurice Merleau-Ponty, *Phénoménologie de la perception*, Paris, 1945, p. 296.
5. Cf. Hubert Damisch, *L'Origine de la perspective*, Paris, 1987; new edition, 'Champs' series, 1993, Part 1.
6. 'I also note that [Rubens'] principal quality, if it is possible to refer to one alone, is the prodigious

projection of his figures, in other words their prodigious life. Without this gift there is no great artist; only the greatest artists manage to solve the problem of projection and thickness.' Eugène Delacroix, *Journal*, 21 October 1860 ; new edition, Paris, 1980, p. 790.
7. *Ibid*. The stereoscopic autochromes taken by Étienne Clémentel in Giverny around 1920 resemble the literal illustration of such a 'joke': the painter of the *Water Lilies*, in which the plane can be seen in all its liquid and chromatic thickness, stands out in high relief against the background of one of his favourite motifs.

8. Maurice Merleau-Ponty, *op. cit.*, p. 261.
9. R. Déjean, cited by Merleau-Ponty, *op. cit.*, p. 268.
10. Louis Figuier, 'Le stéréoscope', in *Les Merveilles de la science ou description populaire des inventions modernes*, Vol. III, Paris, 1869, p. 189.
11. Eugène Delacroix, *Journal*, 5 August 1854; *op. cit.*, pp. 448–49.
12. Cf. Rosalind Krauss, 'Photography's Discursive Spaces', in *The Originality of the Avant-Garde and other Modernist Myths*, Cambridge (Mass.), 1985, p. 138.

1

The golden age
of stereoscopy
1850–1880

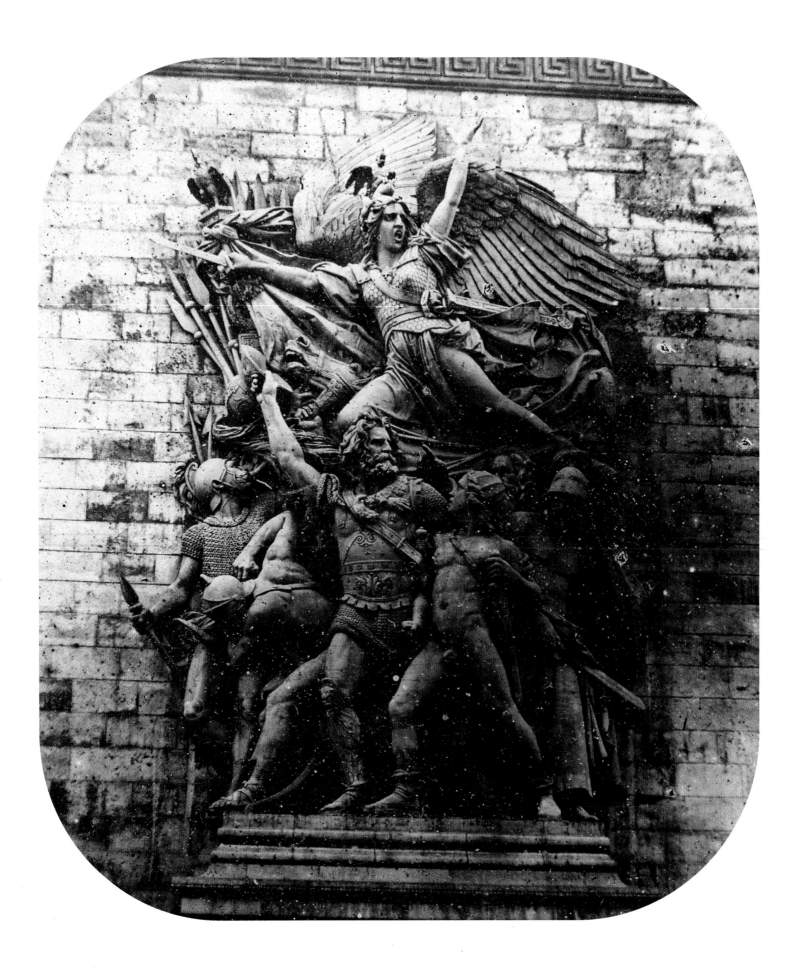

Denis Pellerin

Attributed to Charles Chevalier, **Portrait of Charles
Wheatstone and Charles Chevalier (right)**, c. 1843–44
Reversed quarter-plate daguerreotype; frame 16.0 x 18.7
cm, image 7.0 x 9.5 cm.

*Coll. International Museum of Photography and Film,
George Eastman House, Rochester, New York, catalogue
no. 76.168.13.*

Claude Marie Ferrier, **Bas-relief of the Arc de Triomphe:
'La Marseillaise' or Le Départ des Volontaires de
1792**, c. 1850–52

Coll. Musée Carnavalet, catalogue no. Ph 15842.

Compared with the extensive coverage and commentaries devoted to the discovery of photography, relatively little is known about the origins and development of stereoscopy. The lack of documentation and unverifiable nature of certain claims means there is a great deal of uncertainty surrounding the early development of an instrument which was initially a scientific curiosity before it acquired artistic and commercial status. The stereoscope finally captured the public imagination when it made its debut in Paris and, in the space of a few years, established its reputation in the salons of the bourgeoisie. Its popularity continued throughout the Second Empire and gave rise to a lucrative industry.

The invention of the stereoscope

It is not known what prompted the English physicist Charles Wheatstone (1802–1875) to begin the research that led to the invention of the stereoscope, nor exactly when he began this research. However, it is known that, by 1832, the principal of stereoscopic images had been established and several instruments existed, at least in their early stages.[1]

Wheatstone's first observations were based on the difference between the perception of close and distant objects. He noted that 'when and object is viewed at so great a distance that the optic axes of both eyes are sensibly parallel when directed towards it, the perspective projections of it, seen by each eye separately, and the appearance to the two eyes is precisely the same as when the object is seen by one eye only.' He also noted that 'this similarity no longer exists when the object is placed so near the eyes that to view it the optic axes must converge. Under these conditions, a different perspective projection of it is seen by each eye, and these perspectives are more dissimilar as the convergence of the optic axes becomes greater'.[2]

This simple observation represents the basis of Wheatstone's discovery. 'What would be the visual effect,' he wondered, 'of simultaneously presenting to each eye, instead of the object itself, its projection onto a plane surface as it appears to that eye?'[3] Wheatstone drew the perspectives of different objects, observed by the left and right eyes respectively, and then tried to fuse the images obtained. However, he found that 'as both of these modes of vision are forced and unnatural, eyes unaccustomed to such experiments require some artificial assistance'.[4] By using a box, and then two cardboard tubes, he managed to combine the two images: 'a figure of three-dimensions, as bold in relief as before, is perceived, but it has a different form from that which is seen when the drawings are in their proper place'.[5] During the course of his experiments, Wheatstone was struck by what he called the '*converse* image',[6] produced by the inversion of the right- and left-eye drawings. He compared the relationship between the image seen in this way and the real object with the relationship between a mould and its cast: 'The inside of a tea-cup appears as a solid convex body; [...] A small terrestrial globe appears as a concave hemisphere; [...] A bust, regarded in front becomes a deep, hollow mask'.[7] He noted, however, that 'the natural appearance of the object continues to intrude itself, when sometimes suddenly, and at other times gradually, the converse image occupies its place'. The brain, desperately trying to transform the unaccustomed image into a coherent image, often succeeds in deceiving our senses so that we are unaware of the inversion.[8]

44 Preoccupied by other research, Wheatstone interrupted his experiments on stereoscopy until he wrote the paper which he presented to the Royal Society of London, on 21 June 1838.[9] In this paper, he described the instrument that made it possible to verify the various theories advanced. The instrument, which Wheatstone called 'a Stereoscope to indicate its property of representing solid figures',[10] produces its effect by means of two mirrors placed at an angle of 45° to one another. The observer slides two drawings into vertical plates on each side of the mirrors and, placing his or her nose as close as possible to the common edge of two mirrors, perceives a three-dimensional image [11]. Wheatstone illustrated his text with geometric figures, stating that colour would greatly enhance the three-dimensional effect. He even went as far as to assert that 'careful attention would enable an artist to draw and paint the two component pictures'.[12] Wheatstone's revelations and instrument were received with great interest in scientific circles, but his discoveries made no impact on the general public.

Several instruments were made and used in physics laboratories, while Wheatstone's drawings were reproduced and used to demonstrate his theories. However, it was not long before the stereoscope soon sank virtually into oblivion. As the Parisian chemist Marc Antoine Gaudin (1804–1880) remarked in November 1851: 'the use of the stereoscope would have been limited to flat-sided geometric figures, without the intervention of the daguerreotype.'[13] His colleague and rival, popularizer François Napoléon Marie Moigno (1804–1884), also stated: 'Without photography, the stereoscope, if you will forgive the somewhat forced comparison, would have remained a dwarf, a cretin, an idiot; through photography, it has become a giant, a genie with brave and intrepid wings.'[14] In spite of Wheatstone's assertion, no artist succeeded in drawing the two images (two-dimensional projections) of a complex object with sufficient accuracy to enable the images obtained to fuse exactly in the stereoscope and produce a three-dimensional image. However, 'what was almost impossible for even the most skilled draftsman, became an easy task for any photographer.'[15] In August 1839, several months after Wheatstone had presented his paper, the French government published 'free to the world' the invention of Jacques Louis Mandé Daguerre (1787–1851), with the exception of England where Daguerre took out a patent. The process was commercialized under the name 'daguerreotype'. In less than a year, three methods making it possible to make permanent the images of the *camera obscura* (dark chamber) had been developed with varying degrees of success: the daguerreotype, the direct positive process developed by Hippolyte Bayard (1801–1887) of France and the calotype (or Talbotype) developed by Henry William Fox Talbot (1800–1877) of Great Britain.

Wheatstone immediately understood the importance of photography for the development of his invention. In 1840, he asked Fox Talbot to produce two images that could be observed in his instrument.[16] In a letter dated 15 December, [17] Wheatstone thanked Talbot 'for the photographs you have made for the stereoscope'. But the inventor does not appear to have given the photographer precise instructions since the angle he chose arbitrarily between the left and right sides of his 'dark chamber' was too great: 'the angle you have taken (47.5°) is too large'. Considering that 'the differences in the two pictures are consequently too great' to produce a good three-dimensional image, Wheatstone suggested that '25° would be a much better angle'. Several months later, Henry Collen produced a stereoscopic portrait of the mathematician Charles Babbage, again at Wheatstone's request, using the calotype.[18] In spite of the existence of these early images (which have unfortunately been lost), prints produced for use in the stereoscope were limited to isolated experiments between 1840 and 1850, and were not commercialized in any way.

On 26 March 1849,[19] the Scottish physicist Sir David Brewster (1781–1868) described a simplified – less cumbersome and more practical – version of Wheatstone's stereoscope. The mirrors had been replaced by two adjacent half-lenses,[20] joined at their narrowest point and set in a pyramidal box.[21] The two images, now mounted on the same support, were placed on the opposite side of the wood or tinplate box whose open sides allowed the light to pass through it. Brewster's description was accompanied by a plate consisting of sixteen different figures most of which showed variants of his instrument. This had been made by Mr Loudon, an optician from Dundee, who sent models to a number of British aristocrats in London and other British cities. As well as a drawing of a truncated cone, which he used as an example in his description, Brewster

Wheatstone stereoscope

Detail of an engraved plate from Charles Chevalier's sale catalogue: *DAGUERRÉOTYPIE ET PHOTOGRAPHIE SUR PAPIER, VERRE ET MÉTAL. CATALOGUE TRÈS COMPLET EXPLICATIF ET ILLUSTRÉ DES APPAREILS PERFECTIONNÉS DE CHARLES CHEVALIER* [no date]. This stereoscope is described on p. 51: 'WHEATSTONE STEREOSCOPES/MAKING IT POSSIBLE TO VIEW LARGE-FORMAT PRINTS, IN VARNISHED WALNUT, MIRRORS, SUPPLEMENTARY LENSES, ETC./1074. Half- and standard-size prints. 90 [francs]'. The illustration (engraving by Petitcolin after Michel) is taken from a plate at the end of the volume.

Coll. Marie-Thérèse and André Jammes.

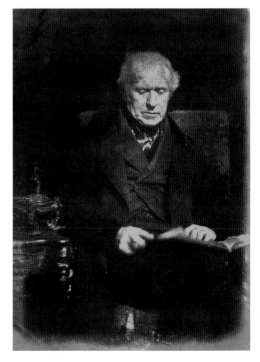

David Octavius Hill and Robert Adamson, **Portrait of Sir David Brewster**, c. 1843–44
Salt paper; 19.4 x 13.8 cm.

Coll. J. Paul Getty Museum, catalogue no. 84.XM.445.15.

also presented two self-portraits produced by Dr Adamson [22] of the University of St Andrews in Edinburgh, and various lithographs drawn by Schenck [23] from stereoscopic daguerreotypes. [24]

Paris: capital of the stereoscope

Brewster's instrument did not interest English manufacturers any more than Wheatstone's had done and it would have undoubtedly shared the same fate if the Scotsman had not gone to Paris in 1850 [25] and met François Moigno. [26] The priest introduced him to the optician Louis Jules Duboscq (1817–1886), the son-in-law of the famous manufacturer of optical instruments Jean-Baptiste François Soleil (1798–1878). [27] The two men understood 'the great advantages to be obtained from this instrument and M. Duboscq immediately made several models'. [28] He also produced several daguerreotypes to accompany his instruments, using a method that had hitherto never been described in great detail and which consisted of 'using a single daguerreotype to take two images of a statue, bas-relief, group or landscape, or two portraits of the same person, one after the other, from the same distance and from equal angles.' [29] Brewster, and later Duboscq, had envisaged the use of a binocular *camera obscura*, but apart from the impossibility of obtaining absolutely identical lenses, they believed that the distance between the lenses should increase in direct proportion to the size of the subject, which meant that the instrument would soon reach 'impossible dimensions'. [30] Jules Duboscq was the first to produce photographic prints for the stereoscope in France and, by the end of 1850, was able to offer his customers stereographs on daguerreotype, glass and paper. According to his catalogue printed in 1852 (the first of its kind [31]), Duboscq's collection consisted mainly of reproductions of busts of English and French notables, statuettes, [32] vases, a natural history group and a life portrait. The only prints produced outdoors – available on glass and paper – showed the four bas-reliefs on the Arc de Triomphe, the Fontaine Cuvier and the equestrian statue of Henri IV on the Pont-Neuf in Paris. These 'outdoor' prints, produced by Claude Marie Ferrier, are still the earliest stereoscopic images of the French capital on record. [33]

Although it was possible to buy prints produced in 1850, the stereoscope was not widely available to the general public until the first Great Exhibition, which opened at London's Crystal Palace on 1 May 1851. Duboscq's stand apparently featured a model of Brewster's lenticular stereoscope. During one of her visits, Queen Victoria was said to have been fascinated by the instrument and, according to the inventor, [34] spent a long time examining the stereoscopic prints produced by Duboscq. At Brewster's request, Duboscq, who could hardly pass up such an opportunity, made a deluxe model of the stereoscope for the young queen. Although no evidence has so far been found to support this anecdote, [35] which is recounted by several sources, it was used to great advantage on both sides of the Channel and helped to launch the fashion for the stereoscope. According to Moigno, 'in 1851, over one thousand stereoscopes were sold in France, England and Germany'. [36] Brewster confirmed, if not the production, at least the fashion for the instrument. According to him, Duboscq was unable to meet the deluge of orders that came flooding in. English opticians, who had initially rejected Brewster's instrument, began to make what promised to be an extremely profitable item. In an article published by the French periodical *La Lumière*, in November 1853, it appears that fifteen hundred stereoscopes – twelve hundred in mahogany and the rest in rosewood and cardboard – were sold each year 'in Paris alone'. It also stated that 'the stereoscope is usually bought with lithographs and daguerreotypes'. The photographer and naturalist Henri de la Blanchère (1821–1880) confirmed that 'at the time (1852), the stereoscope of Sir David Brewster contained nothing but opaque drawings, lithographs, photographs on paper or daguerreotype plates '. [37] Although the daguerreotype technique had been perfected and it was now possible to obtain beautiful prints with complete certainty, this type of image was nevertheless unique, costly (ten francs each in Duboscq's 1852 catalogue) and its production relatively limited. To compensate for these disadvantages, manufacturers produced stereoscopes with lithographs. These were sold from 1851: 'M. Duboscq [offers a] printed collection of solids with white edges on a black background, which create the illusion of geometric figures' [38]. These images, called 'crystals [39]' in the first advertisement published in *La Lumière*, appear to have been as popular with adults as they were with children. Marc Antoine Gaudin described it as 'a very curious spectacle' and the French poet and

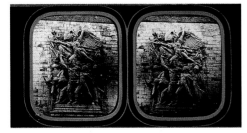

Claude Marie Ferrier, **Bas-relief of the Arc de Triomphe: 'La Marseillaise' or the Départ des Volontaires de 1792**, c. 1850–52

Stereoscopic view, albumen on glass with black-painted border and two narrow gold lines around each image. Inscribed on the front: 'arc de l'étoile 4', top right and 'bas-relief le départ 4', bottom right, handwritten in blue ink on the edges of the mount; mount 8.5 x 17.5 cm.

Coll. Musée Carnavalet, catalogue no. Ph 15842.

This image by Ferrier appeared in the first catalogue of stereoscopic views, published in 1852 by Duboscq. It cost 15 francs and was entitled 'Le Départ, bas-relief de l'Arc de Triomphe de l'Étoile'. The sculpture, by François Rude (1784–1855), is the best-known sculpture of the Arc de Triomphe.

46

critic Charles Baudelaire (1821–1867) made reference to it in his *Morale du joujou* (1853) when speaking of the stereoscope as a scientific toy.

Although the stereoscope was even described by some as 'philosophical', efforts to interest the French scientific authorities in the instrument appear to have been in vain. Louis Figuier (1819–1894) relates, with a great deal of humour, the attempts made by François Moigno to interest members of the Académie des Sciences in the launch of the stereoscope: François Arago suffered from double vision, Felix Savart and Antoine

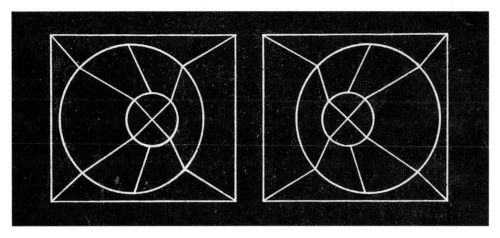

Duboscq-Soleil, **Geometric figure**, 1851
Stereoscopic view, lithograph; 8 x 18 cm.

Coll. Pierre-Marc Richard.

Becquerel were both blind in one eye, while Claude Pouillet had a divergent squint. Jean-Baptiste Biot, the most senior member of the academy, had excellent vision but was suddenly affected by 'voluntary blindness'[40] when presented with the instrument. Only the physicist Regnault 'examined the instrument of his colleague from London with the greatest care. He was delighted by the effects it produced…'[41] Regnault's support was not enough and Brewster's instrument continued to be regarded as an amusing curiosity by the majority of members in these scientific circles. Some publishers realised the commercial potential of the instrument and did their utmost to promote its development. Alexis Gaudin (1816–1894), who bought *La Lumière*[42] in 1851, was one of the first to devote several articles to the stereoscope. In a few years, he had made it the speciality of his publishing house in the Rue de la Perle. Full-page advertisements, detailed commentaries of the new collections that he published, catalogues, the creation of a column almost exclusively devoted to these 'magic glasses', prizes in the form of photographs and stereoscopes for subscribers… Gaudin covered every possible angle.

However, it was not until 1855 and the first Great Exhibition held in Paris, that stereoscopy really began to make an impression.[43] In 1856, a 'Stereoscopes' section made a tentative appearance in the Paris trade directory.[44] Four years later, there were fifteen or so entries in this section and others under 'Photographers'. The period between 1856 and 1867 can be regarded as the golden age of the stereoscope on both sides of the Channel, for the sheer diversity of the subjects treated and the imagination used to recreate interiors that it was still technically impossible to reproduce. Many artists photographed the monuments of Paris and the changes taking place in the capital. They gradually extended their sphere of activity and, in 1856, the first stereoscopic travel images appeared on the market: views of Pompeii by Grillet, travels in Brittany and the Pyrenees by Furne and Tournier. At the same time as these binocular travel images, a great many tableaux were produced, either entirely imaginary or inspired by paintings, engravings or the operas and plays currently in vogue. In 1858 and 1859, new genres began to appear: interiors of imperial and official residences (the Tuileries, Senate, Hôtel de Ville), journeys to distant lands and many genre scenes created in Paris studios. These reconstructions with extras, painted scenery and a great many props and accessories were widely distributed throughout Europe and as far afield as the United States. In 1860, the first scenes using clay figurines were brought out: 'diableries' (satirical scenes composed with little skeletons) and '*Théâtres de Paris*'.[45] In 1862, the fashion for '*Vues animées*' – lively outdoor scenes of Paris – was launched. At the same time as varying the subjects, publishers also made every effort to vary the presentation of the prints. The cardboard mounts were changed every year and the images were sometimes available in several qualities: standard or coloured, opaque or

Duboscq-Soleil, **Vase of flowers**, c. 1852
Stereoscopic daguerreotype 8.7 x 17.5 cm.
Inscription in French: 'STEREOSCOPIC VIEWS/PATENTED WITHOUT GOVERNMENT GUARANTEE 5 FRANCS/MATHEMATICAL SUPERIMPOSITION OF OUTLINES AND SHADOWS'.

Coll. Galerie Le Fell.

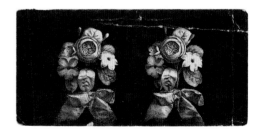

Duboscq-Soleil, **Vase of flowers**, c. 1852
Stereoscopic view, lithograph, after a daguerreotype; 8.3 x 17.0 cm.

Coll. Pierre-Marc Richard.

10785
La stéréoscopomanie fait des progrès.

Félix Nadar, **Stereoscopy is all the rage**, c. 1856
Engraving on wood for the *Petit journal pour rire*,
no. 39, p. 2; 8.0 x 5.8 cm.

Coll. Robert Blake.

47

tissue views. The fall in price over the years made the stereoscope more affordable by the less well-off sections of society.[46] Its popularity became such that the instrument attracted the interest of those looking to make an easy profit. Illegal copies [47] became increasingly widespread and small shopkeepers on the Parisian boulevards sold inexpensive, third-rate prints over the Christmas and New Year period.

Modern times

The 1867 Great Exhibition gave rise to a proliferation of stereoscopic images, but the Franco-Prussian War and Paris Commune dealt a severe blow to this now flourishing industry. The many series on the ruins of Paris were not enough to re-launch production. The industrialization of the manufacturing process – concentrated in the hands of a small number of publishers [48] – led to a significant decrease in the quality of the prints and the defection of a public for whom the stereoscope had ceased to be a novelty. In the 1890s, there was renewed interest in the stereoscope due to the meteoric development of amateur photography and the arrival on the market of views by American publishers. Although the 1900 Great Exhibition boosted production, the stereoscope encountered new competition from the postcard [49] and the increasing place occupied by photography in the press.[50] Professional binocular prints enjoyed renewed popularity after World War I, with the distribution of thousands of spectacular and poignant prints of life in the trenches, the destruction caused by bombing and the victory parade along the Champs-Élysées in Paris. During the 1920s and '30s, some Parisian publishers enjoyed a limited success with images carefully printed on glazed board [51] but most of the stereoscopic images produced during this period were the work of amateurs. World War II did nothing to revive the interest in the stereoscope since the only views published had been taken by German photographers during the Occupation. With the development of new media in the 1950s, stereoscopic production tended to focus on travel and tourism, an area of production that has more or less survived to the present day [52] and still gives rise to the occasional publishing initiative. From the outset, the indispensable optical intermediary of prisms or lenses created an obstacle to the development of the stereoscope and the images produced for use with the instrument. Stereoscopy continues to remain a difficult technique, in spite of modern materials and resources. The discovery of binocular 3-D will, however, never cease to be a source of wonder each time it is experienced. To the spatial displacement that so amazed our forbears, has been added a new – temporal – dimension which enables us to explore the past through the medium of old stereographs passed down over the generations. This journey through time merely adds to the charm of these glass or cardboard rectangles whose magic can only be fully appreciated through the eyepieces of a stereoscope.

1. Herbert Mayo, Wheatstone's colleague, briefly described Wheatstone's research in 1833, in the third edition of his work *Outlines of Human Physiology*. The date of the invention of the stereoscope was confirmed twenty years later – during a dispute about precedence – in a letter from the London optician Murray to Wheatstone: ['On examining the accounts submitted to you by Mr Newman [...], I find that my earliest knowledge of your mirror stereoscopes and prism stereoscopes dates from the second half of 1832.']
2. Charles Wheatstone, *Contribution to the Physiology of Vision – On Some Remarkable and Hitherto Unobserved Phenomena of Binocular Vision* (1838 and 1852), Chapter 1.
3. Charles Wheatstone, *op. cit.*, Chapter 2.
4. *Idem.*
5. *Idem.*
6. Charles Wheatstone, *op. cit.*, Chapter 5.
7. Charles Wheatstone, *op. cit.*, Chapter 23. Wheatstone regarded his second paper (1852) as a continuation of the first (1838) and continued to number the chapters sequentially. Thus Chapters 1–16 date from 1838, and Chapters 17–24 from 1852.
8. Wheatstone developed this subject in 1852 and built an instrument that he called a 'pseudoscope'. The pseudoscope aroused a certain degree of interest but was never commercialized.
9. *On various – hitherto unobserved – phenomena of binocular vision.*
10. The word 'stereoscope' is derived from two Greek roots: *stereos* ('solid') and *scopein* ('to look'). Pierre Th. Dufour, who translated Wheatstone's paper into French in 1919, pointed out in his notes that the terms 'stereoscope' and 'stereoscopy' had already been used 'in 1815 by Jean G. A. Chevallier (*Le Conservateur de la vue*, 4th edition, Paris, 1820, p. 458) to describe a phantasmagorical instrument that made it possible to project large, opaque objects. Since then, this instrument has been variously referred to as a 'megascope' and an 'episcope'. However, there is no evidence to suggest that Wheatstone read this work, which allows us to regard the term 'stereoscope' as an original creation on his part.
11. Wheatstone described his stereoscope thus: '"AA" are two plane mirrors, about 4 inches square, inserted in frames, and so adjusted that their backs form an angle of 90° with each other; these mirrors are fixed by their common edge against an upright "B" or [...] against the middle line of a vertical board, cut away

in such a manner as to allow the eyes to be placed before the two mirrors. "CC" are two sliding boards to which are attached the upright boards "DD", which may thus be removed to different distances from the mirrors' (*op. cit.*, Chapter 3).

12. Charles Wheatstone, *ibidem*, 13.
13. *La Lumière*, 30 November 1851.
14. *Le Cosmos*, first issue, undated [1852].
15. *La Lumière*, *op. cit.*
16. Images which have unfortunately been lost or separated since, by definition, the prints intended for the reflective stereoscope were not mounted on the same support.
17. The letter was reproduced in the May–June 1991 issue of the American publication *Stereo World*, in an article by Abram I. J. Klooswijk entitled 'The First Stereo Photo ?'
18. In an article published in April 1854, Collen referred to stereoscopic portraits produced with the daguerreotype by Beard. Wheatstone cited other names in his second paper on the stereoscope published in 1852 : 'At my request, Mr Talbot, the inventor, and Mr Collen (one of the first cultivators of the art) obligingly prepared for me stereoscopic Talbotypes [calotypes] of full-sized statues, buildings and even portraits of living persons. [...] To M. Fizeau and M. Claudet I was indebted for the first Daguerreotypes executed for the stereoscope.' (Wheatstone, op. cit., Chapter 19). Although Wheatstone does not mention dates, it is unlikely that Claudet (the first licensee of the daguerreotype) was working before 1850. When Arago died in 1853, Claudet found among his prints two portraits of the physicist and astronomer, produced in 1844, which he managed to fuse stereoscopically although they were not originally intended for that purpose.
19. Paper given by David Brewster on the modifications and refinements made for the stereoscope, read by the author at a public session of the Royal Society of Scotland on 26 March 1849, and published by the Society in 1850.
20. The use of two half-lenses was justified at the time by the impossibility of obtaining lenses that were exactly the same. Cutting a large lens in half was the only way of guaranteeing two eyepieces with an identical focal distance.
21. Wheatstone stated in his second paper (1852, Chapter 18) that he had 'for many years past' employed a refracting stereoscope using prisms, and went on to describe the instrument in detail.
22. The brother of the Edinburgh photographer and calotypist Robert Adamson.
23. August Friedriech Schenck (1828–1901), who studied under the artist Leon Cogniet.
24. While Adamson's prints do not appear to have survived, at least one of Schenck's lithographs was preserved for posterity. It was published at the same time as Brewster's paper in *Proceedings of the Royal Scottish Society of Arts*, and represents a cast from one of the two statues by Guillaume Coustou (1677–1746) known as the 'Chevaux de Marly' ('Horses of Marly') now in the Louvre Museum, Paris.
25. The exact date of this visit is uncertain. According to the differing accounts of various commentators, it took place in the spring or autumn of 1850, while Louis Figuier (*Les Merveilles de la science*, 1869, Vol. III) dates it to 1851.
26. François Napoléon Marie Moigno was one of the first, if not the first, to present the stereoscope to the French public. On 28 December 1850, La Presse published his account of Brewster's visit to Paris and the success of the model of the stereoscope made by Louis Jules Duboscq. Moigno's *Le Stereoscope, ses effets merveilleux. Le Pseudoscope, ses effets étranges* (Paris, A. Franck, publisher and bookseller, and L.J. Duboscq, optician, 1852) was the first work devoted to the stereoscope.
27. François Napoléon Marie Moigno, op. cit., p. 15.

28. Louis Figuier, *Les Merveilles de la science*, Vol. III, p. 192. Furne & Jouvet, 1869.
29. Louis Jules Duboscq, patent n° 13069, certificate of addition dated 16 February 1852.
30. In 1853, the 'quinetoscope', the first binocular camera made by the Parisian lithographer Alexandre Marie Quinet (patent n° 15716, 25 February 1853), appeared on the market. It gave rise to a polemic, which lasted for several years, between the partisans of the moderate three-dimensional effect, obtained with a distance between the two lenses of the camera that was approximately equal to the inter-pupilary distance, and the advocates of a three-dimensional effect that was exaggerated, obtained by increasing this distance in direct proportion to the distance between the instrument and the subject.
31. Published on the inside back cover of the work by François Napoléon Marie Moigno, op. cit.
32. An equestrian statue of the Duke of Wellington, dancers and the Three Graces by Canova, a Greek slave by Powers, an Amazon by Bell, a Medici Venus, a 'Cheval de Marly', the Laocoon statue, 'light poetry' by Pradier, several Venuses, etc.
33. These photographs reappeared in the catalogue of 1856, published by Alexis Gaudin & Frère.
34. David Brewster, *The Stereoscope, its History, Theory and Construction*, 1856.
35. Research carried out into the royal collections of Windsor did not discover the famous stereoscope, while Queen Victoria's journal made no allusion to either of the two episodes.
36. François Napoléon Marie Moigno, op. cit., p. 15.
37. *Monographie du stéréoscope*, 1860, p. 16.
38. Marc Antoine Gaudin, *La Lumière*, 30 November 1851. This collection and several rival series contained a number of examples already used by Wheatstone and Brewster in their respective papers.
39. *La Lumière*, 27 March 1853. Advertisement for Houlliez-Goguin, makers of quality paper, n° 5, Boulevard des Capucines.
40. Louis Figuier, *Les Merveilles de la science*, Vol. III; Le Stereoscope, 1860, p. 194.
41. Louis Figuier, *Les Merveilles de la science*, Vol. III; Le Stereoscope, p. 192.
42. Founded in February 1851 by Benito de Montfort and François Moigno, *La Lumière* can be regarded as the first French periodical devoted to photography. It was bought by Alexis Gaudin, in October 1851, and continued to be published until March 1867.
43. In March 1856, the French photographer Antoine Claudet, then living in London, was surprised by the stereoscope's lack of success in France: 'This wonderful invention is admired by all enlightened people in England, and is found in all classes of society. There is not an aristocratic drawing room [in the country] that does not have a stereoscope and collections of views and stereoscopic portraits on its table. I cannot understand why this is not happening in France …'
44. Initially, publishers of stereoscopic prints were listed under 'Photographers'. Some continued to be listed in this section and never made use of the newly created heading.
45. These series were published until the 1900s, when it finally became technically possible to photograph actors under poor lighting conditions.
46. In 1858, coloured tableaux (the most expensive) were sold for between twelve and fifteen francs a dozen. Six years later, they were selling for six francs for fifty. Views that cost five francs a dozen in 1858 were selling for two francs in 1864.
47. Certain unscrupulous photographers photographed an original print and used the resulting negative to produce a new run of prints which were sold to an undiscriminating public.
48. From 1875 there were no more than thirty or so entries for stereoscopy under 'Photographers' and 'Stereoscopes' in the Paris trade directory, compared

with some sixty or so between 1865 and 1867.
49. However, a fairly large number of stereoscopic postcards were produced. The companies L.L. (Léon & Levy) and E.L.D. published several series on Paris.
50. The first photographs appeared in *L'Illustration*, in 1890, before appearing in most other French newspapers and periodicals.
51. This is particularly true for the Paris-Stereo company which produced no less than fifteen series on Paris.
52. Bruguiere, Lestrade and Romo, distributors of stereoscopic views, survived until relatively recently. Lestrade's *stereocartes* ('stereocards') can still be bought at certain monuments and museums in Paris and the French provinces.

Ferrier and Soulier, **Panorama with the Pont Louis-Philippe and the demolition of the Ile Saint-Louis**,
c. 1861
Stereoscopic view, albumen on glass with black-painted border and two narrow gold lines. Inscription in French bottom left: 'Paris 1620, panoramic view of the Pont Louis-Philippe bridge'; mount 8.3 x 17.0 cm. Ferrier and Soulier catalogues 1864 and 1870, no. 1620.

Coll. Serge Kakou.

The Pont Louis-Philippe bridge, demolished in 1861–62, linked the Ile de la Cité to the Right Bank, via the tip of the Ile Saint-Louis.

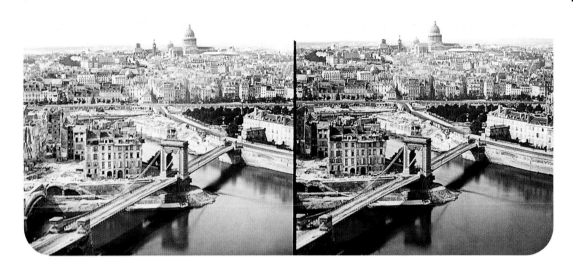

The new Paris

Napoléon III gave Baron Georges Eugène Haussmann (1809–1891), prefect of the Seine département, the task of organizing the great nineteenth-century renovation of Paris. Haussmann established new architectural rules (the height of buildings and streets), gave the city new public buildings (town halls, markets, abattoirs), major thoroughfares (Boulevard de Sébastopol, Avenue de l'Opéra) and an indispensable infrastructure for the modernization of the city (water and sewage systems, railways, street furniture). He surrounded himself with engineers such as Jean-Charles Alphand (1817–1891) and architects such as Gabriel Davioud (1823–1881), and obtained unprecedented administrative, financial and technical resources. In 1860 he extended the city boundaries to the military fortifications completed in 1845 by Louis Adolphe Thiers (1797–1877), which had already incorporated the villages on the outskirts of Paris – Auteuil, Passy, Les Batignolles, Montmartre, La Chapelle, La Villette, Belleville, Charonne, Bercy, Vaugirard and Grenelle – and annexed the open spaces of the Bois de Boulogne and Bois de Vincennes.

A great many stereoscopic views record the upheaval that took place within the city. Ferrier and Soulier, associates between 1859 and 1864, specialized in views on glass at a time when the daguerreotype was declining in popularity and most publishers were favouring the use of paper. Although glass has several disadvantages (fragility and weight), the extreme luminosity and fineness of the images make them truly delightful. Today they positively shine alongside the many views on albumen paper that have faded over the years.

Following page

Map of Paris showing the streets constructed between 1854 and 1879, 1889
No. 12 in the series 'Les Travaux de Paris' 1789–1889. Inscriptions in French: 'PARIS IN 1871./The roadworks carried out between 1854 and 1871/are indicated in yellow and red./(The year indicates the date of completion.)', top left-hand corner. 'Engraved by L. Wuhrer, Rue de l'Abbé de l'Epée 4.', bottom left; 'Printed by Monrocq, Paris', bottom right; 67.9 x 85.5 cm.

Coll. Bibliothèque Historique de la Ville de Paris, catalogue no. A1026, pl. 12.

50

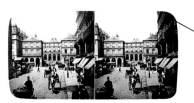

1. Ferrier (father and son) and Soulier,
The Gare Saint Lazare, between
1859 and 1864
Stereoscopic view, albumen on glass.

Coll. Serge Kakou.

To provide a new entrance to the station
which had become considerably busier,
the Rue de Rome was built in 1859, along
the west façade.

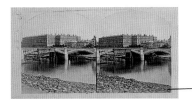

2. Anonymous, **The Pont de Solferino
under construction**, 1858–59
Stereoscopic view, albumen print; mount
8.6 x 17.8 cm.

*Coll. Musée Carnavalet, catalogue
no. Ph 11409.*

The bridge was opened in 1859. It was
named after the French victory over Austria
in June 1859, during the Italian campaign.

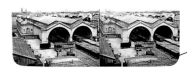

3. Ferrier and Soulier, **Tracks at the Gare
Montparnasse**, between 1859 and 1864
Stereoscopic view, albumen on glass.

Coll. Serge Kakou.

Entrance to this railway station, rebuilt
between 1848 and 1864 by the architect
Lenoir, was from the Rue de Rennes,
opened near the station in 1853.

4. Anonymous, **The Rue de Rivoli**,
c. 1860s
Stereoscopic tissue view, albumen print,
coloured on reverse; mount 8.8 x 17.4 cm.

*Coll. Musée Nicéphore Niepce, Chalon-sur-
Saône, catalogue no. 170575 VTR 27.*

The western end of the Rue de Rivoli was
built between 1800 and 1835, and the
eastern end between 1849 and 1856. This
major Parisian thoroughfare – running from
the Champs-Élysées, along one side of the
Jardin des Tuileries, to the Rue Saint-
Antoine (which leads to the Place de la
Bastille) – was the first, in 1900, to have
a metro line running under it.

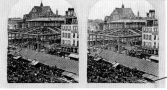

5. Anonymous, **The Marché des
Innocents and the new Halles under
construction**, c. 1859
Stereoscopic view, albumen print.

Coll. Pierre-Marc Richard.

This had been the site of Les Halles, Paris's
central market, since the Middle Ages. It
was decided to renovate it in 1847. After
the construction – soon followed by the
demolition – of an initial building in stone,
which was criticized for its heaviness, the
architect Baltard built ten iron pavilions
between 1853 and 1874.

6. Anonymous, **Montmartre, the Moulin
de la Galette**, 1850s
Stereoscopic view, albumen on glass.

Coll. Musée Carnavalet, Catalogue no. Ph15848.

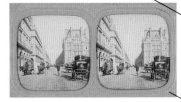

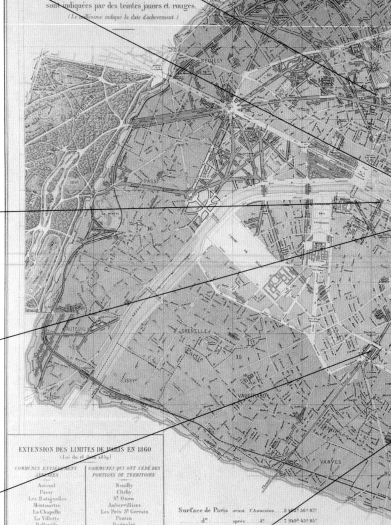

7. Ferrier and Soulier, **Panorama near
the Observatory**, between 1859 and 1864
Stereoscopic view, albumen on glass.

Coll. Serge Kakou.

In the foreground, the Rue de l'Enfer; in the
distance, the domes of the Observatoire,
the Val-de-Grâce church and the Panthéon.

8. Anonymous, **A footpath in Montmartre**, c. 1855
Stereoscopic view, albumen on glass, tinted.

Coll. Serge Kakou.

The little village of Montmartre rapidly grew to become a town with a population of 57,000 by 1861, a year after it was annexed by Paris. Located close to the capital, this district attracted an impoverished population in search of cheap accommodation. The northern part, made up of wastelands, was occupied by rag traders and workers' homes. Under the Second Empire, Montmartre retained its quaint appearance, with its windmills, its little houses in the midst of housing developments, and above all its open-air dance halls, the *guinguettes*.

12. Chapus, **The Maze in the Buttes-Chaumont park**, c. 1874
Stereoscopic view, albumen print.

Coll. Bibliothèque Nationale de France, catalogue no. EK5/CR 2312 no. 381.

The Buttes-Chaumont hill was, before it was developed as a park, one of the most sinister areas of the capital. Waste dumps and slaughterhouses stood alongside open and underground quarries. The gypsum was used in the construction of the capital's buildings.

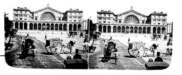

10. Ferrier and Soulier, **The Gare de l'Est**, between 1859 and 1864
Stereoscopic view, albumen on glass.

Coll. Serge Kakou.

This station was built between 1847 and 1850. It was inaugurated in 1852 with the Paris-Strasbourg line.

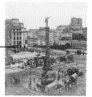 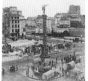

13. Ferrier and Soulier, **The Place du Châtelet under construction**, 1856–58
Stereoscopic view, albumenized salt print.

Coll. Pierre-Marc Richard.

Work on the square is in progress. The fountain has not yet been moved (it was moved in 1858).

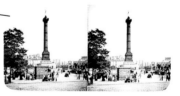

11. Ferrier and Soulier, **The Place de la Bastille**, between 1859 and 1864
Stereoscopic view, albumen on glass with black-painted border and two narrow gold lines. Inscription in French on the front: '16a. Instant view of the column on the [Place de la] Bastille, no. 1. Paris.', bottom left; mount 8.4 x 17.1 cm.
Ferrier and Soulier catalogues 1864 and 1870, no. 16a.

Coll. Serge Kakou.

In 1859 the Boulevard Richard-Lenoir was built, leading from the Place de la Bastille and partially covering the Canal Saint-Martin. In the same year the Avenue Daumesnil was opened along the new viaduct of the Vincennes railway.

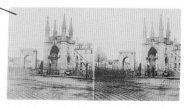

14. Brisson, **The Passerelle de la Cité and Pont Louis-Philippe**, before 1858
Stereoscopic view, albumenized salt print.

Coll. Bibliothèque Nationale de France, catalogue no. EK5.

The bridges linking the tip of the Île Saint-Louis, the Île de la Cité and the Right Bank were rebuilt between 1860 and 1862.

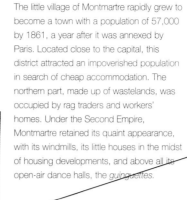

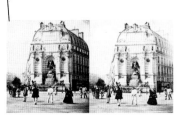

9. Braun, **The Fontaine Saint-Michel**, 1860s
Stereoscopic view, albumen print.

Coll. Pierre-Marc Richard.

The fountain was built between 1858 and 1860 by Davioud, on the corner of the Boulevard Saint-Michel and the Rue Danton.

52

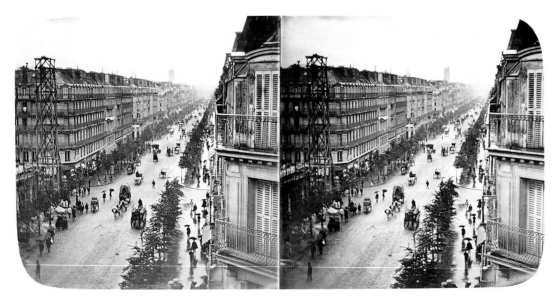

Ferrier (father and son) and Soulier,
The Boulevard de Sébastopol in the rain,
1858–64
Stereoscopic view, albumen on glass with black-painted border and two narrow gold lines.
Inscription in French on the front: '24b View of the Boulevard de Sébastopol, Paris (instant view) FERRIER father, son and SOULIER', bottom; mount 8.4 x 17.1 cm.
Ferrier and Soulier catalogues 1864 and 1870, no. 24b.

Coll. Serge Kakou.

This major thoroughfare was regarded as a strategic route that would enable the rapid quashing of uprisings. Work began on the section of the boulevard shown here in early 1858, and the entire thoroughfare was inaugurated on 5 April that same year, in the presence of Napoleon III and Empress Eugènie and the prefect Georges Eugène Haussmann. This view often appeared in the Ferrier and Soulier catalogue. Their studio was at 99 (later 113), Boulevard de Sébastopol.

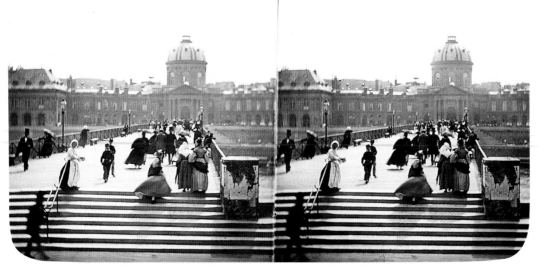

Attributed to Ferrier and Soulier, **The Pont des Arts and Institut de France**,
c. 1859–62
Stereoscopic view, albumen on glass with black-painted border and two narrow gold lines.
Inscription in French on the front: 'Parisian scenes: Pont des Arts bridge', bottom left, handwritten; mount 8.4 x 17.2 cm.
The Ferrier and Soulier catalogues of 1864 and 1870 show two images entitled 'Pont des Arts and Palais de l'Institut' (no. 81a).

Coll. Serge Kakou.

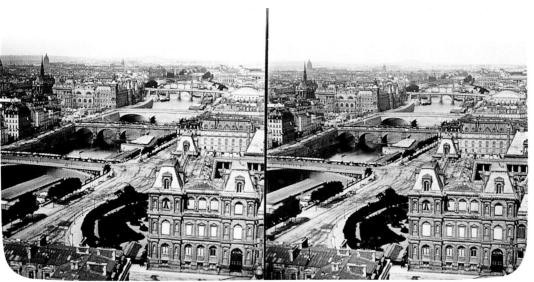

Attributed to Ferrier and Soulier, **Panorama of the eight bridges taken from the Église Saint-Gervais**, 1860–62
Stereoscopic view, albumen on glass with black-painted border and two narrow gold lines.
Inscription in French on the front: 'Panorama of Paris (view of the eight bridges)', bottom left; mount 8.4 x 17.1 cm.
The Ferrier and Soulier catalogues of 1859, 1864 and 1870 show an image entitled 'A panorama of Paris, view of the bridges' (no. 78).

Coll. Serge Kakou.

The construction of the Tribunal de Commerce (1860–65) can be seen on the left. The Pont au Change bridge, completed in August 1860, gives access to the almost completed theatres on the Place du Châtelet. The back of the Hôtel de Ville can be seen in the foreground.

Ferrier (father and son) and Soulier,
**The Avenue Foch, towards the Arc
de Triomphe**, between 1859 and 1864
Stereoscopic view, albumen on glass with
black-painted border and two narrow gold lines.
Inscription in French on the front: '96a. Instant
view of the Avenue de l'Impératrice. Paris.
FERRIER father, son and SOULIER', bottom; mount
8.4 x 17.1 cm.
Ferrier and Soulier catalogues 1864 and 1870,
no. 96a.

Coll. Serge Kakou.

The Avenue de l'Impératrice, linking the Arc de
Triomphe with the new Bois de Boulogne, was
opened by the architect Jacques Ignace Hittorff
(1792–1867) in 1854. With a width of 120
metres, it was one of the most impressive
avenues in Paris and was extremely popular
with the city's high society. It became the
Avenue Foch in 1929.

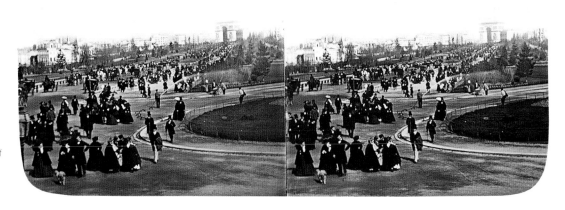

Attributed to Ferrier and Soulier, **The Place
du Châtelet**, between 1858 and 1870
Stereoscopic view, albumen on glass with
black-painted border and two narrow gold lines.
Inscription in French on the front; 'Instant view of
the Place du Châtelet. Paris', bottom left; mount
8.4 x 17.1 cm.
The Ferrier and Soulier catalogues of
1864 and 1870 show an image entitled
'Place du Châtelet' (no. 91 b).

Coll. Serge Kakou.

On 21 April 1858, the fountain was moved
12 metres to the west, in twenty-seven minutes,
to the centre of the newly renovated square.

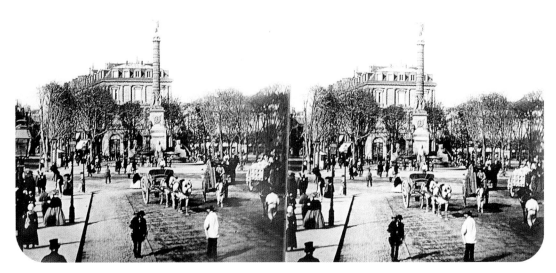

Attributed to Ferrier and Soulier, **The Quai des
Grands-Augustins and Pont-Neuf**, 1860s
Stereoscopic view, albumen on glass with black-
painted border and two narrow gold lines.
Inscription in French on the front: 'Paris. View
of the Pont-Neuf bridge and the Louvre', bottom
left, handwritten engraving;
mount 8.3 x 17.1 cm.

Coll. Serge Kakou.

In 1857 the quays of Paris had some sixty-eight
bouquinistes, mainly on the Left Bank. These
bookstalls could be up to 10 metres long.
Threatened by the construction work carried out
under the prefect Georges Eugène Haussmann
(1809–1891), they were protected by a decree
of 10 October 1859.

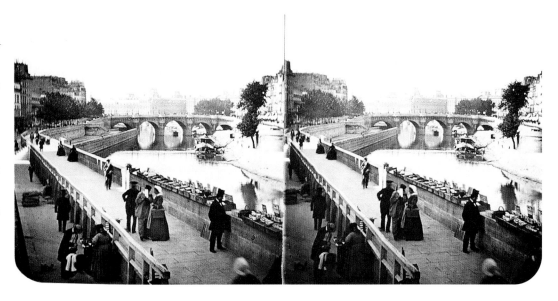

54

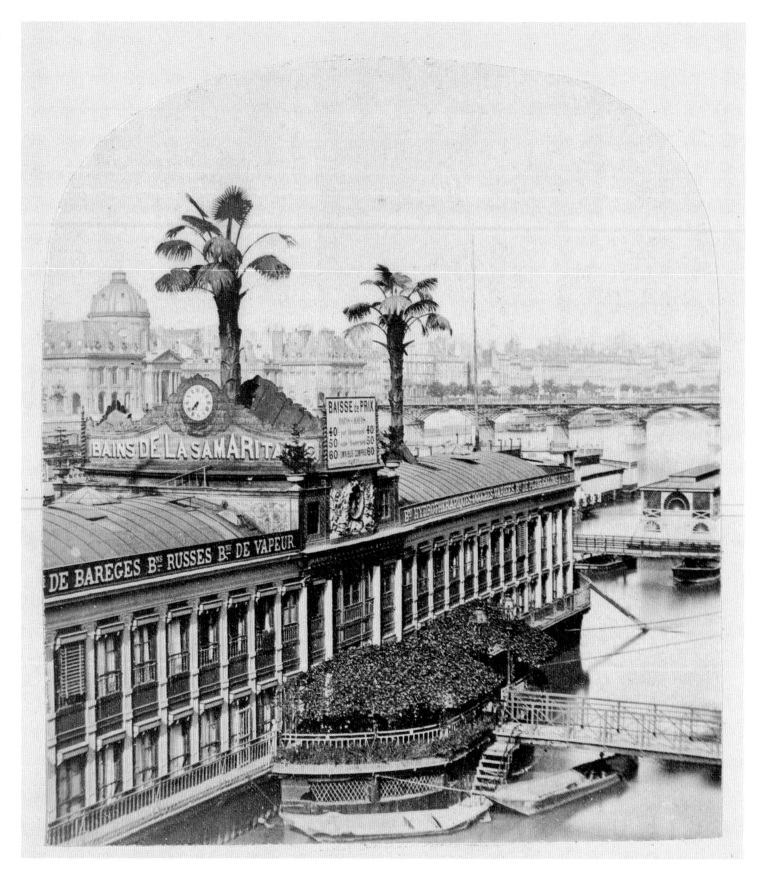

Anonymous, **The Samaritaine baths, Quai du Louvre**, 1860s
Stereoscopic view, albumen print; mount
8.4 x 17.5 cm.

Coll. Musée Carnavalet, catalogue no. Ph 9544.

A great many baths and floating wash-houses existed along the quays of Paris until after World War II.

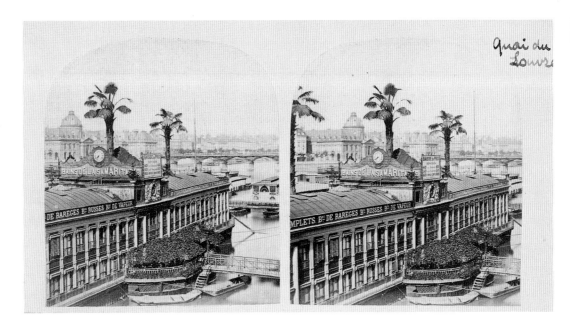

Attributed to Ferrier and Soulier, **Panorama of the Champ de Mars**, 1862
Stereoscopic view, albumen on glass with black-painted border and two narrow gold lines. Inscription in French on the front: 'Paris Panorama of the Champ de Mars', bottom left, handwritten engraving; mount 8.4 x 17.1 cm.

Coll. Serge Kakou.

This could be the inspection of the troops of the army of Paris and the Garde Nationale, carried out by Napoleon III on the Champ de Mars on 14 August 1862. The view was taken from the Chaillot hill. The Eiffel Tower was built on the Champ de Mars in 1889.

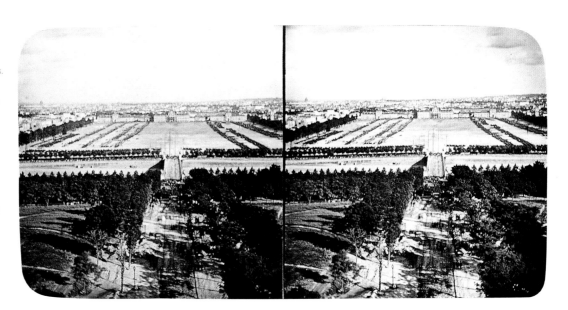

Anonymous, **View of the Arc de Triomphe, taken from the Avenue d'Iéna**, c. 1860
Stereoscopic view, albumen on coloured glass. Inscribed in French on the front: '3 Arc de Triomphe de l'Étoile' and labelled with a '3', handwritten in black ink; mount 8.4 x 17.4 cm.

Coll. Musée Carnavalet, catalogue no. Ph 15841.

Commissioned by Napoleon I in 1806 to honour the victories of the French armies, the Arc de Triomphe was inaugurated in 1836. The Place de l'Étoile on which it stands was completely transformed between 1854 and 1857, and the number of avenues radiating from it increased from five to twelve.

56 The banks of the Seine

Until the late nineteenth century, the Seine was the backbone of the city, with its ceaseless traffic of barges and passenger boats, it specialist docks (timber, wine, cereals, stone, sand, coal etc.). Above all, its water was used for drinking, washing and cleaning. The industrial and urban revolution, which took place between 1830 and 1900, gradually tore the Parisians away from the natural link that bound them to their city, while strengthening the architectural and aesthetic importance of this major waterway.

During the second half of the nineteenth century, the banks of the Seine hummed with the activities of craftsmen and of industry and commerce. Trade continued to increase (tonnage of incoming goods in 1824: 1,200,000 tonnes; in 1862: 3,200,000 tonnes; in 1891: 6,000,000 tonnes). The biggest transformations took place during this period: rebuilding of all the bridges on the Île de la Cité and some of those on the Île Saint-Louis, cleaning up and development of the banks, the removal of the old pumps, like that of the Pont Notre-Dame bridge, channelling and regulation of the river, the construction of residential property and the building or renovation of prestigious official buildings between the Tuileries and the Hôtel de Ville, on both banks.

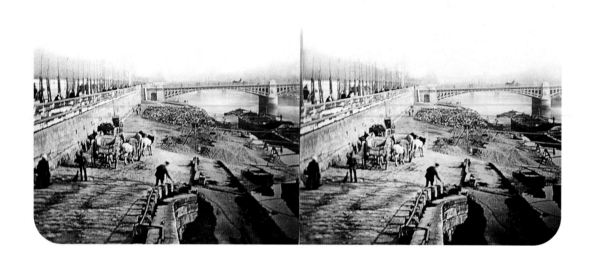

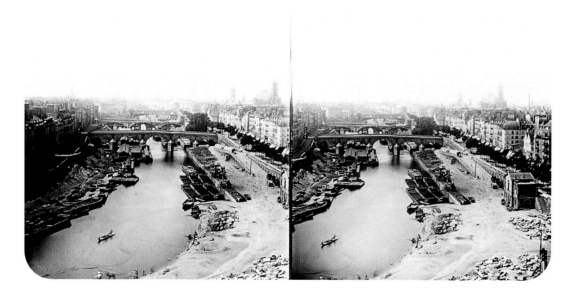

Ferrier and Soulier, **The Seine, panoramic view taken from the Quai des Célestins**, 1860–61
Stereoscopic view, albumen on glass with black-painted border and two narrow gold lines. Inscription in French: '1601 Paris, panoramic view taken from the Quai des Célestins', bottom left; mount 8.4 x 17.1 cm. Ferrier and Soulier catalogues 1864 and 1870, no. 1601.

Coll. Serge Kakou.

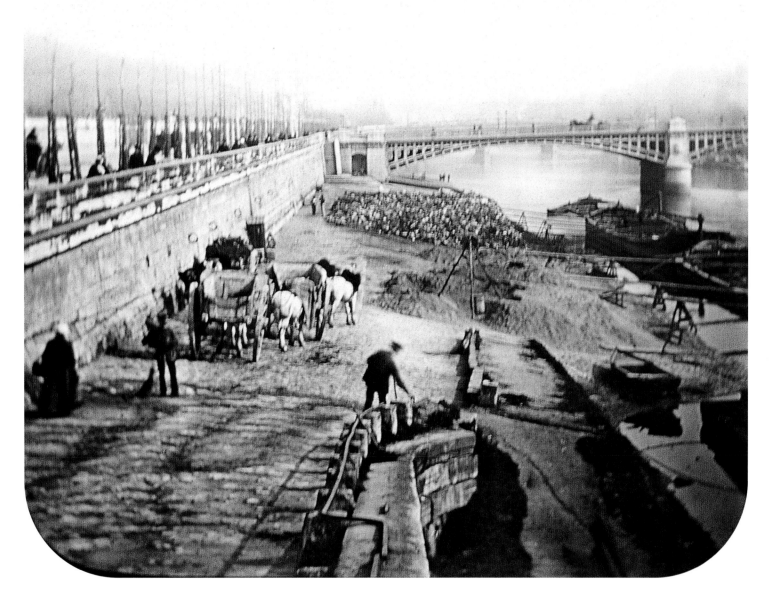

Ferrier and Soulier, **The Banks of the
Seine, Quai des Tuileries**, between 1859
and 1864
Stereoscopic view, albumen on glass with
black-painted border and two narrow gold
lines. Inscription in French: '51b Instant view
of the Quai des Tuileries on the Seine,
Paris.', bottom left; mount 8.4 x 17.1 cm.

Coll. Serge Kakou.

The Pont de Solferino bridge can be seen
in the background.

58

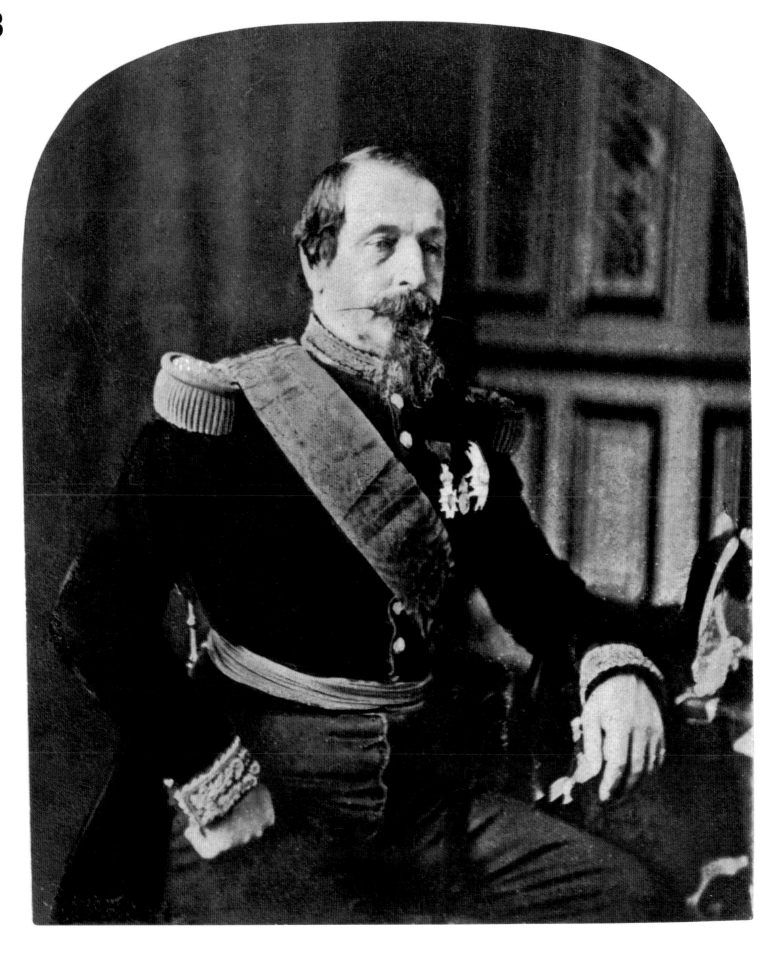

Mayer and Pierson, **Napoleon III (1808–1873)**, 20 April 1858
Stereoscopic view, coloured albumen print. Inscribed in English on reverse: 'HIS MAJESTY NAPOLEON III./(CHARLES LOUIS.)/EMPEROR OF THE FRENCH./BORN 20 APRIL 1808, SON OF LOUIS NAPOLEON, KING OF HOLLAND, AND OF HIS/QUEEN HORTENSE EUGENIE; MARRIED 29 JANUARY 1853, TO EUGINIE, EMPRESS/OF THE FRENCH, BORN 5 MAY 1826./THIS PORTRAIT WAS PHOTOGRAPHED FROM LIFE BY MESSIEURS MAYER BROTHERS/AND PIERSON, PHOTOGRAPHERS TO HIS MAJESTY./ENTERED AT STATIONERS' HALL. Registered.' Printed in black; mount 8.3 x 17.4 cm.

Coll. Musée Carnavalet, catalogue no. Ph 14168.

Louis Napoléon Bonaparte, President of the Second Republic between 1848 and 1852, carried out a successful coup d'État on 2 December 1851 and restored the Empire in 1852. On 2 September 1870, following the French defeat at Sedan by Prussia which led to the downfall of the Second Empire, he went into exile in England where he died three years later. This portrait was taken on his fiftieth birthday.

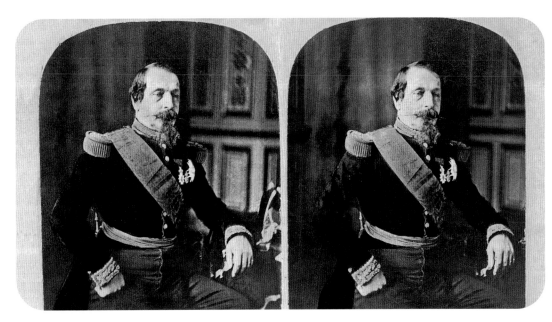

Disdéri, **The Empress Eugénie (1826–1920)**, c. 1860
Stereoscopic view, albumen print; inscribed in French on the front: 'D & C', bottom left; 'Registered', top left; printed label in French on reverse: '2, Place Vendôme,/corner of the Rue St Honoré./MITAINE/Optician. Manufacturer'; mount 8.6 x 17.2 cm.

Coll. Pierre-Marc Richard.

The Empress Eugénie, a Spanish countess, married Napoleon III on 29 January 1853.

Thompson, **Portrait of a boy holding a hat**, 1850s
Stereoscopic daguerreotype with black-painted border. Inscribed in French on the front: 'W. THOMPSON, Rue de Choiseul, 22.', on the, right in gold lettering; mount 8.5 x 17.2 cm.

Coll. Musée d'Orsay, catalogue no. pho 1983. 165.418.

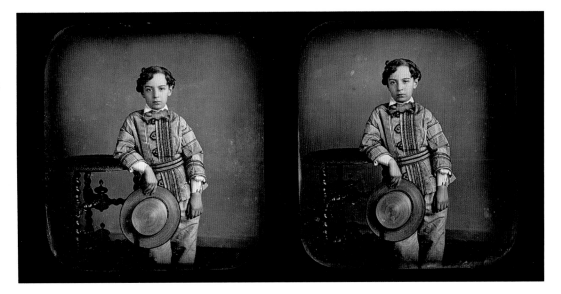

60 The Bièvre

The Bièvre is a little river which has its source just outside Paris, in the lake of Saint-Quentin-en-Yvelines. It flows through Paris, across the present-day 12th arrondissement, and into the Seine by the Pont d'Austerlitz bridge. In 1832 this was a description of the river in a police report: 'The Bièvre river, whose course is around six hundred *toises* [approximately 2 miles] from Paris, has a mud bed whose depth is six feet or more. It receives waste water from laundries, foundries, starch works, the tanning and tawing industry, painting studios, wash-houses, livestock-breeding, etc. Along its banks are five large hospitals, four army barracks, a prison, a large anatomy theatre, whose waste runs into the river, as well as household sewage, the effluent from all the houses along its banks; slaughtered animals are thrown into it. Children have fallen into the water, and although they have been pulled out immediately, several have died, poisoned by the filthy sludge covering them.' From 1860 this river was gradually covered over for reasons of hygiene.

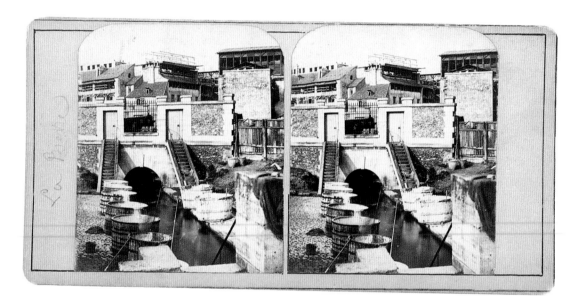

Anonymous, **The Bièvre, tanneries**, 1862
Stereoscopic view, albumen print; mount
8.5 x 17.5 cm.

Coll. Pierre-Marc Richard.

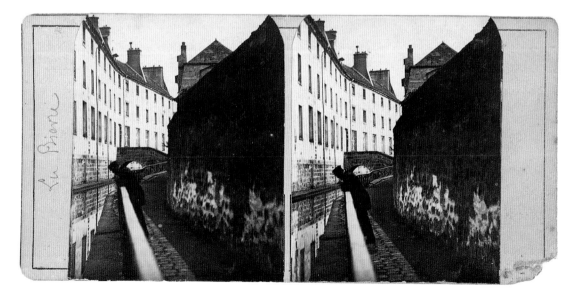

Anonymous, **The Bièvre, near the Avenue des Gobelins**, 1862
Stereoscopic view, albumen print; mount
8.5 x 17.5 cm.

Coll. Pierre-Marc Richard.

Anonymous, **The Bièvre, near the Poterne
des Peupliers**, 1862
Stereoscopic view, albumen print; mount 8.5 x 17.5 cm.

Coll. Pierre-Marc Richard.

62

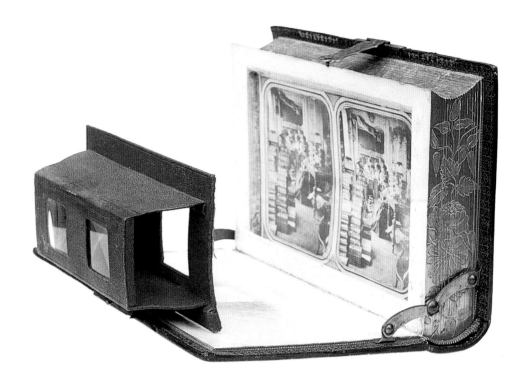

Saugrin, **Stereoscope in the form of a book**, 1860s
Inscribed in French on the spine:
MAGIC/ALBUM/SAUGRIN/INVENTOR/PARIS/FRENCH & FOREIGN PATENTS WITHOUT GOVERNMENT GUARANTEE', in gold lettering;
20.8 x 14.7 x 4.2 cm.

Coll. Roedema van Loon.

This is one of the stereoscopes patented by Saugrin, on 23 January 1862 (patent no. 52741).

Saugrin, **Stereoscope workshop**, 1862 or later
Stereoscopic view, albumen print.

Coll. Roedema van Loon.

This image is included in the 'Magic Album' stereoscope (see above).

The effects of colour and light

Tissue views on albumen paper are among some of the most magical stereoscopic images. The photographs are backed with thin hand-painted paper and mounted between a double cardboard 'frame' or, more unusually, two glass plates. Details sometimes have pinholes or cut-outs through which the light passes. Lit from the front, they look like ordinary monochrome images taken by day. When lit from behind, however, they are transformed into coloured or night images, often with the additional effects of a moon, clouds or flames. The publishers of stereoscopic views often produced an opaque and transparent version of certain images, and the stereoscopes of the period were fitted with a mirror for lighting the front of the image and a frosted-glass panel that enabled it to be viewed as a transparency.

In the nineteenth century some French inventors called these views 'dioramic', a reference to the Diorama of Louis-Jacques-Mandé Daguerre (1787–1851), opened in Paris between 1822 and 1839. Here, the effects of night and day were created using monumental scenery, with backcloths painted on both sides and variable lighting. Before stereoscopy, devices such as the 'Polyorama Panoptique' were already using these effects with larger-format images, as well as for engravings.

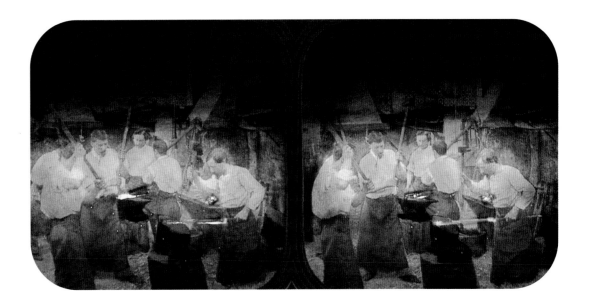

Lefort, **Blacksmiths**, c. 1859–62
Stereoscopic tissue view, albumen print
with cut-outs, coloured on reverse and with
coloured stickers. Inscription in French on
reverse: 'BANSEL/OPTICIAN FT/14, R. DE SEINE,
PARIS.', stamped on the left in blue ink;
mount 8.2 x 17.2 cm.

Coll. Pierre-Marc Richard.

64

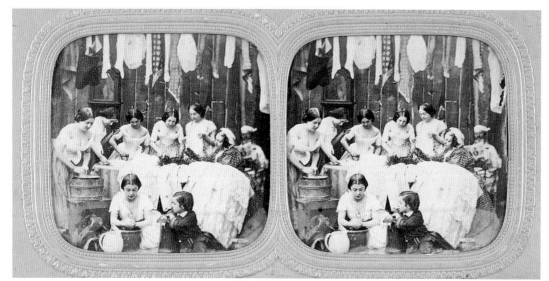

Gaudin, **Women washing and ironing**,
c. 1858
Stereoscopic tissue view, albumen print,
coloured on reverse. Inscription: 'E.L.' (Ernest
Legendre, card manufacturer); mount 8.5 x
17.5 cm.

Coll. Denis Pellerin.

Bal Bullier

In 1847 François Bullier (1796–1869) became the owner of the dance hall known as the 'Grande Chartreuse', at 31, Avenue de l'Observatoire, and renamed it the 'Closerie des Lilas'. It subsequently became better known as the Bal Bullier and was mainly frequented by students. The dance hall – whose decor was inspired by the Alhambra in Granada – also offered such entertainments as billiards and shooting (with the crossbow or pistol).

Bullier was extremely interested in stereoscopy and the Musée Carnavalet has a collection of stereoscopic photographs that belonged to him.

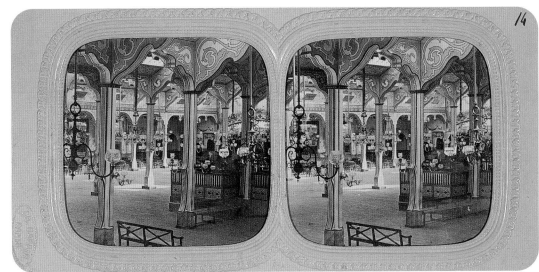

Anonymous, **Portrait of François Bullier**, c. 1855
Coloured stereoscopic daguerreotype with black-painted border. Handwritten inscription in French: 'My portrait'; mount 8.3 x 17.1 cm.

Coll. Musée Carnavalet, catalogue no. Ph 15827.

Gaudin, **Salon, café and orchestra of the Bal Bullier**, 1860s
Stereoscopic tissue view, albumen print with cut-outs, coloured on reverse and with coloured stickers. Inscriptions: embossed: 'CH. GAUDIN/PARIS', bottom left; 'E.L.' (Ernest Legendre, card manufacturer); '14', top right, handwritten in black ink; on reverse: 'Salon, café and orchestra of the Jardin Bullier 14', handwritten in French in black ink; mount 8.6 x 17.4 cm.

Coll. Musée Carnavalet, catalogue no. Ph 15878.

66

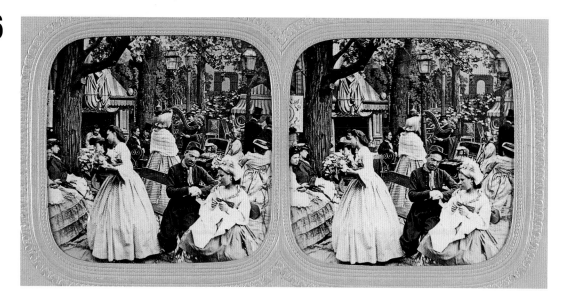

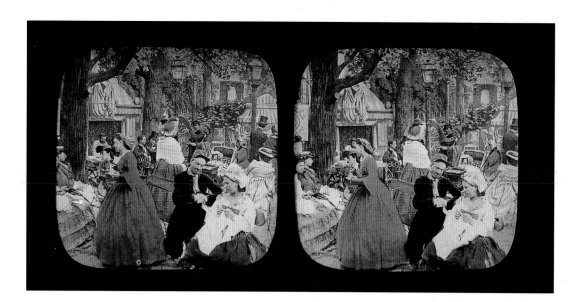

Genre scenes

Along with 'instant views' taken spontaneously in the street, the 'genre scenes' composed by photographers constitute an extremely vivid dimension of Parisian stereoscopic photography. They record many aspects of everyday life in a more or less caricatural form. Pierre Henri Amand Lefort produced some of the most successful works in the genre. He created some truly impressive decors (sixty or so painted backcloths, impressive objects and a large number of 'extras') in his studio at 33, Rue du Faubourg-Saint-Martin, where he recreated a station, a seashore, a forge, a church, a department store and even the Champs-Élysées.

Lefort, **Concert on the Champs-Élysées**, c. 1859–60
Stereoscopic tissue view, albumen print, coloured on reverse. Inscription: 'E.L.' (Ernest Legendre, card manufacturer); mount 8.5 x 17.4 cm.

Coll. Denis Pellerin.

Arc de Triomphe de l'Étoile, photograph no. 65 of Jouvin's album.

Coll. Marie-Thérèse and André Jammes.

Church of Notre-Dame de Lorette, photograph no. 64 of Jouvin's album.

Coll. Marie-Thérèse and André Jammes.

Place de la Concorde, photograph no. 66 of Jouvin's album.

Coll. Marie-Thérèse and André Jammes.

70 A house in Paris

The series entitled *Une maison à Paris* ('a house in Paris') fits into the tradition of satirical engravings showing a cross-section through a building. The apartment building created by the photographers is depicted from the attic to the cellar. It is typical of the way Paris buildings were divided up in the 1860s. The lower floors were taken up with commercial activities, while the higher floors were occupied by the poorest people. During the latter half of the nineteenth century, social distribution tended to be by district rather than by floor. Then, at the beginning of the twentieth century, the advent of the lift reversed the traditional hierarchy, making the higher floors more desirable.

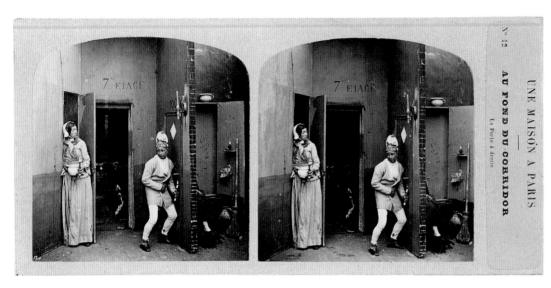

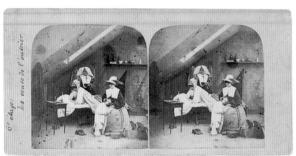

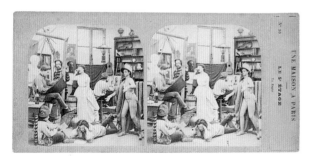

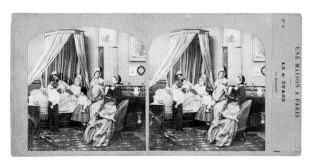

Furne and Tournier, **Une maison à Paris
(A house in Paris), series of 12 images
showing the floors of an apartment
building**, before 1861
Stereoscopic views, albumen prints. Inscription printed in French on a blue label: 'A house in Paris', followed by the caption and the series number (for three of the views, the label is on the reverse); mount approx. 8.6 x 17.6 cm.

Coll. Denis Pellerin.

The series *Une maison à Paris* (registered for copyright in 1860) is made up of twelve numbered photographs, although there are variants for some of them. For the later images in the series, the label is on the reverse.

The residents and trades of the building are as follows: in the cellar, the kitchens and the cooper; on the ground floor, the concierge and the restaurant; on the mezzanine, the hairdresser; on the first floor, the milliner; on the second floor, the pawnbroker; on the third floor, the dentist; on the fourth floor, the bourgeois; on the fifth floor, the artist; on the sixth floor, the labourer's widow; and on the seventh floor, 'at the end of the corridor' – the WCs.

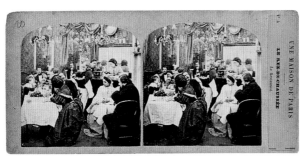

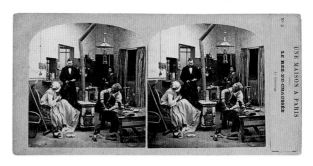

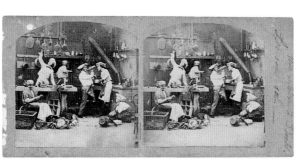

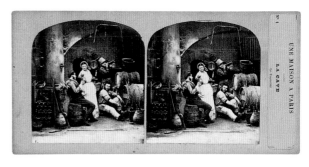

72 The Great Exhibitions

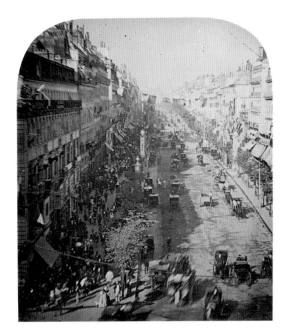 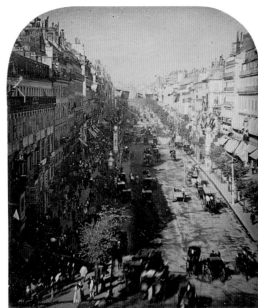

The World Fair of 1855

The first international exhibition took place in London in 1851 in a temporary building, the Crystal Palace. In France, the following year, the prince-president Louis Napoleon, the future Napoleon III, decided to hold a similar event in Paris in 1855.

Between 1853 and 1855, Viel and Desjardins built a monument opposite the Élysée Palace, on the site which is now the Avenue Winston Churchill (between the Grand Palais and the Petit Palais). This 'palais de l'industrie' designed to host World Fairs, was 250 metres long and 100 metres wide. It had an iron framework, concealed, for aesthetic reasons, behind a stone façade.

The rest of the exhibition was divided between a number of other buildings: a gallery 1 kilometre in length and 28 metres wide ran between the Pont de l'Alma bridge (built for the occasion) and the Pont de la Concorde bridge.

Below the Avenue Montaigne there was a space entirely devoted to the fine arts. Ingres and Delacroix exhibited their works there, while opposite, Courbet, who had been rejected by the official Salon, built at his own expense a lightweight structure where he displayed his paintings. The fact that works of art were part of the exhibition alongside agricultural produce and industrial developments was the great innovation of this Fair.

This first World Fair in Paris attracted 24,000 exhibitors (nearly half of them French) and around 5 million visitors between 15 May and 15 November. Queen Victoria, the first British sovereign officially invited to Paris, was the most prestigious guest at this event.

Anonymous, **The Boulevard des Italiens, decked out for the visit of Queen Victoria**, 1855
Stereoscopic daguerreotype with black-painted border. Inscription in English on label on reverse: 'Boulevart [sic]/des/Italiens/HM Visit', handwritten in black ink; mount 8.4 x 17.3 cm.

Coll. J. Paul Getty Museum, Los Angeles, catalogue no. 84.XH.710.9.

Anonymous, **The Palais de l'Industrie, World Fair of 1855**
Stereoscopic view, albumen on glass, 8.3 x 17.0 cm.

Coll. Cinémathèque française.

The World Fair of 1867

The organizers of this second World Fair in Paris commissioned an oval building on the Champ de Mars. This iron and glass construction was 482 metres long by 370 metres wide. It consisted of seven concentric galleries, each one devoted to a different activity. Other sections of the Fair were scattered over the Champ de Mars and the Île de Billancourt.

The public travelled to the exhibition on bateaux-mouches, the riverboat service inaugurated specifically for the Fair. Visitors flocked to admire Félix Léon Edoux's elevators, Krupps's giant cannon and the diving suit demonstrations.

Napoleon III, who saw the Fair as an opportunity to spread social ideas, organized a workers' housing competition, introduced reduced-rate tickets for certain categories of visitor, and authorized the government to pay for the travel expenses of some workers elected by their peers to come to Paris and report back on the event.

More than thirty foreign countries took part in this Fair. The 52,200 exhibitors attracted an audience of 6,800,000 visitors (11 million according to some sources) between April 1 and October 31.

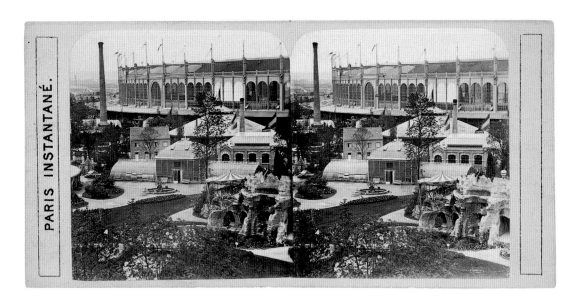

Anonymous, **General view of the World Fair of 1867**
Stereoscopic view, albumen print. Inscriptions in French: 'PARIS INSTANT PHOTOGRAPH'; on reverse: 'Exhibition/Reserved garden', handwritten; mount 8.6 x 17.2 cm.

Coll. Musée Carnavalet.

The World Fair of 1878

This event took place seven years after the unrest of 1870–71. To prevent it turning into a political gathering, the Republican government put down attempts to organize an international socialist congress. This was the context of the third Paris World Fair, which focused more on exoticism and Japanese art, which appeared in France at that time, than on political concerns.

The site for this Fair, as for the previous one, was the Champ de Mars and a new building was erected at Trocadéro for the occasion. Many participating countries were able to exhibit a building that was representative of their national architecture on the Rue des Nations, built in line with the Pont d'Iéna bridge.

The 52,800 exhibitors presented the latest inventions: the refrigerator, the typewriter, and the identity card with photograph. The Fair welcomed more than 16 million visitors between May 1 and the end of October.

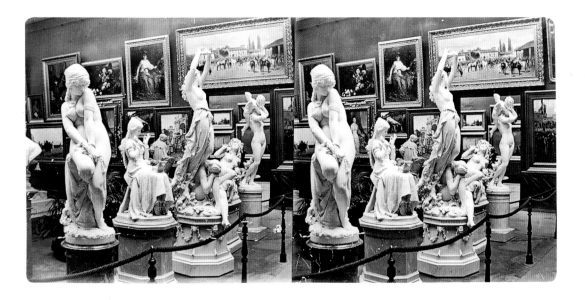

Lachenal and Favre, **Italian sculptures, the World Fair of 1878**
Stereoscopic view, albumen on glass. Inscription in French on the front: 'L.F. 4375 Italian Section, Exhibition 1878', below the left-hand image; mount 8.4 x 17.0 cm.

Coll. Société Française de Photographie, catalogue no. 1001-118.

74 The Paris Commune, 1871

In the spring of 1871 the citizens of Paris responded to the French government's capitulation in the Franco-Prussian War with a rebellion that led to the erection of many barricades throughout the city. For two months the Communards' attempt to establish a new form of government was marked by such symbolic actions as the overturning of the Colonne Vendôme, with its statue of Napoleon I, as an expression of their rejection of the established order. The Parisian rebellion was suppressed by the government of Louis Adolphe Thiers (1797–1877) during the *semaine sanglante*, the so-called 'bloody week' of 21–28 May 1871. Certain strategic buildings, such as the Hôtel de Ville and the Palais des Tuileries, were burnt as the Communards retreated or damaged during the fighting. Although stereoscopic photographs provide an unprecedented record of these events, far fewer images were taken during the rebellion than of the aftermath. Some photographers even reconstructed scenes to the detriment of the Communards.

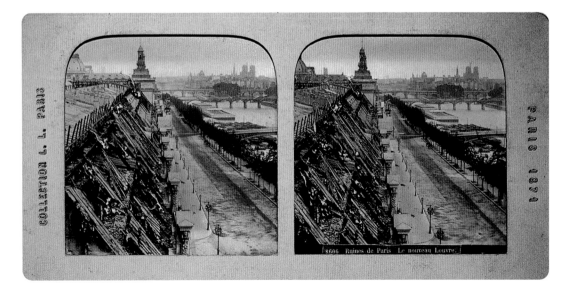

G.C., **The Paris Commune, Colonne Vendôme**, 1871
Stereoscopic view, albumen print. Inscription in French: 'La France Stéréoscopique./by G.C.', printed on the left side of the mount; mount 8.5 x 17.5 cm.

Coll. Musée Carnavalet, catalogue no. Ph 15281.

The Journal Officiel of 17 May 1871 described how the decree issued by the Paris Commune ordering the demolition of the Colonne Vendôme 'was executed yesterday to the cheers of a densely packed crowd which grew serious and thoughtful as it witnessed the collapse of an odious monument, raised to the false glory of a monster of ambition'.

The Colonne Vendôme, dedicated to the glory of the victorious soldiers of Austerlitz and surmounted by a statue of Napoleon I, was demolished on 16 May 1871.

Its destruction was attributed to the painter Gustave Courbet (1819–1877) who had indeed suggested it should be destroyed, but in a statement predating the actual decree. Although he did not take an active part in the event, he was held responsible and, two years later, faced financial ruin when he was made to pay for the reconstruction of the column.

Léon and Lévy, **The Paris Commune, the Louvre**, 1871
Stereoscopic tissue view, albumen print with cut-outs, coloured on reverse. Inscriptions in French: '8606 Paris Ruins The new Louvre', below the right-hand image; 'COLLECTION L.L. PARIS', printed on the left side of the mount, and 'PARIS 1871', on the right side; mount 8.7 x 17.7 cm.

Coll. Wim van Keulen.

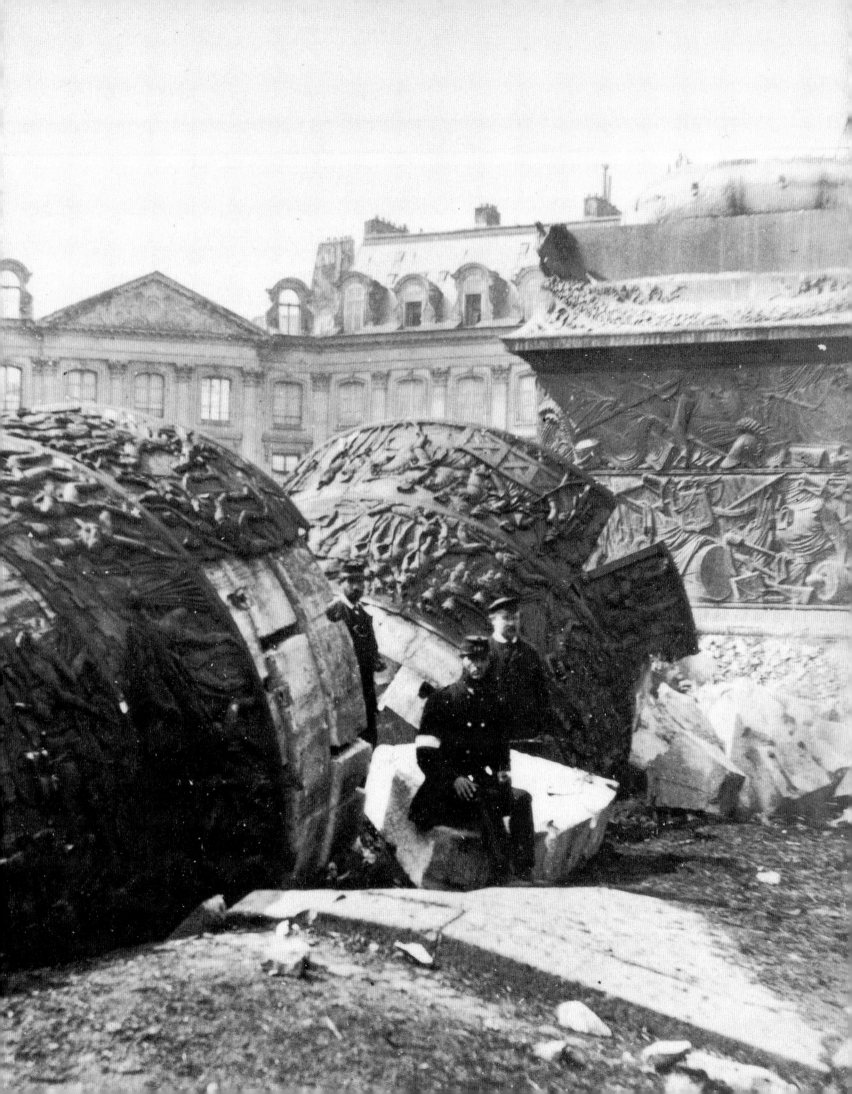

76

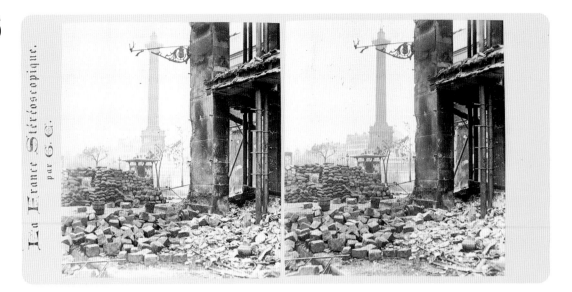

G.C., **The Paris Commune, Barricade on the Place de la Bastille**, 1871
Stereoscopic view, albumen print. Inscription in French on the front: 'La France Stéréoscopique./ by G.C.', printed on the left of the mount; mount 8.5 x 17.5 cm.

Coll. Musée Carnavalet, catalogue no. Ph 15281.

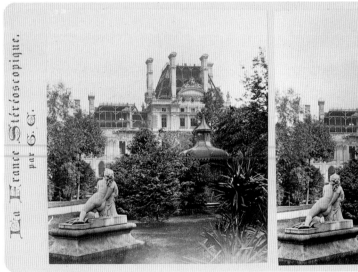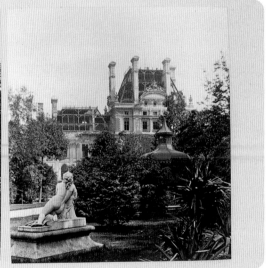

G.C., **The Paris Commune, Jardin des Tuileries**, 1871
Stereoscopic view, albumen print. Inscription in French on the front: 'La France Stéréoscopique./by G.C.', printed on the left of the mount; mount 8.6 x 17.5 cm.

Coll. Musée Carnavalet, catalogue no. Ph 15283.

The Tuileries palace no longer exists. Before it was burnt by the Communards in 1871, it bounded the Louvre near the Flore and Marsan pavilions. The ruins, which were not cleared until 1884, were replaced by the gardens in 1889.

Anonymous, **The Paris Commune, inside the Palais des Tuileries**, 1871
Stereoscopic view, albumen print; mount 8.6 x 17.5 cm.

Coll. Musée Carnavalet, catalogue no. Ph 13717.

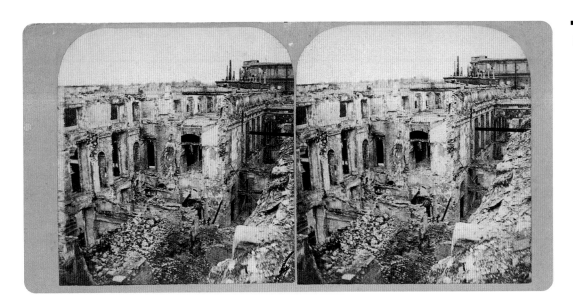

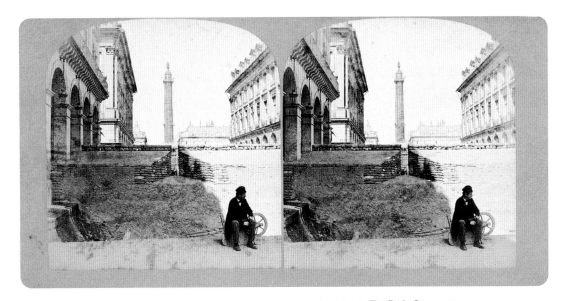

Anonymous, **The Paris Commune, barricade on the Rue de Castiglione, near the Place Vendôme**, 1871
Stereoscopic view, albumen print; mount 8.7 x 17.7 cm.

Coll. Pierre-Marc Richard.

The barricade on the Rue de Castiglione was regarded as a masterpiece of the genre. It blocked the end of the Rue de Rivoli near the Place de la Concorde and was surrounded by a ten-metre ditch. The Versaillais had to skirt round the barricade to capture it.

78

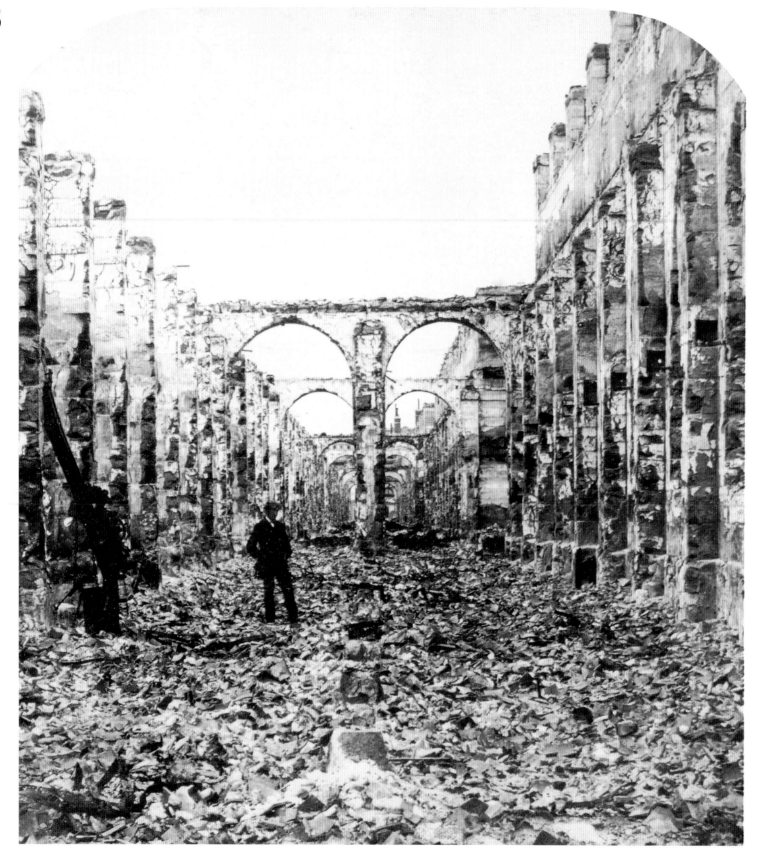

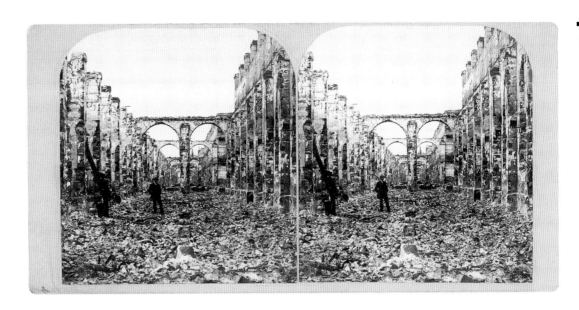

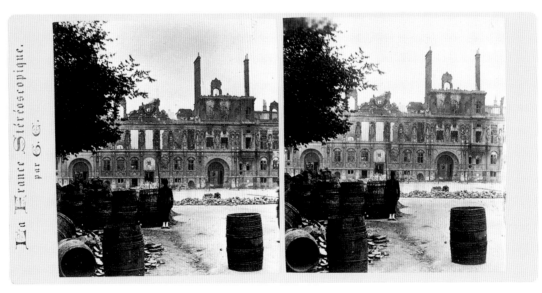

G.C., **The Paris Commune, façade of the Hôtel de Ville**, 1871

Stereoscopic view, albumen print. Inscription in French on the front: 'La France Stéréoscopique./by G.C.', printed on the left side of the mount; mount 8.5 x 17.5 cm.

Coll. Musée Carnavalet, catalogue no. Ph 15280.

The sixteenth-century Hôtel de Ville, the Paris town hall, was chosen as the seat of the government of the Défense Nationale which proclaimed the Republic on 4 September 1870, and the Paris Commune on 26 March 1871. The building was burnt on 24 May 1871, but was subsequently rebuilt in the style of the original.

Anonymous, **The Paris Commune, the grenier d'abondance**, 1871

Stereoscopic view, albumen print; mount 8.6 x 17.5 cm.

Coll. Musée Carnavalet, catalogue no. Ph 13718.

The *grenier d'abondance* was built alongside the Arsenal between 1807 and 1808, and measured 350 x 25 x 23 m. Also known as the *grenier de réserve*, it was given to the city of Paris by the state in 1842. It was initially a public food warehouse where the city's bakers had to store enough wheat and flour to enable it to withstand a three-month siege. Oil and wine were stored in the basement.

François Willème, **Françoise Willème standing**, c. 1861
Plaster statuette. Inscription in French on the base, stamped
onto the plaster: 'PHOTO-SC/W […] Co./PATENTED WITHOUT
GOVERNMENT GUARANTEE'; carved into the plaster in French:
'to his friend Leheutre/Willème'; 'No. 276/1040', under the
base; ht 37.5 cm, diameter base 14.0 cm.

*Coll. International Museum of Photography and Film, George
Eastman House, Rochester, NY, catalogue no. 91.2824.2.*

In 1859 the painter, sculptor and photographer François
Willème (b. Sedan 1830) invented the process known as

'Photosculpture' which he also called 'photographic
sculpture'. He patented the invention in France in 1860
(no.46,358) and continued to improve it until 1864.

In 1866 the French essayist and critic
Paul de Saint-Victor (1827–1881) made the following
comment about Willème's work: 'Modern man has never
been more clearly represented in his very particular bearing
and style. This image of a man of the world or a financier is
such that it will later come to assume the value of a typical
nineteenth-century figure'.

One of the sculptor's most glorious exploits was to go
to Madrid to photograph the Spanish royal family using his

new process, for which he received the Order of Charles III.
His workshop closed in 1867 and he returned to Sedan
where he lived and worked as a photographer and sculptor.
He later retired to Roubaix where he died in 1905.

In 1924 the original of this beautifully executed statuette
was copied by Lanson, one of Willème's former employees,
at the request of its owner, Gabriel Cromer, so that the
Société Française de Photographie could have a copy (now
in the Musée National des Arts et Métiers). The original is in
the Cromer collection which is preserved at George
Eastman House in Rochester, New York.

Photosculpture – the fortunes **81**
of a sculptural process based
on photography

Photosculpture – the fortunes of a sculptural process based on photography

Philippe Sorel

François Willème, **Wooden head**, 1859–61
Inscription in French under the base, label handwritten in ink
by Gabriel Cromer: 'Willème Photographic/Photosculpture/
Collection./Statuette made by/the artist by cutting up/
a series of profiles/of the subject from the same number/
of photographs./See my letter of 23 May 24 to/the Société
Française de Photographie from Gabriel Cromer/One-off
piece'; total ht 19.6 cm, sculpture 14.0 cm; diameter:
top 6.0 cm, base 8.5 cm.

*Coll. International Museum of Photography and Film, George
Eastman House, Rochester, NY, catalogue no. 85.517.1.*

This wooden head was probably shown to the Société
Française de Photographie by Willème in May 1861, during
the session at which he explained his new photographic
process. However, the head was produced using a different
technique from the one he subsequently developed and
marketed. According to Willème, after taking fifty different
angle shots of a statue, one hundred strips of wood were
assembled two by two so that they could be cut out
according to the profiles of the photographs.

Photosculpture, a process which from the outset made use of photography, light
projection, the pantograph, and the sculptural techniques of modelling and casting, was
invented in 1859 by François Willème (1830–1905). From this date through to the early
twentieth century it underwent various developments resulting from technical advances,
and it should be considered as a sculptural, just as much as a photographic, process.
Willème's goal was to simplify and speed up the modelling phase[1] – of portraits in
particular – in order to produce editions of sculptural works using materials and
reproduction processes which had long been employed by artists and were steadily
improved during the nineteenth century.

Casting, engraving and printing have traditionally accompanied the arts of drawing
and sculpture, as well as many other technical processes of a non-artistic character.
The discovery of classical sculptures in the early sixteenth century led collectors and
scholars to seek reproductions of these works – in the form of casts or copies, to scale
or in miniature, or simply of drawings or prints. From the Renaissance onwards,
sculpture, like printing, acquired the dual status of being both a creative art and a
means of creating multiple reproductions. As a result it became subdivided into a series
of individual technical processes, which were often entrusted to specialists (casters,
masons, foundrymen, chasers) who over the course of time invented and developed
techniques such as pointing, the piece mould, the lost-wax method, sand-casting, and
electroplating, as well as expanding the range of materials used to make copies, casts
and miniatures.

During the eighteenth century, factories producing earthenware, porcelain, biscuit
and terracotta introduced significant improvements to the casting and firing processes,
while bronze became so widespread that sand-casting supplanted the lost-wax
method, which had fallen almost into oblivion in France by the early nineteenth century.
These technical advances made it possible to produce exact replicas of excellent
quality in large numbers. The progress in pointing techniques, which evolved from the
flat circular dial to the machine that was invented by sculptor and medal engraver
Nicolas Marie Gatteaux (1751–1832) in the early nineteenth century and improved soon
after, made it possible to supply customers with exact reproductions of sculptures in
a variety of sizes. At the same time, some of the most famous sculptors were, without
admitting it, using casting from life to produce more faithful portraits, while waxwork
museums were becoming more common, displaying works in which colour was
combined with casting to heighten the effect of realism.

In 1786, picking up on the delightful Greek legend of Kora, daughter of the potter
Dibutades, tracing the profile of her beloved on the wall from his shadow, Chrétien and
Quénédey invented the Physionotrace. This technique involves tracing on a screen the
outline of a face whose shadow is projected by a light source. The artist reproduces the
model's features within the silhouette obtained in this way. This technique satisfied a
growing taste for exact accuracy of representation, which is also evident in scientific
prints of the period. The inventors used these portraits to produce small-scale prints,
which made the physical appearance of famous political and military figures familiar to
a wide public.

Under the Restoration and the July Monarchy, portrait sculptures became more
common, in the form of medallions, busts and full-length figures, produced in small-

82

scale formats, which may not have been acceptable to the Salon Officiel du Louvre but were certainly popular with the public. The sculptor Dantan Jeune (1800–1869) specialized in portraits and caricatures in plaster and in bronze. He reproduced them in the form of affordable lithographs and introduced caricature 'cartes de visite', in the form of miniature sculpted caricature busts. Photographer Félix Nadar (1820–1910) later acknowledged that he had been inspired by Dantan's commercial success when he launched his 'Panthéon Nadar', a large lithograph fresco of portraits produced in part from photographs. There is no doubt that Dantan, David d'Angers (1788–1856), Jean Auguste Barre (1811–1896), Paul Joseph Gayrard (1807–1855) and many other sculptors, like the producers of 'prosopographies'[2] illustrated with lithographs and engravings, were among the precursors of portrait photographers such as Nadar, Pierre Petit (1832–1909) and Disdéri (1819–1889), who produced collections of photographs of famous people – the 'Galerie Contemporaine', for example.

It was in this context of the commercial development of applied artistic processes that sculptor and photographer François Willème patented his photosculpture process.[3]

The sculptor's invention had been foreshadowed by a number of pictorial precedents in the seventeenth century: the right and left profiles of King Charles I of England, painted by Van Dyck, those of Richelieu painted by Philippe de Champaigne, and Hyacinthe Rigaud's profile portraits of his mother, all produced to serve as models for portrait sculptures in the round.

Willème was himself a sculptor before becoming a photographer, and his idea was to use photography to save models and sculptors from long and costly sittings. Standing or seated at the centre of a rotunda measuring 10 metres in diameter, lit by a glass roof, the person was photographed simultaneously by twenty-four cameras. All the photographs were subsequently projected onto a translucent screen, at the rear of which an assistant traced the outline of the silhouette with a point attached to a pantograph. At the other end of the pantograph, a cutting tool cut out the same silhouette in a mass of clay set on a circular base, which turned by 15° after each outline. This provided the rough shape of the work: the sculptor then removed the ridges left by the cutting planes and retouched the work.

Two observations on Willème's process should be made at this point: on the one hand, it picked up on the idea expressed by Benvenuto Cellini in the mid-sixteenth century, and endorsed by Rodin in the late nineteenth century, that a statue results from the observation of a sum of profiles; on the other hand, it combined the two sculptural processes identified by Plato – removing material (cutting) and adding it (modelling).

Cutting a block of clay using a mechanically guided cutting tool is difficult as the blade tends to stick to the material and misshape it. In addition, the sculptors themselves had to model those features which were not rendered by the photographs, such as the horizontal areas: the top of the skull, the upper part of the shoulders, a folded forearm, the effects of embroidery or satin in garments, and so on. In all probability the manual input required was very substantial, taking time and therefore increasing the costs involved.

In 1862 Willème opened a studio on the Avenue de l'Étoile[4] (now Avenue de Wagram), in a building with a five-bayed façade rising to an attic ornamented with busts in circular niches; at the centre of the building was a rotunda surmounted with a dome. Busts and statuettes were displayed in a gallery. Willème participated in the photographic exhibition of 1863 at the Palais de l'Industrie, in the Vienna Great Exhibition of 1864 and in the Paris Great Exhibition of 1867. His company closed down in the year after this, for reasons which remain unclear. Very few works of the 'Société de Photosculpture de France' are still preserved today; those that do survive are made of galvanoplasty, plaster and biscuit. Many of the pieces made by this last technique display a blue mark with the initials of Gilles Jeune, whose workshop was active on Rue de Paradis in Paris from 1845 to 1869. Willème's output is strikingly small when compared with that of companies such as Barbedienne, Susse or Thiébaut, or artists like Jean-Baptiste (known as Auguste) Clésinger (1814–1883), Pierre Carrier-Belleuse (1851–1932) or Jean-Baptiste Carpeaux (1827–1875).

Even though it was supported in promotional articles penned by famous figures – Théophile Gautier, for example – Willème's process was destined to fail. The portrait-statuette, which was popular in the 1830s and 1840s, had fallen out of fashion. Since the mid-century the increasing popularity of eighteenth-century art led artists and

François Willème, **Making a bust using photosculpture**, 1860

Ink drawings highlighted with watercolour. Extract from the French patent no. 46,358, registered on 14 August 1860, for a 'photosculpture process'; sheet 32.3 x 48.7 cm.

Coll. Institut National de la Propriété Industrielle.

Morin, **Façade of 'La Photosculpture' studio on the Avenue de l'Étoile**, 1864

Woodcut illustration; sheet 14.5 x 25.5 cm.

Coll. Musée Carnavalet, catalogue no. Topo PC 133C.

Anonymous, **Interior of the 'salon de pose', Avenue de l'Étoile**, 1864

Woodcut illustration in *Le Monde Illustré* of 31 December 1864. Inscribed in French: 'PHOTOSCULPTURE. Rotunda used as a *salon de pose* (posing room). – Twenty-four different views of the subject are taken simultaneously by twenty-four lenses', below the image; sheet 14.5 x 25.5 cm.

Coll. Musée Carnavalet, catalogue no. Topo PC 133C.

François Willème (1830–1905) opened his studio in 1862, near the former Barrière du Roule, at 42, Avenue de l'Étoile (which later became the Avenue de Wagram). According to a description by the French poet, novelist, critic and journalist Théophile Gautier (1811–1872): 'you pass through an elegant gallery decorated with rich Turkish hangings'. A few steps led to the *salon de pose*, 'a vast rotunda, with a floor covered in fine mats and walls in soft neutral tones, and totally devoid of any kind of equipment [...] Twenty-four consoles attached to the circular wall supported the statuettes or busts of various well-known figures whose

image has been reproduced by photosculpture [...] below the consoles shone twenty-four eyes, twenty-four lenses which you did not see, but which were watching you [...]'. The room was lit by the white and blue panes of the glass dome and draped canopies. The rotunda was surrounded by the management office, the laboratories and the studios of the pantographer, moulders and sculptors, reached via the entrance at no. 40 (which can be seen to the right of the façade).

The Société Générale de Photosculpture de France was established with the financial backing of the banker Pereire, the director of the Crédit Foncier Soubeyran and Paul Dalloz, editor of *Le Moniteur Universel*.

In 1867 the premises were taken over by the sculptor Clésinger and used for the more traditional production of sculptures. The rotunda was converted into a foundry.

François Willème, **24 photos of a child for a photosculpture**, c. 1860

Four strips of six small albumen prints. Inscription in French on the reverse of the strip numbered 1–6: 'G. Cromer photograph collection/Photosculpture Willème –/complete set for Willème's first trials. The model is probably/one of his daughters. He worked in an ordinary photographer's studio, moving the camera around/the model. Therefore, 24 successive shots/probably a unique set/Willème is seen in the background of shots 11 and 12/Prints 1/9th of a plate, = 4 x 5 cm. We can see the ball and the string suspending it used to centre the various images for the pantographer.'; each image 4.8 x 3.6 cm, each strip 28.0 x 35.5 cm.

Coll. International Museum of Photography and Film, George Eastman House, Rochester, NY, catalogue no. 81.2795m 11, 12, 13, 14.

This document belonged to Gabriel Cromer. The photographer can be seen in the background in shots 11 and 12. The model is probably one of Willème's daughters. A silver ball is suspended above the model's head, perpendicular to the dais. This is to make it easier to centre the photograph when it is projected and sculpted with the pantograph.

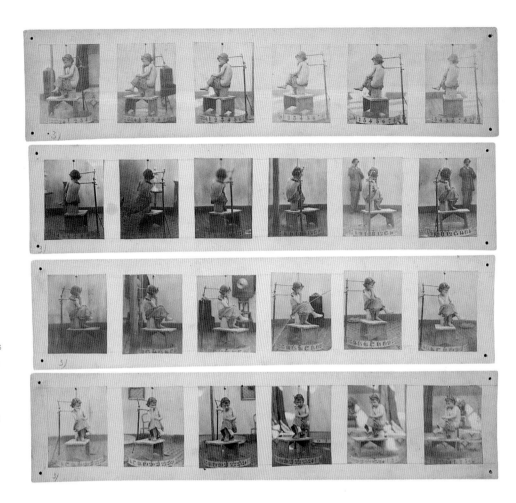

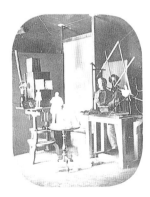

Gabriel Cromer, **Scene showing the projection of an image and sculpture using a pantograph in François Willème's photosculpture studio**, 1924

Lantern slide, gelatin silver on glass. Inscriptions in French: 'G. Cromer-Willème inventor/of Photosculpture', left; '4', top; 'Conference at the Société Française of 23 May 1924', and '2558', right; mount 8.5 x 10.0 cm.

Coll. Société Française de Photographie, catalogue no. 523.

amateurs to turn away from the classical portrait in favour of a more lifelike depiction of the figure and a freer way of working. Terracotta sculptures in this style, which were cast and then retouched before firing, more effectively conveyed an impression of artistic spontaneity, or *fa presto*.

The contemporary fashion for photography, and for the 'carte-de-visite' format in particular,[5] was another factor that impeded the success of photosculpture. Despite a number of factors in its favour – improvements made to Willème's process by Antoine Claudet in London, in his 'photoplastigraphy' process introduced in 1865 [6]; the opening by Huston and Krug of a branch of Willème's company in New York in 1867 [7]; and support from critics, artists and entrepreneurs interested in an industrial art process which could bring sculpture within the reach of the masses – photosculpture did not achieve the hoped-for success.

From the 1890s, while the portrait-statuette regained ground, new photosculpture processes were introduced, such as those developed by Potschke[8] (1892) and Cardin[9] (1910). However, as the fashion for *fa presto* persisted, the delightful statuettes of Théodore Rivière (1857–1912), and Troubetskoy (1866–1938), in which realism was tempered by psychology and elegance, continued to prevail over photosculpture.

At this stage photosculptural processes were developed to make it possible for amateur photographers to produce medallion portraits. Willème himself had produced photosculpture medallions using his own process (presumably he reduced to relief a half-figure in the round, based on a complete figure). The medallion portrait had, though to a lesser extent than the portrait statuette, fallen out of favour under the Second Empire, before seeing a resurgence of interest late in the century through the work of sculptors such as Oscar Roty (1846–1911), Alexandre Louis Marie Charpentier (1856–1909) and César Henri Isidore Cros (1840–1907). Medallion portraits using the new photosculpture processes were obtained by using the bichromated gelatin process of Hill and Barratt[10] (1896), Lernac's 'photostérie' process[11] (1899), and the process developed by Marion[12] (1900). It is uncertain if bichromated gelatin casting was more successful than earlier photosculpture processes.

In the 1920s Claudius Givaudan (1872–1945) invented a camera with a vertical

84

circular apparatus that projected bands of light onto the face of the model, seated in the centre. These bands of light, alternating with bands of shadow, produced contour lines on the photographs and so the profile photograph of the face could be used, by a process different to Willème's, to determine the successive planes of the sculpture, which were then retouched by the artist. However, this invention was not able to rival the skills of the sculptors themselves.

In the twentieth century, computer-based image processing methods were used for an increasingly wide range of applications: in the sciences and technology, for both microscopic and macroscopic applications and for representing movement, as well as in the arts and the media. As in earlier centuries, artists have followed these technical developments with interest and turned to them for inspiration – with a particular fascination for developments in scientific imaging. Technicians and artists use computers to enhance the 'realism' of their productions – clearly with the aim of pleasing the public, which on the whole prefers images that reproduce reality as closely as possible – while for more than a century the sculptural arts have been exploring a variety of technical and aesthetic paths. Today, thanks to the new digital imaging systems, anyone can obtain a faithful portrait – as in Willème's era, and in accordance with his own aspirations – or they can leave the artist free to express a personal vision of the subject.

Charles Marville (1816–c. 1878), **A poster for La Photosculpture in the Rue Saint-Jacques**, c. 1865
Detail of a photograph, albumen print; whole image 30.2 x 27.5 cm.

Coll. Musée Carnavalet, catalogue no. Ph 763.

The words 'Photosculpture/ten-second pose/. . . near the Arc de Triomphe de l'Étoile' can be read on the partly torn poster.

1. See the remarkable article by Wolfgang Drost, 'La Photosculpture entre art industriel et artisanat, la réussite de François Willème', in *Gazette des beaux-arts*, October 1985, pp. 113–29. This includes a comprehensive bibliography on photosculpture. And, François Willème, 'La Sculpture photographique', in *Bulletin de la Société française de photographie*, 1861, pp. 150–51.
2. Prosopography: a detailed description of the features and posture of people or animals; by extension, a list of annotated portraits published in the nineteenth century.
3. Willème's patent for a 'photosculpture process': 14 August 1860 (no. 46,358). A number of additions were made, on the following dates: 6 April 1861, 9 September 1863 and 14 June 1864 (coll. Institut National de la Propriété Industrielle).
4. Théophile Gautier, text of the prospectus of the Société Générale de Photosculpture de France, also published in *Le Moniteur Universel*, Vol. VII, 1864, pp. 396–98, and in *Le Monde Illustré*, 17 December 1864, Vol. XV, pp. 396–98; François Napoléon Marie Moigno, 'Photo-sculpture, art nouveau imaginé par M. François Willème', in *Revue Photographique*, 1861, pp. 136–40, and 1863, pp. 141–45.

5. Photograph affixed to a small card.
6. Ernest Lacan, 'Revue photographique', in *Le Moniteur de la Photographie*, no. 4, year 5, 1 May 1865, pp. 25–26, reproduced in Revue Photographique, 1865, pp. 99–103; Claudet, 'Perfectionnements apportés à la photosculpture', in *Revue Photographique*, 1865, p. 89; A. F. J. Claudet, 'Description de la photoplastigraphie. Nouveau procédé de photosculpture', in *La Lumière*, 1865, pp. 38 and 42.
7. Cf. Le Moniteur de la Photographie, 1867, no. 3, 15 April 1867, p. 20.
8. *Bulletin de la Société française de photographie*, 1896, pp. 507–09.
9. *Ibid.*, 1865, pp. 88–89 ; 99–107 ; 1908, pp. 59–62 ; 1910, pp. 307–11.
10. *Bulletin de la Société française de photographie*, 1896, pp. 507–09.
11. *Ibid.*, 1899, pp. 131–33 ; and *Bulletin du Photo-Club de Paris*, 1901, pp. 425–28.
12. *Bulletin de la Société française de photographie*, 1900, pp. 313–20.

François Willème, **Left profile of Pope Pius IX (1792–1878)**, c. 1864–1867
Photosculpture, reproduced in biscuit; recessed inscription on the shoulder: 'PHOTOSCULPTURE'; inside, blue stamp GJ [Gilles Jeune]; 16.3 x 12.0 x 3.5 cm.

Coll. Gérard Lévy.

Pius IX was the longest-reigning pope. He was responsible for making the 'Immaculate Conception' and 'papal infallibility' part of the official dogma of the Church.

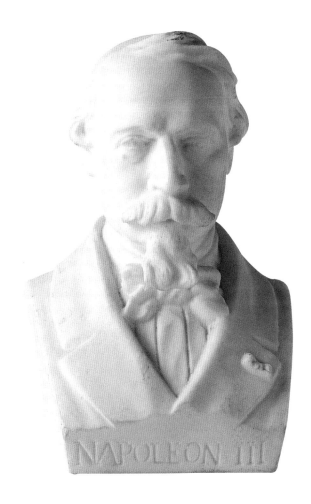

François Willème, **Bust of Napoleon III (1808–1873)**,
c. 1864–67
Photosculpture, reproduced in biscuit. Inscription
on the front of the base: 'NAPOLEON III'; inside, blue stamp
GJ [Gilles Jeune]; 11 x 8 x 6 cm.

Coll. Gérard Lévy.

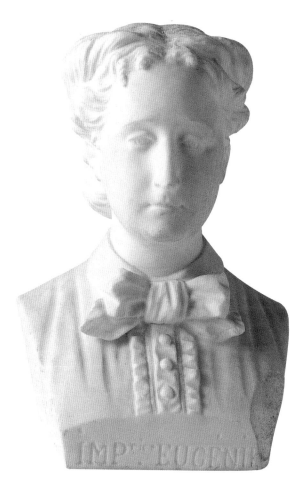

François Willème, **Bust of the Empress Eugénie
(1826–1920)**, c. 1864–67
Photosculpture, reproduced in biscuit. Inscription in French
on the front of the base: 'EMPRESS EUGENIE'; on the right side
of the bust: '(1) 826'; inside, blue stamp GJ [Gilles Jeune];
11 x 8 x 6 cm.

Coll. Gérard Lévy.

Small busts of this type were known as 'bustes-cartes'
(card-busts). Traces of 'seams' can be seen on the surface
of the biscuit, an indication that they were reproduced
in a mould.

86

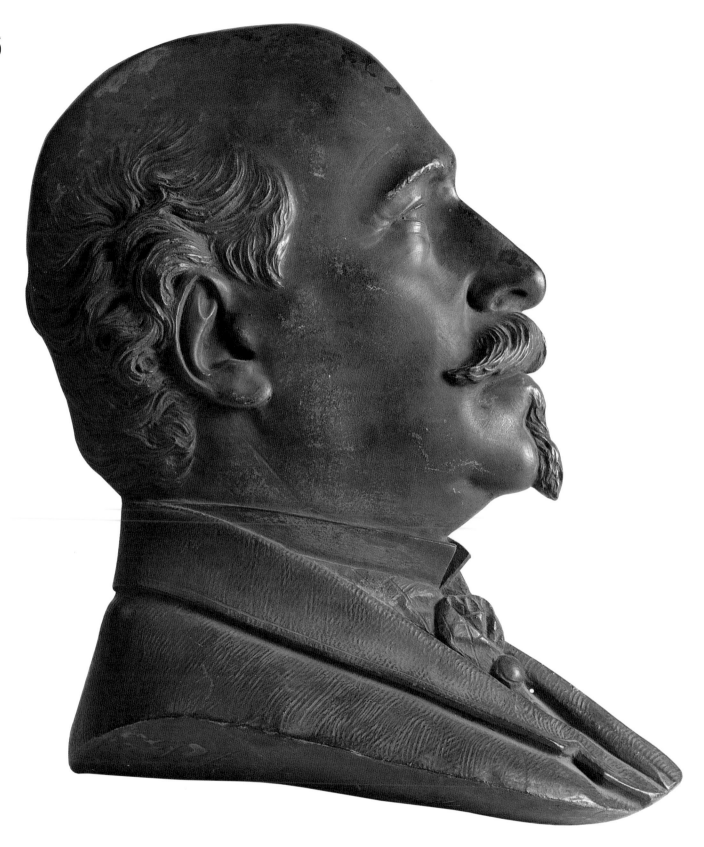

François Willème, **Right profile of Duc Charles de Morny (1811–1865)**, c. 1864–67
Photosculpture, reproduced in galvanoplasty, imitation bronze patina. Recessed inscription on the base: 'Photosculpture'; 35.0 x 25.5 x 7.5 cm.

Coll. Gérard Lévy.

The Duc de Morny, Napoleon III's half-brother, was a leading political figure under the Second Empire.

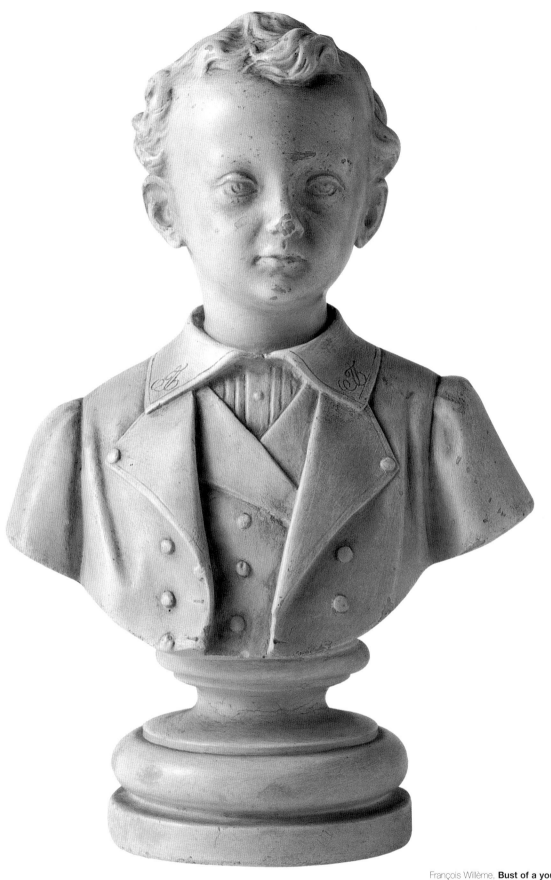

François Willème, **Bust of a young boy**, c. 1864–67
Photosculpture, reproduced in painted plaster. Inscription in
French on metal seal on reverse: 'PHOTOSCULPTURE/WILLEME
& CO/PATENTED WITHOUT GOVERNMENT GUARANTEE';
20.0 x 13.5 x 8.5 cm.

Coll. Gérard Lévy.

88

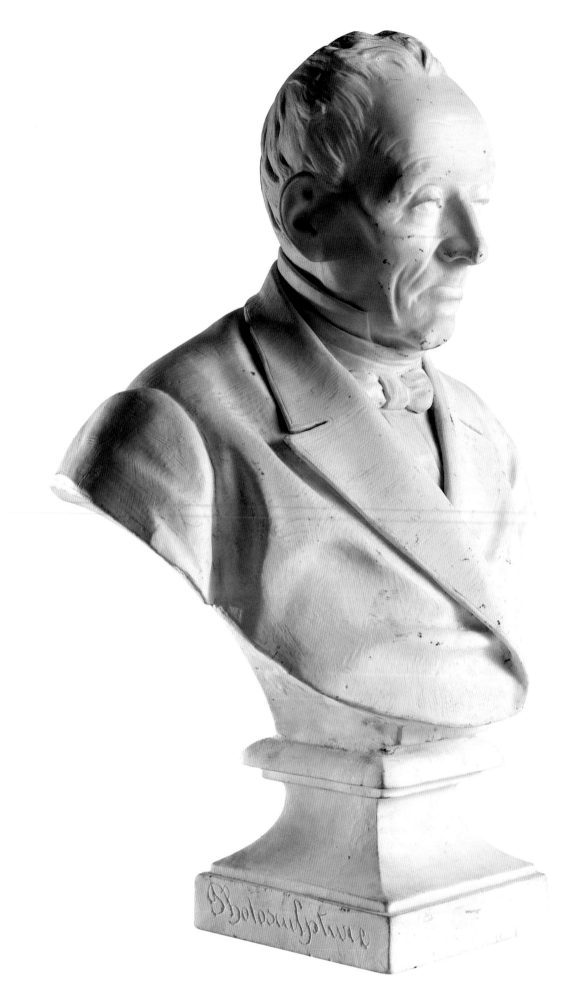

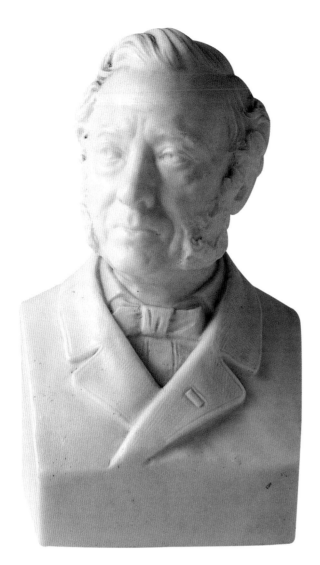

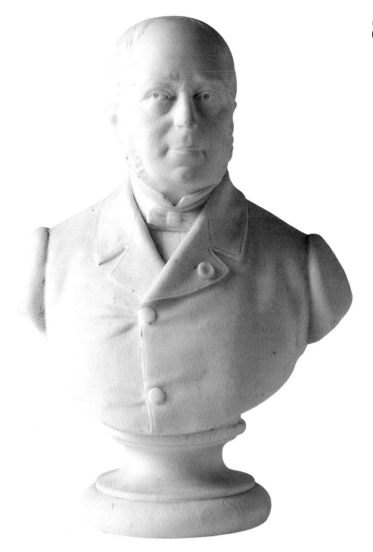

François Willème, **Bust of a man**, c. 1864–67
Photosculpture, reproduced in biscuit. Inscribed with a blue
stamp: GJ [Gilles Jeune] and '104', recessed on the back;
15 x 9 x 7 cm.

Coll. Gérard Lévy.

François Willème, **Bust of a man**, c. 1864–67
Photosculpture, reproduced in biscuit. Inscription:
'Photosculpture', recessed on the right of the plinth;
21.5 x 15.5 x 10.0 cm.

Coll. Gérard Lévy.

François Willème, **Bust of Claude Joseph Bonnet (1786–1867)**,
1867
Photosculpture, reproduced in biscuit. Inscriptions in French:
'Photosculpture' and '26 March 1867', recessed on the base;
32.5 x 22.5 x 15.0 cm.

*Coll. Musée Nicéphore Niepce, Chalon-sur-Saône, catalogue
no. 80.138.1.*

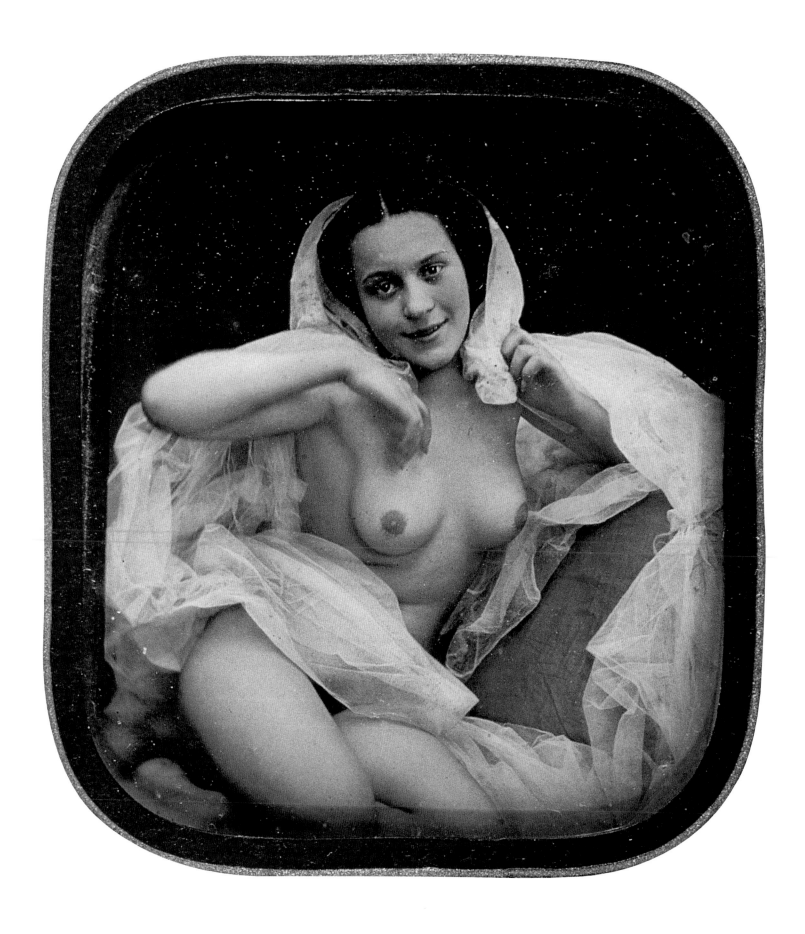

Anonymous, **Smiling nude with veils**, 1850s
Tinted stereoscopic daguerreotype; mount
8.5 x 17.5 cm.

Coll. Musée d'Orsay, catalogue no. pho 1983.165.400.

File BB3 and the erotic image in the Second Empire

Denis Pellerin

File BB3, a bound file containing information relating to the illegal production of erotic images, 1855–68
The file contains 303 handwritten pages; 30 x 22 cm.

Coll. Archives de la Préfecture de Police de Paris, catalogue no. BB/3.

The file is open at pages 86 and 87.

Although it is difficult to calculate exactly how many obscene or licentious binocular photographs were made in the Second Empire, we know for certain that, with the appearance of the stereoscope, a flourishing underground industry developed to produce and circulate erotic or pornographic images on daguerreotype, glass or paper. An invaluable document containing police reports relating to offences against public morals survived the fires of the Paris Commune of 1871. This 'register without a name',[1] kept in the archives of the Préfecture de Police in Paris under shelf mark BB3,[2] contains statements, arrest reports and pictures which quite clearly show the size of this lucrative sector of the photographic industry.

Under the terms of the law concerning the press of 17 May 1819, articles 1 to 21 of which were slightly amended by decree on 17 February 1852, manufacturers had to submit several copies of their pictures to the Ministry of the Interior or the Préfecture de Police. The state intended in this way to prevent – or at least restrict – the circulation of images undermining public morality: convicted offenders could expect to receive a term of imprisonment ranging from one month to a year, as well as a fine of 16 to 1,000 francs. This body of measures was used frequently during the Second Empire, as can be seen by the pages of file BB3, which contain the names of people suspected – after an investigation or denunciation[3] – of making, selling or circulating objects and images that offended public morality.[4] In addition to these, there were usually brief particulars from the Registrar General's office, concise reports of arrests or searches, the terms of any sentences given and a list of known accomplices. Around 100 photographs, selected from the confiscated prints,[5] have been untidily pasted opposite the name of certain offenders in order to make it easier to identify them in case of subsequent offences. These pages show that, as well as the official market for stereoscopic products, there was an alternative industry whose key players were often respectable merchants who had discovered that this activity was an easy way of substantially increasing their income.

It is impossible to determine the exact proportion of traders who were actually involved in the production of illicit prints since the file only lists suspects or arrests, but it is interesting to note that many of the eighty-nine men and women described as photographers were famous for producing thousands of harmless stereoscopic views of sculptures, journeys, monuments, landscapes or genre scenes. The great names in stereoscopy are featured in these pages: Auguste Belloc, Alexandre Bertrand, Alfred Cordier also known as Billon-Daguerre, Adolphe Félix Gentil and his partner Auguste Speisser, Félix Moulin, Pierre Petit, Henri Plaut, Alexandre Quinet, Jules Raudnitz and Eugène Thiébault. Their names appear alongside those of colourists (mainly women), travelling salesmen, people arrested for peddling obscene images in public and, naturally enough, about 100 female models and twenty male models. Although the women reoffended fairly frequently,[6] this was not true of the men, who only modelled occasionally. It should also be noted that the latter were punished more harshly by the law. While the average sentence for women was 51 days in prison (min. 8, max. 365) with a fine of 41 francs (min. 16, max. 100),[7] the average sentence for men was 168 days (min. 30, max. 365) and a fine of 110 francs (min. 16, max. 500). The average age of male models was 31 (min. 18, max. 52), while the average age of women was only 21 (min. 15, max. 39). The small number of male models made

92

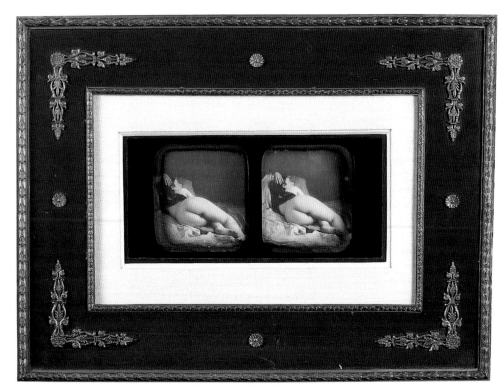

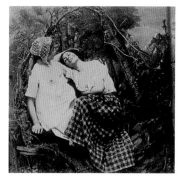

Attributed to Braquehais, **Reclining nude**, 1850s
Lightly tinted stereoscopic daguerreotype. Inscription in French
in gold lettering on label on reverse: 'AUX ARTS INDUSTIELS./No. 4,
Boulevard St Martin, No. 4./A PARIS/AN^{NE} MAISON FONTAINE/MME
JULIENNE SEUR/Sale and Hire of Painting and Prints/Framing,
Office & Artists' Supplies'; mount 8.5 x 17.2 cm.

Coll. Gérard Lévy.

Attributed to Belloc, **Two women in a wood**, c. 1855–60
Stereoscopic view, coloured albumen print; mount
8.6 x 16.9 cm.

Coll. Bibliothèque Nationale de France, catalogue no. EK5.

it impossible to carry out a statistical analysis of their socio-professional background,[8] but an analysis of their female counterparts proved quite revealing. The breakdown by profession of the ninety-four models mentioned in the file is as follows: profession unknown: 20; marked 'no profession': 3; streetwalkers: 12; florists: 18; linen maids, laundresses: 16; seamstresses: 16; other professions: 10.[9]

These pages tell the story of women who encountered a photographer, agreed to pose for him in the scantiest of outfits, either on their own or accompanied, and usually wound up in prison. One of them, 17-year-old Augustine Guy, known as Desbureau, a seamstress, was sentenced for the first time in September 1857 to a month in prison and fined 100 francs for posing for a certain Lepage. Less than a year later, she received the same sentence for modelling for photographs taken by one Darnay. Arrested a third time in 1859, she was released. Listed as a streetwalker by the *bureau des mœurs* (vice department) in August 1860, she was again sentenced to a month in prison for a similar offence in October of the same year. She then ended up in a licensed brothel on the Rue Sainte-Anne. A fourth arrest in July 1861 fortunately resulted in an acquittal. The file makes no mention of Mademoiselle Desbureau after that date.

As well as being extremely informative about the models' background, file BB3 contains a great deal of information about the hidden side of the pornographic photographic industry. Although short, the police reports reveal the extent of this clandestine business, its organization and the attempts by the police to curb it, if not stamp it out completely. Besides the photographer, the production unit usually comprised one or several colourists, peddlers, agents and travelling salesmen, as well as various procuresses who had the job of finding models. On 15 July 1861 the photographer and monumental mason Joseph Lacroix and his mistress, Joséphine Sent, a 28-year-old seamstress, were arrested following a complaint made by a man called Coliche, 'who accused the Sent girl of having taken his 16-year-old daughter to Monsieur Lacroix who allegedly took the girl's photograph, after making her uncover her breasts and lift up her petticoats to the waist with her legs slightly apart.' Some photographers did not use procuresses and went looking for suitable models themselves. According to one report, Pierre Petit was particularly interested in finding 'streetwalkers to pose for him'. Sometimes, the photographer did not need to search for a model or use the services of a third party. Louis Germain, for example, was investigated after the 'statement by a 17-year-old girl, Esther Ravaux, who admitted that she had posed nude at Germain's studio to please her lover who wanted her photograph taken like that.' The unscrupulous lover was occasionally none other than the photographer himself, who managed to keep his costs down in this way. Joseph

File BB3, open (above) at page 201 and at pages 98
and 99, and (opposite) at page 181.

Coll. Archives de la Préfecture de Police de Paris, catalogue no. BB/3.

Penne, for example, lived with one of his models on the Rue Cadet and often visited the Rue de Paris in Belleville where a second mistress, Madame Morizet, worked as his colourist. At her home, the police found '708 obscene prints and 750 licentious prints' which they confiscated.

The police made frequent searches and sometimes seized a great deal of material, although the file is often vague about how much was found. The reporters noted that 'a large number', 'a vast quantity', or 'a certain number' of banned prints was confiscated, which makes it difficult to calculate the amount produced. Others fortunately provide more accurate figures although they do not always specify whether the litigious prints and negatives were made for the stereoscope or not.[10] Joseph Auguste Belloc probably holds the record in this respect. A search warrant dated 9 October 1860 for premises on the Rue de Lancry made it possible to 'seize from Madame Ducellier, née Poirier: '1. Nineteen obscene photographs that she was colouring. Seizure from two safes, a writing desk and a darkroom of 1,200 card-mounted obscene photographs, a certain number of boxes disguised as books bearing the title *Œuvre de Buffon (Complete Works of Buffon)* and containing a certain number of photographs. 2. 3,000 obscene photographs on paper. 3. 307 negatives used to make the above-mentioned obscene photographs. 4. Three basins made of gutta-percha containing a certain number of prints in production. 5. Four albums containing a certain number of photographs depicting naked women. 6. 102 photographs on paper (large format) depicting naked women in licentious positions'. It would seem, however, that none of the thousands of licentious prints confiscated by the police have survived.[11] 195 stereograms contained in the fake bindings disguised as zoological books that were confiscated from Belloc are now kept in the collection of the Bibliothèque Nationale de France, having been donated by the public prosecutor on 16 November 1866, in other words six years after the search.[12] Charged in December 1856 with 'engaging in the sale of obscene material' and found in possession of a substantial number of obscene negatives and prints, Belloc could have been taken as an example and imprisoned for several years. This was not the case, however, and he was released on bail 'after a protest by his cousin, Major General Lafont de Villier'. One of Belloc's colleagues, photographer Marie Léopold Demesse, at whose home some ten erotic and pornographic negatives had been found, may have had his petition for pardon granted because he was also choirmaster at the Église des Batignolles!

Not all the dealers who were arrested were as lucky. Although there were a few adjournments, dismissals and acquittals which may appear suspicious looking at the information on file and which tend to prove that the law at times punished the models more severely than the photographers, it should be noted that offenders received an average sentence of 147 days in prison (min. 15 days, max. 3 years) with a fine of 195 francs. Although not all of them served their sentences, some – who had fled or could not be found – were sentenced in their absence, while others voluntarily gave themselves up. This was the case with Léon Jouvin who paid his fine, went to Sainte-Pélagie of his own accord and benefited from a reduction in the rest of his sentence. In 1863 Auguste Speisser also gave himself up at a hearing of the magistrate's court, which did not prevent him from being arrested and sentenced two years later on the same grounds[13], with his partner Adolphe Félix Gentil-Descarrières. Neither the sentence received by the two men, nor the highly pornographic nature of their prints, stood in the way of their producing, several months later, a series of some fifty stereoscopic prints of the imperial residence of Fontainebleau, which included one the few binocular photographs of Emperor Napoléon III. The saddest story is undoubtedly that of Henry Louis Colombier who, sentenced on 26 June 1862 to six months' imprisonment for having, by his own confession, made 800 obscene negatives, died in prison.

The individuals mentioned in the file were often arrested after they had been caught in the act. Inspectors Hamelin, Piel or Remise (to mention only a few) worked undercover as interested buyers and then arrested the offenders. The photographer Alexandre Quinet and the print dealer Etienne Jean-Paul Guérard were caught in this manner, the former when he was selling some obscene engravings on the Boulevard Bonne-Nouvelle, the latter when he was on his way to have some 'obscene photographs for the stereoscope' coloured. Sometimes, the arrest was deferred. The police officers purchased some illicit prints and, having obtained his address, allowed their prospective victim to leave. With their exhibits, the detectives obtained a warrant

Three false bindings containing erotic stereoscopic images, 1860
Each binding is entitled 'ŒUVRES/DE/BUFFON' and has a number on the spine; 19.7 x 14.0 x 4.5 cm.

Coll. Bibliothèque Nationale de France, catalogue no. Ae27/4°, Ae28/4°, Ae29/4°.

These bindings were confiscated from the studio of photographer Joseph Auguste Belloc.

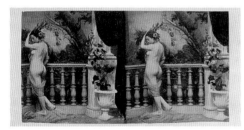

Attributed to Belloc, **Woman posing with a veil**, c. 1855–60
Stereoscopic image, albumen print, coloured and varnished; mount 8.7 x 16.9 cm.

Coll. Bibliothèque Nationale de France, catalogue no. EK5.

94

from the police superintendent or examining magistrate and paid a visit to their dealer's home or studio. These visits were sometimes eventful, like the one paid to François Deruaz who, taken by surprise at the home of his colourist with a 16-year-old model, threw the incriminating prints out of the window. Searches were carried out with great care and every nook and cranny was examined with a fine-tooth comb, since the suspects devised some ingenious hiding places.

Tired of repeated police raids, various photographers met in September 1857, at the instigation of François Benjamin Lamiche, his partner Dessoye and several others, 'with the aim of sending a petition to the Minister of the Interior and the Emperor about the confiscation of photographs'. The document, which was signed by Bertrand, Blot, Chevalier, Gastain, Gougin, Lepage, Malacrida, Millet, Mitaine, Plaut, Raudnitz, Rideau, Serres, Thiébault, Kreinitz and Soleil, had entirely the opposite effect. Not only did the number of searches, confiscations and arrests escalate, but the signatories were singled out for particularly close attention by the vice squad at the *bureau des mœurs* and were tagged with the description: 'Attended the meeting at the home of Lamiche and signed the photographers' petition'.

It is interesting to note that although the pages of file BB3 contain the names of suspected or sentenced models, colourists, dealers and photographers, they make no mention of the purchasers of these prints liable to undermine 'public morals and accepted standards of good behaviour'. Although it was strictly illegal to pose for photographs of a lewd nature or to make, reproduce, colour or circulate them and although the judges came down hard on those who 'speculate in immorality and encourage young women, who are probably already ruined but who surrender all sense of propriety in these immoral studios, to share in the dangers of their illicit trade',[14] there was no law forbidding possession of these banned images. Once they had been purchased, these prints entered the private domain and were no longer illegal. Because they were expensive and could only be afforded by a wealthy minority, these images were usually scrutinized in bourgeois drawing rooms.

'Although, at first glance, one takes in the overall effect', said Marc Antoine Gaudin when describing the impact of the magical instrument, 'when one studies the details, one is amazed at how attractive they are and truly one is never bored by them'.[15] If the picture had been subtly coloured, the illusion was at its most effective and the spectator seemed 'to be brought as close as possible to the object, within the image or rather within its reproduction'.[16] This is borne out by the description by journalist Ernest Lacan of a daguerreotype portrait made for the stereoscope by Alexis Gouin. Although the print in question depicts a woman dressed for a dance, the markedly erotic tenor of this passage makes it easier to understand the excitement felt by purchasers of suggestive or explicit pornographic pictures produced for the stereoscope. 'Stretch out your hand and touch her silky dress [...] And what about that lace whose transparent folds provide a glimpse of her rounded arm, does it not seem as if you are about to crush it beneath your fingers? And can you not see the daylight passing between the pearls of her necklace and the delicate skin of her neck? And what about the shadow of her lashes over her clear blue eyes, and the faint smile hovering about her lips? And can you not see the blood moving beneath her downy cheeks, the force which brings her soft, translucent, skin to life?'[17] There is no doubt that the large, although probably exaggerated, scale of this illicit output of erotic images, and the publicity it received, even indirectly, in the newspapers of the period, was detrimental to the stereoscope, giving it a bad name from which it has still not recovered. Although countless artistic prints, genre scenes and topographical views of far better quality were produced for it, these never succeeded in completely clearing its reputation.

The production of erotic prints for the stereoscope escalated after the fall of the Second Empire. This period saw the appearance of prints, which were no longer sold secretly, of bathing beauties clad in pink swimsuits in poses described as 'artistic'. Entire series were devoted to the *Lever de la Parisienne* (Parisian Woman Rising), the *Coucher de la Parisienne* (Parisian Woman Preparing for Bed) or to *Nos Mondaines* (Our Socialites). The 3-D postcard took over from these pictures before World War I and the monthly magazine *Stéréo-Nu* provided its readers with a dozen printed examples of nude women posing in the studio or in natural settings. Although the 1930s saw an increase in the number of these images of nudes, often in smaller formats, improvements made in printing techniques have played a decisive role in

File BB3, open at page 143

Coll. Archives de la Préfecture de Police de Paris, catalogue no. BB/3.

the continuing circulation of countless anaglyph pictures in fairly specialized magazines. Viewed through coloured gelatin, contemporary models with all-over tans now appear in centre spreads or even on the cover. Neither these young women nor their employers will ever have to languish on the damp straw of the prison cell. Laws change with the times! Only the spectator's fascination and the impression of tangibility remain unaltered.

The review *Le Déshabillé au stéréoscope*, 1906
or later
Published by La Nouvelle Librairie Artistique, Paris

Coll. Bibliothèque Nationale de France.

This review was published fortnightly with nine coloured stereoscopic images. The whole package was to be sold 'under hermetically sealed cover'.

1. By analogy with the untitled 'book without a name' cited by Maxime Du Camp in his work *Paris, Ses Organes, Ses Fonctions et Sa Vie (Paris, Its Mechanisms, Its Workings, and Its Life)*, this was the register in which, until 1870, the administrative authorities of the Second Empire entered information about 'registered prostitutes'.
2. This is an album measuring about 30 x 22 cm, containing 303 numbered hand-written sheets covering the period November 1855–August 1868.
3. On 31 May 1867 there are several lines about the painter Gustave Courbet, 'accused of possessing an obscene painting and showing it at his private exhibition open to the public at the Rond-point de l'Alma. On investigation, only one item was noted, and that was only a nude'. Was this the painting called *L'Origine du Monde (The Origin of the World)*, painted for the Ottoman diplomat Khalil-Bey, which belonged to the collection owned by the philosopher Lacan for many years and is now kept at the Musée d'Orsay?
4. Although the file mainly deals with photographs and engravings, there are also the names of manufacturers of rubber 'comforters', pipes carved in obscene shapes or dolls which, when undressed, revealed their genitals.
5. These were usually half-stereographs or 'carte-de-visite' photographs. The file contains exactly 100.
6. Some female models were arrested and sentenced on four different occasions.
7. A 15-year-old girl, arrested for posing for Courrier, was however sentenced to live in a reformatory until the age of 21.
8. The twenty or so male models in the file included two soldiers from the 72nd regiment of the line, a café owner, a tailor, two tapestry-makers, a saddler, a shop assistant, two salesmen, a carpenter, a wine merchant, two florists, a stage actor, a manservant, a colourist, a travelling salesman and a chorister.
9. This last category comprises two machinists, a chair bottomer, a polisher, a chambermaid, a lady companion, a shopkeeper, a stitcher and a net factory worker.
10. Only some of the prints seized at the house of photographers Marie Léopold Demesse, Adolphe Félix Gentil, Eugène Picot, Alfred François Cordier known as Billon-Daguerre and Antoine Gros were specifically listed as being produced 'for the stereoscope'. This does not mean, however, that the negatives and prints seized at the homes of other parties were not used for the stereoscope: quite the contrary. As the photographs of models pasted in the file were usually half-stereographs, it is likely that most of the confiscated pictures were binocular.
11. In the archives at the Préfecture de Police, it has not been possible to find out for certain whether these thousands of pictures were deliberately destroyed, whether they burned in the fires of the Commune or whether they have quite simply 'disappeared'.
12. It is worth noting that these prints are simply described as 'photographs', which would tend to confirm the reports' lack of accuracy and the likelihood that stereoscopic views formed a fairly high proportion of the total quantity of pictures confiscated.
13. Found in possession of 800 Stanhopes (microscopic photographs mounted under a small magnifying glass), twenty prints made for the stereoscope and 300 negatives.
14. 'Photographies obscènes' (obscene photographs) in *La Gazette des Tribunaux* (the police gazette). Cited by the *Revue Photographique* in 1860.
15. Marc Antoine Gaudin, *La Lumière*, 30 November 1864.
16. Walter Benjamin, *La Petite Histoire de la Photographie*. Translation by André Gunthert, published in the journal *Etudes Photographiques*, no. 1, November 1996, p. 22.
17. Ernest Lacan, *La Lumière*, 29 October 1853.

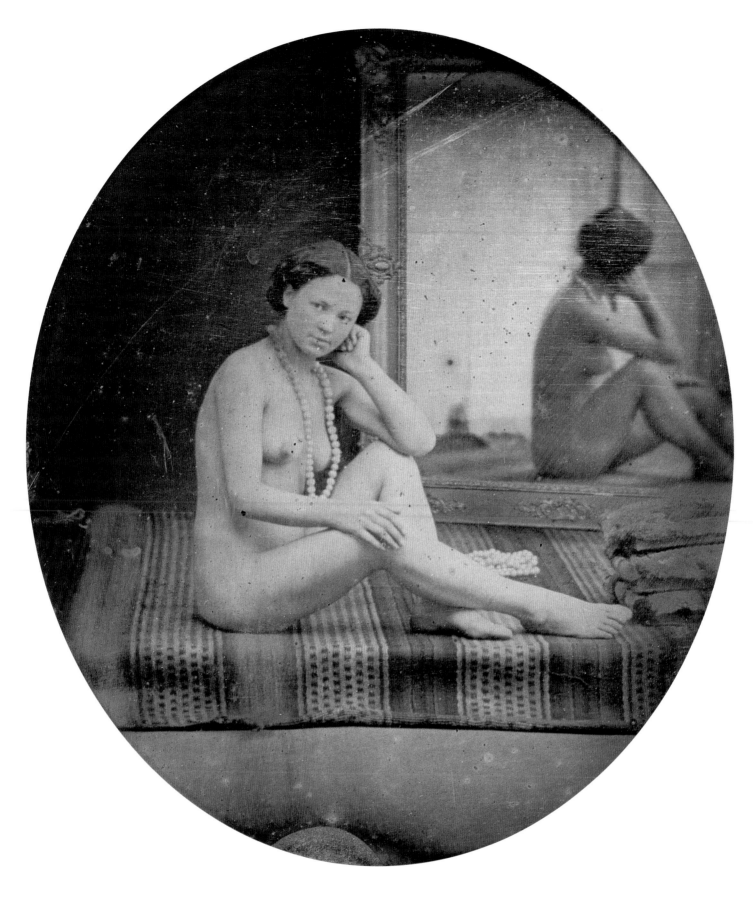

Anonymous, **Seated nude**, 1850s
Coloured stereoscopic daguerreotype;
mount 8.5 x 17.4 cm.

Coll. Musée d'Orsay, catalogue no. pho 1983.165.412.

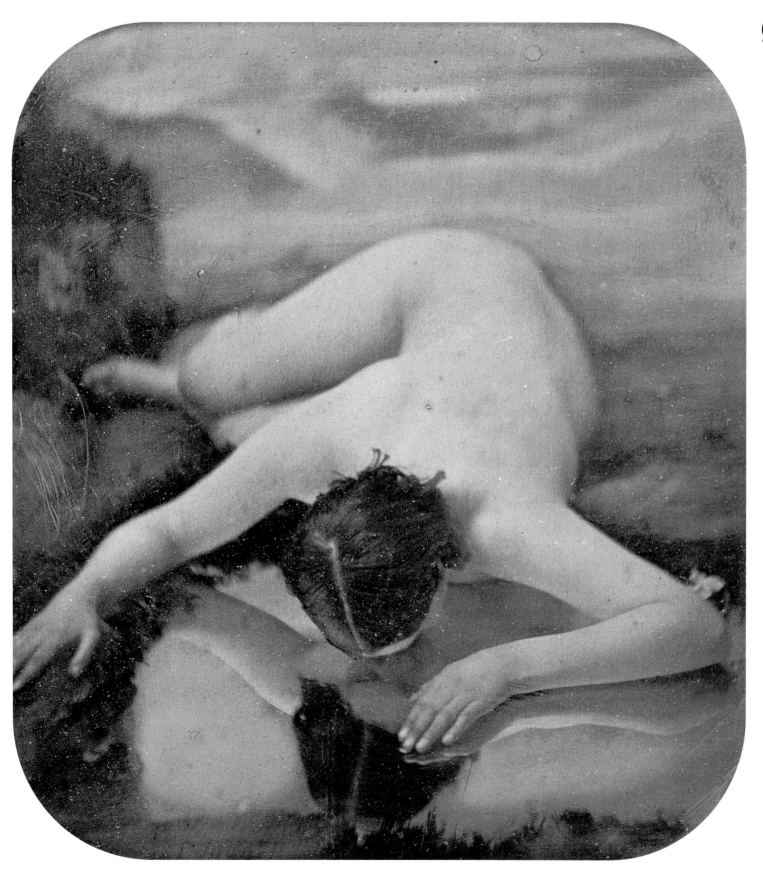

Anonymous, **Nude bending over a mirror**, 1850s
Coloured stereoscopic daguerreotype; mount
8.7 x 17.5 cm.

Coll. Musée d'Orsay, catalogue no. pho 1983.165.409.

98

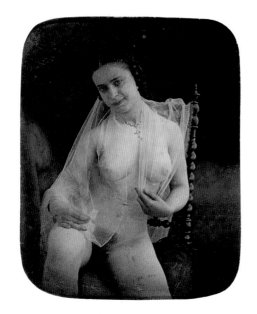
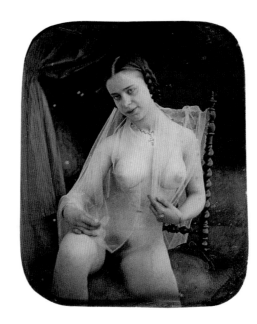

Anonymous, **Nude with veils**, 1850s
Coloured stereoscopic daguerreotype with retouched
gemstones; mount 8.3 x 16.6 cm.

Coll. Musée d'Orsay, catalogue no. pho 1983.165.401.

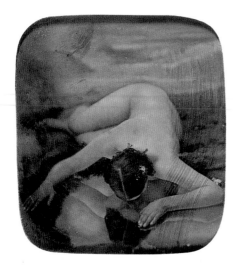
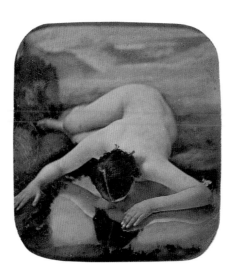

Anonymous, **Nude bending over a mirror**, 1850s
Coloured stereoscopic daguerreotype; mount
8.7 x 17.5 cm.

Coll. Musée d'Orsay, catalogue no. pho 1983.165.409.

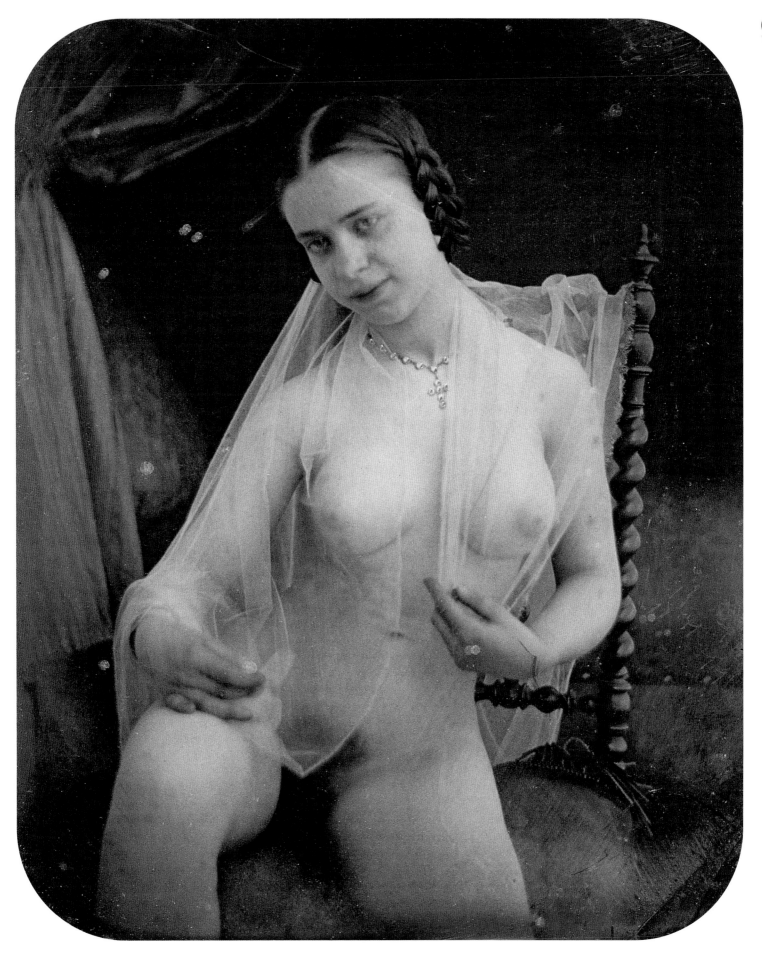

100 Stereoscopic devices

Jacques Périn

The Duboscq stereoscope

Device for viewing stereoscopic images, c. 1852
Jules Louis Duboscq, manufacturer, Paris
Patent no. 13,069, 16 February 1852
Varnished walnut, glass, metal alloy
Engraved inscriptions in French: 'Gold Medal','DS','Patented without governmental guarantee','J. Duboscq patented without governmental guarantee Rue Odéon, Paris';
10.0 x 16.5 x 19.5 cm.

Coll. Musée National des Arts et Métiers, catalogue no. 05393-0001.

In 1850 the Scottish physicist Sir David Brewster (1781–1868) visited the scientific journalist and renowned popularizer, François Moigno, in Paris. Brewster wanted to show him the model of the refractive stereoscope that he had developed for viewing three-dimensional photographs. In spite of his reputation, Brewster's invention had not been well received by his British colleagues, which was the reason for his visit to France.

Moigno became an enthusiastic disciple of stereoscopy and introduced his eminent colleague to the French opticians Duboscq and Soleil, whose studios he described as the 'centre and point of departure for progress in the field of optics' (Moigno, *Le Stéréoscope, ses effets merveilleux. Le Pseudoscope, ses effets étranges*, Paris, 1852). Duboscq and Soleil, sensing the brilliant future of the invention, set to work to produce good-quality devices at prices that were affordable for the general public. They also produced views to be offered for sale with the device.

In 1851 Duboscq and Soleil officially presented the stereoscope at the Great Exhibition in London and were awarded a gold medal. A model was specially made and presented to Queen Victoria who was enthusiastic about the effect produced by the device. Duboscq and Soleil returned to Paris with orders for several thousand models.

Charles Chevalier's 'chambre à tiroir'

Camera for taking stereoscopic daguerreotypes, c. 1855
Charles Chevalier, manufacturer, Paris
Polished walnut and brass; 17 x 27 x 37 cm.

Brass Hermagis adjustable lenses of the Petzval type
Stereoscopic base: 12 mm
Lens-cap shutter system

Coll. Musée Français de la Photographie, Bièvres, catalogue no. 85/5510.

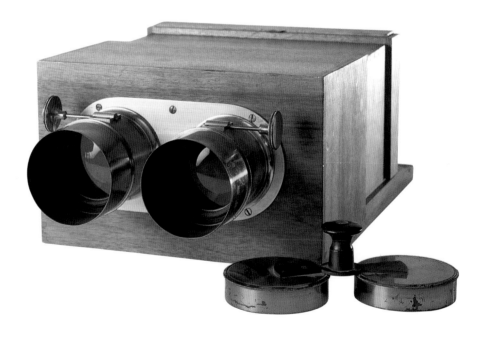

Following the Great Exhibition held in London in 1851, stereoscopy became increasingly popular. The first devices with two lenses were invented: in 1853, Alexandre Marie Quinet patented the first device of this type (the 'quinétoscope', no. 15,716, 25 February 1853).

The French optician Charles Chevalier, whose shop was on the Quai de l'Horloge in Paris, manufactured lenses for the camera obscura, magic lanterns, microscopes and telescopes long before the invention of photography. For use in stereoscopic photography, he adapted a classic camera, like the one produced by Alphonse Giroux in 1839 for daguerreotypes. He fitted it with two lenses that made it possible to obtain the two images required for three-dimensional views. The 'chambre à tiroir', with its drawer-like sliding mechanism, quite simply made it possible to focus the images. The device is typical of the early days of stereoscopic photography.

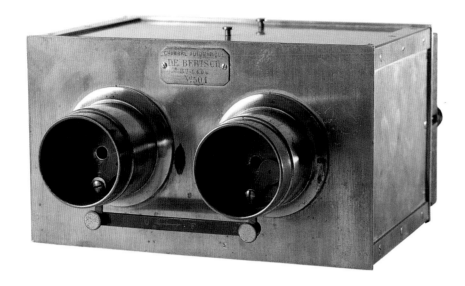

Bertsch's automatic camera

Camera for taking stereoscopic views, c. 1860
Auguste Nicolas Adolphe Bertsch, inventor, Paris
Patent no. 52,182, 9 December 1861
Polished brass; 9.5 x 18.0 x 18.0 cm.

Achromatic lenses: f16
Stereoscopic base: 90 mm

Coll. Musée Français de la Photographie, Bièvres, catalogue no. 85/5016.

In 1860 Bertsch presented three cameras designed for taking simple photographs using the wet collodion process: a chamber for microscopic views (37 x 37 mm), a cylindrical automatic chamber for 6 x 6 cm photographs and a parallelepipedal automatic chamber for images of the same format (patent no. 45,755, 29 June 1860).

In 1861 he put a stereoscopic automatic chamber on sale that was based on the earlier model. These cameras had the following points in common: they were made entirely of polished brass, they were simple to operate and, above all, they had a lens-cap shutter system. However, the stereoscopic model had rotating shutters for each lens, operated by a small connecting rod that made it possible to photograph two images simultaneously. So that photographs could be taken using the wet collodion process – which is necessarily limited by the short space of time available between taking and developing the images – these cameras were accompanied by a carrying box which served as a portable laboratory. It was used to store the chemicals required for the immediate development of the glass negatives taken.

The Holmes-Bates Stereoscope

Device for viewing stereoscopic images, c. 1869
Oliver Wendell Holmes, inventor
Joseph L. Bates, manufacturer, Boston
American patent: 13 August 1867
One in aluminium, the other in varnished walnut;
10 x 19 x 33 cm.

Coll. Musée Français de la Photographie, Bièvres, catalogue no. 67/731 and 95/5327.

In the early 1860s the American writer Oliver Wendell Holmes, a great collector of stereoscopic photographs, developed a viewer which, as well as being easy to use and inexpensive to make, could be used to view stereoscopic images on all kinds of support, both opaque and transparent. In association with Joseph L. Bates, he perfected and marketed his invention ('History of the American Stereoscope' from The Philadelphia Photographer, 1869), initially in the United States and then worldwide, as the Holmes-Bates or American Stereoscope (in France it was more generally known as the 'stéréoscope méxicain').

It immediately became the ultimate in popular stereoscopic instruments and its popularity lasted a number of decades, especially in Europe where it was copied and improved and presented in a number of different versions: simple or richly decorated, in polished or varnished wood, with engraved or embossed metal, resin and inlaid lacquer.

The manufacture and sale of large numbers of these stereoscopes was promoted by the large-scale production of all kinds of series of stereoscopic cards (one of the most popular themes was that of the Great Exhibitions). These stereoscopes were sometimes used as publicity material and were also produced by the first Paris food-store chains – Damoy and Félix Potin – which became involved in the production of stereoscopic views.

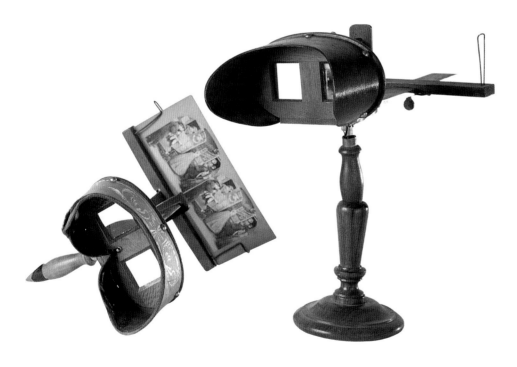

Anonymous, **The World Fair of 1855**
Reverse stereoscopic daguerreotype with black-painted border; mount 8.5 x 17.0 cm.

Coll. Musée Carnavalet, catalogue no. Ph 20122.

In the photograph, a sign for J. Defries & Son, London, is visible.

Marinier, **Crinoline descent into Hell**, before 1869
Stereoscopic albumen print. Inscriptions on reverse: on the right, copyright stamp in red ink, and '5156', in pencil; 'PICTURESQUE PHOTOGRAPH/MARNIER : PATENTED WITHOUT GOVERNMENT GUARANTEE/FAUBOURG ST MARTIN, 35', in French, stamped in blue ink; mount 8.0 x 17.6 cm.

Coll. Bibliothèque Nationale de France, catalogue no. EK5.

From 1860 the first *diableries* appeared – satirical stereoscopic tableaux composed with plaster figures of skeletons. These scenes were taken from everyday life or politics and were very popular at the time. Other images with little figures depicted scenes from plays, religious scenes or fairy tales. These photos, which were generally sold in sets, were often transparent and coloured, and were very much in demand because of their high quality and their spectacular three-dimensionality.

Pierre Adolphe Hennetier created the sculptures for this scene (his signature is visible on the image). He also worked on Marinier's theatre series *Actualités théâtrales*.

Charles Desavary, **Portrait of the painter Jean-Baptiste Camille Corot (1796–1875)**, c. 1871
Stereoscopic view, albumen print. Inscription in French on reverse: 'P. Stéréoscope/Ch. Savary (print 15)/. . ./1871', in pencil; mount 8.7 x 17.4 cm.

Coll. Bibliothèque Nationale de France, catalogue no. EK5.

At the World Fair of 1855 the Emperor bought a painting from Corot: *La Charrette, souvenir de Marcoussis*, which helped make him famous. Speaking of the painter, who was known for his generosity, the photographer Nadar evoked 'the fervent esteem he inspired in the entire younger generation'. His pupils were Pissaro, Morisot and Lépine.

Chronology 1830-1880

1832 *The principles of stereoscopy are first set out by the English physicist Charles Wheatstone.*

1838 *Wheatstone presents his research into stereoscopy and the mirror stereoscope to the Royal Society in London, on 21 June.*

1839 The invention of photography is officially announced: Louis Jacques Daguerre presents his 'daguerreotype' process to the Académie des Sciences in Paris. At around the same time, William Henry Fox Talbot and Hippolyte Bayard announce the invention of processes for photographs on paper.

1850 *The Englishman David Brewster travels to Paris to present his lenticular stereoscope to the optician Jules Louis Duboscq, who then begins manufacturing stereoscopes and stereoscopic images in France.*
Louis-Désiré Blanquart-Evrard develops a process for printing photographs on albumen paper (which will be the most widely used type of photograph for more than forty years to come).

1851 The first Great Exhibition is held in London; *stereoscopic photography is a great success.*
The first photographs are registered for copyright at the Bibliothèque Impériale (the future Bibliothèque Nationale) in Paris, on 6 September.
Construction begins on the new Halles market in Paris, in ironwork, designed by Victor Baltard, on 15 September.
Coup d'État by Louis Napoleon Bonaparte, President of the French Republic, on 2 December, to retain power; referendum approving the *coup d'État*.
The population of Paris (before the annexation of the outlying districts in 1860) is 1,053,261.

1852 *First patent for stereoscopy taken out by Duboscq for various stereoscope models and photographic methods. Publication of the first sales catalogue of stereoscopic images by the same inventor.*
Louis Napoleon Bonaparte moves into the Tuileries palace, the traditional royal residence; the inauguration takes place on 24 February amid lavish festivities.
Proclamation of the Second Empire (1852–70) on 2 December, the anniversary of the coronation of Napoleon I in 1804: Louis Napoleon Bonaparte becomes Napoleon III. Work begins on laying out the Bois de Boulogne, a new park on the western boundary of Paris.
Construction of the Cirque d'Hiver by Jacques Hittorff.
Opening of the Gare de l'Est with the Paris–Strasbourg line; new Gare Montparnasse. First department store in Paris: *Le Bon Marché*; other similar stores soon follow (*Grands Magasins du Louvre*, 1855; *Bazar de l'Hôtel de Ville*, 1856; *Printemps*, 1865; *Samaritaine*, 1871).

1853 *1,500 stereoscopes sold in Paris during the year. Alexandre Marie Quinet takes out the first patent for a stereoscopic camera with two lenses.*
The German Wilhelm Rollmann invents a system for viewing stereoscopic drawings using coloured filters.
Napoleon III marries Eugénie de Montijo, on 20 January at Notre-Dame.
Baron Georges Eugène Haussmann is appointed Prefect of the Seine, on 22 June; the major urban schemes he directs until 1870 are to transform Paris: wide boulevards and squares, open spaces, a sewage system.

1854 André Adolphe Eugéne Disdéri takes out a patent for the photographic 'carte de visite'.
Construction of the Avenue de l'Impératrice

(now Avenue Foch), stretching from the Arc de Triomphe to the Bois de Boulogne; it becomes a promenade for high society.
Opening of the first pavilions by Baltard in the new Halles (the entire market finally completed in 1874).
France and England declare war on Russia (Crimea), on 27 March.

1855 The first Great Exhibition in Paris attracts 5 million visitors between 15 May and 15 November.
Queen Victoria of England visits in August.
The fashion for crinolines is in full swing in Paris.

1856 *First French patent for a stereoscope designed as a free-standing viewer with a series of images that can be shown in succession; it is also the first patent for an application of stereoscopy in advertising.*
Baptism of the imperial prince at Notre-Dame.
The population of Paris stands at 1,174,346.

1857 *The number of patents for stereoscopy during the Second Empire peaks. The first stereoscopic photographs are registered for copyright in March by Fronty, and shortly afterwards by Marc Antoine Gaudin; by the end of the year the total is around 2,300 images, of which 448 are views of Paris.*
Lawsuit against Duboscq: he loses the monopoly he demanded on the stereoscopes that he patented.
Publication, in July, of the magazine Le Stéréoscope, journal des modes stéréoscopiques, offering its subscribers stereoscopic images and a stereoscope (until May 1859).
Opening of seven new avenues leading off from the Arc de Triomphe.
Gustave Flaubert, *Madame Bovary*, and Charles Baudelaire, *Les Fleurs du mal*: the two writers are prosecuted for immorality.
Inauguration of the new wings of the Louvre.

1858 *Joseph Charles d'Almeida presents two stereoscopic projection systems to the Académie des Sciences: one using coloured filters and the other alternating images.*
Mayer and Pierson, stereoscopic portrait of Napoleon III for his fiftieth birthday.
5 April, opening of the Boulevard de Sébastopol running north from Place du Châtelet to the Gare de l'Est.

1859 French intervention in Italy: victory against Austria (Magenta, Solferino). Return of the troops to Paris: 5,000 men parade through the city.
Restoration of the spire of Notre-Dame by Eugène Viollet-le-Duc.
The Absinthe Drinker by the painter Edouard Manet refused by the Salon.
Charles Darwin, *On the Origin of Species by Means of Natural Selection*.
Since 1852, 27,478 houses demolished in Paris for the major building programme of the Second Empire.

1860 *19.6% of the photographs copyrighted are stereoscopic views.*
The first diableries appear – satirical stereoscopic images composed with plaster figures of skeletons.
François Willème patents 'photosculpture' on 14 August.
The daguerreotype is almost obsolete, superseded by albumen prints.
The Fontaine Saint-Michel and the new Pont au Change bridge are inaugurated on 15 August.
Annexation of outlying districts including Montmartre, Belleville, Auteuil . . . and the establishment of twenty *arrondissements* in Paris.

1861 The population of newly expanded Paris is now 1,696,141.
Opening of the Boulevard Malesherbes.

1862 *François Willème opens a photosculpture studio at 42, Avenue de Wagram.*
Start of construction of the Opéra de Paris by Charles Garnier.
Opening of two new theatres, Place du Châtelet, built by Gabriel Davioud. Sarah Bernhardt makes her début at the Théâtre-Français (now the Comédie-Française).
Victor Hugo, *Les Misérables*.

1863 *Hippolyte Jouvin copyrights a series of around 200 stereoscopic images: Vues instantanées de Paris (instant views of Paris).*
Launch of photographer Félix Nadar's air balloon *Le Géant* from the Champ-de-Mars.
The first 'Salon des refusés' in Paris (the painters rejected by the official Salon): Manet causes a scandal with *Le Déjeuner sur l'herbe*.

1864 Opening of the new, enlarged Gare du Nord.
The right to strike is granted.

1865 Louis Pasteur embarks on his research into infectious diseases and demonstrates, later, that they are caused by micro-organisms.
Cholera epidemic at the end of the year killing more than 4,000 people in Paris.

1866 *François Willème opens a branch of his photosculpture studio in the Boulevard des Capucines.*
Jacques Offenbach, *La Vie parisienne*.
The population of Paris stands at 1,825,274.

1867 The second Great Exhibition in Paris attracts 11 million visitors; *Léon and Lévy market a series of more than 600 stereoscopic images of the event.*
Opening of the Buttes-Chaumont park, built over former quarries in one of the recently annexed districts in the north-east of Paris.
Opening of the abattoirs at Porte de la Villette.

1868 *40.1% of photographs copyrighted are stereoscopic images.* A colour photography process using three colours is patented by Louis Ducos du Hauron; Charles Cros develops a similar method shortly afterwards.
The 'vélocipède' (bicycle) becomes available in France.
Inauguration of the Église Saint-Augustin.

1870 France declares war on Prussia. Proclamation of the Republic on the initiative of Léon Gambetta, on the announcement of Napoleon III's capture and the capitulation of Sedan, on 4 September (3rd Republic, 1870–1940). Many die during the Siege of Paris.
Emmanuel Arago, appointed mayor of Paris, is replaced two months later by Jules Ferry.
First 'pigeongrammes' (microscopic photographs transported by carrier pigeons).

1871 Capitulation of Paris on 28 January, and Prussian soldiers parade through the capital on 1 March.
The Paris Commune begins on 18 March and ends on 28 May. Adolphe Thiers' government, which is installed at Versailles, crushes the Commune during the 'Bloody Week' of 21 to 28 May, leaving several thousand dead. On 23 May, the Communards burn down public monuments (Tuileries palace, Hôtel de Ville, Cour des comptes, Quai d'Orsay, Palais de justice, Légion d'honneur . . .).
The Treaty of Frankfurt (forcing France to hand over Alsace-Lorraine).
Thiers becomes President on 31 August.

1872 *Charles Gaudin, one of the leading Paris publishers of stereoscopic images, goes bankrupt.*
Sir Richard Wallace gives Paris new free fountains.

1873 *First French patent for a 'stereographoscope', a device that combines a stereoscope and a large magnifying lens for all sorts of images.*
The Gaîté-Lyrique theatre becomes, under the directorship of Offenbach, a major venue for comic opera and, later, operetta. Thiers resigns; Marshal MacMahon is elected President.

1874 First Impressionist exhibition in the studio of the photographer Nadar – 35, Boulevard des Capucines. In the following years, they were often to paint the changes in the capital.
Rebuilding of the Vendôme column, destroyed by the Commune.
Child labour law (not under the age of 12 and no more than 12 hours a day).

1875 Inauguration of the Opéra de Paris (under construction since 1862).

1876 Emile Zola, *Le Ventre de Paris*, depicts the Halles market.
Auguste Renoir, *Le Bal du Moulin de la Galette*.

1877 Opening of the Avenue de l'Opéra.
Construction begins on the basilica of the Sacré-Cœur in Montmartre.
Series of paintings of the Gare Saint-Lazare by Claude Monet.
Gustave Caillebotte, *Le Boulevard sous la pluie*. Invention of the phonograph by the American, Thomas Edison.

1878 The third Great Exhibition in Paris attracts 16 million visitors.
First attempt at electric street lighting, Place and Avenue de l'Opéra.
The architect Gabriel Davioud builds the first 'Trocadéro' on the Chaillot hill.

1879 Preliminary work on installing a telephone network in France (following the invention of this device three years earlier by the American Alexander Graham Bell).
Jules Grévy is elected President of France.

2

New ways of creating
3-D images 1880-1940

STEREO CLUB FRANÇAIS

Fondé à Paris en 1903

BULLETIN PHOTOGRAPHIQUE

consacré à la STEREOSCOPIE

Siège Social
Paris
9 Rue Bergère (9ᵉ Arrᵗ)

G.D

Amateur stereoscopic photography: the example of the Stéréo-Club Français

Clément Chéroux

Cover of a book for enthusiasts, 1894
F. Drouin, *Le stéréoscope et la photographie
stéréoscopique.*

Coll. Société Française de Photographie, catalogue no. 856.

Beginning in the 1890s, as more and more enthusiasts
took up stereoscopic photography, a great many books
of this kind were published, combining practical advice with
a history of the technique.

Emile Cagneux, **Benjamin Lihou, founder of the
Stéréo-Club Français, on a trip to Mantes**, 1909
Stereoscopic image published in the supplement of the
Bulletin du Stéréo-Club français, no. 49, January 1910.

Coll. Société Française de Photographie.

Anonymous, **Cover of the Bulletin du Stéréo-Club
français, no. 1**, March 1904

Coll. Stéréo-Club Français.

In the late nineteenth century the world of photography underwent a dramatic
transformation. The introduction of the gelatin-silver bromide process in the 1880s
unleashed a long chain of further developments, helping to bring about lasting changes
in photographic techniques, practices and subjects.[1] One of the consequences of
these developments was a dramatic rise in amateur photography. Simpler methods and
lower costs meant that photography was no longer the exclusive domain of a privileged
few, but a pastime accessible to the majority. Based on the production figures of the
leading photographic plate manufacturers, it is estimated that nearly one million
negatives were being produced worldwide each day around the turn of the century.[2]
During the same period, according to trade and industry figures, the number of amateur
photographers in France was estimated at between 250,000 and 300,000: already
a considerable number.[3]

However, this sharp increase in the number of photographers does not mean that
all the operational difficulties had been ironed out. Although photography had been
simplified, it was still a tricky procedure for beginners. 'Væ solis. Misfortune to those
who work alone,'[4] wrote Albert Londe in 1893. Certainly this expression applied perfectly
to novice photographers. In the early days of the gelatin-silver bromide process, working
unaccompanied on photography was a recipe for disaster. It was in a beginner's best
interest to join forces with other, more seasoned amateurs, in order to avoid the
inevitable initial difficulties, uncertainty in the choice of cameras or materials, costly
experiments, and mistakes in handling equipment. Working with them offered the benefit
of sensible advice and the answers to all a beginner's questions. Again, in the words
of Albert Londe, 'Join together, combine forces'.[5]

The development of amateur photography was therefore accompanied by an
increase in the number of photographic groups, as individual photographers banded
together to create societies of enthusiasts. In the 1880s the hegemony of the Société
Française de Photographie (SFP) was challenged by the creation of a number of other
associations. From the 1890s there was such a proliferation of photographic clubs and
associations that it becomes difficult to draw up an exhaustive list. In 1892 there were
a total of thirty-eight photographic societies in France (eight of them in Paris[6]). By 1900
this number had reached fifty,[7] rising to 120 by the year 1907.[8] Photography was so
popular that some of the Parisian department stores even started their own staff
photography clubs – *La Samaritaine, La Belle Jardinière and the Galeries Lafayette*,
for example.[9] It was during this period of intensive activity that the Stéréo-Club Français
(SCF) was born.

The photographic societies founded at this time all seem to have their own specialist
agenda: picture-swapping for the Photo-Postal-Club Français, cycling for the Photo-
Vélo-Club de Paris and, of course, stereoscopic photography for the Stéréo-Club.
Despite the diversity of their specialist interests, all these associations operated along
similar lines. As the Stéréo-Club was no exception to this rule, it presents a fairly
accurate picture of what photographic societies were like in the early twentieth century.

Most of these associations were formed on the initiative of a group of enthusiasts
for a particular type of photography that was not specifically catered for by the Société
Française de Photographie or by other groups. This was the case with the Stéréo-Club,
which was founded by Benjamin Lihou in 1903 with this observation: ' . . . no

108

specialist society or magazine for stereoscopy. No link between the amateurs who are devoted to the pleasures of this highly attractive application of photography'.[10] Initially the society had its headquarters at 9, Rue Bergère in Paris. Later, in October 1905, it moved into the headquarters of the SFP at 51, Rue de Clichy. It was here for nearly half a century that the Stéréo-Club held its social events in 'the most perfect bonhomie and amicability'[11].

As with other photographic societies, the club's principal activities were publishing a newsletter and organizing excursions and competitions. The competitions, a vehicle for friendly rivalry and emulation, seem to have made a crucial contribution to the society's vitality and the motivation of its members.[12] The directors of the Stéréo-Club were well aware of this and made sure that they held regular competitions for their members on diverse, if clichéd, themes: sunsets, craftsmen, beggars, etc.

Excursions within the Paris region were another type of activity combining technical competitiveness and sociability. They were generally prepared in minute detail: an excursion leader examined the selected location in advance, identified interesting subjects, applied for permits and booked a table at a local inn for lunch. This ensured that the photographers were free to hunt out their perfect viewpoint and wait for the right moment, coming back at the end of the day with their bag full of negatives.

These six to eight excursions each year were reported in the society's newsletter, in accounts that were romanticized, humorous – and sometimes even in verse. The newsletter, which provided an effective link between the society and its members, also published the club's annual reports, the minutes of meetings, details of forthcoming events, and the list of members, as well as advertisements and the inevitable small ads for buying or selling equipment. However, a large part of it was given over to technical information, through in-depth articles, test reports, technical instructions and advice. 'It reflects the original work of the society's members on the one hand, and their social activities on the other. These are the historical annals of the Stéréo-Club Français,'[13] wrote Benjamin Lihou.

Paradoxically, although the leaders of the Stéréo-Club Français were probably unaware of the irony, the first picture published in the first issue of the newsletter was entitled 'An Arrest'. To start with an arrest was perhaps not the best of auspices for the new enterprise – indeed it was arguably tantamount to predicting a swift end to its activities. Yet in fact things turned out quite differently: neither the historical events of the twentieth century nor the many radical changes in the world of photography itself were able to undermine the vitality of the group, which is still in existence today, with more than 600 members. The Stéréo-Club is the only one of the photographic societies created at the turn of the century that is still active.

The crisis, which affected all photographic societies in the years 1907–08, seems to have had a less severe impact on the Stéréo-Club: according to Benjamin Lihou, it profited more than others from the popularity of the Lumière brothers' Autochrome process, which added the benefits of the three-colour process to the stereoscopic relief effect.[14] In 1909 the Stéréo-Club also survived the death of its founder and most ardent champion, Benjamin Lihou. Its activities came to a halt in 1914 with the outbreak of war, but resumed in 1916 with a few excursions and the reappearance of the newsletter. In the issue of October–December 1916, a letter was published from a soldier on the Vosges front, recording his pleasure at receiving it: '[it] reminded me of the times when we were at leisure to devote ourselves to the pleasures of photography and to seeing each other at our monthly meetings. How far away that is now'.[15] World War II had a much more disastrous effect on the club. Its activities came to a complete standstill and it was not until 1947 that a slim newsletter reappeared, consisting of just a dozen or so mimeographed pages.[16] Nonetheless, the club's activities did resume their former course, following the established rhythm of its regular events. The post-war period was marked by two major developments: the introduction of Kodachrome in the late 1940s, and then the use of polarized light for projections in the 1950s.[17] The combination of these two innovations offered viewers of projections a three-dimensional effect that was better than anything they had previously experienced, and the number of meetings increased,[18] foreshadowing the enormous popularity of slide shows in the 1960s and 1970s. Today the club members' interests, which have always kept abreast of the very latest technical developments, include the computer-assisted creation of virtual 3-D images, as demonstrated by the large number of articles on this subject in the newsletter.

Boxes of stereoscopic glass plates, early twentieth century

Coll. Musée Carnavalet.

Anonymous, **'An arrest'**, 1904
Stereoscopic image published in the *Bulletin du Stéréo-Club français*, no. 1, March 1904. Inscription in French beneath the image: 'Taken with the 'Physiographe' camera'.
Coll. Société Française de Photographie.

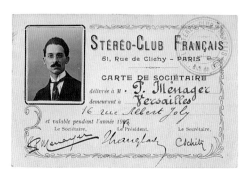

Stéréo-Club Français membership card

Coll. Emmanuelle Michaud.

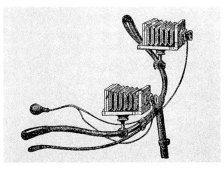

Engravings from various magazines,
1890–1910

Coll. Société Française de Photographie.

With the exception of the two World Wars, the club's activities have remained substantially the same throughout the twentieth century. Now, as in the past, members receive a monthly newsletter, meet monthly and hold technical workshops, projection evenings and a few excursions, with motivation levels as high as they ever were. In this respect the Stéréo-Club provides an extraordinary 'case study' for understanding, from today's perspective, the driving forces behind amateur photography and the formation of photographic groups at the start of the century.

How can we explain its longevity? Because of the very nature of the process involved, stereoscopy demands a high level of technical involvement. Amateur stereoscopic photographers are, therefore, by their nature particularly inclined towards technical matters. In most cases this technical bias was probably the basis for their interest in the club: the various activities (projections, excursions, newsletter, etc.) were really just vehicles for channelling and pursuing what was primarily a technical passion. This is evidenced by the very small amount of space allotted to aesthetic, historical and theoretical issues in the pages of the newsletter, which is more or less entirely given over to technical matters. So many other societies representing the reverse position have now disappeared that it seems justified to attribute the longevity of the Stéréo-Club to this strong technological bias. Over time, the driving preoccupations of other societies became irrelevant, outdated or entirely obsolete. Similarly, the goals and aspirations that had prompted the creation of some organizations were fulfilled in time, rendering their very existence superfluous. By contrast, the technical motivation that prompted the foundation of the Stéréo-Club has hardly changed at all. The technology may have developed but its aims have remained the same: the goal has always been to reproduce an impression of relief. In short, it is because this goal has remained unchanged that the Stéréo-Club Français has survived: constant in its goal and unyielding in its purpose.

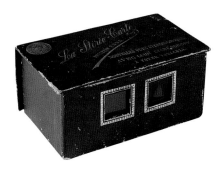

The 'Stéréo-Carte' Stereoscope, 1900–10
Cardboard stereoscope for postcards. Inscription in French: 'The 'Stéréo-Carte'/Patented without government guarantee/New stereoscopic views/complete with variable-focus/stereoscope'; 8.0 x 17.2 x 10.7 cm.

Coll. Musée Carnavalet, catalogue no. Ph 14524.

Stereoscopic postcards became increasingly popular in the early twentieth century. They were distributed by various specialist publishing houses like Léon & Lévy (L.L.) or Julien Damoy.

The author wishes to thank the following for their valuable advice: Denis Pellerin, Marcel Durkheim, Rolland Duchesne and Georges Mougeot.

1. Cf. André Gunthert, *La Conquête de l'instantané. Archéologie de l'imaginaire photographique en France*, 1841–1895, PhD thesis at the École des Hautes Études en Sciences Sociales, Paris, 1999.
2. Figure quoted by E. Mouchelet, 'Les sociétés de photographie', *Photo-Gazette*, 1904, p. 160.
3. Figure quoted by Louis Gastine, 'L'œuvre des sociétés photographiques françaises', *La Photographie française*, 1902, p. 232.
4. Albert Londe, 'Du rôle de l'amateur de photographie au point de vue artistique et scientifique', *Bulletin du Photo-Club de Paris*, 1893, p. 57.
5. *Ibid.*
6. Figure quoted by anonymous author, 'Union nationale des sociétés photographiques de France. Statut', *Bulletin de la Société française de photographie*, 1892, p. 300.
7. Figure quoted by Louis Gastine, article quoted above, p. 231.
8. Figure quoted by Charles Gravier, 'Les sociétés photographiques françaises', *Le Moniteur de la photographie*, 1907, p. 31.
9. Cf. Charles Gravier, 'Les sociétés photographiques', *Le Moniteur de la photographie*, Paris, 1905, pp. 140–41; and anon., 'Nouvelles et informations', *La Revue de photographie*, 1906, p. 94.
10. Benjamin Lihou, 'A nos lecteurs', *Bulletin du Stéréo-Club français*, 1904, p. 2.
11. L. D., 'Lettre ouverte à M. Lihou, président du SCF', *Bulletin du Stéréo-Club français*, 1908, p. 99.
12. André Desmottes (in 'Les débuts du Stéréo-Club', *Bulletin du Stéréo-Club français*, 1994, p. 15) notes that at the end of 1906 the Stéréo-Club Français had 228 members (including five women) located as follows: Paris region: 115 members; the rest of France (including Algeria): 87 members; overseas: 26 members.
13. Benjamin Lihou, 'A nos amis, à nos lecteurs', *Bulletin du Stéréo-Club français*, 1907, p. 2.
14. Cf. Benjamin Lihou, 'Rapport sur l'année 1908', *Bulletin du Stéréo-Club français*, 1909, p. 66.
15. *Bulletin du Stéréo-Club français*, 1916, special edition no. 2, p. 15.
16. The decline of the SFP, which led to the sale of its headquarters in Rue de Clichy, deprived the club of its base for holding meetings and projection evenings. Since then it has changed location frequently, unable to find suitable premises for a permanent base. Current address: 7 bis, rue de la Bienfaisance, 75008 Paris.
17. Cf. Jean Soulas, '45 ans de club', *Bulletin du Stéréo-Club français*, 1994, p. 20.
18. André Desmottes (article quoted above, pp. 15–16) notes that, paradoxically, right up to the 1950s, monocular projections were not considered inappropriate at the Stéréo-Club. In Desmottes's view, the club seems to have disregarded 3D projection techniques for reasons of visual comfort, even though such techniques did exist and were regularly discussed in the newsletter.

110

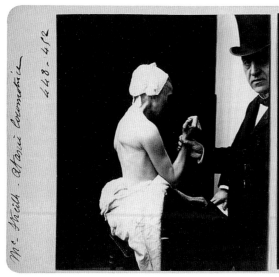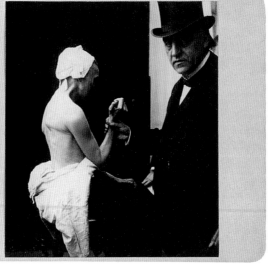

Anonymous, **Doctor Jean Martin Charcot
(1825–93) with a female patient**, c. 1875
Stereoscopic view, albumen print. Inscription
in French: 'Mme Steith, locomotor
ataxia/448–452'; mount 8.7 x 17.8 cm.

Coll. Musée de l'Hôpital Saint-Louis.

Charcot, founder of the neurological school
at the Salpêtrière Hospital, devoted himself to
distinguishing between hysterical convulsions
and epileptic fits. Freud was his student for
six months in 1885 and was greatly
influenced by his work. Charcot took
numerous photographs of his patients.

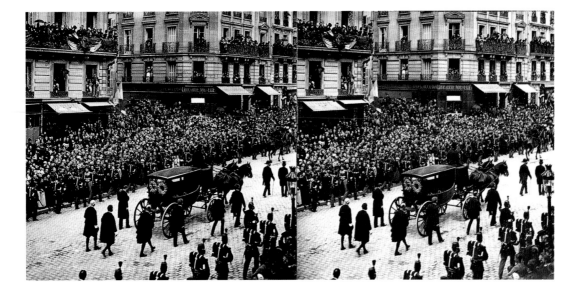

Anonymous, **The funeral of Victor Hugo
(1802–85), Rue Soufflot**, 1 June 1885
Stereoscopic view, gelatin silver on glass.
Inscription: series number '9240';
mount 8.4 x 17.0 cm.

Coll. Maison Victor Hugo, catalogue no. Ph 2695.

By the end of his life, the French poet Victor
Hugo had come to embody all the aspirations
and contradictions of the French people,
having been an anticlerical and a spiritualist,
a one-time monarchist then a republican,
a supporter of Napoleon I and an adversary
of Napoleon III, an opponent of the Paris
Commune and a champion of the
Communards. The French government
organized a state funeral to pay homage to
a man universally recognized as a genius.
At 11.30 a.m. the funeral procession left the
Arc de Triomphe, which had been converted
into a mortuary chapel the night before,
arriving at 7 p.m. at the Panthéon, a church
that was resecularized for this burial. Charles
Garnier, architect of the Paris Opéra,
designed the catafalque at the Arc de
Triomphe and Saint-Saëns conducted the
funerary hymns. The country had never before
witnessed a national funeral of this size.
 People paid a small fortune to rent the
balconies along the route taken by the
procession and a crowd of around one million
people gathered in the streets to catch a
glimpse of the funeral cortège.

112

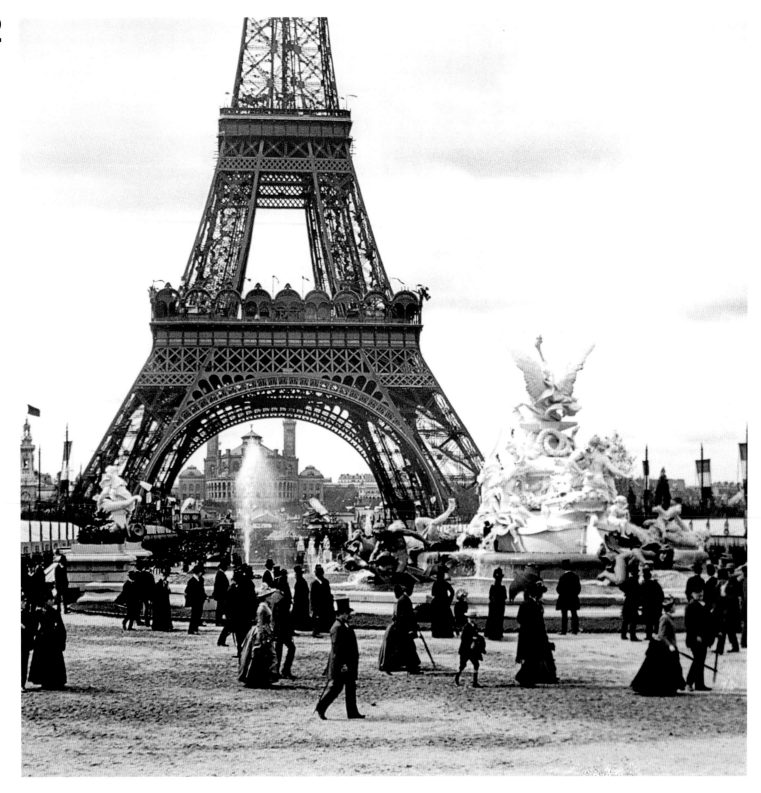

The Great Exhibition of 1889

The Great Exhibition of 1889 was held on the Champ-de-Mars and along the Left Bank of the Seine as far as the esplanade of Les Invalides. There were two main attractions: the Galerie des Machines, a hall forty-five metres high and 420 metres long, and the '300-metre Tower', also known as the 'Tour Eiffel'. The first building, which housed representatives from the industrial sector, held the world record for the span of its vaulted roof. The Eiffel Tower, built in twenty-seven months by the engineer Gustave Eiffel, was originally destined for demolition, its only real purpose being to highlight the technical expertise of modern builders. Between the Champ-de-Mars and Les Invalides, in the Rue de Caire, visitors could also admire the reconstruction of a medina which the organizers, keen to preserve an air of realism, peopled with 150 natives who were instructed to mimic their everyday activities. This event provided a forum for 62,000 exhibitors and attracted more than 32,000,000 visitors. Absentees of note included members of the European monarchies, who refused to celebrate the Republic exactly 100 years after the French Revolution.

Anonymous, **The Eiffel Tower on the first day of the Great Exhibition**, 6 May 1889
Stereoscopic view, gelatin silver on glass. Inscription: series number '15017'; mount 8.4 x 17.2 cm.

Coll. Cinémathèque Française, Collection des Appareils.

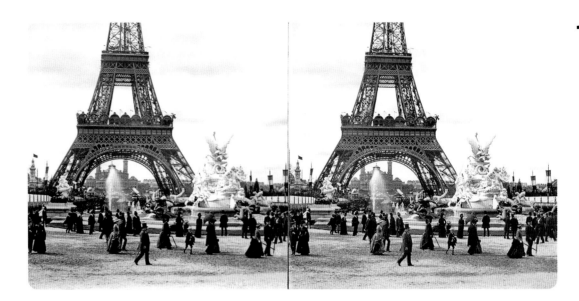

Great Exhibition of 1900

The number of visitors to the Great Exhibitions soared as they became increasingly popular. There were no longer enough boats to accommodate the visitors flocking to the exhibition from all over the world. A one-track electric railway and a two-speed moving walkway were built to improve the flow of people. However, the major innovation of this exhibition was the Paris metro; ten kilometres of track were opened for the occasion between Porte de Vincennes and Porte Maillot. The Great Exhibition of 1900 nevertheless confirmed the waning popularity of technological attractions in favour of spectacular and exotic sights. As well as occupying the same sites as the previous one, the Exhibition also extended along the Right Bank between the Cours-la-Reine and the Chaillot hill and covered certain areas used for the 1855 exhibition. 83,000 exhibitors welcomed 48,000,000 people. The Great Exhibition of 1900 was a resounding success, having entertained ten times as many visitors as the very first Great Exhibition held in Paris. The Grand Palais and the Petit Palais, which stand at the foot of the Champs-Élysées, are permanent reminders of this great event.

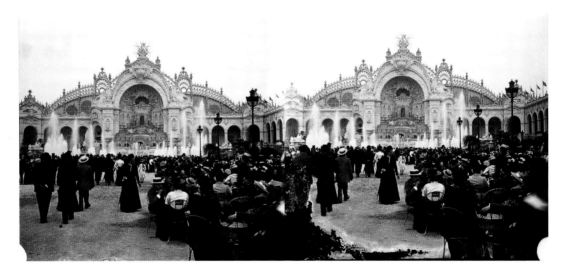

Lucien Cresson, **The Champ-de-Mars during the Great Exhibition of 1900: the Château d'Eau and the Palais de l'Électricité**
Stereoscopic view, modern print from a gelatin silver negative on glass; plate 8.9 x 17.9 cm.

Coll. Musée Carnavalet, catalogue no. Ph 2437/25.

In the evenings, the coloured illumination of water jets from the Château d'Eau proved extremely popular with visitors to the Exhibition.

114

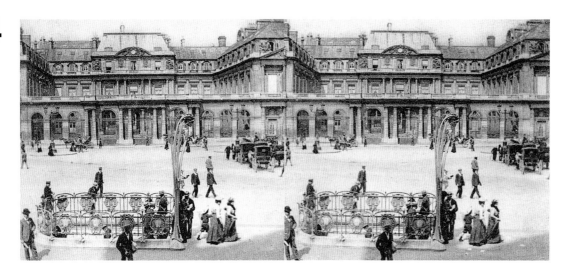

Léon & Lévy, **The Place du Palais Royal**, 1900–10
Stereoscopic postcard. Inscription: '17 Paris. – La Place du Palais Royal. – L.L.'; 8.9 x 13.7 cm.

Coll. Musée Carnavalet, catalogue no. Ph 14524/17.

The first metro line was opened on 19 July 1900, during the Great Exhibition, by President Loubet. The station entrances, like that of the Palais Royal station, were designed by architect Hector Guimard (1867–1942) in Art-Nouveau style.

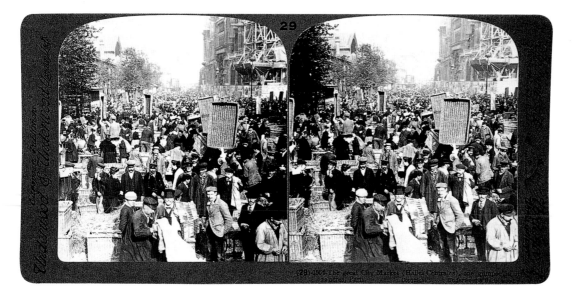

Underwood & Underwood, **The Halles Centrales**, c. 1900
Stereoscopic view, gelatin silver print; mount 8.8 x 17.8 cm.

Gernsheim Collection, Harry Ranson Humanities Research Center, University of Texas at Austin.

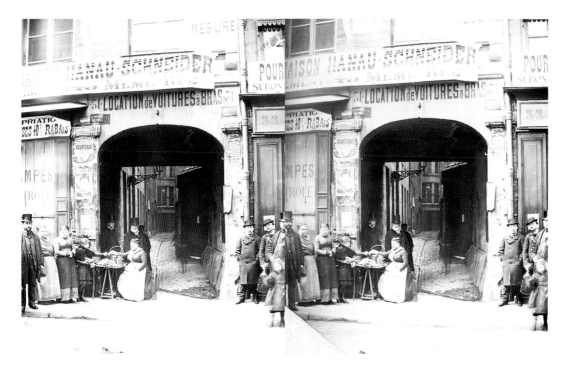

Henri Godefroy, **The Passage de la Bouteille, Rue Montorgeuil**, 1890–1900
Pseudoscopic view, gelatin chloride print; images 11.2 x 17 cm.

Coll. Musée Carnavalet, catalogue no. Ph 9548.

The original image is pseudoscopic, but has been reproduced here in stereo.

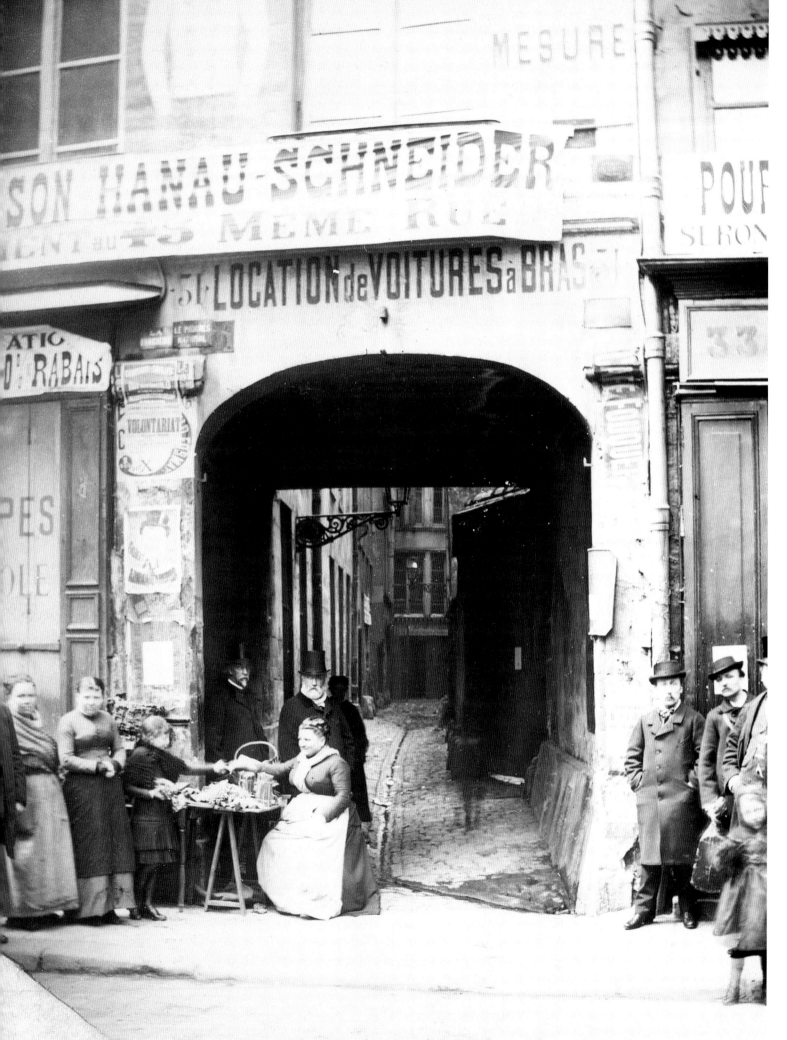

116 Jacques Henri Lartigue (1894-1986)

In 1902 Lartigue's father lent him a 'Spido-Gaumont' stereoscopic camera which used 6 x 13 cm glass plates. The boy carefully collected the views he took with their captions in a school notebook, creating an accurate and evocative account of his world. Between 1902 and 1928, as well as some 100 autochrome plates, Lartigue took nearly 5,000 stereoscopic photos, about 1,000 of which exist as positives on glass. In 1912 he began using a Knapp Nettel 6 x 13 stereoscopic camera, which also enabled him to take panoramic views. His discovery of this format gradually led him to abandon stereoscopy.

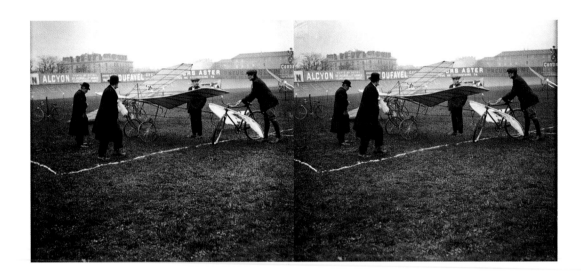

Jacques-Henri Lartigue, **The second light aircraft competition at the Parc des Princes aerodrome**, 24 November 1912 Stereoscopic view, gelatin silver on glass; plate 6 x 13 cm.

Coll. Les Amis de J. H. Lartigue, catalogue no. 1912–029LRT294 W.

The author wrote in his diary: '24 November. Paris. Sunday. Rose early at 7 a.m. to go to Mass quickly and then out to the Parc des Princes aerodrome to see the "light aircraft" competition […] I entered the airfield. As well as the inventors and photographers, there were several film studios: "Pathé-journal", "Gaumont", "Eclair". A light aircraft is a bicycle with wings with which one endeavours, without a motor, without wind, without launching oneself into the air, without having the contraption drawn by an automobile, "to fly like a bird", by one's own efforts alone! This year, like last year, there was no winner, since no one managed to get off the ground. Nevertheless, the judges laid flat on their stomachs to see if both wheels left the ground at the same time.'

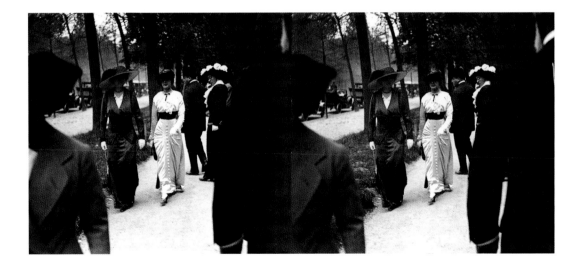

Jacques-Henri Lartigue, **On the Sentier de la Vertu, Bois de Boulogne**, 31 May 1912 Stereoscopic view, gelatin silver on glass; plate 6 x 13 cm.

Coll. Les Amis de J. H. Lartigue, catalogue no. 1912–144LRT2791 W.

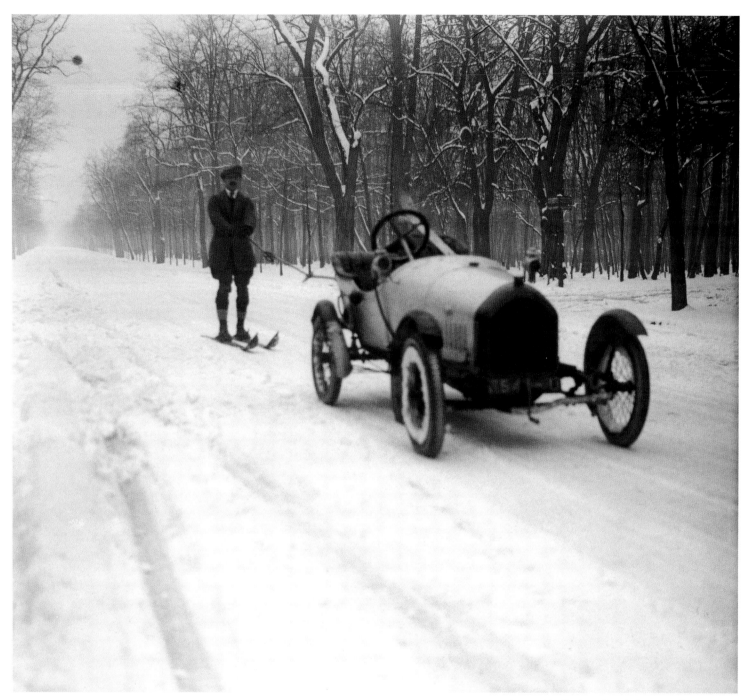

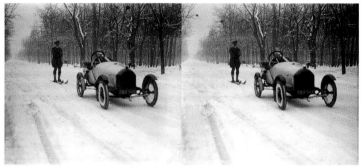

Jacques-Henri Lartigue, **Francis Pigueron, skating champion, in the Bois de Boulogne**, February 1916
Stereoscopic view, gelatin silver on glass; plate 6 x 13 cm.

Coll. Les Amis de J. H. Lartigue, catalogue no. 1916–010LRT4567 W.

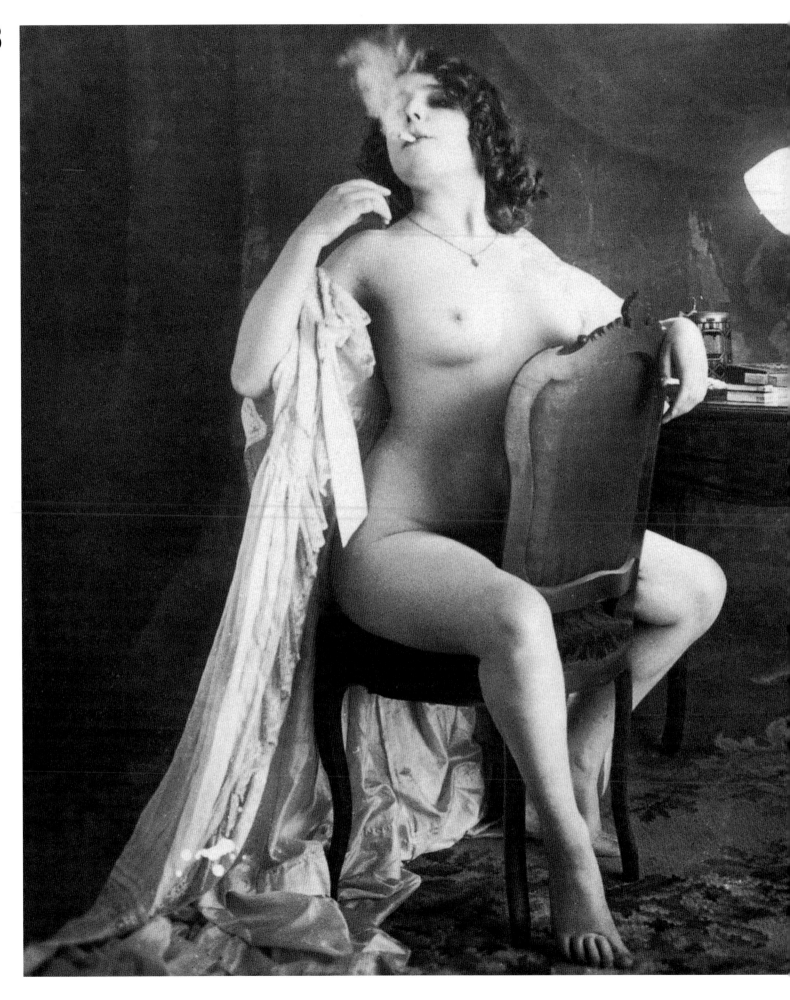

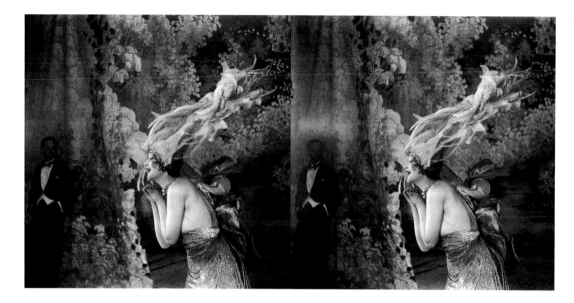

Jacques-Henri Lartigue, **Gaby Deslys (1881–1920)
at the Casino de Paris, during the shooting of the
film _Bouclette_**, February 1918
Stereoscopic view, gelatin silver on glass; plate 6 x 13 cm.

*Coll. Les Amis de J. H. Lartigue, catalogue
no. 1918–001LRT403 W.*

Gabriella Caire, alias Gaby Deslys, was a singer and
chorus-line leader. After a triumphant reception in New York,
she returned to France and rejuvenated the music-hall
genre by introducing American rhythms. She invented a
new style – be-feathered stars performing on huge
staircases – which was to be adopted by Mistinguett. In this
photo, she is playing the lead in the film by Mercantou and
Hervil, an adaptation of Marcel L'Herbier's *L'Ange de Minuit*.

The Mattey stereoscopic viewer

Device for viewing stereoscopic images
c. 1900
A. Mattey, manufacturer, Paris
Polished walnut
50 x 25 x 25 cm
Unidentified lenses
Chain-driven mechanism

*Coll. Musée Français de la Photographie, Bièvres, catalogue
no. 88/6809.*

The first stereoscopes, whose mechanism comprised
a chain turning on an axis and holding a sequence of
twelve stereoscopic plates, made their appearance in 1857.
Increasingly sophisticated versions of this type of viewing
device were soon manufactured, sometimes holding as
many as 200 views.

　　The stereoscopic viewer was not just a simple device
for looking at photographs, but also a genuine decorative
object which enjoyed pride of place in drawing rooms.
Walnut, oak, mahogany, ebonized pear wood, ebony, ivory
or mother of pearl marquetry, Chinese lacquer inlaid with
bronze . . . or pokerwork floral motifs as in the model
featured here: the full range of cabinetmaking techniques
could be used.　**Jacques Périn**

Anonymous, **Woman smoking a cigarette**, 1910–20
Stereoscopic view, gelatin silver print. Inscription: 'STL'
and '757' on the right-hand image; mount 8 x 17 cm.

Coll. Pierre-Marc Richard.

N.° 4594 — Jeanne qui rit
et Jeanne qui pleure.
Image composite à
examiner successivement
à travers des écrans rouge
et bleu verdâtre.

The anaglyph, a new form of stereoscopy

Denis Pellerin

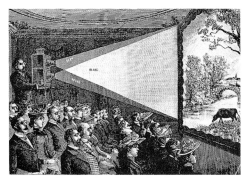

Anaglyphic projection by Alfred Molteni, 1890
Illustration in G. Mareschal, 'Projections stéréoscopiques',
La Nature, no. 917, 27 December 1890, p. 49.

Léon Gimpel, **Jeanne laughing and Jeanne crying**,
before 1924
Composite image on an autochrome plate. Inscribed in
French by the photographer: 'No. 4594 – Jeanne
laughing/and Jeanne crying./Composite image to be/viewed
successively/through red/and blue-green filters'; mount
9 x 12 cm.

*Coll. Société Française de Photographie, catalogue
no. 806A958.*

Gimpel said that this image was 'designed to make it
possible for people to understand the phenomenon of the
absorption of colours by complementary colours, on which
the anaglyph principle is based. This photograph [...] should
be viewed not with the two eyepieces of the glasses used
simultaneously, but one after the other (using only one eye).'
(Gimpel's journal, p. 131).

In an article published in the French periodical *La Lumière*, in November 1851, the Parisian chemist Marc Antoine Gaudin (1804–1880) made reference to the short-lived project whereby the optician Jules Duboscq aimed to 'produce three-dimensional images on a backdrop using the megascope'.[1] Gaudin later had the idea of doing away with the stereoscope and producing 'daguerreotypes, which give the maximum three-dimensional effect, and projecting them onto a backdrop, enlarged and in colour, with a view to offering a marvellous spectacle to an entire audience'.[2] To this end, he placed a diaphragm pierced by two small apertures in front of a large-diameter objective, with the distance between the apertures equal to the average interpupillary distance. The image obtained would automatically be stereoscopic 'since it [would] result from the superimposition of two images seen from different angles'.[3] Research into the viewing of stereoscopic images on a screen continued and two processes had soon been developed by the inventors: alternate vision[4] and separation by complementary colours. The difficulties of implementing the first method soon gave the advantage to the second, which became known as the 'anaglyphic' process.

In 1853 the German mathematician Wilhelm Rollmann[5] (1821–after 1890) presented stereoscopic drawings in yellow and blue, observed through blue and red lenses,[6] based on the principle that certain colours are invisible when seen through a filter of a given colour. In France, the principle of coloured filters was first used by Joseph Charles d'Almeida in 1858.[7] Using two projectors fitted with red and green filters, he superposed photographic stereographs on a screen, while each member of the audience was given one red and one green filter. 'With a stereoscope, each person has to look in turn,' wrote d'Almeida. 'I set out to produce an arrangement whereby [...] the three-dimensional images could be seen from various points in the room.'[8] Although it is not known whether d'Almeida continued to develop this process,[9] it is certain that, in 1890, the Parisian optician Alfred Molteni (1837–1907) was renowned for his anaglyphic projections and attributed their invention to d'Almeida.[10]

On 15 September 1891 the French inventor Louis Ducos du Hauron (1837–1920) submitted a patent for 'prints, photographs and stereoscopic images that produce their effect in daylight without the use of the stereoscope'.[11] The process, which he called the 'anaglyph', involved the superimposition on paper (and not the projection) of the images of a stereoscopic pair in red and blue. According to Ducos du Hauron, this not only made it possible to 'provide illustrated publications with more attractive material' but also, unlike stereoscopic prints, to increase the size of the images as desired.[12] For Ducos du Hauron, the anaglyph was not merely a source of entertainment, it was also a scientific instrument. He agreed to give up the rights on his patent for any attempt 'which aimed to print and publish an anaglyphic image of the moon suspended in space'.[13] Ducos du Hauron's invention was not marketed immediately. It is possible that technical difficulties[14] may have delayed its manufacture, since the process was not widely used in France until the 1920s.

The autochrome – a process of colour photography marketed in 1907 – was indirectly responsible for the renewed interest in anaglyphs. In his memoirs[15], the Parisian photographer Léon Gimpel (1878–1948), who described the invention of the autochrome as the 'eighth wonder of the world', tells how he produced his first anaglyphic trials 'directly from nature' on autochrome plates with a traditional monocular

122

camera. The first image was taken by placing a green filter in front of the lens. Then the camera was offset to the left and a second image taken on the same plate using a red instead of a green filter. In 1919 Gimpel also had the idea of transforming standard stereographs into anaglyphs by rephotographing them onto autochrome plates through coloured filters.

In 1923, with the help of his friend Emile Touchet, secretary of the French Astronomic Society, Gimpel found in the society's archives two prints of the moon taken at the Paris Observatory in 1902 and 1904. When viewed stereoscopically, these prints created a three-dimensional effect. After countless difficulties (sixty-six days' work and ninety-seven autochrome plates), Gimpel finally managed to convert the two images into an anaglyphic print. When it was shown in the offices of the French weekly *L'Illustration*, the image – which represented the achievement of the aim stated by Ducos du Hauron twenty years earlier – aroused great enthusiasm among the editorial staff who decided to publish it. Following extensive publicity coverage in the issues of 12 and 19 January 1924, the anaglyph of the moon appeared the following week (26 January), accompanied by an explanatory text, a pair of spectacles with different coloured lenses and eleven more anaglyphic prints. It was hugely successful: 'newsagents [...] were overwhelmed by the demand' and, outside the offices of *L'Illustration* in the Rue Saint-Georges, 'the police had to be called in to control the crowd and ensure that they formed an orderly queue'.[16] Although the magazine printed 80,000 additional copies, this still did not meet the overwhelming demand among its readers. On 28 June 1924 *L'Illustration* published another series of eight anaglyphs devoted entirely to Paris.[17] This was followed, on 24 January 1925, by a third and final series of nine views of the regions and monuments of France.[18] The other French publications could not ignore such a popular success and suddenly they all wanted to publish anaglyphs.[19]

According to Gimpel, advertising 'was the first [sector] to take advantage of the popularization and development of anaglyphs'.[20] The first advertisement to use an anaglyph in Paris appears to date from April 1924. It was an image entitled 'an amazing anaglyph' and showed furniture and other items in the department store of Kirby, Beard & Cie., 5, Rue Auber in Paris.[21] Other companies soon followed suit. For 1924, Gimpel cites the Apollo razor, Léon Voir polish, the funeral industry, Peugeot (a catalogue of nine anaglyphs for the Salon de l'Automobile at the Grand Palais) and Salf overcoats.[22] In 1925, Gimpel produced a publicity brochure for Rivoire & Carret pasta. From 1931, the pharmaceutical industry (Laboratoires Bottu and Laboratoires Midy) appears to have been particularly interested in this type of publicity and, from 1931, used a great many topographical, medical, museological and erotic images. Even the spectacles were used as a publicity medium by many companies.[23]

During the 1930s, albums of anaglyphic images of Paris were published: *Zoo de Paris* (two volumes), *Paris* (two volumes), *Musée de l'Homme* and *La Sculpture au musée du Louvre*. The first anaglyphic comic book, *Mighty Mouse*, was published in the United States in 1953. Although it gave rise to a lucrative industry, it was mainly limited to the American market.

The fashion for printed anaglyphs encouraged further research into projected images. At the time of the work carried out by Ducos du Hauron, Alfred Molteni organized demonstrations of the process. However, Léon Gimpel and Emile Touchet found the existing systems impractical and, in 1924, developed an anaglyphic projector[24] for stereoscopic views. The device was marketed by the Gaumont company, which also distributed an anaglyphic projector that was adapted to their 'stéréodrome' multiple-view stereoscope. Other makers, such as Jules Richard, also began to manufacture this type of device.

Anaglyphic projections continued in various ways (fixed and animated images) until World War II, when the invention of polarizing filters made it possible to project stereoscopic images in their natural colours.[25] In 1982 an experiment in anaglyphic 3-D was carried out on French television[26], but was a resounding failure.

Anaglyphs have never enjoyed the same degree of success as stereoscopic prints but, due to the low cost of manufacturing bicoloured spectacles and printing techniques that make it possible to publish anaglyphs in their natural colours, there is still every chance that they will continue to appear periodically in the press[27]. It is also possible that the development of digital imagery and the widespread use of computers may revive interest in anaglyphs which can now be viewed on computer screens. The projection of

Léon Gimpel, **Aerial view of the Eiffel Tower and the Trocadéro**, after 1911
Anaglyph on an autochrome plate. Inscribed in French by the photographer: 'No. 4273 – the Eiffel Tower and Trocadéro seen from an aeroplane'; 8.9 x 12.0 cm.

Coll. Société Française de Photographie, catalogue no. 806A988.

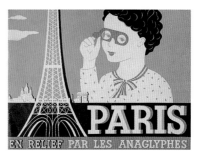

Cover for album of anaglyphs, c. 1937
Published by Les Editions en Anaglyphes, 35, Rue Tournefort, Paris; Imprimerie Aulard; 'Distribution O.C.O, 7 rue des Grands-Augustins, Paris', no date; about 21 x 27 cm.

Coll. Musée Carnavalet.

Hurrah, 1964
Collection including Mighty Mouse and other strip cartoons, Publications Périodiques Modernes, Paris; 26.7 x 18.4 cm.

Coll. Jacques Périn.

anaglyphic films in the theatre of the Louvre Museum in Paris, in November 1997,[28] not only proved that three-dimensional cinema has lost none of its powers of fascination, but also that the use of bicoloured spectacles was just as taxing for the eyes of modern audiences who find it easier to adapt to polarizing spectacles.

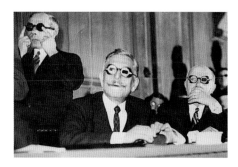

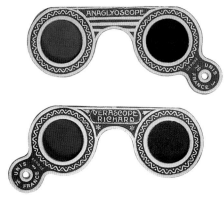

Anonymous, **Anaglyphic projection by Louis Lumière at the Académie des Sciences**,
25 February 1935
Gelatin silver photographs; 13.1 x 18.3 cm.

Coll. Olivier Auboin-Vermorel.

In 1935 Louis Lumière presented improvements to anaglyphic movies. He was seeking to reduce eye strain by means of a more careful choice of colours, which had to have the same density. 'One of the filters thus obtained is yellow with a tinge of green, the other is blue. They are practically complementary and make it possible to reconstitute white by the superimposition of two beams of similarly coloured light on the projection screen' (in *C.R.A.S.*, 1935, Vol. 200, pp. 701–04).

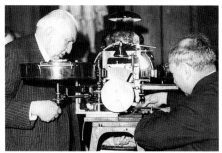

Anaglyphic viewing glasses, c. 1925

Coll. Jacques Périn.

These glasses were sold by, among others, the Gaumont company. In Gaumont's 1925 catalogue they are listed at 4.50 francs a dozen, while 'dual-coloured glasses in imitation tortoiseshell, non-flammable material' cost 35 francs, and the anaglyphic projector sold for home use with the 'Stéréodrome' stereoscope is listed at 1,075 francs or 1,175 francs depending on the model.

1. Marc Antoine Gaudin, *La Lumière*, 30 November 1851. The 'megascope' was defined at the time as an 'instrument which magnifies objects, and which is used to observe opaque bodies that cannot be seen under the microscope' or as a 'sort of dark chamber used to obtain enlarged copies'. (*Grand Dictionnaire Universel du XIXe Siècle*, Nîmes, C. Lacour, 1991 [Larousse, 1866–76], p. 1443.

2. *Ibid.*

3. *Ibid.*

4. A mechanical device covered the right and then the left eye during the alternate projection of the two images of a stereoscopic pair.

5. He was teaching mathematics at the Lycée de Stargard when he made his discovery. He later taught at the Lycée de Stralsund, where he retired in 1890 after 42 years in the profession.

6. Wilhelm Rollmann, 'Zwei neue stereoskopische Methoden', in *Poggendorf's Annalen (Annalen der Physik und Chemie)*, Vol. XC (vol. 166), 1853.

7. Joseph Charles d'Almeida, 'Nouvel appareil stéréoscopique', *Les comptes rendus des séances de l'Académie des Sciences*, 12 July 1858, Vol. 47, pp. 61–63.

8. *Ibid.*

9. All that survives of Rollmann and d'Almeida's research are the articles written in the 1850s, which appeared in several contemporary publications.

10. See the article by Laurent Mannoni in the present work for more information on Molteni and anaglyphic cinema.

11. Patent no. 216,465.

12. Louis Ducos du Hauron, *L'Art des Anaglyphes*, paper presented to the Société Française de Photographie, Mustapha Printers, A. Cougnard, Mustapha, Algiers, 1893, p. 4.

13. *Ibid.*, p. 5 [italics in the original text].

14. In his *Histoire de la Photographie* (Baschet & Cie, Paris, 1945), Raymond Lecuyer attributes these difficulties to the printing inks used at the time. He believed that the colours available 'were not strictly complementary and did not have the necessary vividness or transparency'.

15. Léon Gimpel, *Quarante Ans de Reportages Photographiques, Vol. I, 1897–1932*, February 1944, p. 51 (unpublished manuscript, coll. Société Française de Photographie).

16. *Ibid.*, pp. 128, 134.

17. Panoramic view from Saint-Gervais, the fountain of the Paris Observatory, the interior of the Church of Saint-Etienne-du-Mont and five rooms in the Louvre Museum.

18. The publication of anaglyphs in *L'Illustration* came to an abrupt halt in 1925 when the then minister for the postal services classed bicoloured spectacles as a promotional product which would, therefore, incur an additional charge over and above the distribution costs of the publication. The stereoscopic photographs used to produce the anaglyphs that appeared in the periodical can be seen in the archives of *L'Illustration* which are today preserved by the Keystone photo agency in Paris.

19. Gimpel, *op. cit.*, pp. 135–38, drew up a list of some forty-nine periodicals which printed or made reference to anaglyphs on 143 separate occasions between 1924 and 1933.

20. *Ibid.*, p. 135.

21. *Ibid.*, p. 139.

22. This advertisement appeared in *L'Illustration* on 22 November 1924, p. 9, and showed a group of people posing near the waterfall in the Bois de Boulogne in Paris.

23. Gimpel, *op. cit.*, p. 135, cited 'tobacco, champagne, clothing, razor, shoe [and] cigarette' companies as users of this type of publicity. In 1924, the Folies-Bergères and the Casino de Paris distributed these spectacles for their '3-D-shadow' or 'anaglyph' shows, when the audience saw three-dimensional silhouettes of the performers produced on a translucent screen by two projectors fitted with red and blue filters.

24. Patent no. 576,046. The prototype is today preserved by the Société Française de Photographie.

25. The Stéréo-Club Français favoured simple projections until the 1950s, when projections by polarized light were introduced (see the article by Clément Chéroux in the present work). Was this an implicit criticism of the quality and comfort of anaglyphs?

26. On 19 October 1982 the film *The Creature from the Black Lagoon* (1954) was shown on French television. The spectacles proved ineffectual, since the chromatic difference between the spectacles and the image was too great.

27. For example, *Paris Match*: 'Les plus beaux paysages de France', a series of French landscapes, with the Eiffel Tower featured on the cover (30 December 1983), 'Les vedettes du sport et du spectacle', a series of popular entertainers and sports personalities (6 January 1984), 'La France in relief' (5 July 1985) and 'Dinosaures en anaglyphes' (28 October 1993). Other examples include *ça m'intéresse* (May 1992), *Playboy* (summer 1996) and *Science et Vie Junior* (March 1998).

28. The 3-D cinema series, *Le relief au cinema*, 9–26 October 1997.

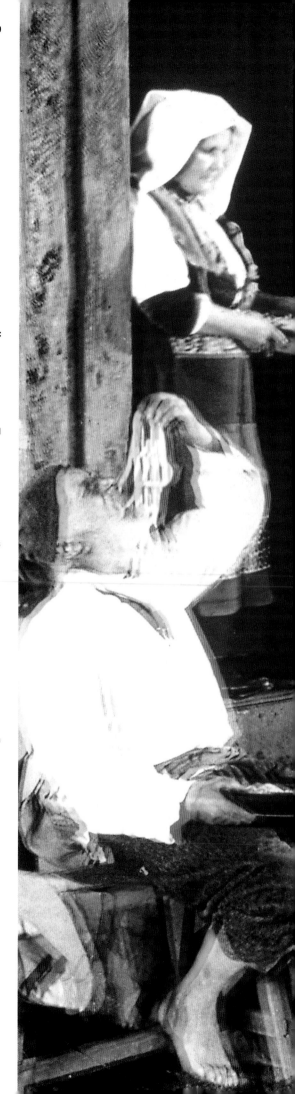

Journal of the photographer Léon Gimpel, 1944
Handwritten text with ink drawings. Page 148 of the
manuscript *Quarante ans de reportages photographiques:
souvenirs de Léon Gimpel, collaborateur à l'Illustration*.
Volume 1 1897–1932; 31.5 x 21.8 x 4.0 cm (book closed)

Coll. Société Française de Photographie.

Léon Gimpel, **Advertisement for Rivoire & Carret pasta:
'Macaroni eaten in the Italian style'**, 1925
Anaglyph on two separate (red and green) superimposed
glass plates.
Inscribed in French by the photographer: 'No. 10595/96 –
Paris (Gaumont Studios)/11 February 1925. Macaroni eaten
in the Italian style – advertisement for Rivoire & Carret,
manufacturers of short-cut pasta'; printed label: 'Léon Gimpel
Collection'; 8.9 x 12.0 cm.

*Coll. Société Française de Photographie, catalogue
no. 806A961.*

Gimpel tells the story behind this image in his memoirs,
pp. 147–48:

'[I]n February 1925 [...] following an advertising agency's
suggestion that Rivoire & Carret should use anaglyphs to
champion the cause of short macaroni, a strange expedition
was organized one day: a group of real Italians (men and
women recruited from the painters' "model market" near
the Gare Montparnasse), advertising representatives carrying
huge portions of cooked macaroni (both long and short)
and the author of these lines carrying his new stereoscopic
camera all met at the Gaumont studios at La Villette where
they were greeted by an attractive set representing a
picturesque narrow street in old Naples.

There our Italians posed eating their long macaroni in
the "Italian style", in other words, by picking up a handful of
pasta with their fingers and bending their heads backwards
to make eating easier . . . In a nearby set depicting a modern
living room, some French diners ate short macaroni normally,
in the "French style" [...]

The two "macaroni" anaglyphs were used to illustrate
a small brochure whose cover (also an anaglyph) depicted
a panoramic view of Paris, as seen from the bell tower of
St Gervais [...] This brochure, while promoting the superiority
of short macaroni over long macaroni, also provided some
basic information about binocular vision and anaglyphs; it
was meant to be distributed to the best students in schools
and was a highly original advertising initiative.'

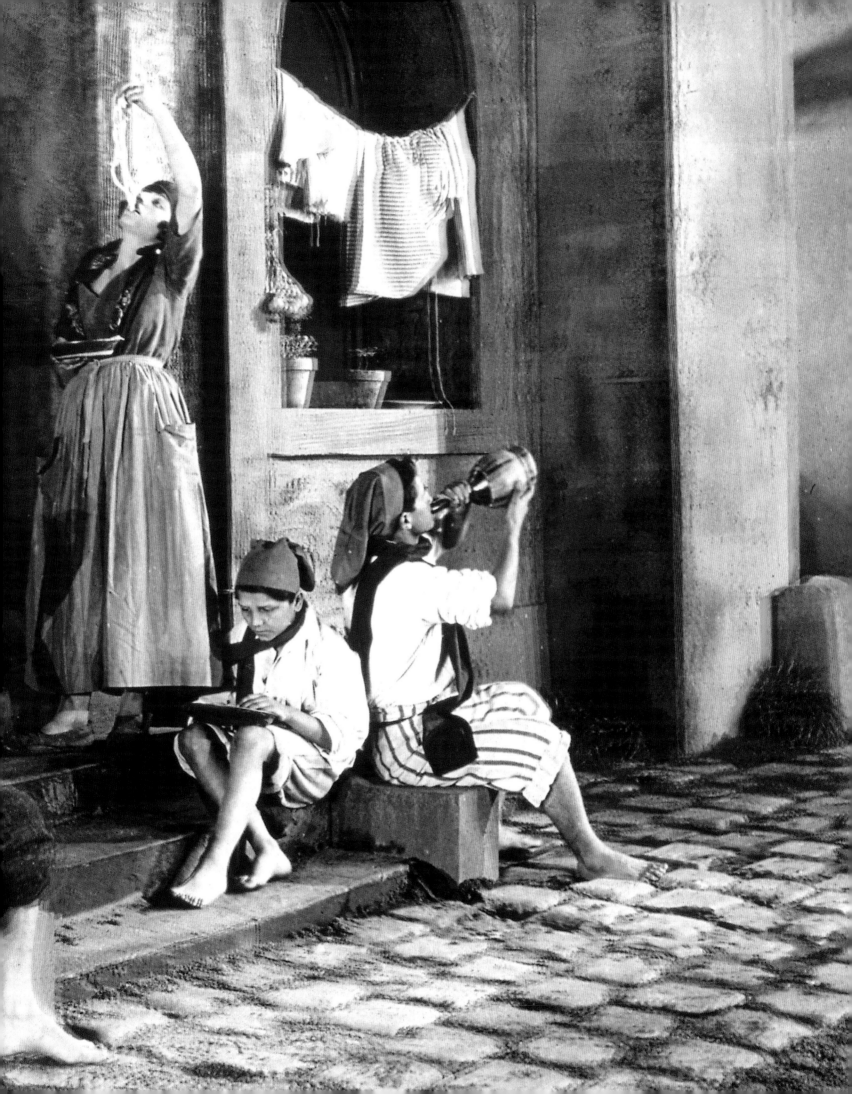

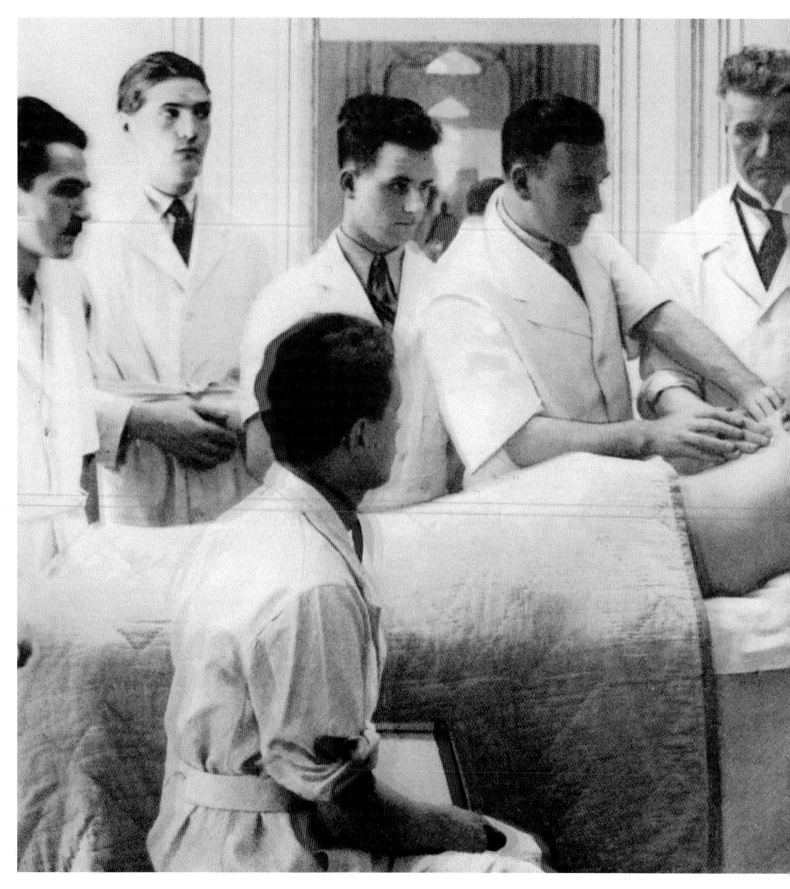

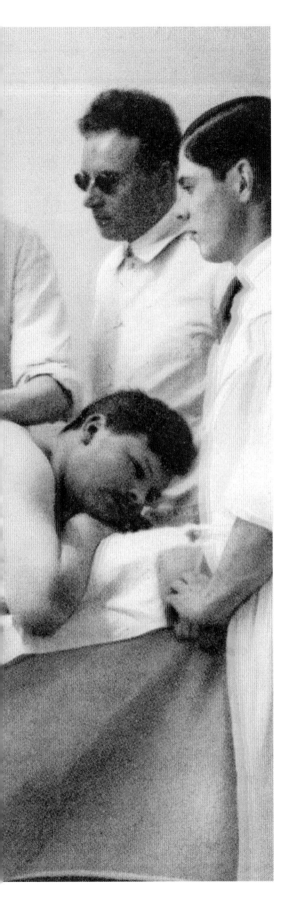

Léon Gimpel, **Advertisement for Néalgyl Bottu: massage school for the blind**, 16 March 1934
Printed anaglyph. Inscription in French: 'PARIS. – MASSAGE SCHOOL FOR THE BLIND (VALENTIN HAUY ASSOCIATION FOR THE WELFARE OF THE BLIND)'; on the reverse: 'Published by the LABORATOIRES BOTTU: 115, Rue Notre-Dame-des-Champs, Paris 6th arrondissement/Brussels agency: 33, avenue Roodebeek' with advertising copy; 13.8 x 19.7 cm.

Coll. Jacques Périn.

The Société Française de Photographie has a stereoscopic version of this image.

Laboratoires Bottu, **Cover of the portfolio containing anaglyphic advertisements**, 1930s
Inscription in French on the cover: 'Stereoscopic plates published by the Laboratoires Bottu'; in French on the back cover: 'Instructions for use/To be viewed through the two-colour lorgnette, placing the green side in front of the right eye and the red side in front of the left eye. Stare for several seconds gradually moving the subject as far away as possible'.

Coll. Jacques Périn.

Anonymous, **Advertisement for Néalgyl Bottu: woman in bed talking on the telephone**, after 1931
Printed anaglyph. Inscription in French: 'Published by LABORATOIRES BOTTU: 115, Rue Notre-Dame-des-Champs, Paris 6th arrondissement/Brussels agency: 33, avenue Roodebeek' with advertising copy; 15.5 x 21.0 cm.

Coll. Jacques Périn.

Copy printed beneath the image: 'Hello! Hello! . . . My dear, I'm still in bed, it's pure idleness, because since I've been taking NEALGYL Bottu tablets, my period pains have completely stopped; now I look forward to the dreaded date with a smile'.

130

Anonymous, **Nudes**, 1930s–40s
Printed anaglyphs, plates taken from the album of nudes
*Nus Académiques dans la Nature en Relief par les
Anaglyphes*, published by Les Editions en Anaglyphes,
no date.

Coll. Jacques Périn.

132 Louis Ducos du Hauron (1837-1920)

The photographer and inventor Louis Ducos du Hauron took an interest in stereoscopy and the methods of stereoscopic projection (patent no. 61,976 in 1864) early in his career. In 1868 he was also one of the inventors of colour photography based on the trichrome process (using coloured filters).

In the 1850s anaglyphs only existed in projection form. Ducos du Hauron was the first, in 1891, to register a French patent for anaglyphs: this concerned a technique for printing anaglyphs on paper. His works are therefore the oldest surviving images produced using this process, which he called 'anaglyphic' two years later. In a pioneering move for the time, he also endeavoured to produce coloured anaglyphs, although no examples of these have been found (patent 1891, *Bulletin de la Société française de photographie*, 1896). He also continued his research by working on colour stereoscopic photographs (patents no. 271,704 in 1897; no. 362,004 in 1905).

Louis Ducos du Hauron, **The Louvre Museum**, between 1891 and 1893
Printed anaglyph. Inscriptions in French: 'A CORNER OF THE SALLE DE MÉCÈNE/LOUVRE MUSEUM'; 'INVENTOR: L. DUCOS DU HAURON. – PATENTED WITHOUT GOVERNMENT GUARANTEE'; 'PHOTOENGRAVING: CHAMBET PRINTERS, ANNEMASSE (HAUTE-SAVOIE)'; 'CLICHÉ BONNAMY, 43, RUE DU BAC, PARIS'; within a sun-like shape: 'POST/TENEBRAS/SPERO/LUCEM'; below it: 'MANUFACTURER'S MARK'; 'F. 42'; plate 23.8 x 16.5 cm.

Coll. Société Française de Photographie, catalogue no. III-13.

Anonymous, **The Church of Saint-Eustache**,
c. 1900–05
Printed anaglyph, plate taken from the album *Vues*
plastographiques du monde/Clichés plastographiques
('Plastographicical Views of the World'), *Series no. 1, Part 7;*
'Une tournée à Paris' ('An Excursion to Paris') published by
DV; 22.6 x 31.0 cm.

Coll. Musée Nicéphore Niepce, Chalon-sur-Saône, catalogue
no. EM 47.2.

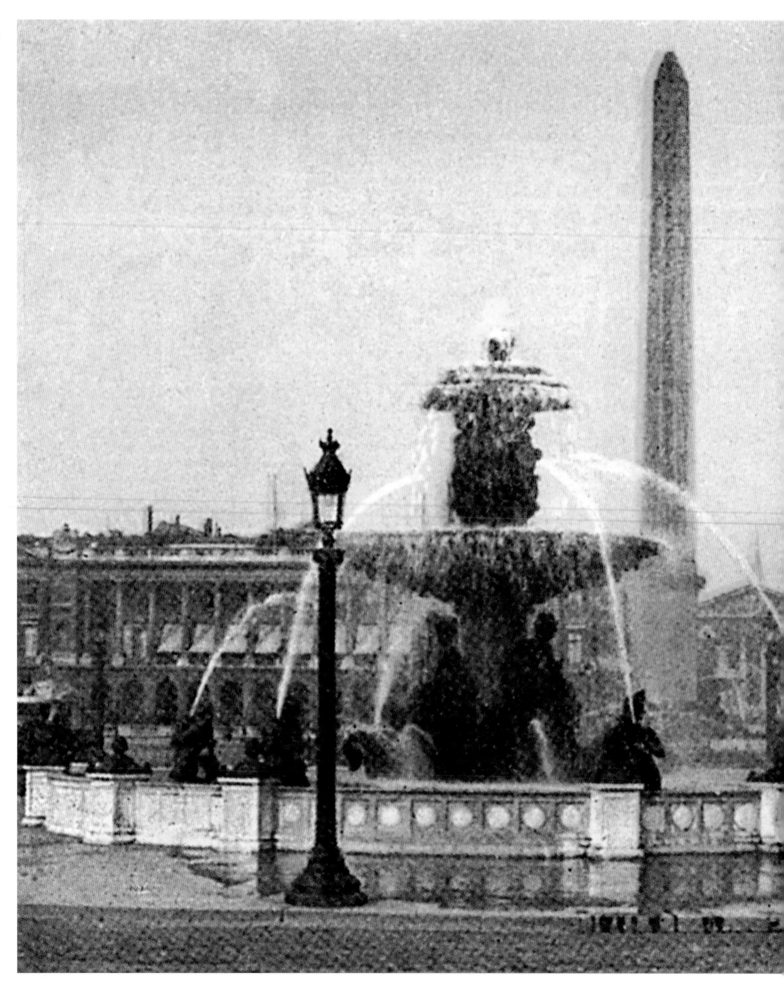

SCÈNE D'OPÉRATION DANS UN HOPITAL DE PARIS.

POMMADE MIDY

VUE DE LA FACULTÉ DE MÉDECINE DE PARIS.
(cour intérieure)

SUPPOSITOIRES MIDY

Anonymous, **Series of advertisements for Midy pharmaceutical products**, 1930s
Printed anaglyphs. Inscription in French: advertising text for the Laboratoire Midy on the back of each image: 'OPERATION IN A HOSPITAL IN PARIS'; 'VIEW OF THE FACULTY OF MEDICINE, PARIS'; 13.8 x 8.8 cm.

Coll. Jacques Pèrin.

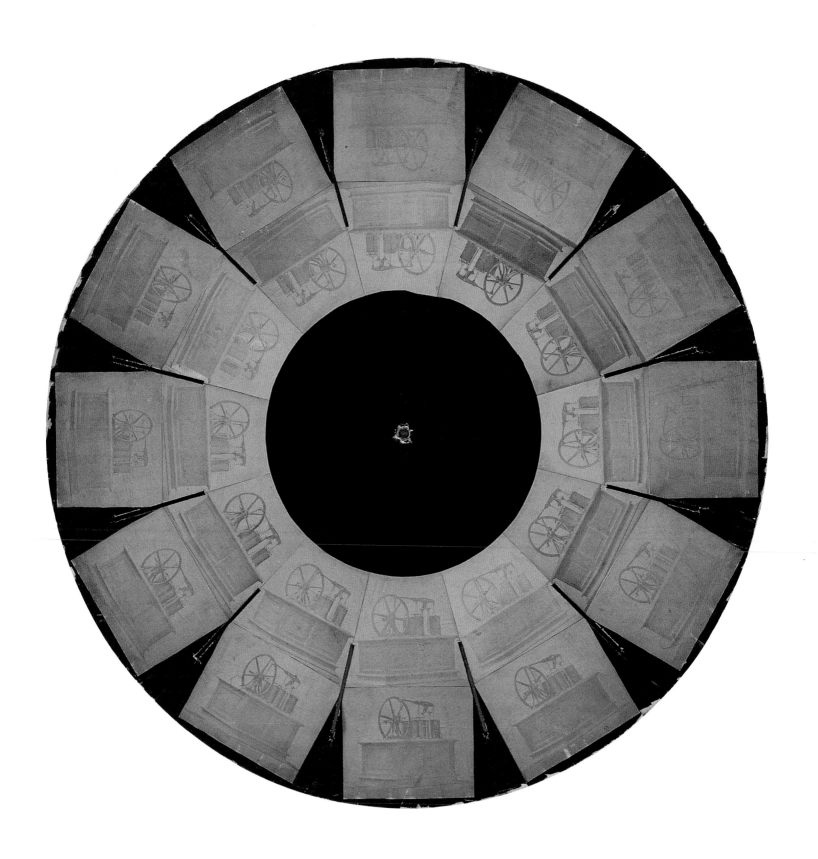

The 'feeling of life': the birth of stereoscopic film

Laurent Mannoni

Advertisement for Duboscq and Ferrier showing the Bioscope, 1855

Coll. Roxanne Debuisson.

The Bioscope can be seen bottom left, with its rotating disc.

Jules Duboscq, **Bioscope disc**, c. 1852
Stereoscopic photographs, albumen prints on cardboard disc with twelve windows; diameter: 33.5 cm.

Coll. Joseph Plateau, Musée de l'Histoire des Sciences, University of Ghent, Belgium, catalogue no. MW96/1859.

This is the only known example of a bioscope disk.

In the 1850s a first wave of bold explorers set off in pursuit of a utopian dream: since photography now made it possible to capture the once fleeting images of the camera obscura, and since these images could be given three dimensions, would it not be possible to apply the same processes to all living movements? These Promethean pioneers longed to fulfil the ancient fantasy of 'seeing uninterrupted movement from one place to another',[1] in three dimensions, in all its detail, animation and even its sound and colour. But in seeking to combine the techniques of 'animated photography', stroboscopy and stereoscopy, all as yet in their infancy, the inventors had set themselves a very difficult task.

This first wave of utopians was succeeded by further waves of more realistic specialists. The long series of inventions and improvements that followed laid the foundations of the three-dimensional cinema of today – a cinema whose technical development and marketing remain, let us not forget, wide open to study. Strangely, the few works on 3-D cinema that do exist timidly explore the history of the very early years of stereoscopic animation;[2] all the more reason for us to review its major developments here.

Around 1849 the British physicist Charles Wheatstone (1802–1875), inventor of the mirror stereoscope with its accompanying geometric drawings (1838), made the following suggestion to his Belgian colleague Joseph Plateau (1801–1883), famous creator of the first stroboscopic discs: '[...] combine the principle of the stereoscope with that of the phenakistoscope [...] Then shapes that are simply painted on paper would inevitably be seen in three dimensions and moving, and would thus entirely present all the appearances of life. It would be the illusion of art taken to its highest point'.[3] As the photographic techniques of the day did not yet make it possible to capture the different phases of a movement, Wheatstone suggested that Plateau should take sixteen different stereoscopic daguerreotypes of a plaster figure, which would be gradually moved. Pairs of drawings of the moving sculpture could then be transferred to two stereoscopic discs. 'A long job,' said Plateau, 'but one that would be easily recompensed by the wonderful nature of the results'.

It was in 1852 that Wheatstone and Plateau's ideas found their first concrete applications. Here we encounter another major figure: the Parisian optician Louis Jules Duboscq (1817–1886) who, with the help of François Moigno, had successfully marketed David Brewster's refracting stereoscope in 1851.

On 16 February 1852 Duboscq registered an important patent (no.13,069, with seven later additions, the last in 1857) for 'an instrument system called a stereoscope, making photographic images created on flat surfaces appear in three dimensions, even on transparent materials, glass etc., and which can project enlarged images on to screens'. It was in the addition of 12 November 1852 that Duboscq described the 'stereoscope-fantascope or Bioscope', an apparatus 'which combines the essential properties of the stereoscope with the most wonderful properties of M. Plateau's Phenakistiscope'. The aim was to provide 'the feeling of three dimensions and movement, or the feeling of life' by placing twelve pairs of stereoscopic images, representing twelve phases of a movement, around the circumference of a stroboscopic disc. When the disc was spun, the stereoscopic images could be viewed through mirrors or lenses. Duboscq marketed several models of his 'Bioscope', but

138

without much success: no example of the instrument has yet been found, and only one disc is known to exist. No doubt the technical and visual qualities of this device did not live up to expectations; furthermore, we do not know how Duboscq made his series of stereoscopic images (representing 'moving machines'). A contemporary noted sharply, 'We may not hope that the Bioscope will ever be sold in great number; but, as it requires a considerable number of proofs, up to twenty-four or thirty-two to obtain a single effect, it will in any case offer a considerable market to photography'.[4]

At the same time as Duboscq another French photographer, Antoine Claudet (1797–1867), then living in London, was trying to 'obtain three dimensions with movement'. His first 'fantascopic stereoscope' was unveiled in London in 1852 and patented on 23 March 1853.[5] In 1865 he published an important paper on 'Moving photographic figures'.[6] Claudet had the merit of providing solid theoretical foundations for the perception of movement and three-dimensionality, but he himself confessed to being relatively disappointed by his stereoscope with a sliding shutter, through which it was possible to view the three-dimensional animated image of 'a man raising and replacing his hat'.

Following Duboscq and Claudet, many forgotten inventors and photographic specialists disappeared down the same path: Parisian painter Philippe Benoist and his animated stereoscope;[7] engineer Adam Jundzill of London, who sought to show stereoscopic 'cartoons in motion' using his 'kinimoscope' in 1856;[8] the Paris company Furne & Tournier, who produced a 'stereoscope-phenakistoscope';[9] Coleman Sellers, the American inventor of some remarkable stereoscopic zootropes in 1861;[10] lastly, Parisian André David, whose device, based on Claudet's system, was patented in 1873.[11]

Between 1859 and 1862 the Belgian Henry Désiré Du Mont was also carrying out original research in the area of stereoscopic animation. In his first patent registered in Paris in November 1859,[12] he describes various stroboscopic discs called 'omniscopes', including a double model 'to produce the effect of three-dimensions and movement'. His second patent, dated 2 May 1861, was for a camera equipped with a magazine containing ten or twelve glass plates.[13] These would pass through the focal point of the lens in rapid succession. A stereoscopic version was planned to make images for the 'omniscope', invented two years earlier. Du Mont presented his system to the Société Française de Photographie in Paris on 17 January 1862, but nothing seems to have come of his impressive experiments.

Wheatstone and Plateau's idea of 1849 was not fully applied and put into use until 1867, with the 'photobioscope' designed by the Englishman Henry Cook and the Italian Gaetano Bonelli. In development from 1862, the 'photobioscope' was a device for viewing transparent glass discs. These discs contained two rows of successive photographs showing the different sides of a plaster figure – a return to Plateau's idea of a 'moving sculpture'. The successive images were still made in a rather haphazard manner – the light-sensitive surfaces of the time (wet collodion) lacked speed and only simulated movement could be photographed – and Cook, moreover, was always very secretive about his camera. However, the only glass disc to have survived and which is preserved (incomplete) in the Musée National des Arts et Métiers in Paris, reveals a certain degree of technical dexterity. The viewer, which is held in the same museum, represents an excellent synthesis of Brewster's binocular stereoscope and Faraday and Plateau's stroboscopic disc with shutter. When Cook, who tended towards hyperbole, presented the 'photobioscope' at the Société Française de Photographie in Paris on 2 August 1867, it was easy to believe him when he said that 'the vital question has been settled [...] We are seeing another complete revolution in the art of photography. Landscapes in which trees bend before the wind, leaves that tremble and gleam in the sunlight, boats and birds that glide over the rippling surface of the water, the formations of armies and fleets, in fact every imaginable kind of movement, caught in passing, could provide us with information.'[14]

The height of complexity was probably reached by Louis-Arthur Ducos du Hauron, whose 1864 patent contains the description of a revolutionary camera and viewer, monoscopic or stereoscopic, equipped with a battery of 580 lenses.[15] A true forerunner of Marey, Ducos du Hauron hoped that his device would 'give swift wings to time', or 'enable the slow unfolding of transformations whose speed sometimes makes them invisible to sight'. However, nothing remains of his experiments.

With Cook, Bonelli and Ducos du Hauron, the stereoscopic animated photography

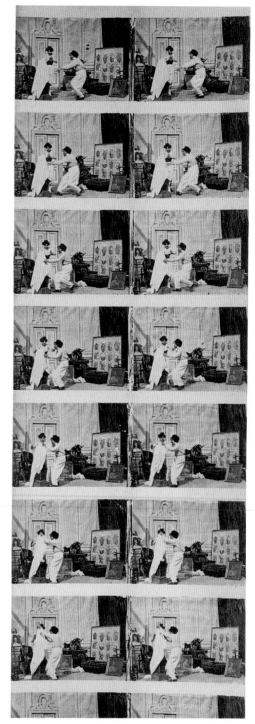

Anonymous, **Strip of animated stereoscopic images**, c. 1900
Detail of a strip of printed stereoscopic images; 10 x 1,300 cm.

Coll. Olivier Auboin-Vermorel.

These images were looked at using the Bünzli and Continsouza viewer.

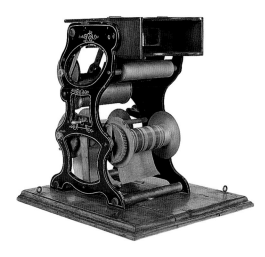

René Bünzli and and Victor Continsouza, **Stereoscopic film viewer**, 1900
Device with two prismatic lenses and an oscillating mirror; steel, wood, glass, brass; frosted-glass screen, manually operated; 31 x 27 x 31 cm.

Coll. Cinémathèque Française, Collection des Appareils, catalogue no. AP-95-1656.

Machine for a paper tape 10 cm wide. The tape placed inside this machine pulls a cog and cam mechanism that makes the mirror oscillate. The mirror also acts as a shutter.

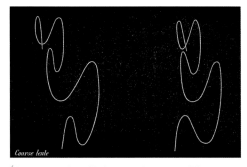

Étienne-Jules Marey, **Trajectory of a man walking**, 1885
Stereoscopic view, published in 'Locomotion de l'homme, images stéréoscopiques des trajectoires que décrit dans l'espace un point du tronc pendant la marche, la course et les autres allures', *Bulletin de la Sociéte Française de Photographie*, 1886, pp. 52–56.

'A man dressed in black with a small shiny ball attached at the level of his sacrum walked on flat ground. The chrono-camera was placed 2 metres to the left behind him above his path. The image obtained showed his movement through the three spatial dimensions. However, despite the perspective, the figure was not very clear except for those who knew the trajectory in advance. [...] I therefore substituted a stereoscopic camera for the simple camera.' (É. J. Marey)

of the Second Empire in France reached a dead end. The photobioscope marks the end of the first wave of utopian inventors, who dreamed of giving photography all the illusion of life. If the specialists of the 1870s had lost their enthusiasm for stereoscopic animation, it was because their primary aim had – sensibly – become not simply to take successive images of rapid movements (so analysing them) but also to represent them on screen (thereby synthesizing them). Among the foremost masters of analysis and synthesis was Étienne-Jules Marey (1830–1904).

Marey was interested in stereoscopy long before he perfected his extraordinary chronophotography in 1880. In the 1870s he and his student Gaston Carlet created three-dimensional versions of lines obtained using his 'graphic method' – again with a view to synthesizing his analyses. In one example a strange wire sculpture, a 'solid figure' observed in perspective on a very precise plane, represents the winding trajectory of a walking man's pubic bone.[16] Some years later, in 1885, Marey sought to recreate the 'solid figure' he had obtained with Carlet. He placed a shutter disc inside a stereoscopic apparatus and recorded the trajectories of a walking and running man on a glass plate. He was quite proud of the result: 'Seen in the stereoscope, [these figures] are perfectly three-dimensional: it is as though one is looking at a wire twisted in various directions and periodically repeating the same inflections'.[17]

Marey seems to have been far more attracted to the abstraction of Wheatstone's early geometrical figures than he was to traditional stereoscopic images. His fascination found its full expression in 1892 and 1893, when he set off on what he himself termed 'a return to the origins of geometry, a materialization of geometrical designs' in three dimensions.[18] He found his inspiration at the Conservatoire National des Arts et Métiers, which had (and still has) a magnificent collection of geometrical figures made from wires stretched between two metal frames. These were used for illustrative purposes by lecturers at the C.N.A.M. Aside from his interest in notions of perspective, Marey wanted to prove how geometrical figures were formed by the movements of lines, whose exact trajectories he wanted to preserve. To this end, using a stereoscopic chamber with a shutter, he chronophotographed the shapes created by a wire moving under a light in front of a black background. To obtain the shape of a cylinder he turned the wire parallel to a central vertical axis. If the rotating wire was set at an oblique angle to the axis, the shape caught by the camera was a magnificent hyperboloid. If the wire was made to touch the axis, a cone was obtained. Better still, Marey obtained stereoscopic and chronophotographic images of a hyperboloid on which he superimposed the image of a asymptotic cone; this three-dimensional superimposition opened up a new perspective in the field of photographic effects. Stereoscopy also enabled Marey to present a pair of chronophotographic images of a half-circle of shiny metal, whose rotation formed a beautiful sphere. When Marey then recorded the movement of this half-circle without a shutter, his glass plate showed him a luminous sphere like a glass ball, a 'shape strange and hard to understand' which he liked very much.

Ultimately, it is probably Marey who best symbolizes the meeting of stereoscopy and photographic animation in the nineteenth century. His 1887 zootrope, in which he showed eleven statuettes made using chronophotographs representing a seagull in eleven stages of flight, offers an unforgettable sight: the bird is seen with amazing clarity, in three dimensions, flying in slow motion. Here Marey certainly did attain a kind of ultimate perfection: an animated image in three dimensions, in slow motion and in colour (he said he had painted one of his bird series). Was it possible to go further? Had Henry Cook's famous 'vital question' of exactly twenty years earlier finally been answered?

Another, perhaps less aesthetically bold answer was put forward by Georges Demenÿ (1850–1917), Marey's laboratory assistant at the Physiological Station in the Bois de Boulogne in the west of Paris. Demenÿ was less of a purist in his vision of chronophotography. He liked to film scenes from everyday life and performances of dance, magic, theatre or music. Several old copies of chronophotographic films show that Demenÿ equipped one of his cameras with stereoscopic lenses, probably around 1893–95. The images that have been preserved show a man sawing wood and a man sneezing – perhaps imitating the 'Edison Kinetoscopic Record of a Sneeze', made by Edison in January 1894.

We have now reached an important moment: the stereoscopic recording of the successive phases of a movement on celluloid film. The pioneer in this field was probably neither Marey nor Demenÿ, but the Englishman William Friese-Greene

140 (1855–1921) who, in 1890, in collaboration with the British engineer Frederick Henry Varley, developed the first stereoscopic film camera that is still preserved to this day.[19] A very rare fragile fragment of the first stereoscopic film made by Friese-Greene and Varley around 1890 can be found in the Will Day collection of the Cinémathèque Française: it is 15.5 cm x 45.5 cm and consists of two rows of six successive images of a man walking down a street, seen from behind. It is a poetic and rather strange sight, as though this elegant top-hatted gentleman judged the problem to have been definitively solved and so was leaving the scene, with an enigmatic and slightly contemptuous air.

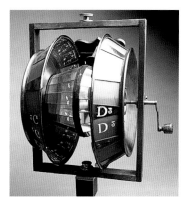

As the nineteenth century nears its end, so the patents and combined stereoscopic-cinematographic devices multiply. The scope of this study clearly does not allow us to review them all, but we can note some of the more interesting in passing. For example, the Frenchman Émile Reynaud, who found a brilliant solution to the problem of animated projection in 1892 with his Optical Theatre, had long planned to produce a stereoscopic version of his praxinoscope, patented in 1877.[20] It was not until 1902 in Paris that he designed the excellent 'stereocinematographic apparatus',[21] in which a ring of prismatic mirrors creates a shutter effect for the viewing of two rows of successive images printed on paper. In the United States, experiments were attempted using a mutoscope with double images, as shown by a few rare images preserved in the Will Day collection at the Smithsonian Institution. In the event, a related patent was registered by Charles Francis Jenkins in 1898.[22] In the same year in Paris, Lucien Bull, one of Marey's best students, made a viewer for the extraordinary high-speed stereoscopic films he was making on the flight of insects.[23] We should also mention the 'stereoscopic animator' made by Frenchmen René Bünzli and Victor Continsouza (future manufacturers of Pathé cameras), patented twice in 1899 and 1900 and marketed around this time.[24] In this fine apparatus, an oscillating mirror provides the shutter effect, making it possible to view stereoscopic films printed on paper – generally showing slightly bawdy scenes. Later, from about 1910, Continsouza made Pathé a superb and huge stereoscopic camera, now preserved in the Cinémathèque Française, allowing the recording of two rows of images on 35 mm film. However, Pathé's production of stereoscopic films always remained very limited and was never really marketed.

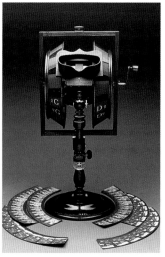

The Reynaud Binocular Praxinoscope
Device for viewing animated stereoscopic views on paper
1907
Émile Reynaud, inventor and manufacturer, Paris
Patent no. 379,483, 2 July 1907
Steel, wood, brass, glass, mirror
59 x 37 x 32 cm.

Coll. Musée des Arts et Métiers, catalogue no. 16554-0001.

Émile Reynaud initially perfected a simple version of the Praxinoscope (patent no. 120,484, 30 August 1877). He described it as follows: 'The special aim of this invention is to produce the illusion of movement using drawings which show the successive stages of an action [...] The principle is based on an optical law of reflection in flat mirrors.'

The Praxinoscope, followed by the optical theatre invented sixteen months later, immediately sold widely, despite being expensive and regarded at the time as toys.

In 1902 Émile Reynaud patented a 'stereocinematographic device' followed, five years later, by a 'device providing a continuous movement and unbroken vision for animated stereoscopic images'. He called the latter a 'stereoscopic binocular praxinoscope'.

Two rotating drums containing two strips of stereoscopic photographs of a subject in motion, connected to two other drums composed of mirrors and supplemented by an optical unit minimizing the 'image by image' vision, made it possible to see the animation continuously and in 3-D. Unfortunately, this is the only known example of this unique device. **Jacques Périn**

Up until this point, stereoscopic animation has generally involved looking through two lenses at pairs of successive images. In the nineteenth century the anaglyphic technique advocated by Joseph d'Almeida and Louis Ducos du Hauron was also adopted early on. For example, on 9 June 1890, at the Société Française de Photographie, the lanternist Alfred Molteni organized a screening of anaglyphic images which caused quite a stir. Molteni himself explained the principle behind his projections to Marey (who asked him for information about the technique), in a handwritten letter dated 5 December 1890: 'A double apparatus is used, consisting of two lanterns which have been rendered convergent so that they project on to the same point on the screen. One of the sides of a stereoscopic image on glass is placed into one of the lanterns; the second image goes in the other lantern. Behind one of the photographs there is a red glass, behind the other a green glass. Thus there is both a green image and a red image on the screen. If the viewer now puts on a pair of spectacles with a green glass over one eye and a red glass over the other, as each eye sees a distinct image, a sensation of three dimensions is created immediately and is very pronounced in some images.'[25]

The anaglyphic process was very simple and was marketed in several forms: glass plates for projection or paper prints sold with strange two-coloured spectacles. Cinematography adopted the process early in 1896, demonstrating the renewal of interest among its pioneers in the old utopia of three-dimensional animation. Paul Mortier, who was based in Lyon, built on the work of Émile Reynaud to design a reversible camera called an 'Alethoscope' with revolutionary systems: to obtain three dimensions, as he wrote in his patent of 17 February 1896, 'coloured filters in complementary colours must be placed in front of the two projection lenses and the spectators must be provided with similarly coloured spectacles (anaglyphic process)'.

Claude Louis Grivolas, the industrialist who enabled Charles Pathé to construct his empire, also designed a comparatively complex anaglyphic system, which he patented in 1901.[26] Two synchronized cameras film the same subject from different angles; their operation ensures that frames are registered alternately. All the images from both

cameras are then printed in order on a single piece of film. The projector has a shutter with two opaque blades and two coloured filters (pale red and blue), so that the even-numbered images of the first film are red and the odd-numbered images of the second are blue. The spectator has to wear spectacles with red (right eye) and blue (left eye) glasses, so that the images appear to be moving in three dimensions.

The anaglyphic process was later explored in 1909 by the Gaumont company,[27] then by Louis Lumière in 1935; in 1936 the Americans J.A. Norling and J.-F. Leventhal made a short film for MGM which had to be viewed through glasses with red and blue filters. This process, known as 'Audioscopiks', led to further experiments in the USA, notably in 1953 when MGM revived an old idea with the 'Metroscopix' system, presenting it as new. It was, however, impossible to make colour films and after a while viewing anaglyphic films becomes very tiring for the eyes.

In February 1896 Paul Mortier also laid down the principles of a complex and highly ingenious technique: spectators were given special glasses with an electrical alternator driving shutters which were perfectly synchronized with the shutters of two linked projectors. In this way each eye would see only the projections of the corresponding series of images. Synchronization was easily obtained by connecting a small multipolar electrical alternator to the apparatus and having a small synchronized device running off the alternating current produced to run the shutter system of each pair of spectacles.[28] Two years later Auguste Rateau, a Frenchman living in London, took this idea a stage further:[29] two camera lenses alternately recorded a series of slightly different images of the scene to be reproduced. These images were projected on to a screen and looked at through what resembled a pair of binoculars in which a shutter vibrated or turned in synchrony with the shutter of the projector. This enabled the viewer to see each image on the screen alternately with one eye then the other. The shutters were also synchronized electrically. These experiments were important because Paul Mortier and Auguste Rateau's forgotten patents set out the principles of the modern idea behind 3-D Imax/Omnimax film. Moreover, they had their first concrete application in 1936, with the French Maury-Houssin device.

Another, more satisfactory path involved polarization. Here too, the idea was an old one. Englishman John Anderton set out its principles in a patent dated 1893.[30] Two magic lanterns equipped with Nicol prisms projected polarized light through a set of stereoscopic images. Much later, on 4 May 1939, the American Norling held one of the first public screenings of a film using polarized light (it was an advertisement for the Chrysler company). It used two projectors with polarizing filters: one polarized the light vertically, the other horizontally. The screen was coated with aluminium to stop the light from becoming depolarized and the viewer watched the film through spectacles with polarizing filters. At last it was possible to show images in colour. The commercial development of the polarized light process was held back for some time by the problem of the screen, which had to be metallic, and of the synchronization of the two projectors, although these were soon replaced by a single projector equipped with a system of mirrors. Nevertheless, many of the 3-D films that were made in the USA during the 1950s in an attempt to compete with television are based on the principle of polarized light stereoscopy: Alfred Hitchcock's Dial M. for Murder (1954) is probably the most famous example.

We should also mention the process involving screens with a network of lines, which had the advantage of avoiding the use of the traditional spectacles, but was never very successful. In this system two images split into very narrow vertical strips (by means of a network of lines placed very close to the screen) were projected so that the strips of the odd row belonged to the image for the right eye and those of the even row were destined for the left eye. When the viewer looks at the images through a network of lines, each eye sees only the image intended for it. The problem with this mechanism is that the images cannot be seen by everyone in the cinema. Any seats which are not set at the ideal angle to the screen are then unavailable for use. The idea of line screens, like most other stereoscopy and animation techniques, is based on very old theories: it was Nicéron the elder in the seventeenth century who first revealed the principle by which pictures made of images painted on prisms could be seen in two ways.

What is the state of three-dimensional film today? During the 1950s the production of anaglyphic films or films using polarized light had to compete with wide-screen systems – CinemaScope and other types of Cinerama. Just a decade or so ago there

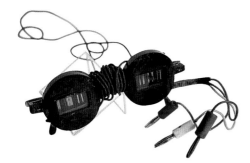

Houssin & Maury, **Glasses with shutters for stereoscopic projection**, 1931–32

Coll. Musée Français de la Photographie, Bièvres.

The glasses are linked to a projector by electric wires, so that the vision of each eye is alternately blocked in synchrony with the images projected.

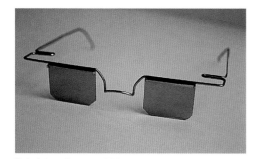

Polarizing glasses, 1930s or later
Metal frames, polarizing lenses

Coll. Musée Français de la Photographie, Bièvres.

142 was a lot of talk about 'cineholography', using the hologram principle. Today, too, the old dream remains: audiences are still strongly attracted to the idea of 3-D cinema. A revolutionary process for digital three-dimensional film is already being discussed, in terms as fantastical as those of the nineteenth century. Perhaps the 'vital question' will indeed one day be answered.

1. Jean Leurechon, *Récréation mathématique*, Pont-à-Mousson, 1621, p. 103.

2. See for example Adrian Cornwell-Clyne, 3-D *Kinematography and New Screen Techniques*, London, Hutchinson's scientific and technical publications, 1954; R.M. Hayes, *3-D Movies: a History and Filmography of Stereoscopic Cinema*, London and Chicago, St-James Press, 1989; Thierry Lefebvre and Philippe-Alain Michaud (eds), 'Le relief au cinéma', special edition of the journal *1895*, AFRHC, October 1997, Paris.

3. Joseph Plateau, 'Troisième note sur de nouvelles applications curieuses de la persistance des impressions de la rétine', *Bulletin de l'Académie royale des sciences de Bruxelles*, 1849, Vol. XVI, no. 7, pp. 38–39.

4. 'Notices extraites des recueils français et étrangers. Sur le stéréoscope, par M. Jules Duboscq', *Bulletin de la Société française de photographie*, March 1857, p. 77.

5. Antoine Claudet, British patent no. 711, 23 March 1853, 'Improvements in stereoscopes'.

6. *Le Moniteur de la photographie*, no.15, 15 October 1865, pp. 114–16.

7. Benoist, French patent no.16,055, 5 April 1853, 'Instrument d'optique dit images animées' ; British patent no. 1,965, 23 August 1856, 'An improvement in the construction of sterioscopes [*sic*]'.

8. Jundzill, British patent no. 1,245, 24 May 1856, 'An instrument for animating stereoscopic figures'.

9. Furne fils and H. Tournier, French patent no. 46,340, 14 August 1860, 'Stéréoscope employé comme phénakistiscope'.

10. Coleman Sellers, American patent no. 31,357, 5 February 1861, 'Exhibiting stereoscopic pictures of moving objects'.

11. André David, patent no. 100,076, 22 August 1873, 'Appareil binoculaire dit stéréoscope animé'.

12. H.D. Du Mont, patent no. 42,843, 17 November 1859, 'Appareils dits Omniscopes'.

13. H.D. Du Mont, patent no. 49,520, 2 May 1861, 'Appareil photographique propre à reproduire les phases successives d'un mouvement'.

14. 'Procès-verbal de la séance du 2 août 1867', *Bulletin de la Société française de photographie*, 15 August 1867, p. 202.

15. Louis-Arthur Ducos du Hauron, patent no. 61,976, 1 March 1864, 'Appareil destiné à reproduire photographiquement une scène quelconque, avec toutes les transformations qu'elle a subies, pendant un temps déterminé'.

16. A reconstruction of this sculpture is preserved in the Cinémathèque Française.

17. 'Locomotion de l'homme. Images stéréoscopiques des trajectoires que décrit dans l'espace un point du tronc pendant la marche, la course et les autres allures', *Les comptes rendus de l'Académie des Sciences*, 2 June 1885, Vol. 100, no. 22, pp. 1359–63.

18. Marey, 'Photographie expérimentale', *Paris-Photographe*, 1893, p. 100. On Marey and the question of three-dimensionality see Michel Frizot, 'Le temps de l'espace – les préoccupations stéréognosiques de Marey', *1895*, *op. cit.*, pp. 59–81.

19. Varley patented on his own an invention to protect this camera: British patent no. 4,704, 26 March 1890, 'Improvements in cameras for photographing objects in motion'. The device is preserved in the National Museum of Photography, Film and Television, Bradford.

20. The stereoscopic praxinoscope was described by Émile Reynaud in his patent no. 120,484 of 30 August 1877: 'Appareil pour obtenir l'illusion du mouvement à l'aide de glaces mobiles'.

21. Reynaud, patent no. 322,825, 9 July 1902, 'Appareil stéréocinématographique'. This device is also described in *La Nature*, no. 1,843, 19 September 1908, p. 256. An example of it, accompanied by its images, is preserved in the Musée des Arts et Métiers in Paris; the Cinémathèque Française also has some original images.

22. Jenkins, American patent no. 671,111, 7 March 1898: 'Stereoscopic Mutoscope'.

23. Lucien Bull and Miltiade Kossonis, patent no. 283,645, 2 December 1898: 'Appareil pour la vision des images cinématographiques dit l'Iconoscope'. A device of this type and some of Bull's stereoscopic films are preserved in the Cinémathèque Française.

24. René Bünzli and Victor Continsouza, patent no. 294,549, 21 November 1899, 'Animateur stéréoscopique'; Bünzli, patent no. 296,332, 20 January 1900, 'Stéréoscope animé dit Animateur stéréoscopique'.

25. Letter published in Lefebvre, Malthête and Mannoni, *Lettres d'Etienne-Jules Marey à Georges Demenÿ 1880–1894*, AFRHC-BiFi, 2000, Paris, pp. 495–96. See also Mareschal, 'Projections stéréoscopiques', in *La Nature*, no. 917, 27 December 1890.

26. Claude Agricol Louis Grivolas, patent no. 310,864, 20 May 1901, 'Appareil pour projections animées en relief'.

27. Société des Établissements Gaumont, patent no. 420,163, 15 November 1909, 'Projection cinéstéréoscopique'.

28. Paul Mortier, patent no. 254,090, 17 February 1896, 'Appareil dénommé Aléthoscope, destiné à enregistrer photographiquement les scénes animées et à les reproduire soit par projection, soit par vision directe avec ou sans l'illusion du relief'.

29. Rateau, British patent no. 18,014, 31 July 1897, 'Improvements in chrono-photographic apparatus'. This system is presented in *Le Moniteur de la photographie*, no. 16, 15 August 1898.

30. John Anderton, American patent no. 542,321, 5 July 1893, 'Method by which pictures projected upon screens by magic lanterns are seen in relief'.

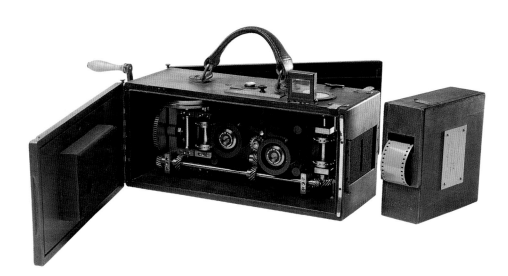

Stereoscopic devices **143**

Jacques Périn

The Richard Stereoscopic Cinematographic Camera

Cinematographic device for taking animated stereoscopic images
c. 1910
Jules Richard, inventor, Paris
Patent no. 414,159, 12 June 1909
Polished walnut, brass, steel
14 x 43 x 24 cm

E. Krauss Tessar Zeiss f4.5/40 mm lenses
65 mm stereoscopic base
Diaphragm with 6 aperture settings

Coll. Musée Français de la Photographie, Bièvres, catalogue no. 98/9980.

This camera, remarkable both for its rarity and for the quality of its workmanship, was probably a prototype. It was highly representative of the first generation of stereoscopic cameras (1890, first English patent; 1896, first French patent). The vertical separation between the two lenses made it possible to take two strips of horizontal images (13 x 19 mm) at the same time and on the same perforated nitrate film (35 mm, standard cinematographic format). The 65 mm gap between the lenses resulted in the horizontal separation of the views on the film. Accordingly, image 1 on the upper part of the film coincided with image 4 on the lower part of the film, number 2 with number 5, number 3 with number 6 and so on. This distinctive feature had to be corrected by the projector's optical system. Only one other camera similar to this model is now known to exist, but there are no examples of its corresponding projector.

The precision and sophistication of the mechanism, as well as the quality of the materials used in making this camera, show the importance placed by the manufacturer on the future of the 3-D animated image. Several decades ahead of its time, this object has earned its place in the pantheon of remarkable pieces in an all-too-short history.

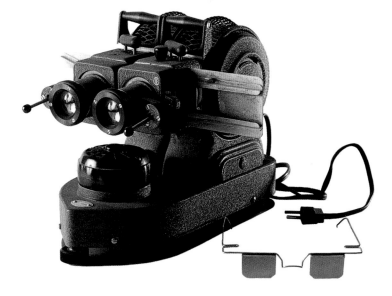

The Richard Polarized Light Projector

Device for the polarized projection of stereoscopic slides
1950
Jules Richard company, manufacturer, Paris
Frosted lacquered metal
25 x 29 x 35 cm
2 x 400W bulbs and 2 x 500W bulbs
Simple f80 mm, f85 mm and f2.8/105 mm lenses
'Polaroid'-type glasses with plastic lenses

Coll. Musée Français de la Photographie, Bièvres, catalogue no. mfp/000.

The principle of light polarization was clearly defined in 1815 by Sir David Brewster, but it was not until a century later that this specific process was used in photographic and cinematographic projection.

Before 1950 anaglyphic projection was much more popular than polarized projection. Glasses with polarizing lenses had to be worn to view the images and in 1932, in the United States, Edwin Herbert Land invented and began to market affordable glasses.

This method of projection subsequently became more widely available. From 1950, 3-D films shown in cinemas using polarized light struck back at competition both from the new medium of television and from the private showing of slides, which had become increasingly popular and was causing people to desert the cinemas.

The three successive models of Jules Richard's polarizing projector (sold from 1950 to 1964) made it possible to project 45 x 107 mm glass plates, 24 x 30 mm pairs of stereoscopic images or 24 x 36 mm slides. The extremely high cost of this device, the equivalent in 1953 of 18,000 francs today (£1,800), meant that it was bought exclusively by very wealthy customers.

Despite the undeniable qualities of polarized light projection – comfortable viewing, accurate reproduction of colours, bright, clear pictures – this technique could not halt the slow decline of public interest in 3-D images.

Claudius Givaudan, **Photosculpture of Louis Lumière (1864–1948)**, 1924
Gilt metal; inscribed: 'C. GIVAUDAN/1924';
18.3 x 12.5 x 1.9 cm.

Coll. Olivier Auboin-Vermorel.

Givaudan made a matching sculpture – a portrait of Auguste Lumière with the inscription in French: 'AUGUSTE LUMIERE/ MEMBER OF THE ACADEMIE DE MEDECINE' – and a double portrait of the brothers, using the same profiles, signed and dated 1925.

Louis Lumière was particularly interested in three-dimensional photography: he invented 'photostéréosynthése' (1920), proposed a solution for Lippmann's 'photographie intégrale' (1926) and worked on anaglyphic three-dimensional cinema (1935). Claudius Givaudan (1872–1945) from Lyon, an engineer at the Vermorel factories, also made photosculptures of various members of this family who were friends of the Lumières.

Photostéréosynthèse: a new approach to 3-D photography

Michel Frizot

Louis Lumière, **Auguste Lumière's moustache**, c. 1920

Gelatin silver print; about 6 x 8 cm.

Coll. Institut Lumière, Lyon.

Louis Lumière, **Portrait of Auguste Lumière without a moustache**, c. 1920

Gelatin silver print; 23.7 x 17.5 cm.

Coll. Institut Lumière, Lyon.

Study of visual planes for the 'photostéréosynthèse' process.

One might describe any object as being made up of an infinite number of superimposed planes of varying shape (like so many parallel flat sections), or – to put it more simply – very thin parallel slices. Theoretically a very close approximation to the object can be made by assembling a limited number of these slices. The idea of 'photo-stereo-synthesis' invented by Louis Lumière (1864–1948) involves obtaining these sections photographically (this is also the principle of Claudius Givaudan's photosculpture process, c. 1926). If successive photographs of a three-dimensional object can be taken such that each view relates to only one frontal plane ('the intersection of the object by a plane'), its volume can be rebuilt by placing these planes back in their relative positions. This vision is theoretical and, in practice, the number of planes or parallel slices must be reduced to a few units.

A technical solution, known as 'photostéréosynthèse', was provided by Louis Lumière in a lecture at the Académie des Sciences on 8 November 1920.[1] A cross-section of the object is equivalent, in photography, to a plane of sharpness or focus with Louis Lumière's technique. Several shots of the subject (six or seven) are taken, always from the same distance and focusing on a very thin plane (with very little depth of field) while leaving all the other points in front and behind the chosen plane blurred and out of focus. The prints of each image on glass (only the sharp points remain clearly visible) are then superimposed to recreate the solidity of the model.

In practice, it was almost impossible for Louis Lumière to do this with a normally functioning lens, even open to f/2: the discrimination between sharp and blurred was not good enough. He therefore devised two methods (one with two inverting prisms linked to the lens was apparently not used). The method adopted is based on the following principle: when the sharp image of points on the object plane forms on the image plane (the other points, outside the object plane, have a blurred image) moving the lens parallel to these two planes leads to movement of the whole image on the image plane. However, the points on the object plane all move the same distance, whereas the out-of-focus points undergo an additional translation which is greater the farther away they are from the object plane (in front or behind it). Consequently, if the sensitive surface receiving the image moves by a suitably calculated distance in co-ordination with the lens movement, all the sharp points have a stable position on the surface and the other (unfocused, blurred) points are moved. This lens movement takes place during the exposure, and as a result, points that are already blurred (represented by a circle of diffused light) are blurred even more, leaving a trace that lengthens as the object points of which they are the image become more distant from the chosen object plane.

To create this effect, the lens moves in a circle while remaining in a plane parallel to the object and image planes: on the image, the sharp points remain clear, while all the others describe a circle whose radius is in direct proportion to the distance of each object point from the plane being focused on. This device is therefore designed to retain all the sharpness of all the points on the focused plane whilst greatly accentuating the blurring of points lying outside this focusing plane and further diffusing the light emitted from them over a ring-shaped, circular trajectory. This causes extreme 'dilution' of the image of areas in front of or behind the sharp object plane.

The special camera developed by Louis Lumière for this technique comprises a

146

camera body mounted on a track (focal distance 21 cm) which, for each of the six or seven shots of different object planes, moves one centimetre (for the three front planes) or two centimetres (for the rear planes). The focusing remains constant (this camera was intended for portrait work and vertical sections passing through the nose, eyes, ears, etc.). The circular movement described by the lens or by the baseboard supporting it (with a radius of 4 cm) is obtained by turning a crank and pulley device; this rotation is transmitted to multiplier cranks, then other co-axial, low-speed cranks impart a co-ordinated rotation of 6 cm radius to the frame carrying the sensitive surface. The synchronous rotation of lens and image plane takes place during the photographing of each plane.

The negatives obtained (on a 1:2 scale in this configuration where the lens-object distance is double the lens-image distance) are printed as positives on glass (slides) by enlarging to natural scale with a very low density 'so that, when superimposed, these transparent images form a composite image whose total intensity is that of an ordinary slide'.[2] The glass plates are placed one behind another at the same distance as the original object planes, then mounted in a wooden frame and backlit. The whole thing must be viewed along the shooting axis, perpendicular to the planes of the images and at a 'suitable distance'. Under these conditions, 'the three-dimensional impression is absolutely striking'.[3]

Lumière's work with 'photostéréosynthèse', which was limited to portraiture, seems not to have produced many examples and its use was in any case confined to family and friends. Coustet notes its application to microscopy by F. Bastin[4] but there is no known example of this. The difficulties inherent in the long exposure, the successive shots, the need for the subject to remain still, the viewing requirements and the high cost must have been a deterrent to the widespread use of this process which was not marketed despite the ingenious nature of the device.

Louis Lumière, **Portraits of Auguste Lumière, stages in 'photostéréosynthése'**, c. 1920
Gelatin silver prints; each print about 24 x 18 cm.

Coll. Institut Lumière, Lyon.

Here there are nine prints whereas six or seven glass plates usually constitute a definitive work. Auguste Lumière, elder brother of Louis, was one of the most · photographed models of the 'photostéréosynthèse' process.

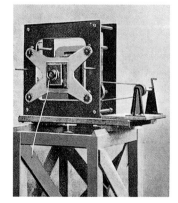

Photograph of the camera used in 'photostéréosynthèse', before 1945
Published in Raymond Lecuyer, *Histoire de la Photographie*, Baschet et Cie, Paris, 1945, p. 289.

Coll. Musée Carnavalet.

This camera seems to have been lost. Today it is known only from drawings and photographs.

1. *Les comptes rendus de l'Académie des Sciences*, 8 November 1920, Vol. 171, p. 891ff.
2. Ernest Coustet, *La photographie stéréoscopique en noir et en couleurs*, Charles Mendel, Paris, no date, p. 221.
3. *Ibid.*, p. 221.
4. *Ibid.*, p. 223 (a fly).

Louis Lumière, **Auguste Lumière (1862–1954)**, 1920s
'Photostéréosynthèse', 7 gelatin silver photographs on glass;
mount 24.2 x 18.5 x 4.2 cm.

Coll. Bibliothèque Municipale de Lyon, catalogue no. P002-05652.

148

Louis Lumière, **Jules Carpentier (1851–1921)**,1920s
'Photostéréosynthèse', 7 gelatin silver photographs on
glass; mount 41.2 x 31.3 x 9.0 cm.

Coll. Bibliothéque Municipale de Lyon.

Jules Carpentier, a graduate of the École Polytechnique,
specialized in the manufacture of precision components
for optics and electricity. It was he who mass-produced
the Lumière 'cinématographe'. He is perhaps the
Jules Carpentier who registered several patents in
1893 and 1895 for stereoscopic systems.

Louis Lumière, **Yvonne Lumière (1907-1993)**,
1920s
Photostéréosynthèse, 5 gelatin silver photographs on glass;
mount 41 x 31 x 9 cm.

Coll. Musée Français de la Photographie, Bièvres.

'Photostéréosynthèse' photographs of this period were
always presented in the form of a box containing the glass
plates making up the image.

Louis Lumière, **President Alexandre Millerand
(1859–1943)**, 1920s
'Photostéréosynthèse', 7 gelatin silver photographs
on glass; mount 41 x 31 x 9 cm.

Coll. Joachim Bonnemaison.

Former Paris lawyer, then government minister from 1899,
Alexandre Millerand was elected president of the Republic
in September 1920. He was forced to resign in June 1924.

Louis Lumière, **Yvonne Lumière (1907–93)**, 1920s
'Photostéréosynthèse', 5 gelatin silver photographs on glass;
mount 24.5 x 18.3 x 4.7 cm.

*Coll. Bibliothèque Municipale de Lyon, catalogue
no. P0002-05655.*

This portrait of Louis Lumière's daughter is the only known
profile view in 'photostéréosynthèse'.

Pierre Arthur Camille Cardin, **Bust of Monsieur Sueur**, 1910
Plaster on wooden base. Inscribed in French and signed: '476 Cardin no. 3/bust of Sueur/a gift from the sculptor in 1910'; 31.0 x 22.5 x 15.10 cm.

Coll. Société Française de Photographie, catalogue no. 476-3.

Anonymous, **Cardin with one of his photosculptures**, 1907
Autochrome on glass; 11.8 x 9.0 cm.

Coll. Société Française de Photographie, catalogue no. 476-8.

Here, Cardin poses in the studio of the Société Française de Photographie in front of the bust of one of its members, Georges Roy. Behind the sculpture, at the foot of the stand, are two of the four photographs required for the creation of the photosculpture.

Pierre Arthur Camille Cardin, **Patent for 'Photosculpture'**, 1906
Printed plate, 28 x 32 cm, part of patent no. 370,820, registered on 15 September 1906.

Coll. Institut National de la Propriété Industrielle.

Cardin created 'three-dimensional busts, statues and medallions . . . from four instant photographs taken on a single plate and by a single lens'. In 1912 he tried to market his process in Paris by setting up an association to raise the necessary finance. The price for 'half life-size portrait-busts' was set at 225 francs, the production cost being estimated at 100 francs, including a week's work to make each one. Cardin estimated that to cover his annual expenses of 12,500 francs, he would need to make 100 busts.

Photosculpture
1900-1930

Following François Willème's inventions (see chapter 1), new photosculpture processes were developed at the beginning of the twentieth century. Around 1912, Pierre Arthur Camille Cardin from Nantes tried to commercialize his sculpture method, which was based on four photographs. He created 3-D portraits and envisaged his process being applied to making busts of celebrities and reproducing works of art.

Claudius Givaudan from Lyon (1872–1945), a friend of the Lumière brothers, photographed well-known personalities in his circle in order to create bas-relief portraits. Givaudan was an engineer and worked in a wide number of spheres. Photosculpture seems to have been his only invention in the field of photography.

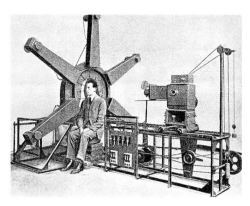

Claudius Givaudan, **Camera for Givaudan's photosculpture**, 1926

Illustration from the article 'Photosculpture et photostéréotomie (Procédés C. Givaudan)' in the *Bulletin de la Société française de photographie*, July 1926, p. 199.

Coll. Société Française de Photographie.

Givaudan presented his 'photostéréotomie' process to the Société Française de Photographie on 25 June 1926. His camera was described in patent no. 592,163 registered on 1 December 1923, in which he acknowledges the contribution of the German Willy Selke, who invented a similar device in 1898 (patent no. 281,387) 'in which the subject is lit in successive bands of light. These sections are reproduced on supports and give three dimensions when stacked'. In Givaudan's system the lighting mechanism surrounds the subject and 'moves with each photograph, by a distance equal to the thickness of a section to be produced' (Givaudan, *op. cit.*, p. 199). Today the device is preserved in the Musée Nicéphore Niepce in Chalon-sur-Saône.

Claudius Givaudan, **Series of profiles of Édouard Herriot (1872-1957)**, 1920s

69 metal plates; overall size 18.3 x 13.5 x 1.0 cm.

Coll. Musée Nicéphore Nièpce, Chalon-sur-Saône.

Each photographic profile is transferred onto a thin sheet of metal. These plates, identified by holes, are assembled to reconstitute the shape of the subject. This is then used as a mould for creating the sculpture.

Claudius Givaudan, **Photosculpture of Édouard Herriot (1872–1957)**, 1920s

Plaster sculptures; 25.5 x 17.3 cm

Coll. Musée Nicéphore Niepce, Chalon-sur-Saône.

After the first mould has been made, the traces of the strips of metal used to make the mould are removed. Édouard Herriot was also a subject for Louis Lumière's 'photostéréosynthèse' method.

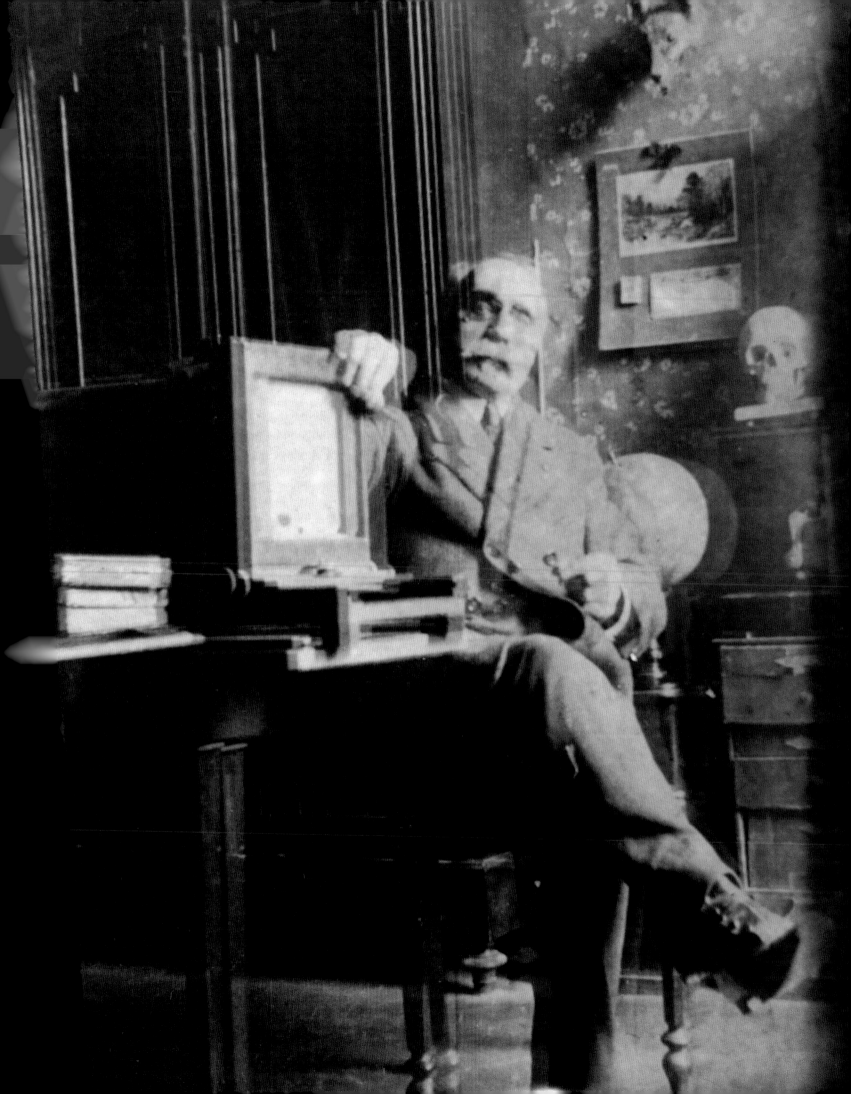

Line screen systems

Michel Frizot

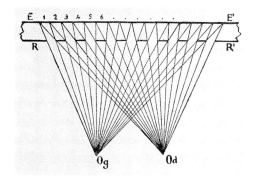

3-D vision using a line screen system, before 1930
Illustration from Eugène Estanave, *Relief photographique à vision directe. Photographies animées et autres applications des réseaux lignées ou quadrillés*, F. Meiller, Vitry-sur-Seine, 1930, p. 25.

Coll. Gérard Lévy.

Eugène Estanave, **Self-portrait with a camera**, after 1907
Gelatin silver photograph and vertical line screen on glass; mount 18.1 x 13.0 cm.

Coll. Gérard Lévy.

Eugène Estanave worked with the French physicist Gabriel Lippmann, who made a name for himself by inventing in 1891 a process for colour photography based on interference, for which he won the Nobel Prize for Physics in 1908. That same year Lippmann presented to the Académie des Sciences (of which he had been a member since 1883) the principle of 'photographie intégrale', a 3-D photography technique based on the use of a spherical-lens screen.

Lippmann invited Estanave to work with him in his laboratory at the Sorbonne and supported his work, presenting it to the Académie des Sciences. Estanave, who regarded Lippmann as his mentor, worked on the practical realization of 'photographie intégrale'.

On the walls in the background of this portrait, a fox's head and a skull can be seen. These were objects photographed by Estanave in other images using the line screen system.

Line screen systems belong to a group of 'direct-vision' three-dimensional techniques. In other words, they do not use a special viewing device (such as a stereoscope). However, this direct vision still requires a suitable optical system (line screen), in this case placed extremely close to the image surface.

Eugène Estanave (b. 1867), who was responsible for numerous developments in these techniques in France, recognized that in 1896 the engineer A. Berthier was the first to make these systems known.[1] Estanave also stressed the early contribution made by Frederic Ives, from Philadelphia, with his Parallax Stereograms of 1903 that were presented to the Académie des Sciences in Paris in 1904.[2] Other researchers employed the line screens in Europe but Estanave, a mathematician and physicist, developed them systematically and very rigorously from 1904 until devoting a book to them in 1930.[3]

As with stereoscopy and anaglyphs, three-dimensional photography with a line screen is based on the property of binocular vision to create the impression of relief, provided each eye is given the possibility of seeing a differentiated image more or less corresponding to binocular parallax. This is how it was explained by Estanave : if one starts with a typical stereoscopic pair (one image intended for the left eye, and one for the right) and cuts it up into vertical strips, a new image can be made by alternately sticking together the first strip from the first image and the second from the other image and so on. The resulting image is 'composite': it contains the original parallax information, but mixed together. If a screen made of alternating opaque and transparent strips of the same width is placed a short distance in front of this composite image to mask every other strip and is designed so that the strips from the first image are visible to the left eye and those from the second image can be seen by the right eye, the brain combines the two and reconstructs a three-dimensional impression. Although each image has had half of its real surface removed, a feeling of continuity remains and, the narrower the strips, the more so. Effectively putting this principle into practice therefore involves creating a composite image with eighty to one hundred strips per centimetre.[4] The masking is done with a line screen of the same resolution, produced by photographic reduction of a drawn screen.

In order to obtain the precise alternating image directly on the light-sensitive plate, Estanave proposed a kind of 'reversible' system. He used a wide lens (10–12 cm diameter) covered by a card in which two holes had been made and that acted as the aperture (the whole arrangement behaves as if there were two lenses). Two images formed in an unordered way. In order to restore order a line screen is interposed very close to the light-sensitive surface so that the minute strips, masked by the rays coming from the left hole are unmasked as far as the right hole is concerned (the two holes are on the same horizontal axis and the lines of the screen are vertical). Exposure lasts twenty-five to thirty seconds for one-centimetre apertures.[5] A positive image on glass is contact-printed from the negative and mounted so that it can be backlit through a screen identical to the initial one and that is placed at the same distance from the surface of the composite image as when the picture was taken. The relief is 'striking'. Viewing is not difficult, provided one's eyes are centred over the image, which is helped by blocking off the surrounding space with a wide neutral frame. 'You have to want to see, the brain plays a big role', Estanave.

154

The use of line screens is not confined to creating a three-dimensional impression. Estanave also developed another application, 'changing or animated photographs': the two images are obtained consecutively and can depict a subject in two different poses (eyes open – eyes shut, for instance). This time the apertures are on the same vertical axis and the screen lines are horizontal. By slightly tilting the whole plate-screen arrangement, one moves from one image to another, causing the model's pose to change and giving the impression of animation.

Understandably, one of the greatest problems is how to align precisely the composite image with the line screen placed between the image and the eyes, so that only the appropriate parts are masked alternately to each of the eyes. In 1908, Estanave solved these problems by presenting a special photographic plate integral to the screen – the 'plaque autostéréoscopique' (autostereoscopic plate). He also proposed a screen with vertical and horizontal lines, which used with using a four-aperture lens combines three-dimensional and changing images, as well as a special stereoscopic screen for projections.

Estanave concentrated on scientific research and did not market his processes. From the 1920s onwards, line screens gave rise to a lot of humorous and advertising imitations, as well as children's toys, in France and abroad.[6] In the 1930s, Maurice Bonnet made use of this technique in his research on three-dimensional images. He probably marketed line-screen portraits through La Relièphographie, the name of the company he set up in 1937 to develop production of lenticular screen images.

1. *Le Cosmos*, 26 May 1896, pp. 229–31.
2. 'La stéréoscopie sans stéréoscope', *Les comptes rendus de l'Académie des Sciences*, 24 October 1904, Vol. 139, p. 621.
3. Eugéne Estanave, *Relief photographique à vision directe. Photographies animées et autres applications des réseaux lignés ou quadrillés*, F. Meiller, Vitry-sur-Seine, 1930.
4. *Ibid.*, p. 25.
5. *Ibid.*, p. 37.
6. *Ibid.*, pp. 137–39 : Estanave complains that his friends delight in showing them to him. These are 'changing' rather than three-dimensional images.

Maurice Bonnet, **Portrait of a man**, 1937–39
Gelatin silver photograph and vertical line screen on glass, placed inside a wooden and painted-metal light box, with a light bulb and electrical plug. Plaque in French on the back of the box: 'LA RELIEPHOGRAPHIE/PHOTOGRAPHY IN THREE DIMENSIONS/MAURICE BONNET PROCESS/RUE TOURLAQUE – PARIS'; image 40.0 x 2.9 cm, frame 51.4 x 37.6 x 20.6 cm.

Coll. Michel Frizot.

La Relièphographie, the company founded by Maurice Bonnet, began its activities in 1937. This portrait is probably one of its earliest productions. Today only one other image using a line screen by Maurice Bonnet is known. This is a portrait of his older brother André with a dog, in the 1930s. After 1939 the company specialized in images using a lenticular system.

La Relièphographie plate, 1937–39
Metal plate fixed to the back of the light case for the above line screen portrait.

A line screen image normally has a 3-D effect without needing any other devices other than the screen placed on the image. To reproduce these works, they were photographed from two different angles so as to reconstitute the 3-D effect through stereoscopy.

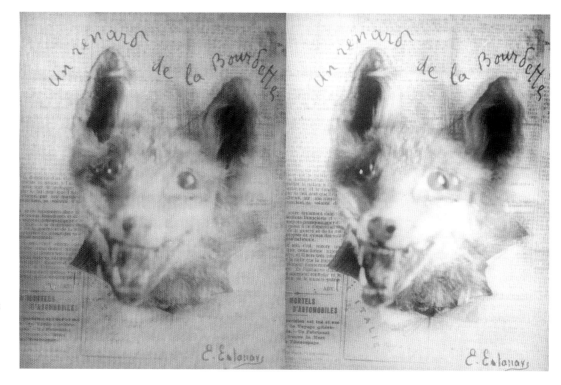

Eugène Estanave, **'Un renard de la Bourdette'**, 1905
Gelatin silver photograph on glass, vertical line screen on glass. Handwritten inscriptions on the image in French: 'A fox at La Bourdette'; 'E. Estanave'; mount 12 x 9 cm.

Coll. Gérard Lévy.

Eugène Estanave, **Wire Loop**, c. 1908–09
X-ray on glass, vertical line screen on glass; mount 18.0 x 24.0 x 0.5 cm, image 9.4 x 13.8 cm.

Coll. Gérard Lévy.

In 1906 Estanave patented a 3-D line screen X-ray process: 'The invention is a device making it possible to create a three-dimensional effect for bodies that are impermeable to X-rays, and thus to project the images onto a screen specifically designed for the three-dimensional projection of X-rays.' (Patent no. 370,470). The system involves a line screen made from a series of taut wires and two light sources. In 1908 in the *Comptes Rendus de l'Académie des Sciences* (Vol. 146, p. 1431), the scientist Gabriel Lippmann 'attached a particular importance to Monsieur Estanave's application of this process to the principles of X-raying. Monsieur Estanave showed him the X-ray of a wire loop which had an excellent three-dimensional effect. This application is worth developing, as it is clearly of such a nature as to be able to improve significantly the use and scope of X-ray techniques.'

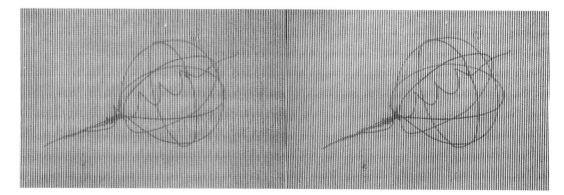

156

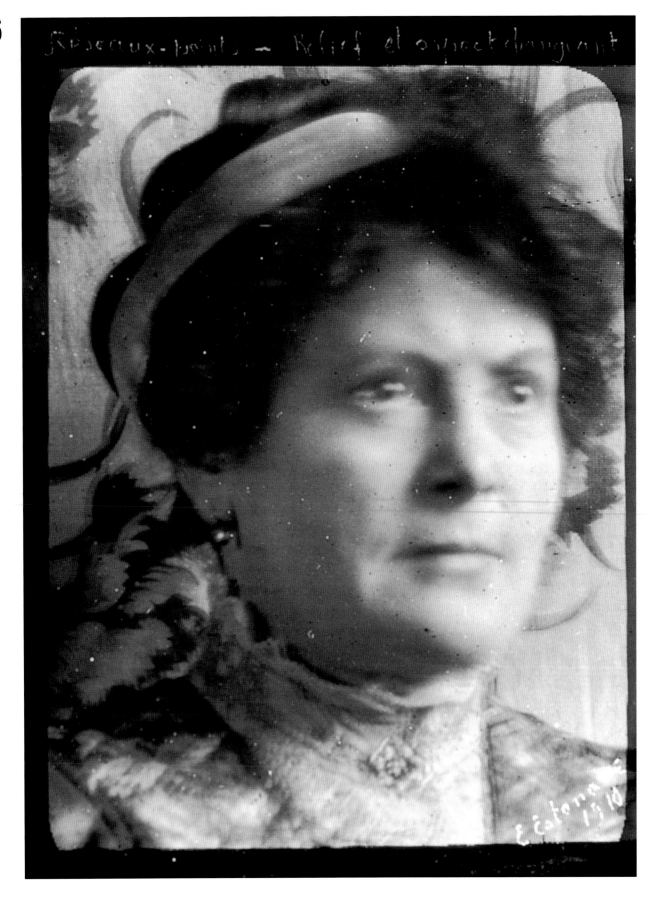

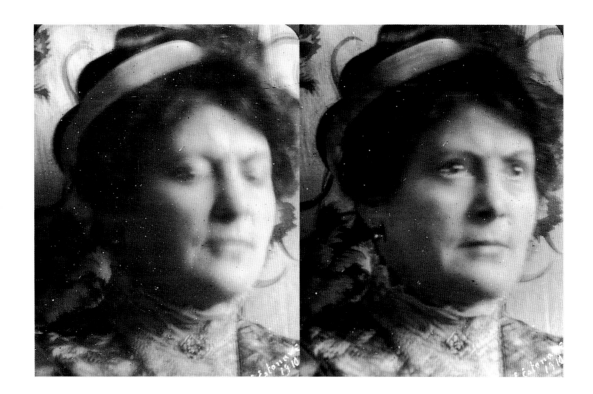

Eugène Estanave, **Portrait of a woman opening and shutting her eyes**, 1910
Gelatin silver photograph on glass, cross-hatched line screen on glass. Handwritten inscription in French on a label on the mount: 'The three-dimensional effect of the changing expression is obtained by staring intently from around 30 cm and raising the head slightly./Homage to the Société Française de Photographie E. Estanave'. Handwritten inscription in French engraved under the protective glass: 'Dot screen 3-D and changing effect'; 'Estanave/1910'; label handwritten in French under the protective glass: '3-D and changing effect – the four images are made up of 691,000 dots'; frame 18.0 x 13.3 x 0.5 cm.

Coll. Société Française de Photographie, catalogue no. 859/12.

This image has a cross-hatched line screen, combining the possibilities of a vertical screen (3-D effect) and a horizontal screen (changing effect). It is made up of four different images: two to show the woman in three dimensions with her eyes open, and two to show her in three dimensions with her eyes shut. This process was patented by Estanave on 3 February 1910 (addition to patent no. 392,871) and presented to the Académie des Sciences the following month.

Anonymous, **Stereoscope in the shape of a chalet**,
nineteenth century
Wood, with music box, for 8.5 x 17.5 cm format views;
lighting by means of a shutter at the back, roof lifts to open;
34 x 20 x 23 cm.

*Coll. Cinémathèque Française, Collection des Appareils, catalogue
no. AP-95-1647.*

A stereoscope in the shape of a chalet was the subject of a
single patent, no. 40,992, registered by Jean-Baptiste Robert
on 12 May 1859.

The inventors of 3-D photography in France: patents 1852–1922

Kim Timby

Stanislas Théodore Pailleux, **Multiple Stereoscope**,
1854

Ink drawings with gouache. Detail of patent no. 19,287,
registered on 7 April 1854; sheet 50.2 x 40.4 cm.

Coll. Institut National de la Propriété Industrielle.

Pailleux, a Parisian photographer, invented a stereoscope in
the shape of a dodecagon with a pair of eyepieces on each
of its twelve sides. Inside, another dodecagon revolving
'around the stand which served as its central axis', was
fitted with a stereoscopic view on each side.

It is hard to know what 3-D photography would be without the inventors; those with
enquiring minds who designed the 'honoïroscope', the 'omniscope', the 'Quinéoscope'[1],
the 'stéréochromoscope', the 'strobostéréoscope' and the 'verascope', or who invented
'photostéréosynthèse', 'stéréoptométrie', the anaglyph, the autostereoscopic plate, the
'bichromatype', photographic statuettes, glasses with magnetic shutters, the cigar-case
stereoscope and the phonograph-stereoscope. Today the term '3-D photography'
covers a multitude of techniques. Over time, a succession of new devices have been
invented: stereoscopes which are lighter, more attractive, easier to use, that can be
adapted to different types of vision; stereoscopes for larger or smaller images; faster
cameras that can take many views at the same time or which are specially designed to
take moving images; alternating, bicoloured, or prismatic glasses for viewing images on
screen; even special screens which are meant to create a three-dimensional effect on
their own.

The different objects, techniques and periods in '3-D photography' are often studied
individually, whereas the patents make it possible to analyse this phenomenon
historically. A patent is the official registration – for which a fee is charged – of an
invention; it enables inventors to protect their ideas and prove that they were the
originators of a technique or object on a specific date.[2] The French patent consists of
a detailed description of the invention (written and usually illustrated), and the inventor's
full name and address (or the name and address of the organization representing the
inventor). Valid for fifteen years, it remains on record and can be consulted.[3]

In examining all the inventions that aim to reproduce a three-dimensional effect using
the photographic image, no judgement has been made on their actual effectiveness.
The period in question spans seventy years (about half the history of 3-D photography[4])
and falls into three fairly clear-cut historical periods.

Léon & Lévy, **Device with hinged frames holding
stereoscopic photographs**, 1865

Ink drawing with gouache. Illustration of patent no. 69,156,
registered on 24 October 1865; 38.5 x 58.9 cm.

Coll. Institut National de la Propriété Industrielle

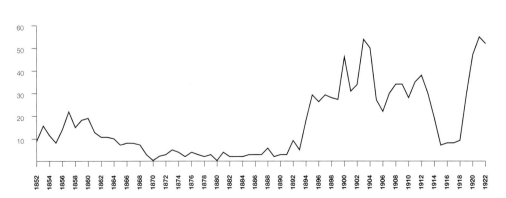

Number of patents registered per year from 1852 to 1922

160 Professional stereoscopy: from 1852 to 1869

The first patent for 3-D photography dates from 1852 and describes a stereoscope. It marked the birth in France of a new industry which rapidly expanded. The main instigators were photographers, printers, engravers, painters, cabinetmakers, picture framers, opticians, artists, publishers of prints or photographs, case makers, engineers, professors, chemists, doctors, shopkeepers, clockmakers, merchants, manufacturers of toys or albums, mechanics, enamellers, photography accessories salesmen, etc.[5] They did a great deal of work on the stereoscopes (70%), but also on new presentations and special effects for the images (20%) and on the techniques or cameras for taking the pictures (12%).

Different types of stereoscope[6] were soon invented: initially devices in which each image was inserted manually one after the other, then larger stereoscopes containing numerous views. In 1854, Stanislas Théodore Pailleux was the first to patent this latter type of invention, with a unit comprising as many pairs of eyepieces as views (no. 19,287), but subsequent patents mainly used one pair of eyepieces behind which passed a series of views. These were attached to a cylinder (first patent in 1856, no. 27,952), mounted on rollers (first patent in 1857, no. 33,085), or at right angles to a continuous chain. For this latter type of mechanism, the American Louis Beckers was responsible for the first French patent (1857, no. 34,522); this is interesting to note, as this type of viewer is still frequently called the 'stéréoscope américain' in France.[7]

Many inventors wanted to improve the stereoscope by, for example, making it easier to carry (many collapsible models were invented[8]) and by simplifying its mode of operation (the eyepieces were adjusted to suit individual vision and multiple-view stereoscopes avoided the need to change the views manually). Others worked on refining the object's appearance and produced models that looked like miniature jewellery boxes, that were in the shape of a chalet, a pair of glasses or a book, or that were quite simply more pleasing to the eye.

The inventors also focused their attention on the stereoscopic images themselves. Many were interested in the 'special effects' that could be obtained by playing with colour, transparency and light. Here, the inspiration was obviously drawn from Daguerre's Diorama, which predated the stereoscope. Pierre Henri Amand Lefort was the first, in 1855, to provide a detailed description of various stereoscopic images on translucent paper (tissue views) that boasted day-and-night lighting effects; this was in a certificate of addition to his patent for the 'polyorama panoptique', an optical box reproducing the effects of the diorama (for which, in 1853, he introduced a stereoscopic version[9]). In 1857 Adolphe Félix Gentil-Descarrières and Louis Stanislas Gadault baptized similar technical innovations respectively 'dioramic' (no. 30,406) and 'stereoscopic polyorama' (no. 32,407). Other inventors, making frequent use of these adjectives, designed processes for obtaining coloured views, for producing images or even types of stereoscope with coloured attachments for creating various effects on the images. A few inventors devised some new subjects for stereoscopy: advertising views (Charles Retournat, 1856, no. 27,952), paintings recreated in three-dimensional form (Jacques Albert de Courchant, 1856, no. 28,325), the portrayal of literary masterpieces (Prosper Bernard Godet, 1857, no. 33,612), images for scientific education (Moïse Lion, 1869, no. 86,635).

The patents of this period were often fairly wordy and provide a fascinating insight into the commercial status of stereoscopy. The need to lower the cost of images (more efficient cameras, simpler manufacturing processes) clearly appeared to be of major concern. In 1853 This, Soulier and Clouzard justified their new method of producing coloured views as follows: 'because high labour costs are detrimental to the sale of this product, we came up with the idea of creating the same effect by painting only one of these two images . . . but using colours which are twice as rich.' (no. 17,333). Louis François Saugrin confirmed this trend the following year: 'Those working with the Daguerreotype have been trying for a long time to find a system which could produce large numbers of images for the stereoscope in a short space of time, with a view to supplying them to members of the public and the trade at a lower cost.' (no. 19,651). He proposed a system that took several stereoscopic views at the same time.

But on the whole, only a few inventors were interested in the actual taking of the photographs. Systems using monocular cameras (the first methods were put forward by Louis Jules Duboscq in 1852) were patented as well as new devices with two lenses,

Adolphe Félix Gentil-Descarrières, **Method of making dioramic photographic prints suitable for use in stereoscopes and dioramas**, 1857
Stereoscopic tissue view, albumen print with cut-outs, gouache and coloured stickers. Illustration of patent no. 30,406, registered on 3 January 1857; images 6.1 x 13.1 cm.

Coll. Institut National de la Propriété Industrielle.

Louis Joseph Auguste Gérard, **Improvements for stereoscopes**, 1858
Ink drawing with gouache. Plate no. 16 of patent no. 36,806, registered on 31 May 1858; 17.0 x 25.5 cm.

Coll. Institut National de la Propriété Industrielle.

The Parisian photographer Gérard believed that the stereoscopes 'did not adequately reflect the changes that occur slowly and gradually in the natural world, shifting from the half-light of morning to the brightness of midday, when the sun is at its height, then on to evening, as the sky darkens, followed by night, illuminated by the moon that gives the picture an eerie quality.'

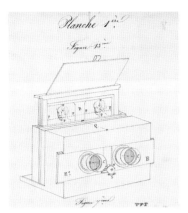

Alexandre Marie Quinet, **Quinétoscope**, 1854
Ink drawing. Detail of illustrations for patent no.
15,716, certificate of addition dated 7 January
1854; 54 x 69 cm.

Coll. Institut National de la Propriété Industrielle.

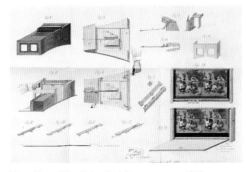

Victor Pierre Siès, **Animated Stereoscope**, 1859
Ink drawings with gouache, hand-coloured stereoscopic
albumen prints. Illustrations of patent no. 43,271, registered
on 19 December 1859; 38.7 x 58.0 cm.

Coll. Institut National de la Propriété Industrielle.

Victor Pierre Siès, a toymaker, invented this stereoscope in
which 'four apparently similar photographic illustrations falling
and rising can create the illusion of movement.'

the first of which was registered in 1853 by Alexandre Marie Quinet.[10]

On the sidelines of ordinary stereoscopy, a variety of more specialized inventions was developed. Some of these combined the effects of movement with a stereoscopic effect.[11] Several patents were concerned with panoramic stereoscopic views, others with the projection of stereoscopic views (although they did not explain how the three-dimensional effect was to be obtained). Finally, embossing and other direct methods of creating a three-dimensional effect (particularly superimposing glass plates) were used.

The eye of the hurricane: from 1870 to 1890

The years between 1870 and 1890 formed a striking contrast to the previous period. Very few patents were registered: only three per year on average, as opposed to twelve previously.[12] Strangely, around a quarter of the patents registered during this period concerned a new type of stereoscope: the stereographoscope, a device which combined two small lenses with one larger one. This type of viewer then disappeared almost completely from the patents.

The number of new inventions declined but stereoscopy continued to remain part of daily life, as can be seen by the remark below, made by an inventor in 1877. Adolphe Block justified his system of interspersing advertisements with stereoscopic views as follows: 'My system has the advantage of affording extremely widespread yet discreet publicity since the stereoscopes and the other devices I use not only appear in private drawing rooms, but also in the lounges of large hotels, bathing establishments, casinos and other very busy places.' (no. 116,745).

This rare and valuable account attests to the presence of stereoscopic viewers in public places. In fact, it was in this period that stereoscopes with a coin-operated mechanism were invented (the first patent to make specific mention of this feature dates from 1887, no. 187,512). This new approach was developed at the turn of the century with about fifteen patents in total, reflecting the fact that stereoscopy was sometimes a fee-paying entertainment.

This period also saw the appearance of the first shutters for stereoscopic cameras. Initially applied to two monocular cameras joined side by side (no. 144,042 in 1881), then the following year to binocular cameras[13], this invention, which made it possible to take faster pictures, coincided with the new photographic emulsions which were more sensitive, prepared industrially and sold ready for use. These new negatives were used in conjunction with smaller hand-held cameras which did not require a tripod. This development obviously transformed the nature of stereoscopic photography.

Manufacturers and enthusiasts: from 1891 to 1922

Two inventions from 1891 symbolize a diversification of and a renewed surge of interest in 3-D photographic techniques: anaglyphs and stereoscopic projection by means of alternating images. During the thirty years that followed, stereoscopy took on many forms; new types of 3-D images appeared on screen and on fixed media. From 1895, this multifaceted period of development went hand in hand with a dramatic rise in the number of patents registered (on average thirty-five per year, except during the war years). The wording of the patents also changed: they became more technical, contained less background information and, from 1902, were printed (as opposed to being handwritten or – rarely – typewritten).

As mentioned earlier, a new generation of stereoscopic cameras emerged and became available to a wider public. Shutters and systems for retracting the glass plates (which made the transition to the next negative easier) became more common and were tackled by specific patents. Cameras using glass plates were complemented by those taking film, and occasionally the same camera would offer both options. Some inventors – in a bid to facilitate the necessary transposition in stereoscopy of right-hand and left-hand views – designed cameras and stereoscopes which automatically inverted the views, or frames to do this while printing the photographs.

The period from 1900 to 1905 was particularly prolific. It saw the appearance of several inventions that were to enable an ordinary camera to take stereoscopic views: initially these were special attachments for a tripod, designed to guide the camera's movement over the recommended distance between right-hand and left-hand views, taken one after the other[14]. In the same vein, various inventors devised systems using prisms or mirrors that were to be placed in front of a lens in order to take the two views

Taber bas-relief syndicate, **Three-dimensional photographic image**, after 1895
Framed, embossed print; frame 27.5 x 32.7 x 0.7 cm.

Coll. Société Française de Photographie, catalogue no. 410–4.

This technique was patented by A. Freeman Taber on 11 November 1895 (no. 251,595). The stamp 'THE TABER BAS-RELIEF/PHOTOGRAPHIC SYNDICATE, Limited/16, Rue de la Rochefoucauld/PARIS', which appeared in English on the back of other images of this nature, suggests that these were sold in Paris. Various different processes for embossed photography were patented throughout the period 1852–1922.

Adolphe Guillaume Larauza, **Photographic Statuette**, 1866
Albumen print. Detail of patent no. 73,081, registered on 28 September 1866; photograph 17.2 x 10.5 cm.

Coll. Institut National de la Propriété Industrielle.

'Photographic statuettes' were made by gluing together portraits taken of the front and back of the subject and mounting them in a small mirrored kiosk.

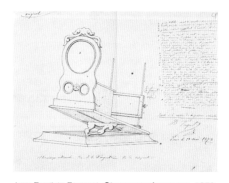

Jean-Baptiste Fouquet, **Stereographoscope**, 1873
Ink drawing. Detail of patent no. 99,450, registered on 14 May 1873; sheet 30.9 x 40.2 cm.

Coll. Institut National de la Propriété Industrielle.

Fouquet, a Parisian manufacturer of optical instruments, registered the first patent for a stereographoscope.

simultaneously. Multifunctional devices were all the rage and combined cameras were also invented to enable the photographer to take stereoscopic or panoramic views.[15] Given this climate, it is hardly surprising that a club for amateur photographers was founded in 1903: the Stéréo-Club Français.[16]

Inventors were now much more concerned with the 3-D images themselves than before 1890, and showed less interest in stereoscopes.[17] The main innovation with regard to the latter was a multiple-view stereoscope invented in 1896[18]: the views (on glass) were stored in a detachable grooved tray. This system, which was ideal for storing these fragile images, became as common as the system which organized views in a chain-driven mechanism. Jules Richard (1896) and the L. Gaumont company (1904) patented special presentations of the captions on the plates used in these stereoscopes.

An extremely promising innovation was 3-D photography in 'natural' colour. The first three-colour processes used in colour photography called for different devices to those used in black-and-white photography: coloured filters and three images led to the development of a range of specialized equipment. The first patent was registered by Camille Nachet in 1894 for a viewer called a 'stéréochromoscope' (no. 237,394). It was followed in 1897 by the first patent for a system for taking coloured stereoscopic views, registered by Louis Ducos du Hauron (no. 271,704).

Shortly after, the stereoscopic postcard made its appearance. During roughly the next ten years from 1899 onwards, various postcards and specialized stereoscopes were invented. Stereoscopic X-rays were introduced in 1907 and the patents dealing with this subject proliferated during the war years.[19] (The war also allowed one inventor to illustrate his application of 1917 with drawings of images showing a 'shrapnel ball lodged at the top of a thigh', no. 506,259.) Cartography also began to benefit from stereoscopic photography; after a first patent registered in 1911 (by the Carl Zeiss company), this field expanded considerably in the post-war years. Finally, several inventors put forward the idea of making sculptures based on a stereoscopic pair.[20]

With the birth of cinema, the 3-D patent record was transformed: from 1896 on, a quarter of patents are related to animated images. The inventors busied themselves with devising new stereoscopes for animated views. The first dated from 1896 and made it possible to view images on film and to take views (no. 254,869). A stereoscope containing a series of views seen one after the other on individual sheets, like a flip-book

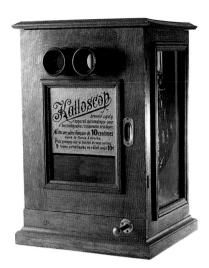

Anonymous, **The 'Kalloscop' Stereoscope, with coin-operated mechanism**, c. 1900
Wood, various metals; 50 x 34 x 30 cm.

Coll. Musée Français de la Photographie, Bièvres, catalogue no. 94.8750.

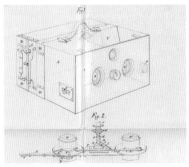

Eugène Hanau, **Stereoscopic camera, the 'Duplex'**, 1890
Ink drawings. Detail of patent no. 205,142, registered on 19 April 1890; sheet 44.2 x 41.4 cm.

Coll. Institut National de la Propriété Industrielle.

One of the first stereoscopic cameras with a shutter.

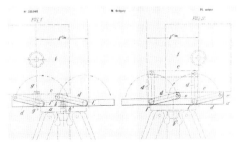

Bernhard Grégory, **New device enabling photographers to take stereoscopic views with ordinary cameras**, 1902
Printed plate. Detail of patent no. 325,940, registered on 29 October 1902; about 28 x 31 cm.

Coll. Institut National de la Propriété Industrielle.

(no. 266,424)[21], was invented the year after. These viewers continued to appeal to inventors until 1905–10, during which time they gradually died out.

It is at this point that 3-D projection really took off. The inventions may not always have produced the three-dimensional effect claimed by their creators,[22] but there was a great deal of active research in this field. The main areas of interest were:

– alternate projection of images in synchrony with the covering of each eye, a system for which the first patent was registered in 1891 by Désiré Bouchard (no. 210,569)[23];

– polarization, mentioned for the first time in 1892 by John Anderton (no. 224,813)[24];

– hand-held stereoscopes guiding each eye to right and left images projected on screen, the first model of this type being Paul Moëssard's stereo binoculars, patented in 1894 (no. 242,333)[25];

– as well as a fairly large number of projection screens which did not require the use of stereoscopic images and whose effect is hard to imagine (curved screens, multiple superimposed translucent screens, etc.).

All these systems were often suggested for both fixed and animated images. At the same time, many inventors were interested in recording cinematographic stereoscopic images. And finally, combining three major aspirations – three-dimensionality, movement and colour – a system for 3-D colour cinema was patented in 1911 by Willard Bradford Featherstone (no. 433,663), who advocated an anaglyphic system.

Although invented in the 1850s, the anaglyph was not patented for the first time until 1891 by Louis Ducos du Hauron in the form of printed images (no. 216,465). Only a few inventors followed his lead by offering these images on a fixed medium.[26] It was for projection – and more specifically for the cinema – that this process attracted many inventors, won over by the inherent potential of bi-coloured glasses. Edmond Fouché was the first, in 1892, to mention using the anaglyphic process on a screen (no. 225,696). He was followed during this period by about thirty others.[27]

3-D photography using a line screen process – which disposed of the stereoscope and glasses – was patented for the first time in France in 1904 by the Italian inventor Giorgio Belloni (no. 344,522), then by the American firm Ives Process Company (no. 346,286)[28], the Frenchman Eugène Pierre Estanave and others.[29] The first lenticular systems arrived on the scene shortly after, under the influence of Gabriel Lippmann's 'photographie intégrale' (not patented), presented to the Académie des Sciences in 1908. The first inventor to register a patent in France for a lenticular screen for three-dimensional photography is Rodolphe Berthon in 1910 (no. 430,600 and certificates of addition nos. 14,438 and 14,439). He also used the screen for colour photography, a domain that was to make increasing use of lenticular film. Berthon developed this colour process with the Keller-Dorian company, which in 1920 registered a single patent (no. 521,533) for creating 3-D images with lenticular film.[30] Patents for lenticular screens applied to the recording of three dimensions were very rare before 1922; only two others were registered, in 1912, by Walter Hess (no. 444,578) and by Louis Camille Chéron (no. 443,216).

When researching into French patents, the easiest way to access documents is by the name of the person filing for the application,[31] a system which favours known inventors. Patents are also subdivided into broad categories, but these are not detailed enough to pinpoint inventions in the field of 3-D photography.[32] For this study, it was essential to carry out a comprehensive inventory. The patents in all categories likely to relate to 3-D photography were read one by one in order to compile a complete list of all inventions, known or unknown. In this way, 1,200 patents registered over a period of seventy years were analysed.

Anyone can patent their own invention, whether it is followed or not by an application. For this reason, patents can throw light on new and original ideas. However, quite apart from individual inventions, these documents, taken together, attest to trends, inventors' motivations and the interaction between different ideas and techniques over a long period of time. Their study provides a valuable insight into the myriad ideas that gave birth to a wide range of inventions in the field of 3-D photography.

1. The 'quinéoscope' [*sic*] was in fact the same device as the one subsequently and widely called a 'quinétoscope'.
2. The label 'S.G.D.G.' ('sans garantie du gouvernement', without governmental guarantee) affixed to certain French devices indicates that they would have been patented.
3. French patents are administered by the Institut National de la Propriété Industrielle, 26 bis, Rue de Saint-Pétersbourg, 75008 Paris.
4. The analysis is based on an exhaustive inventory of French patents. This ongoing research was carried out with the help of a training and research grant from the Ministry of Culture and Communication. The comprehensive list of patents from 1852 to 1939 will be kept at the Association Patrimoine Photographique, 19, Rue Réaumur, 75003 Paris.
5. Inventors often listed their profession; this was only rarely the case in subsequent periods.
6. Mainly lenticular: a single stereoscope with mirrors (Étienne d'Artois, 1857, no. 33,286) was patented during this period.
7. The second, by the French inventor Charles Auguste Sandoz, points out that 'this idea has been discussed, then published in magazines, particularly in America.' (no. 39,024). The first use of the term 'stéréoscope américain' in patents appears to date from 1866: Jules Gustave Schiertz presented a 'stéréoscope français' which was 'designed, by its simplicity, to eliminate mechanical parts and, by lowering the cost price, to provide an inexpensive alternative to the American stereoscopes.' (no. 73,707).
8. Schiertz cites a commercial motive for his invention of 1853 (no. 17,563). Its 'subject is a stereoscope designed to be disassembled into two or several parts, so as to make the instrument more portable, simplify the packaging and facilitate transport or dispatch'.
9. Original patent registered in 1849, no. 7,974. A 'certificate of addition' can be registered at a later date to provide more accurate details or improve the invention.
10. For other binocular devices, see: Louis Cyrus Macaire, 1854 (no. 20,864); Louis François Saugrin, 1854 (no. 19,651); Joseph Benjamin Dancer, 1857 (no. 31,779); Henri Furne junior and Tournier, 1859 (no. 40,032); André Adolphe Disdéri, 1861 (no. 48,736); Henri du Mont, 1861 (no. 49,520); Nicolas Auguste Bertsch, 1861 (no. 52,182); Ernest Bernicard junior, 1863 (no. 59,838); Paul Garbouleau, 1867 (no. 78,335).
11. About ten patents were registered for animated views during this period. See the article by Laurent Mannoni in this volume, as well as: Louis Fleurus Gustave Petitpierre-Pellion, 1858 (no. 39,153); Victor Pierre Siès, 1859 (no. 43,271); Benjamin Victor Idjiez, 1861 (no. 49,332); Léon and Arthur Brin and Philippe Chenevée, 1864 (no. 62,755).
12. During this period there was also a general decline in the number of patents concerning photography.
13. Two patents during this period: G. David, 1882 (no. 151,925) and Georges Groult, 1885 (no. 169,144).
14. The first patent was by Adolf Hesekiel in 1901 (no. 314,488).
15. The first patent was by the L. Gaumont company in 1900 (no. 306,420).
16. See the article by Clément Chéroux in this work.
17. Stereoscopes formed the subject of 31% of the total number of patents for this period, as against 68% before 1890.
18. By Charlie Briggs and Frederick William Masters (no. 255,602), followed by Louis Joseph Emmanuel Colardeau and Jules Richard, 1899 (no. 285,184).
19. In the field of X-ray imagery various systems of direct stereoscopic observation (without photography) using line screen systems and alternating images were also registered.
20. Willy Selke, 1910 and 1921; Elizabeth Edith Townsend, 1922.
21. Nine patents for this type of object – a stereoscopic mutascope – were registered between 1897 and 1905.
22. A certain number of these patents describe systems which do not appear to be viable such as, for example, 3-D cinema by the simple projection of alternating or superimposed right-hand and left-hand images (without a device for separate viewing by each eye).
23. About twenty patents for alternating images were registered before 1922.
24. Few inventors followed him: Edmond Fouché, 1892; Boris Weinberg, 1908; Pierre Marie Gabriel Toulon, 1919; Lucien Pictet and Mario Cantoni, 1921 and Alexandre Théodorovitch Maximoff, 1922.
25. About twenty patents were registered between 1900 and 1922.
26. Maurice Binger, 1900, and Söderbaum, 1903, for anaglyphic viewers, then Emil Schönewald, 1904, for postcards with attached viewing glasses – as well as Régis Badin, 1922, with imitation anaglyphs (created from ordinary images).
27. Including Gaumont in 1909 and Pathé in 1914.
28. After his patent was registered in the United States in 1903.
29. Many patents were also concerned with using line screen systems to create the impression of motion without three-dimensional effects.
30. This link between 3-D lenticular systems and colour was no accident. The principle of the screen selector was developed in colour photography and 3-D photography during the same period; in both cases it enabled the photographer to take an image on a single plate. Many inventors researching 3-D photography using screen systems had formerly worked with colour. This is apparent in the patents concerning 3-D photography. For example, Chéron invented a three-colour process for taking stereoscopic views in 1908 (no. 396,040 and certificate of addition no. 10,512); Ives also worked with different colour processes in addition to 3-D line screen photography.
31. Annual indexes.
32. From 1853 the patents were arranged in twenty categories, which were in turn divided into subgroups from 1874. 3-D photography appears mainly in category 12/2 ('Precision instruments'/'Devices used in physics and chemistry', and later 'in optics' and 'in acoustics as well') and category 17/3 ('Fine Arts', later called 'Industrial Arts'/'Photography'), but also in category 17/1 and in different subgroups of category 18 ('Stationery' and later 'Office items and educational equipment') and in category 20 (a category which changed its name on several occasions, touching on various subjects not included in the other categories).

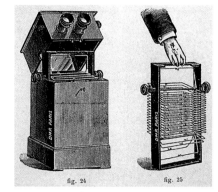

Multiple-view stereoscope, before 1907
Illustration from Achille Delamarre, *Pratique de la photographie stéréoscopique*, coll. Library of the magazine *La Photographie*, H. Desforges, Paris, 1907.

Coll. Société française de photographie, catalogue no. 1703A.

Some stereoscopes like this one, often called 'stéréoscopes américains' in France, had interchangeable chain units.

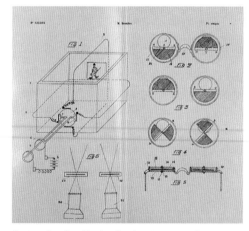

Gustave Bessière, **Device for the stereoscopic projection of fixed or animated views**, 1921
Printed plate. Detail of patent no. 533,542, registered on 28 February 1921; 27 x 31 cm.

Coll. Institut National de la Propriété Industrielle.

Bessière suggested the use of alternating images for three-dimensional projection. Spectators were given pairs of glasses with magnetic shutters which were remotely-operated from across the room 'by the electric field'.

Stereoscopic devices **165**

Jacques Périn

The Verascope

First model, 1893
Camera for taking stereoscopic views on glass plates
Jules Richard, inventor and manufacturer, Paris
Patent no. 211,909, 5 March 1891
Varnished oxidized silver-plated brass
5.5 x 14.0 x 11.0 cm.

f8/55 mm lenses
63 mm stereoscopic base
Cassette holding 12 glass plates, format 45 x 107 mm.

Coll. Musée Français de la Photographie, Bièvres, Catalogue no. 92/8417.

This camera, designed for amateur photographers, was the first in a series of seventy-eight different models, 52,000 of which were manufactured during the sixty years it was on sale. From 1913 it could be equipped with a special attachment for film. The range was enlarged by a further seven models providing larger image formats of 6 x 13 and 7 x 13 cm. The Verascope's popular commercial success can be seen by its record sales figures and unprecedented longevity.

Last model: the F40, 1939
Camera for taking stereoscopic views on flexible film
Jules Richard, inventor and manufacturer, Paris
Patent for the viewfinder system: no. 854,581,
7 January 1939
Brushed metal partially covered in black leather
8 x 17 x 6 cm.

Berthiot f3.5/40 mm lenses
65 mm stereoscope base
Shutter speed 1/250 of a second

Coll. Musée Français de la Photographie, Bièvres, Catalogue no. 92/8217.

Designed just before World War II, the F40 used a standard 35 mm cassette to take twenty-one stereoscopic pairs per film. Between 1938 and 1964, 5,000 of these 'top-of-the-range' cameras were produced. The F40 was regarded as the height of luxury in the world of 3-D photography and was exported to the United States as the 'Busch Camera'. It is still the leading model in this sector today.

The Leroy 'stéréo-panoramique' camera

Camera for taking stereoscopic views on glass plates
1905
Lucien Leroy, inventor and manufacturer, Paris
Patent no. 330,693, 18 March 1903
Black frosted lacquered metal
16 x 15 x 11 cm.

Dagor f8.5/80 mm lenses
5 shutter speeds and exposure times

Coll. Musée Français de la Photographie, Bièvres, Catalogue no. 68/987.

This camera's distinctive design made it one of the most original models of its generation. Entirely fashioned from metal, like many of its contemporary rivals, its striking originality resided in its characteristic platinum lens-holder which made it possible to take simple stereoscopic or panoramic views, according to preference. By covering each of the lenses in turn, it was possible to take simple 6 x 6 cm photographs on the same plate. By uncovering the two lenses, it was then possible to obtain a 6 x 13 cm stereoscopic pair. Finally, an ingenious turret system moved the left-hand lens into a central position, while the inner partition separating the right-hand and left-hand chambers retracted, leaving a single space extending over the entire photographic plate. By covering the right-hand lens, it was possible to take a panoramic view.

To make it easier to use this camera, a swivelling viewfinder enabled the photographer to control the angle of sight for each of these operations. This camera was undoubtedly one of the ancestors of the multiformat camera.

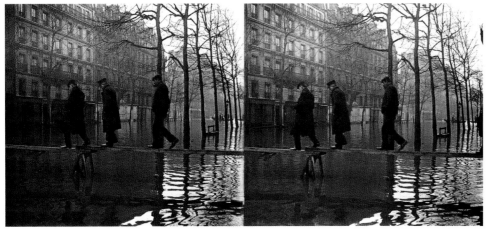

Lucien Cresson, **The Seine floods its banks, Avenue Ledru-Rollin**, 1910
Stereoscopic view, modern print from gelatin silver negative on glass; plate 9.0 x 17.8 cm.

Coll. Musée Carnavalet, Catalogue no. Ph 2437/35.

During this spectacular flood, the river followed the course of its former meander and flooded 720 hectares of Paris.

Anonymous, **A wedding, Boulevard Montparnasse**, 6 July 1914
Stereoscopic view, modern print from gelatin silver negative on glass; plate 5.9 x 13.0 cm.

Coll. Jacques Delamarre.

Family photograph depicting the wedding of Georges Delamarre, a Paris watchmaker and jeweller, in the church of Notre-Dame-des-Champs.

Chronology 1880-1940

c. 1880 Industrialization of the gelatin silver bromide process for producing photographic negatives on glass: this process reduces the exposure time and is easier than previous techniques.

1880 Opening of the Musée Carnavalet, the museum of the history of Paris.

1881 The population of Paris stands at 2,269,023. Jules Ferry introduces compulsory non-religious primary school education.

1882 Alphonse Bertillon introduces the use of the identity photograph in police records.
Inauguration of the new Hôtel de Ville, rebuilt after the old city hall was burnt down during the Paris Commune.

1883 Opening of the Lycée Fénelon, the first lycée for girls, on 22 September.

1885 *Étienne Jules Marey, stereoscopic views of the course taken by a man walking.*
A million people turn out for the state funeral of Victor Hugo, who is buried in the Panthéon.

1886 Georges Seurat, *Sunday Afternoon on the Island of the Grande-Jatte* ('neo-impressionism').

1887 Étienne Jules Marey, chronophotographs of birds in flight.
The fire at the Opéra Comique, caused by gas, leads to the widespread use of electric lighting.

1888 First cameras using film.

1889 Great Exhibition, 6 May–6 November: 61,720 exhibitors, more than 30 million visitors. Inauguration of the Eiffel Tower.
Henri de Toulouse-Lautrec, *Au bal du moulin de la Galette.*
First telephone directory.

1890 Beginning of industrial production of photographic paper.

1891 *Louis Ducos du Hauron, patent for printed anaglyphs, 15 September.*
Gabriel Lippmann, process for colour photography based on interference.

1892 *First French patent mentioning polarized stereoscopic projections.*
First reinforced concrete building in Paris.

1893 *Market launch of the verascope, a camera and stereoscope for stereoscopic views on glass plates.*
Car number plates introduced.

1894 Beginning of the Dreyfus Affair, 31 October.

1895 *After a quiet period of about fifteen years, the number of stereoscopy-related patents starts to increase again spectacularly.*
First public cinematographic presentation by Louis Lumière on 28 December at the Grand Café, on the corner of Boulevard des Capucines and Rue Scribe.
First X-ray photographs.

1896 *A. Berthier publishes the idea of 'direct vision' stereoscopy thanks to a line screen.*
First French patent for a new type of multiple-view stereoscope: the glass plates are placed in special trays.

1897 *First French patent for an animated stereoscope with views on individual sheets, operating like a 'flip-book'.*

1898 Emile Zola writes the front-page article 'J'accuse' in *L'Aurore* in defence of the Jewish Captain Dreyfus, unjustly accused of treason. The case gives rise to the creation of the International League of Human Rights.

1899 *First French patent for a stereoscopic postcard.*

1900 Great Exhibition, 14 April–12 November: 83,047 exhibitors, 50 million visitors. Inauguration of the Grand and the Petit Palais and the Pont Alexandre III bridge. Opening of the Paris Metro on 19 July, with line number 1, Porte de Vincennes – Porte Maillot. Hector Guimard designs the Art-Nouveau metro entrances. First cinematographic newsreels.

1902 First ever identification of a criminal from his fingerprints.

1903 *Foundation of the Stéréo-Club Français. At the age of nine, the photographer Jacques Henri Lartigue takes his first stereoscopic photographs in Paris.*

1904 *Presentation, on 24 October, of Frederic E. Ives's line screen system photos to the Académie des Sciences, brought back from the USA by Léon Gaumont.* First Renault motor-vehicle taxis. First Foire de Paris.

1905 First competition of 'heavier-than-air flying machines' at the Champ-de-Mars, on 11 February. Construction of the Gaumont film studios next to the Buttes-Chaumont park. The Chamber of Deputies votes to separate Church and State.

1906 *Eugène Estanave presents to the Académie des Sciences his initial research into line screen 3-D photos, on 29 October.* First motor omnibuses on the road, on 11 June.

1907 First public telegraphic transmission of a photograph, on 1 February, between Paris and Lyon, with a portrait of the French President Armand Fallières. Autochrome, a colour photographic technique developed by Auguste Lumière, goes on the market in June and meets with great success. Pablo Picasso finishes *Les Demoiselles d'Avignon* in his Paris studio.

1908 *Gabriel Lippmann presents the idea of 'photographie intégrale' to the Académie des Sciences, on 2 March: the first 3-D images using a lenticular system.* Birth of Cubism (Pablo Picasso and Georges Braque).

1909 First escalator at the Père-Lachaise metro station. First one-way streets, Rue de Mogador and Rue de la Chaussée d'Antin.

1910 *Eugène Estanave, line screen portrait of a woman opening and closing her eyes.* The rising Seine reaches its height on 29 January; the city centre is flooded. Opening of the Vélodrome d'Hiver stadium where sporting events and large meetings are held. Robert Delaunay, series of paintings of the Eiffel Tower.

1911 *First attempts by the photographer Léon Gimpel to produce anaglyphs on autochrome plates. First French patent for the use of stereoscopic views for cartography.* Opening of the Luna-Park funfair, Porte Maillot. Divided skirts shown for the first time at Auteuil, causing public outrage.

1913 The last horse-drawn omnibuses and trams withdrawn from 12 January.

1914 Assassination of the socialist Jean Jaurès, militant pacifist, on 31 July. Declaration of war on Germany on 3 August. Paris taxis requisitioned for the Marne, on 2 September, to halt the German advance on Paris. First German air raid on Paris. The Grand Palais is converted to a hospital.

1915 First issue of the anti-establishment magazine *Le Canard enchaîné.* Emergence of the literary and artistic Dada movement.

1917 Ballet Russe performances, with choreography by Léonide Massine, music by Eric Satie, set designs by Picasso and plot by Jean Cocteau, cause a public outcry. Guillaume Apollinaire talks of 'surrealism'.

1918 Bombing of Paris; sandbags placed around monuments to protect them. Armistice on 11 November, bringing the war to an end. The death toll in France is roughly 1,900,000. Jazz arrives in Europe.

1919 First regular flights between Paris and London. Deputies vote to dismantle the fortifications of Paris. Conversion of André Citroën munitions factory, Quai de Javel, into an automobile factory. The painter Joan Mirò moves to Paris.

1920 *Louis Lumière presents 'photostéréosynthèse' to the Académie des Sciences, on 8 November.* Alexandre Millerand becomes President, on 9 November. Signing of the Treaty of Versailles with Germany. Suntanned skin and the 'urchin'-style haircut become fashionable for women. Work begins on the demolition of Louis-Philippe's defence barrier.

1921 First radio programmes broadcast from the transmitter on the Eiffel Tower. The population of Paris reaches 2,906,472, the highest it has ever been.

1922 First traffic lights installed at some crossroads. Man Ray, *'rayographes'.*

1923 *Claudius Givaudan patents a photosculpture system called 'photostéréotomie'.* Le Corbusier's first large construction schemes in Paris.

1924 *Publication of anaglyphs in the magazine* l'Illustration. Gaston Doumergue elected President.

1925 *An anaglyphic projector for amateurs appears in the Gaumont catalogue. Eugène Estanave presents his images made using Lippmann's 'photographie intégrale' process to the Académie des Sciences, on 27 April.* International exhibition of modern decorative and industrial arts establishes a new style, 'Art Deco': 15 million visitors. First surrealist exhibition in Paris, at the Galerie Pierre.

1926 Louis Lumière presents the first talking film to the Académie des Sciences, on 18 October. The Paris mosque is completed.

1927 Abel Gance, *Napoléon*, first French 'talkie'.

1928 André Breton publishes *Nadja*. New Art-Deco building for the department store La Samaritaine, Quai du Louvre.

1931 International colonial exhibition 6 May–5 November: 33 million visitors.

1932 *Industrial manufacture of polarizing filters by the American, Edwin Land.* French President Paul Doumer assassinated, Albert Lebrun is his successor.

1934 Opening of the zoo in the Bois de Vincennes, on 2 June.

1935 *Louis Lumière presents improvements to the anaglyphic cinema to the Académie des Sciences, on 25 February.* Kodachrome film for colour photography goes on the market. First official television broadcast on 26 April. Husband and wife, Frédéric Joliot and Iréne Curie receive the Nobel prize for chemistry.

1936 *Maurice Bonnet uses his first camera for line screen images. L'Ami de Monsieur, a 3-D film by Louis Lumière, is released in Paris on 1 May at the Impérial cinema, Boulevard des Italiens. Invention of the 'vectograph', a polarized stereoscopic image, by the American, Edwin Land.* Mass strikes in Paris. Victory of the Popular Front in the elections; Léon Blum's government in power. The forty-hour week is voted in. Foundation of the Cinémathèque française by Georges Franju and Henri Langlois.

1937 International exhibition of arts and technology (Great Exhibition) 24 May–25 November: 11,000 exhibitors, 31 million visitors. Inauguration of the Palais de Tokyo and the Palais de Chaillot on the Trocadéro hill.

1938 *Invention of the View-Master stereoscope in the USA by William Gruber.* Wives no longer have to swear obedience to their husbands as part of the marriage contract.

1939 *Maurice Bonnet perfects the lenticular system on which he has been working since 1937. The resulting 3-D photographs are exhibited in public for the first time at the exhibition devoted to the 'Age of plastics'.* France goes to war with Germany.

3

**The modern age
1940-2000**

Maurice Bonnet/La Relièphographie, **Liliane Bonnet,
Maurice Bonnet's sister**, c. 1950
Lenticular screen photograph, gelatin silver print mounted
on glass (no screen); 29.8 x 24.3 cm.

Coll. Michèle Bonnet.

Lenticular screen systems and Maurice Bonnet's process

Michel Frizot

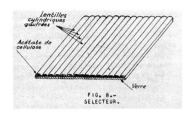

Diagram of a lenticular screen, 1942

Illustration by Maurice Bonnet, *La Photographie en relief, cours-conférences du Centre de perfectionnement technique*, no. 770, Maison de la Chimie, Paris, April 1942.

Coll. Société Française de Photographie, catalogue no. 4453.

Eugène Estanave, **Principle of Lippmann's 'photographie intégrale'**, 1930

Illustration by Eugène Estanave, *Relief photographique à vision directe. Photographies animées et autres applications des réseaux lignés ou quadrillés*, F. Meiller, Vitry-sur-Seine, 1930, p. 128.

Coll. Gérard Lévy.

The term 'photographie intégrale' was coined by Lippmann because it reconstructed the three-dimensionality of the image, as if the edges of the print 'were the frame of a window that opened onto reality'. The spherical lenses were designed to reproduce the relief of the image on a horizontal and vertical plane (unlike cylindrical lenses which only recorded it on a single plane).
From 1908 Eugène Estanave worked on the practical application of 'photographie intégrale', which Lippmann had been unable to complete due to the difficulties of manufacturing the screen. Lippmann is thought to have experimented with his technique using a 12-lens screen. In 1930 Estanave claimed to have succeeded using 95 lenses or 1,250 'pinholes pierced in a thin piece of cardboard'.

The development of 3-D lenticular photographs owes a great deal to the discoveries of Gabriel Lippmann (1845–1921), Estanave's mentor, and particularly to his 'photographie intégrale', presented to the Académie des Sciences in March 1908. This invention involves obtaining 'without a lens and without a camera, a multitude of photographs on a special plate which, when observed backlit, shows the observer not the multitude of recorded images, but a single image of the subject with its relief and variation, depending on the position of the observer'.[1]

Lippmann's special plate would be made up of lenticular spherules on one side, each one acting as a lens, and corresponding convex surfaces on the other side bearing the light-sensitive emulsion. By photographing onto this plate, without placing it in a camera ('each cellular system functions as a camera'), one gets as many images as lenses. After inversion from negative to positive, direct observation of the backlit plate makes a single image appear, 'because of the inversion of the rays of light'.

Maurice Bonnet (1907–1994) took up the idea of a linear lenticular screen, which had already been applied by other researchers such as Kanolt in Philadelphia and von Hess in Germany. In 1937 he set up the company La Relièphographie and improved the process by bringing it to a high degree of technical precision: 'The key element of the new technique developed by La Relièphographie is the optical selector, which looks like a sheet of glass with one of its surfaces finely lenticulated'.[2] The 'selector' is made up of a series of longitudinal (vertical) juxtaposed microscopic lenses, each one acting as a camera lens and forming an image at its focal point, where the light sensitive surface is located. The corrugated surface is then mounted onto a transparent support (a sheet of glass or plexiglass) placed in contact with the light-sensitive surface.[3] If the subject is moved (or the screen and plate are rotated around the subject), a number of different images can be recorded (up to thirty, according to Bonnet).[4] These images are combined in fine lines, almost blending and side-by-side, at the focus of each lenticular element – each 'line' is the image of the subject from a different angle. This optical system is reversible. If it is observed backlit and by binocular vision so that the recorded 'image' is viewed through the screen, the observer sees the subject three-dimensionally. In fact, whatever the position of the observer's eyes (on a horizontal line, given that the lines of the selector must always be vertical), he/she will always perceive a pair of different images, as in stereoscopy. If the observer moves, he/she sees the subject from a variable angle, going through all the shooting positions until returning to the first one, at which point the image appears to jump. Although only a tiny portion of the negative has been exposed, each lens focuses on its image line and the overall product is a perfectly continuous final image, which can, moreover, be photographed in its turn. The screen is made up of lenticular elements that are 0.4 mm wide with a 0.7 mm radius of curvature and a focal distance of 2.1 mm (total thickness of an optical selector with its transparent support); the aperture angle is 16°.[5] It is this corrugated selector, made of plastic and heat- and pressure-moulded on a high-precision recessed metal die, that is responsible for the high image quality obtained with Bonnet's process.

The recording method takes a series of photographs, either simultaneously or successively, depending on the type of device used. Originally, several normal photographs were taken from different angles and without a screen; then each of the views was rephotographed (taken as the subject) onto a single plate with

172

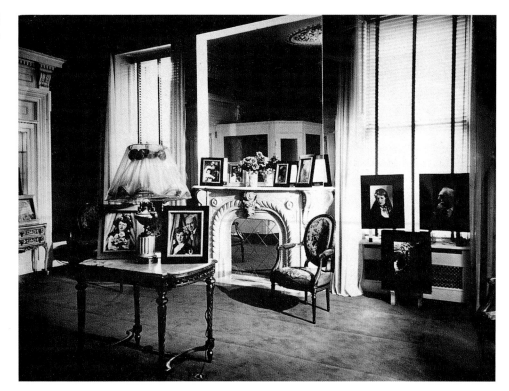

Anonymous, **Interior of Maurice Bonnet's studio
on the Champs-Élysées**, 1940s
Gelatin silver prints; each image 17.3 x 23.4 cm.

Coll. Michèle Bonnet.

Multi-lens camera for lenticular images, 1943
Illustration in Raymond Lecuyer, *Histoire de la photographie*,
Baschet & Cie, Paris, 1945, p. 290.

Coll. Musée Carnavalet.

The principle of this camera was established by Maurice
Bonnet in 1934, and subsequently improved, in particular with
this system developed in 1943. The twenty-six-lens camera
used a negative on glass (6 x 96 cm).

a screen. Subsequently, when creating images in the studio, the camera was mounted
on a rail forming the arc of a circle, the centre of which was the subject being
photographed. The camera moves while still aimed at the subject. At the same time,
a mechanical system has to keep the plate parallel to its starting position as it moves.
Recording is done continuously throughout the movement.

A multi-lens camera was also developed in order to avoid movement of the device
and make it possible to take instantaneous shots. This comprises twenty-six lenses
controlled by a single shutter and gives twenty-six separate and different images. The
negatives are placed back in the camera, backlit, then rephotographed one by one by
a movable rotating printer-reproducer that condenses them onto a single plate fitted with
a lenticular screen. Another type of camera uses a wide-span lens of almost the same
diameter as the plate and in front of which moves a small-aperture diaphragm (a similar
system to Estanave's), which in practice was replaced by a longitudinal slit allowing for
a single instantaneous shot. A central transverse portion of the lens is also sufficient.

For close-up photography, a classic camera with a negative with lenticular screen is
used, mounted on a turntable whose movement is synchronous with that of an identical
turntable on which the object to be photographed is placed.

Maurice Bonnet, who at one time assisted his photographer father, started his
research in 1934 and publicized his processes from 1939 onwards.[6] He set up his
company La Relièphographie in 1937 and in 1942 opened a portrait studio at 152,
Avenue des Champs-Élysées. In 1949 he worked for the Ministry of Defence, and then
created the Lenticular Film Laboratory (1961–1991) at the CNRS (National Centre for
Scientific Research), which was attached to the ANVAR (National Agency for Research
Development) in 1966.

Bonnet also produced advertising images, at first in black and white, later in colour
(Ektachrome 24 x 30 or 30 x 40 cm). In 1967 a company acquired the CNRS licence
for Bonnet's process and, under the name Relieforama, produced advertisements
(presented as Ektachrome images on internally lit boxes) and portraits but it ceased
trading in 1969.

In common with line screens, lenticular screens were able to combine two distinct
subjects, each from different angles, such as a person in two different poses. When
the observer moves, the subject changes from one pose to another, each one in 3-D –
this system was used for portraits and product advertising. It is also possible to abandon
the three-dimensional effect and make do with an animation based on two very simple
images (for producing key-rings, for instance). Bonnet's process found numerous
applications in astronomy, macroscopy, aerial photography, high-speed cinematography

Anonymous, **Camera for lenticular images**, 1945
Gelatin silver print; 21.7 x 14.9 cm.

Coll. Michèle Bonnet.

This camera, designed by Maurice Bonnet to take
snapshots, has a double row of lenses that work
simultaneously. Mirrors placed next to the lenses juxtapose
the images on a single negative. The same camera is then
used to project these images onto another light-sensitive
surface fitted with a screen in order to create the final
imbricated image. This camera was patented in 1945
(no. 945,440), but the principle of its operation was
developed in 1937.

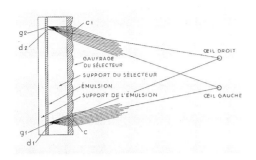

Diagram showing how a lenticular screen works, 1945

Illustration in Raymond Lecuyer, *Histoire de la photographie*, Baschet & Cie, Paris, 1945, p. 291.

Coll. Musée Carnavalet.

Maurice Bonnet and the lathe used to engrave lenticular screens, c. 1975

Lenticular screen photograph, colour slide, screen; mount 40.0 x 31.3 cm.

Coll. Michèle Bonnet.

Maurice Bonnet used a diamond to cut the copper plates that formed the matrices for his lenticular screens.

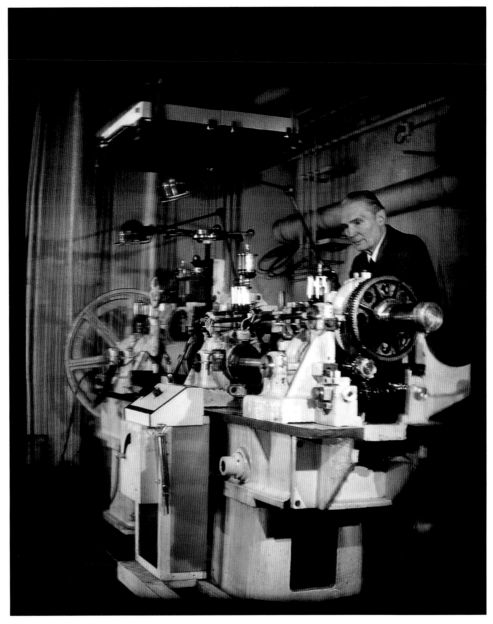

Maurice Bonnet on the cover of the French journal *Actu*, 17 May 1942

Coll. Michèle Bonnet.

and microscopy. It was the subject of numerous French and foreign patents registered after 1941, but it was also widely copied and plagiarized. In France and abroad, lenticular processes have been used since the 1960s for printing postcards – with one view or two changing views, with or without 3-D effects.

1. Eugène Estanave, *Relief photographique à vision directe. Photographies animées et autres applications des réseaux lignés ou quadrillés*, F. Meiller, Vitry-sur-Seine, 1930, pp. 116-117.

2. Extract from lecture notes of Maurice Bonnet, *La Relièphographie, Paris. Ses procédés de photographie en relief*, typed on 'Relièphographie' letterhead, Paris, no date, 14 pp. (author's collection).

3. Later, at the end of his career, the selector was placed directly in contact with the emulsion of the images.

4. *Ibid.*, p. 4.

5. *Ibid.*, p. 2.

6. Among the few surviving images produced by a lenticular system from his early career, there are a few black-and-white pictures of human injuries, in 30 x 40 format. Bonnet did, in fact, work for a time at the Inter-regional Centre for Maxillofacial Surgery, Eaubonne, which is probably where he took these disturbing images (author's collection); see the dissertation by Michèle Bonnet, *Entrelacs biographiques, Maurice Bonnet et la photographie en relief*, Université de Toulouse-Le Mirail, 1996, p. 195.

174

Maurice Bonnet/La Relièphographie, **Jeanne Bonnet,
Maurice Bonnet's mother**, c. 1944–50
Lenticular screen photograph, gelatin silver on glass,
fine superposed vertical and horizontal screens;
29.9 x 24.0 cm.

Coll. Michèle Bonnet.

The double screen creates a three-dimensional image
with the effect of movement (a smile) on the vertical plane.
Maurice Bonnet described the technique in a patent
registered in 1944.

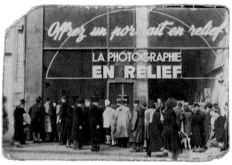

Anonymous, **Window of Maurice Bonnet's studio,
La Relièphographie, 152, Avenue des Champs-
Élysées**, c. 1942–45
Gelatin silver print; 5.7 x 8.6 cm.

Coll. Michèle Bonnet.

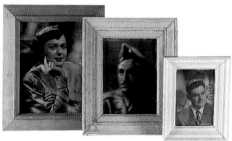

Chevojon, **Woman in Maurice Bonnet's studio**, 1940s
Gelatin silver print. Inscription in French stamped on the
reverse: 'PHOTO/CHEVOJON 9ᵉ CADET/PARIS'; 23.3 x 17.2 cm.

Coll. Michèle Bonnet.

In a lenticular screen image, the subject must be placed
at an exact distance from the camera to obtain the best
3-D effect. The camera body describes an arc as the shot
is taken, the central position of the subject having been
determined using a chain.

Maurice Bonnet/La Relièphographie, **3-D portraits**,
1940s–50s
Lenticular screen photographs, gelatin silver prints,
screens, frames; frames: 39.2 x 33.2 cm, 35.5 x 29.7cm,
25 x 20 cm.

Coll. Michel Frizot, Catherine Tambrun.

La Relièphographie produced and framed various sizes
of photographs.

Maurice Bonnet/La Relièphographie, **Françoise Bonnet,
Maurice Bonnet's wife**, 1948
Lenticular screen photograph, gelatin silver print mounted
on glass, screen; mount 30 x 24 cm.

Coll. Michèle Bonnet.

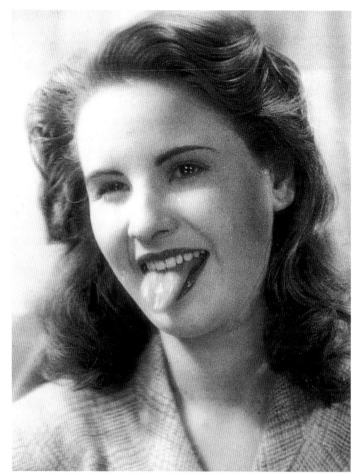

Attributed to Maurice Bonnet, **Woman sticking out her tongue**, c. 1944–50
Lenticular screen photograph, gelatin silver on glass,
fine superimposed vertical and horizontal screens;
30.1 x 24.2 cm.

Coll. Musée Carnavalet, catalogue no. Ph 20264.

The double screen creates a three-dimensional effect
in which the woman sticks out her tongue as the image
is tilted forwards and backwards. Maurice Bonnet described
the technique in a patent registered in 1944.

Anonymous, **Woman watering flowers**, 1940s
Lenticular screen photograph, gelatin silver and screen
on a single piece of glass; 39.9 x 29.8 cm.

Coll. Michel Frizot.

180

Maurice Bonnet/La Relièphographie, **Building in Paris**, c. 1937–45
Lenticular screen photograph, gelatin silver print mounted on glass (no screen); 29.3 x 23.7 cm.

Coll. Musée Carnavalet, catalogue no. Ph 14539.

This image, one of the earliest known outdoor lenticular screen images of Paris, is still very much in the experimental stage. In a patent registered in 1942, Maurice Bonnet explained that he mounted the light-sensitive paper on a glass plate before it was exposed to prevent it becoming distorted and to ensure that the image corresponded to the screen. Ideally, the paper should be slightly smaller than the glass so that the emulsion 'sealed' the edges.

Maurice Bonnet, **Façade of Notre Dame**, c. 1950–60
Lenticular screen photograph, gelatin silver on a fine screen; 18.4 x 16.6 cm.

Coll. Musée Carnavalet, catalogue no. Ph 14536.

Maurice Bonnet, **Apse of Notre Dame**, c. 1937–45
Lenticular screen photograph, gelatin silver print mounted on glass (no screen); mount 39.7 x 29.7 cm.

Coll. Musée Carnavalet, catalogue no. Ph 14545.

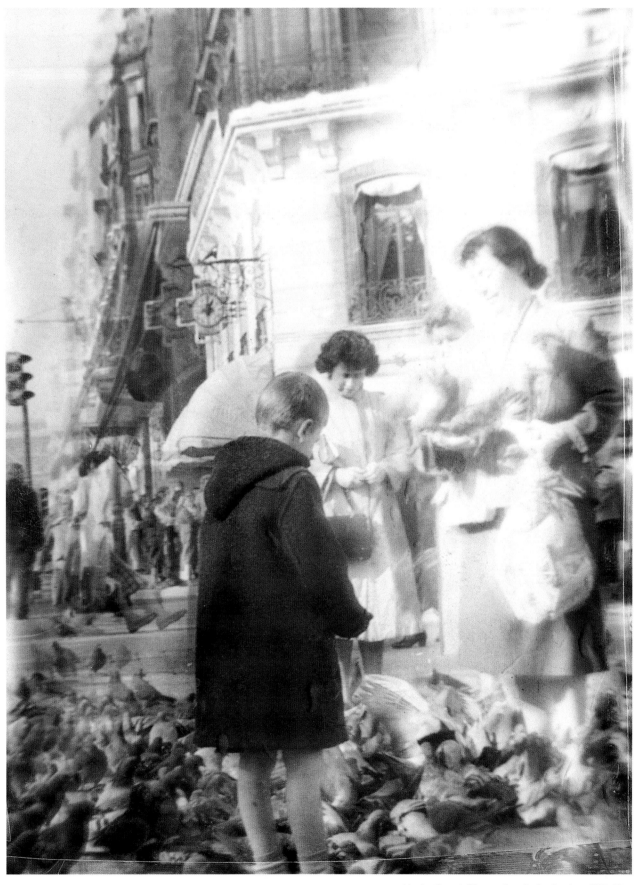

Maurice Bonnet, **Pigeons in a Paris street**, c. 1950–60
Lenticular screen photograph, gelatin silver on a fine screen;
23.7 x 17.8 cm.

Coll. Musée Carnavalet, catalogue no. Ph 14532.

Michel Sarret/Relieforama, **Advertisement for Castellane champagne**, 1967
Lenticular screen photograph, colour transparency, screen, light box. Inscriptions in French on transparent labels on the image: 'production/RELIEFORAMA/Maurice Bonnet Processes – CNRS Licence/157, Rue des Pyrénées, PARIS (XXᵉ) Tel: 797.64.76' and 'Property not distrainable/. . . Castellane/ CHAMPAGNE/EPERNAY'; light box; 34.2 x 28.2 x 14.5 cm.

Coll. Michel Frizot.

Castellane was the first company to commission an image from Relieforama. Around 100 copies of it would have been printed to be used as point-of-sale advertising.

André and Alain Bonnet, **Georges Brassens (1921–1981)**, 1970
Lenticular screen photograph, colour transparency, screen; mount 41 x 31 cm.

Coll. Musée Carnavalet, catalogue no. Ph 14645.

By 1970 Georges Brassens was widely recognized as one of the greatest French singers and songwriters. From the 1950s he established a reputation for his non-conformist view of society and his skilful use of language. The singer Juliette Gréco (following page), the actor Michel Piccoli and the singer Gilbert Bécaud sat for 3-D portraits on the same day as Brassens. The photographs were used as part of the French exhibit at the International Exhibition in Osaka.

184

J. Bonnet, **Juliette Gréco sitting for a 3-D portrait**,
1970
Gelatin silver print. Inscription stamped on the reverse:
'j. bonnet/ . . . /10, RUE DES EPINETTES, 75017 PARIS/ . . . ,'
and a handwritten inscription in French: 'Gréco Osaka
commissioned by the Paris City Council'; 18.0 x 23.8 cm.

Coll. Michèle Bonnet.

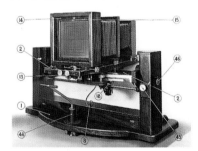

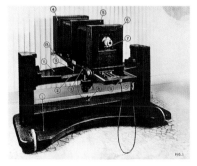

Anonymous, **OP. 3000 camera for lenticular screen
images**, 1940s
Gelatin silver print; 18.1 x 24.2 cm.

Coll. Michèle Bonnet.

Maurice Bonnet developed the principle of this portrait
camera in 1941. The camera body describes an arc as the
portrait is taken, recording the different views of the subject
through the lenticular screen placed on the negative.

André and Alain Bonnet, **Juliette Gréco (b. 1927)**, 1970
Lenticular screen photograph, colour transparency, screen;
mount 41.1 x 31 cm.

Coll. Musée Carnavalet, catalogue no. Ph 14644.

Michel Sarret/Relieforama, **Advertisement for Suralo rainwear**, after 1967
Lenticular screen photograph, colour transparency, screen. Inscriptions in French on transparent labels: 'Relieforama/Maurice Bonnet Processes – CNRS Licence', and 'terital ® RHODIATOCE'; mount 30.9 x 24.9 cm.

Coll. Musée Carnavalet, catalogue no. Ph 19153.

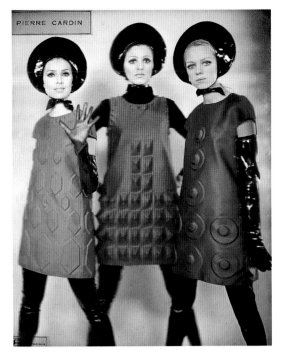

Michel Sarret/Relieforama, **Advertisement for Pierre Cardin**, 1968
Lenticular screen photograph, colour transparency, screen. Inscriptions in French on transparent labels: 'Relieforama/Maurice Bonnet Processes – CNRS Licence', and 'PIERRE CARDIN'; mount 31 x 25 cm.

Coll. Musée Carnavalet, catalogue no. Ph 19154.

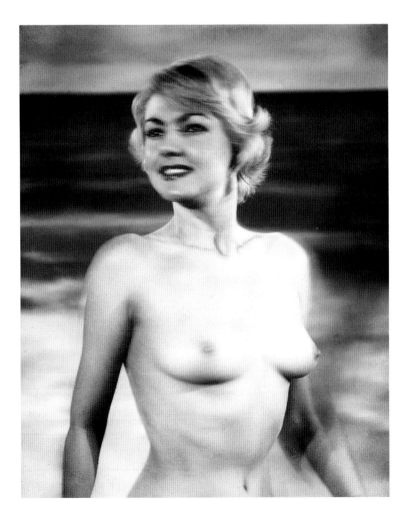

Relieforama, **Eroticism in Pigalle**, c. 1968
Lenticular screen photograph, colour transparency, screen; mount 30.4 x 24.1 cm.

Coll. Michel Frizot.

Relieforama produced a series of (unsigned) images of women for the Pigalle district.

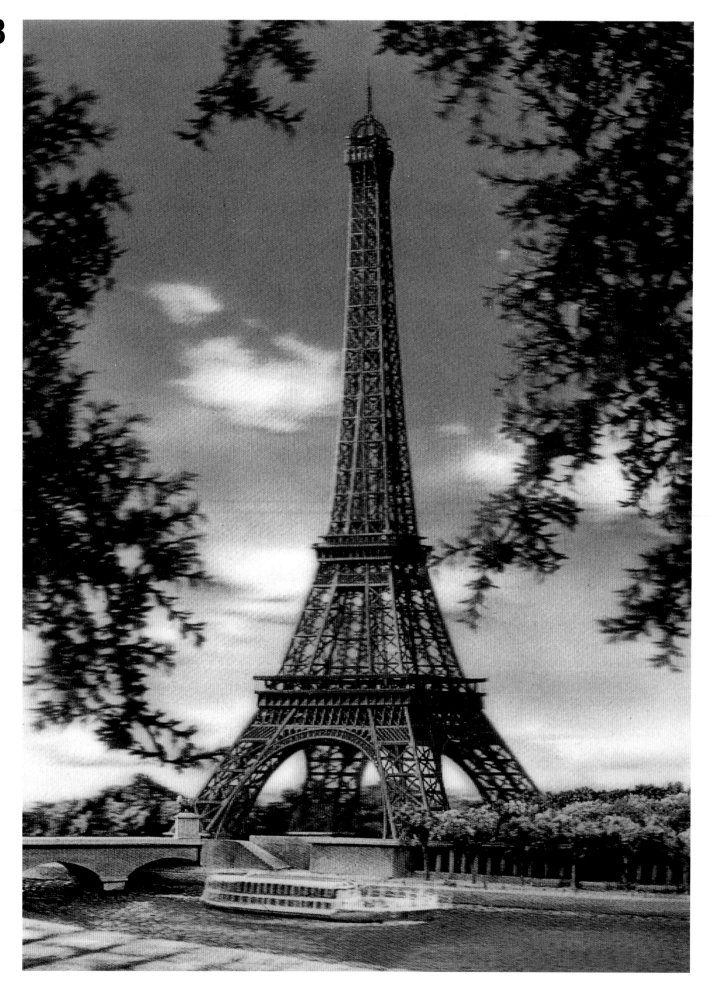

Anonymous, **The Arc de Triomphe**, after 1967
Lenticular screen postcard, printed photograph mounted on
a screen. Inscriptions in French on the reverse: 'Visio-Relief
Visiomatic card – ® PARIS – Printed in Japan © S.P.A.D.E.M.
1967', and 'M.D. PARIS'; 14.5 x 10.5 cm.

Coll. Musée Carnavalet, catalogue no. CP 149.

Anonymous, **The Place du Tertre, Montmartre**, 1970s
Lenticular screen postcard, printed photograph mounted
on a screen. Inscriptions in French on the reverse:
'MONTMARTRE E99 a/Collect 'Visiorelief' cards/MD/Paris', and
'Publi relief 3D ® – Printed in Japan – Copyright S.P.A.D.E.M.';
14.5 x 10.5 cm.

Coll. Musée Carnavalet, catalogue no. CP 145.

Anonymous, **The Eiffel Tower**, after 1967
Lenticular screen postcard, printed photograph mounted on
a screen. Inscriptions in French on the reverse: 'Visio-Relief
Visiomatic card – ® PARIS – Printed in Japan © S.P.A.D.E.M.
1967', and 'M.D. PARIS'; 14.4 x 10.5 cm.

Coll. Musée Carnavalet, catalogue no. CP 134.

190

Maurice Bonnet, **Self-portrait**, c. 1970
Lenticular screen photograph, colour transparency, screen;
mount 41 x 31.1 cm.

Coll. Michèle Bonnet.

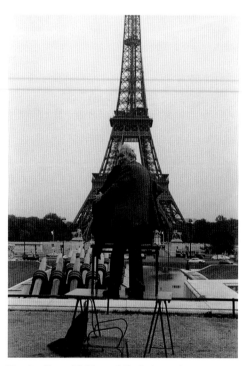

**Maurice Bonnet taking a 3-D photograph
of the Eiffel Tower**, 1969
Colour photograph; 12.8 x 8.9 cm.

Coll. Michèle Bonnet.

Maurice Bonnet, **The Trocadéro fountain
and Eiffel Tower**, 1969
Lenticular screen photograph, colour transparency
(no screen); 39.4 x 29.7 cm.

Coll. Musée Carnavalet, catalogue no. Ph 14544.

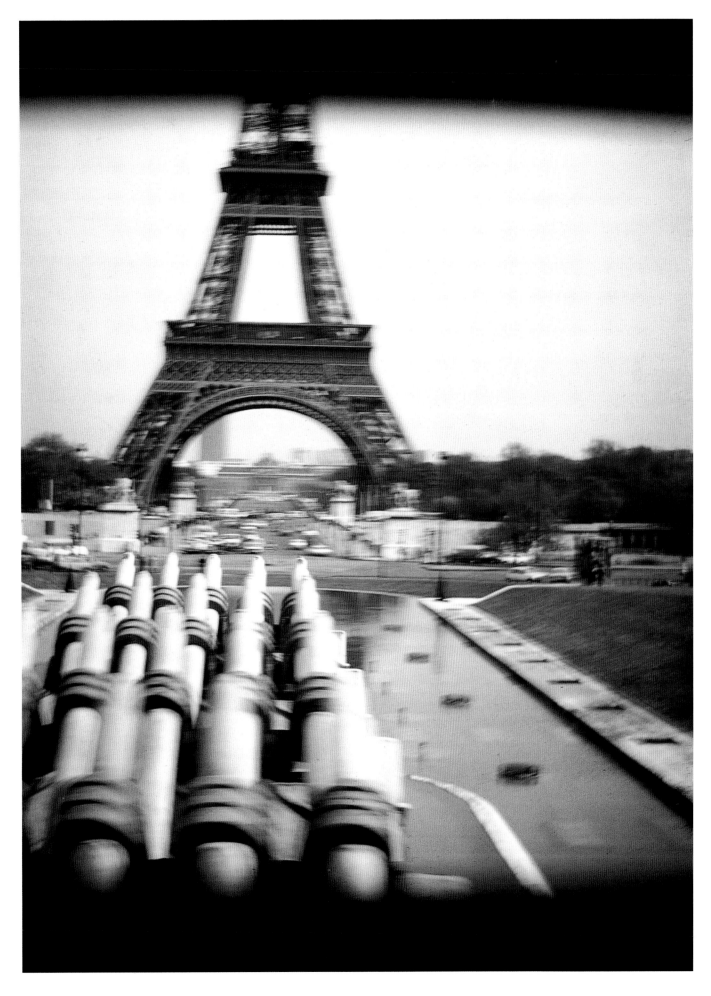

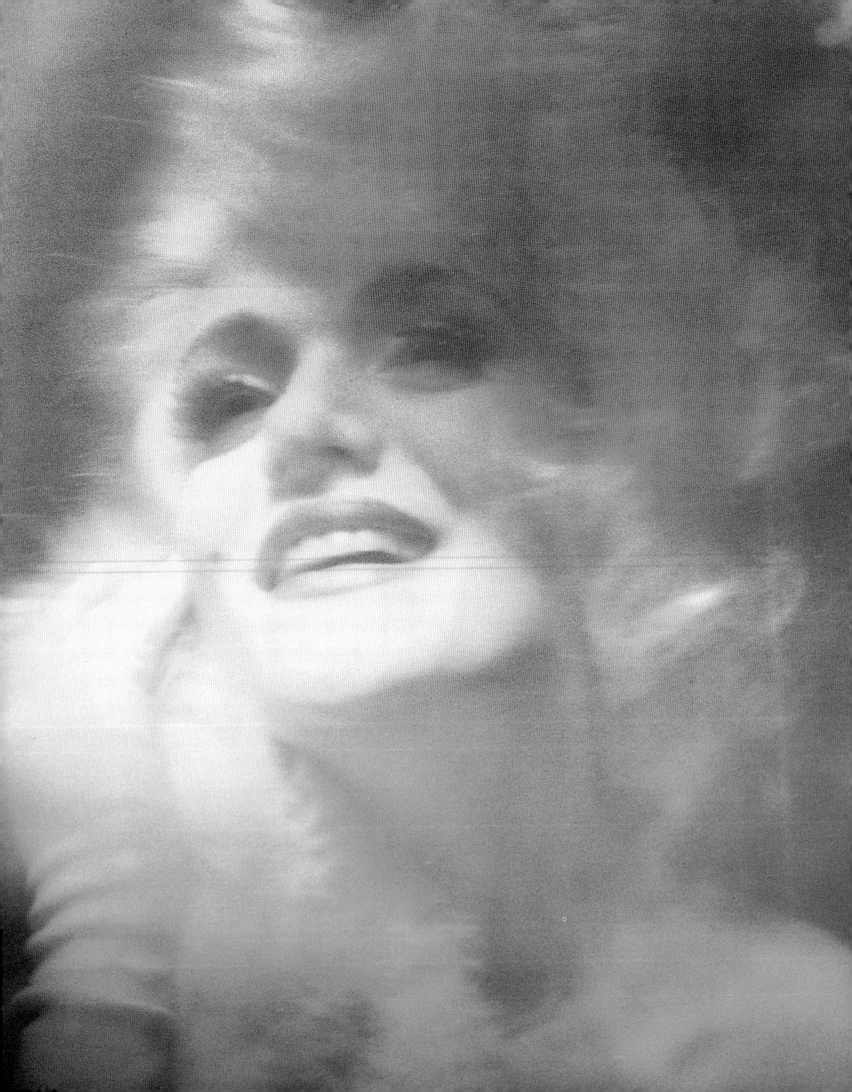

Holography in Paris

Jean-Marc Fournier

Musée de l'Holographie, **The music-hall artist Marylin**, 1986

Transmission hologram on film, visible in white light; 50 x 60 cm.

Coll. Musée de l'Holographie.

Hologram created in the laboratory of the Musée de l'Holographie with a pulsed laser, which acts as a flash (twenty thousand-millionths of a second) and makes it possible to capture moving elements.

Christmas 1999. I can buy holographic eyeshadow in a department store. Everywhere I look I'm assaulted by spangles, changing colours and shimmering sparks. Holography has become an industry whose products appear on greetings cards, wrapping paper and toothpaste packaging. A multitude of anti-fraud systems rely on holograms to protect us from counterfeit products. At any given moment each one of us is carrying a few holograms around, and we find them often in our environment. Clearly visible on our credit cards and on many official documents, they seal compact discs and video cassettes, and flash from cards guaranteeing the authenticity of luxury goods; they are laminated onto skis and incorporated into some types of cheque, all to guarantee the user that a product is genuine, to provide an additional element of security or just to attract our attention. Anyone who wants to be seen without seeing too much can wear holographic sunglasses; extravagant people can buy clothes and underwear made from holographic fabrics. There's something to suit every taste, from the refined to the mediocre, the beautiful to the vulgar. Generally buyers and users don't realize they've got a holographic product in their hands: not all holograms are giant three-dimensional images. Far from it, and with good reason: holography has other applications besides the reproduction of three dimensions. Now that holograms are known primarily for their capacity to show things in 3-D, who would ever imagine that it was years after their invention that anyone noticed that holographic images recreate three-dimensionality?

The father of holography is often considered to be Dennis Gabor (1900–79), a Hungarian physicist then working in Britain, who was trying to improve the resolution of electronic microscopes.[1] In 1948 he published an article in which he coined the word 'holography', which means 'integral recording'. Since he could not experiment with waves used in electron microscopes, he tried to prove the validity of his invention using images made at visible light wavelengths. The invention fell by the wayside and ten years later was all but forgotten. In 1964 two Americans, Emmeth Leith and Juris Upatnieks, unaware of Gabor's earlier work, outlined a method they had been developing for over two years, nowadays called 'off-axis' holography, which makes it possible to record a wave without using a lens, and to encode it in such a way that a complete image can be reconstructed from this recording. In the USSR in 1962, Yuri Denisyuk had drawn on the work done in 1891 by the Frenchman Gabriel Lippmann (1845–1921) to show how it was possible to record and reconstruct a 'wavefront', in other words, how to make a fully three-dimensional photograph. These two entirely independent inventions, both quite different from Gabor's, represent the true starting point of holography. Both in their different ways made it possible to go far beyond the initial stages described by Gabor and, more importantly, they coincided with the appearance of the first lasers, which soon enabled major advances to be made in holography.

We will round off this historical overview by mentioning an article by the well-known Parisian physicist Aimé Cotton (1869–1951) who, without realizing it, had discussed the properties of holography in 1903, long before this technique was 'discovered', with all the observational accuracy and precision of a great scientific mind. He had no lasers, but he knew how to record interference patterns, a common procedure in the late nineteenth century and, more importantly, he recognized that with a particular illumination of these recordings it was possible to reconstruct a wavefront. This is precisely what is entailed in the reading of a hologram.

194

But let us now return to the early 1960s. Leith's work in the USA and Denisyuk's in the Soviet Union a few years earlier soon sent ripples through the scientific world. Denisyuk was trying to create three-dimensional images, demonstrating the principle and proving its feasibility.[2] A couple of years after the creation of the earliest holograms, it emerged in the USA that when recorded holograms reached a size of about ten centimetres, three-dimensionality was restored. Famous laboratories throughout the world then threw themselves into frantic research in holography. To understand this frenzy we have to realize that it was very fashionable to use the newly invented lasers and that holography had fabulous theoretical potential for storing information: a whole encyclopaedia could be contained in a cubic centimetre of crystal. New applications for holography were continually being discovered, such as the non-destructive testing of shapes and surfaces, the measurement of extremely small deformations and the design of new optical components. At this time holographic images were no more than a highly spectacular amusement, the preserve of a few privileged scientists and their friends and families who were lucky enough to have access to the laboratories. In France at that time, in the two largest private research centres, run by Thomson-CSF in Corbeville and by the Compagnie Générale d'Electricité in Marcoussis, experiments were under way to see whether data could be stored in holographic materials. From time to time scientists also amused themselves recording holograms with the aim of creating a three-dimensional image. Some dreamed of a brilliant future for these images, but the necessary materials and lasers had not yet been developed.

Nevertheless, in the late 1960s the inhabitants of Paris were privileged to be able to observe two of these holographic images, which the Palais de la Découverte had put on permanent display in a metro station near the Champs-Élysées.[3] The holograms had been created at the Thomson-CSF laboratories, using a set of geometrical objects (pyramid, cylinder, parallelepiped) to demonstrate the effects of parallax and the perception of three-dimensions produced by a hologram. These images were recorded on holograms in an 18 x 24 cm format and remained on display in the same place for about ten years. Around 1970 the same group put two more holograms on display in the Champs-Élysées, one in the Publicis drugstore and the other, showing a reduced-size model of a car, in the Renault bar. Thomson-CSF also supplied holograms to the Musée Français de la Photographie in Bièvres and produced a few others showing wax figures from the Musée Grévin (La Fontaine and Pierre Curie). They also used a laser specially designed by Georges Bret to create a holographic portrait of the French laureate of the Nobel Prize in physics, Alfred Kastler (1902–84). Some of these pieces were presented on French television at the time by François de Closets.

After a period of great interest, many research projects lose their edge and become routine before declining altogether. So it was with holography: its use in the research laboratories increased very quickly between 1966 and 1970, then declined fairly rapidly until 1975. At the same time lasers became ever more powerful and reliable, and major advances were made in the quality of recording material and in their processing. This made it possible to display a group of very large holograms in a store in the Champs-Élysées area in November 1975. In a shop window on the Rue de Presbourg seven 50 x 60 cm holograms, lit by an argon laser, showed images of a model wearing clothes signed by the designer Frank Olivier. The holograms were mounted on a revolving stand where they first looked like transparent glass plates. They would slowly move into the laser beam, pause to enable it to project the holographic image, then continue turning, once more revealing the diaphanous appearance of the glass support. The full magic of holography was revealed in this display, which also involved a 100 x 60 cm hologram placed against the window pane and projecting an image on either side of it. The projected image formed a light sculpture showing the designer's logo floating in space, both behind and in front of the window. It hung above the pavement about 20 cm from the glass. All the holograms in this first display were made by two scientists from the optics laboratory in Besançon: Gilbert Tribillon and the author of this article. We also conceived, in collaboration with Ivo Kroustolovitch, the presentation and the display unit, which remained in place for a few months.

On Sunday 28 December 1975, on what was at the time France's most popular TV channel, François de Closets presented a three-minute sequence on holography during the 8 o'clock evening news programme. It would be either wishful thinking or ignorance to suggest that a photograph of a hologram could be used to show three dimensions,

Creating a hologram

Holography is a photographic technique based on the combined use of the laser and the phenomenon of light interference. It is one of the few techniques that make it possible to create a direct visualization of a three-dimensional image, and has a great many applications in both the scientific and artistic fields.

A hologram is created using a laser beam. Unlike the white light of the sun (which is random or incoherent), the light waves emitted by a laser are coherent, i.e. they are all of equal length (the same colour) and amplitude (the same intensity). Furthermore, these waves have a spatial coherence (the light is emitted from a single source along parallel rays) and a temporal coherence (all the waves vibrate simultaneously, i.e. they are 'in step').

The laser beam is initially split in two. The first beam illuminates the object used to make the hologram, and the other is sent directly to a photographic plate. Once they have been applied in this way, the beams can be characterized by their associated wavefronts: the 'object' wavefront and the 'reference' wavefront.

The object re-sends its wavefront towards the photographic plate and modifies it by causing the diffusion and phase displacement of the waves (the waves change direction and no longer vibrate simultaneously). The wavefront reflected by the object is complex and bears the imprint of the object.

As they meet on the photographic plate, the wavefronts are said to 'interfere'. The waves either meet when each is in phase at maximum intensity (in which case they reinforce each other and there is an addition of energy), or when they are in opposite phase (in which case the energies cancel each other out). In this way, a network of interference fringes is created with alternate light areas (presence of light) and dark areas (absence of light).

This network of fringes is stationary and stable, and can therefore be recorded in a high-resolution photographic emulsion. The emulsion is exposed at all the points where there was an addition of energy and remains blank where the waves cancelled each other out. The recording set-up must be extremely stable since the fringes measure approximately 0.5 of a micrometre.

When the photographic plate is developed it becomes a hologram which is replaced in the reference wavefront. This produces a three-dimensional image which is absolutely identical to the original object, since the hologram reconstructs the object's complex wavefront.

Pascal Gauchet, Dominique Sevray, Atelier holographique de Paris.

Jean-Marc Fournier and Gilbert Tribillon,
The Venus de Milo and Jean-Marc Fournier, 1976
Transmission hologram on glass, visible by laser;
100 x 150 cm.

Coll. Laboratoire d'Optique de Besançon.

This hologram was created by the optics laboratory in
Besançon using a life-size copy of the sculpture in the
Louvre Museum. It took a fortnight to prepare for an
exposure time of less than 12 seconds. It was extremely
important historically, since it was the first hologram of its
size, and as such has been exhibited in a number of foreign
countries.

Jean-Marc Fournier and Gilbert Tribillon, **Model presenting
a design by Frank Olivier**, 1975
Transmission hologram on glass, visible by laser;
60 x 50 cm.

This hologram was one of a series of seven images in a
revolving display in a window of the Drugstore des Champs-
Élysées, on the Rue de Presbourg.

but giving an idea of three-dimensionality by travelling a movie camera (television
pictures were still shot on film) proved to be a realistic possibility. De Closets, who had
perfectly described the whole of the space odyssey from Sputnik to Neil Armstrong's
walk on the moon, was a master of the art. He had a huge attendance and his
popularizations reached every stratum of the television audience. He illustrated his
account of holography with images of large-format holograms made by Gilbert Tribillon
and this author. In particular de Closets showed a chess game and the TF1 logo, which
we had 'holographed' for the channel's launch of colour broadcasting. This great media
event had unfolded two weeks earlier with all the appropriate flare and fuss. Estimated
audience figures for de Closets's slot, which went out at prime time in a holiday period,
ranged from 25 to 27 million: that evening almost half the population of France 'saw'
holograms. 'Perhaps', quipped de Closets in his commentary, 'you'll soon have a
hologram of the Venus de Milo in your own home'.

This challenge was taken up by Agfa-Gevaert, who specially manufactured a few
giant holographic plates and, in May 1976, Gilbert Tribillon and the present author
used them to record what would long remain the largest hologram in the world:
a three-dimensional image of the Venus de Milo, reproduced life-size by a 100 x 150
cm hologram.[4] This hologram went on tour from Moscow to Tokyo and was displayed
as part of the exhibition entitled 'La couleur dans l'art et dans la ville' ('colour in art and
in the city'), held at the Espace Cardin in Paris from 27 May to 10 June 1977.
For the second time in eighteen months there were giant holograms on display on the
Champs-Élysées. Here we should mention an important fact: many works on holography
have used the hologram of the Venus de Milo to support the idea that holography could
be used to reproduce and exhibit works of art. Indeed, in the USSR this idea became
a reality: superb items from museum collections were holographed. Let us state once
again that, in the minds of the creators of the Venus de Milo hologram in 1976, the aim
was to promote holography to the general public using an extremely well-known work
of art. We, of course, did not have any absurd intention of 'promoting' the Venus de
Milo. However impressive the holographic image and however close to reality in terms
of its faithful and rigorous reproduction of the form, it remains monochrome and is
nothing more than a cocoon of light, in other words, an impalpable mould. The chilly
hues of the laser beam (a crude icy green) could never reproduce the softness of white
light nor the sun's lustre on the marble of the original sculpture. The fact that holography
is itself used as a means of artistic expression is, of course, quite a different matter.

In 1978 in London a huge exhibition of large holograms (mostly 100 x 100 cm)
produced by Nick Phillips, Andy Ward and David Cook was put on display for several
months in Piccadilly Circus. The quality of the emulsions used and of the three
scientists' professional work created a great deal of excitement, giving rise to many
developments in holographic imagery in the Anglo-Saxon world. In the same year
the Holo-Laser company, set up by this author with the Tribillon brothers, Gilbert and
Jean-Louis, put a few large holograms on display in Paris. The first was a model of the
Paris district of La Dèfense as it would look in the future, displayed with white light,
that is to say, freed from reconstruction by laser light. It was followed by the exhibition
of other holograms displayed in various places throughout the French capital.

A familiar sight for Parisians was about to disappear: the old green metro carriages
with their wooden seats, which had carried hundreds of millions of people, were to be
replaced by more modern carriages. The metro company RATP organized an exhibition
dedicated to their memory – a slightly nostalgic trip into the past. One of these so-called
'Sprague' carriages was put in the Châtelet RER station. On one of its windows a
50 x 60 cm hologram projected a holographic reproduction of a model of the same
carriage, creating a kind of Russian-doll effect combining the real carriage and its
intangible image. Hundreds of thousands of visitors walked 'through' this half-real
and half-virtual holographic image.[5]

A few months later, on the initiative of Jean-Marie Caussignac, a specialist in
holographic interferometry at the laboratory of the French national highways department,
we designed a hologram to be used as a road sign. It was later installed for one night's
trial in a tunnel at Porte Maillot on the Paris ring road. A single hologram can diffract
several images simultaneously in different directions from the same supporting medium.
This characteristic could be cleverly exploited in road tunnels, where available space for
road signs is extremely limited. In the trial two different signs were projected, 'LILLE' and

196

'LYON', the first being seen only by drivers in vehicles in one lane, the second by drivers in the other lane. The concept of reducing the space taken up by the 'sign', which was here fully demonstrated in a real situation, was not enough to justify the use of holograms, as the colour of the reconstructed images did not conform to the extremely strict European standards for road signs.

On 25 March 1980 Paris's Musée de l'Holographie opened near the Horloge tower in the Les Halles district. According to its creators its aim was 'to promote holography, which has hitherto been unknown to the general public in France'. It moved three times in its first two years of existence, finally settling in the Forum des Halles, which proved to be a perfect location. Until its closure in April 1996 it received visitors from all over the world – Les Halles is a very popular tourist area in the centre of Paris – who were able to explore a collection of holograms which over the years became probably the largest in the world. As well as maintaining a permanent exhibition and organizing a great many exhibitions throughout France and beyond, the museum had a shop which sold and distributed holograms of all kinds. The museum opened several studios giving various artists access to the equipment they needed to record holograms; in particular, from 1985 to 1988, a pulsed laser was available, allowing the realization of holographic portraits. Some holograms recorded with this apparatus were presented by the Canadian artist Michael Snow at the World Fair in Vancouver in 1986 and at the Pompidou Centre in 1987. A list of all those who have worked with the museum and signed the holograms in its collection would resemble a directory of those engaged in the holographic professions. While the many museums and galleries devoted to holography tend to have a brief existence, such as the museum opened in New York in 1977, the holography museum in Paris, with Anne-Marie Christakis at its head, has survived the roller coaster of the hypothetical market in holographic art. Although today it no longer has an exhibition space, its collections and administrative structure remain, so that it still puts together touring exhibitions.

There are and have been many organizations, associations and companies, some of very brief existence, that have claimed to have produced the first holograms in a given style, or to have invented new types. It is impossible to mention them all and, indeed, the claims made by some are quite surprising to anyone skilled in the art. So many people, on discovering a holographic image, have asserted that the technique is new simply because they were seeing or practising it for the first time.

Large exhibitions of holograms were staged in Paris in the 1980s under the auspices of a range of organizations and sponsored by a wide variety of establishments. Most notable was the one at the Palais de la Découverte, which ran for seventeen months in 1985–86. This contained 145 holograms, including forty-five very large images made by François Mazzero and his team at A-P Holographie. This group had already attracted attention by making various large-scale white-light holograms (reconstructing images without requiring a laser), including one of 100 x 100 cm of the Parc de la Villette, which

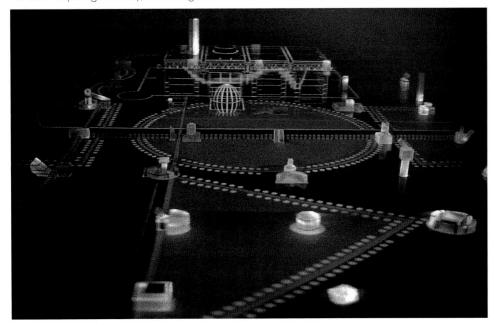

Musée de l'Holographie, **Metro stations by Guimard**, 1981
Stereoscopic holograms.

Coll. Musée de l'Holographie.

Holographic stereograms of the entrances to the Palais-Royal, Porte Dauphine and Place des Abbesses metro stations by Hector Guimard (1867–1942) were created for an Art Nouveau exhibition at the Grand Palais in Paris. Holograms of other Parisian monuments, for example the Arc de Triomphe and Notre Dame, were created using the same technique but were never exhibited.

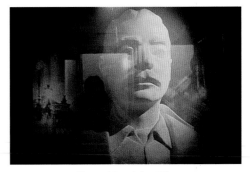

A-P Holographie, **Bust of Puccini**, 1982
Transmission hologram on glass, visible in white light; 100 x 95 cm.

Coll. Musée de l'Holographie.

This promotional hologram was commissioned by Basf. The bust of the Italian composer Puccini, after the sculpture on the Paris Opera House, appears in front of the hologram with a teardrop of light. The façade of the Opera House and a view of the central staircase can be seen in the background.

A-P Holographie, **Model of the Cité des Sciences et de l'Industrie, Parc de la Villette**, 1982
Transmission hologram on film, visible in white light; 113 x 117 cm.

Coll. Musée de l'Holographie.

The image represents a model of the science and industry museum in the Parc de la Villette. At the time of its creation, the rendering of the image, which is similar to that of synthesized images, was extremely original. The hologram was exhibited for two years in the Museum of Holography in New York and for a number of years at La Villette.

With J. Bousigué as its director working with the two holographists François Mazzero and Jean-François Moreau, A-P Holographie, whose laboratory was based at the IUT (University Institute of Technology) in Metz, specialized in the creation of large-format holograms.

Gilbert Tribillon and Jean-Louis Tribillon/Holo-Laser,
Bird's-eye view of the Eiffel Tower, 1982
Transmission hologram on glass plate, visible by laser;
100 x 95 cm.

Coll. Société d'Exploitation de la Tour Eiffel.

This hologram, created using a model of the Eiffel Tower,
is today on display in the Tower.

Olivier Lapidus (b. 1958), **Black shantung suit
embroidered with holograms**, 1994
Polaroid holograms, embroidered by François Lessage
for the 1995 Spring/Summer collection.

Coll. Olivier Lapidus.

Olivier Lapidus dedicated this collection to the theme
of 3-D.

was made in 1982 and became quite famous. At the Aérospatiale stand at the FIT (Forum de l'Industrie et des Techniques) technology exhibition in 1986, the same group presented a 'holographic triptych', 5 metres wide, displaying the projected Hermes spacecraft.

At the Pompidou Centre in the early 1980s, Eve Ritcher, who has done a great deal to promote holography throughout the world, organized what was probably the first big exhibition in France of holograms conceived by various artists, including American-born Sam Moree and British artist Douglas Tyler.

Still under the name of Holo-Laser, the Tribillon brothers made various large-scale holograms, many of which were displayed in Paris. Their holographic representation of the Eiffel Tower has been on permanent exhibition in the tower itself since 1982.

The Atelier Holographique de Paris, created in 1983 by Pascal Gauchet and Jonathan Collins and located in Paris's 11th arrondissement, continually brings contributions to the use of holography as a communication medium. It is actively involved in the development of new methods for recording holograms from digital data. Those watching the productions that regularly leave this workshop find endless enjoyment in the softness of the images and the warm tones, which constitute the Atelier's trademarks. One example of the Atelier's output is the hologram of the terrestrial globe by Martin de Behaïm, held in the French Bibliothèque Nationale.

With the encouragement of Elisa Granval, and the close collaboration of Pascal Gauchet and François Mazzero, Olivier Lapidus had a great success in January 1995, when the high spot of his spring collection was a holographic suit. Anyone lucky enough to attend the fashion show could never forget seeing those sparks of light, like the colours popping out of an opal, endlessly changing and shifting with the model's movements.

Many other holographic displays flourished in Paris, at locations ranging from the prestigious to the obscure, for different lengths of time and with a wide variety of functions. A privileged few have seen two examples of some first steps towards holographic cinema, much trumpeted by the press in the early 1980s.

At the moment holographic art is having great trouble surviving at all, perhaps due to the difficulty of displaying the work and also, let us be frank, to the proliferation of esoteric works and of so many images of poor technical quality. The holographic industry, on the other hand, is doing very well, as reflected in the activity of Hologramme Industries, a public company created in 1982 by Hughes Souparis, which is now quoted on the Paris stock market and employs around fifty people in the Marne-la-Vallée area.

Also, at a few research laboratories in the Paris region, scientists are using holographic techniques to develop elements of tomorrow's optics. Holography acts as a vector, cutting across many branches of science and many fields of application; we cannot always identify the areas in which holographic activity is at its most intense by looking at three-dimensional images, no matter how striking these may be.

1. The aim of this article is to retrace the history of holography in Paris. We are aware of the risks of such an enterprise, which involves writing the history of both a science and series of technologies as well as of a continuous flow of artistic events. It does not seem possible to gauge faultlessly the importance or impact of a particular display, creation or improvement. Certain elements are lacking in this short article; there will be those who do not find their work included, others will criticize the weight given to one element rather than another. But that is how things are. History belongs to those who write it. This author would like to state that he has consulted most of the major figures in this history and thanks them all for the detailed information they have given him, on the basis of which he has selected a few events that seemed to him to have been particularly significant.

2. What is now called a Lippmann-Denisyuk hologram can be seen in white light, without requiring a laser.
3. This metro station is near the Grand Palais, which houses the Palais de la Découverte.
4. Here we can note a characteristic of holographic imagery: the image, which floats in space, can be larger than its supporting medium. Thus a glass plate 100 x 150 cm can hold all the coded information necessary to reconstruct a life-size reproduction of the Venus de Milo, which is 218 cm tall.
5. The observers could, in fact, stand inside the light sculpture formed by the holographic image projected in space.

198

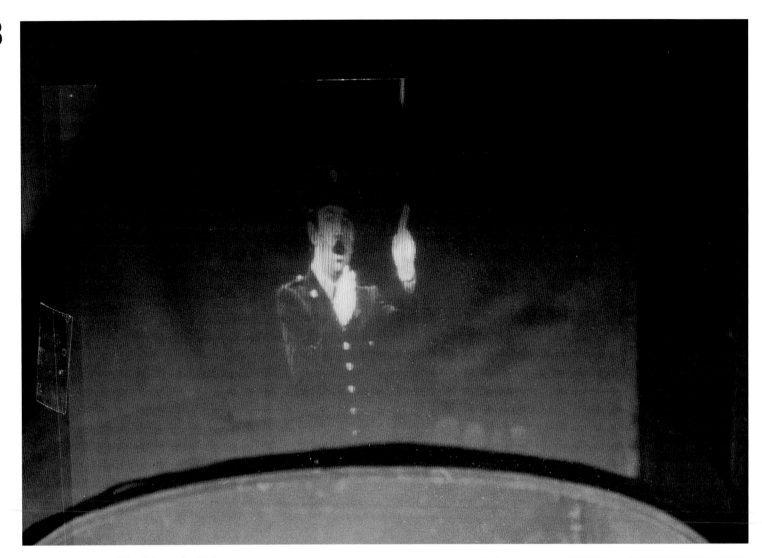

Musée de l'Holographie, **Gérard Jugnot (b. 1951),
in the role of a policeman**, 1984
360° Stereographic hologram.

Coll. Edgar Roskis, Paris.

This hologram was created during the filming of *Pinot,
simple flic (Pinot, an Ordinary Cop)*, one of the many
comedy films starring Gérard Jugnot. Holograms of the
singers Jean Guidoni and Jacques Higelin were also
created using the same method.

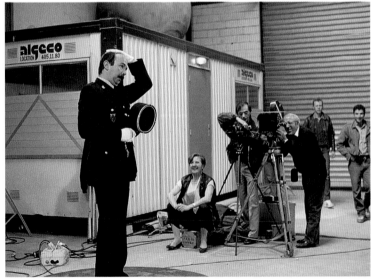

Musée de l'Holographie, **Filming for the hologram
of Gérard Jugnot**, 1984
Colour transparency.

Coll. Musée de l'Holographie.

Here, the actor can be seen standing on a turntable which
made a complete revolution in 45 seconds. This enabled
the camera to take a total of 1,080 shots.

Jean-Marc Fournier and Gilbert Tribillon,
'Sprague' metro carriage, 1978
Transmission hologram on glass, visible by laser;
60 x 50 cm.

Coll. RATP.

As a last tribute to the 'Sprague' metro carriages before
they were taken out of service, the RATP (Paris city
transport authority) commissioned a hologram from
Holo-Laser. The hologram – displayed for a month at the
Châtelet RER (regional express network) station, in the
centre of Paris – was placed in the window of a real
'Sprague' carriage and the holographic image appeared
to be coming out of the frame.

200 Photogrammetry and the first computer-generated images

In 1852 Aimé Laussedat made the first photogrammetric survey, representing Vincennes (just outside Paris), but it is thought to be Henri Deneux who produced the first image of Paris in 1923 (the church of Sainte-Marie in the Rue Saint-Antoine).

Photogrammetry is a technique for determining the dimensions of an object using only measurements of the perspectives in representations of it. This technique is based on the analysis of stereoscopic images. The views are placed in a machine that allows the precise comparison of the position of different points in each image.

The Institut Géographique National (IGN) has made photogrammetric surveys of a number of Parisian monuments, including the Sainte-Chapelle (1944), the ceiling of the Opéra (1964), pavilion no. 7 of Les Halles (1971), the Place des Vosges and the Sainte-Catherine market (1972), the quartier de l'Horloge (1973), the dome of Les Invalides and the Panthéon (1973–85), Notre Dame (1981–84) and the church of Saint-Augustin (1987).

With the first computers, which opened up new possibilities for 3-D modelling, three competing applications were launched simultaneously: the Trapu, the Balsa and the Pers systems. We only have views of Paris taken with the first two software programs developed in the early 1970s.

The first operational attempt to incorporate '3-D' into an urban development plan was in 1972 by the IGN at the request of the Atelier Parisien d'Urbanisme (APUR) to better visualize the banks of the Seine.

Parisian Urban Development Unit (APUR), **Relief of Paris**, 1972
Software: 3D Balsa.

This elevation was produced using plans and aerial photographs. It shows the main hills of Paris: Montmartre to the north and Belleville to the north-east. At about the same time the Parisian Urban Development Unit (APUR) produced images of the Bassin de la Villette, l'École Polytechnique, the Gare de Lyon and Les Halles.

In the late 1980s the unit acquired Arc+ software (for PC) which enabled them to obtain hidden perspectives. This was followed, in 1992, by Turbo software (for Macintosh) which allowed them to concretize computer models and, in the late 1990s, by Microstation-Triforma (for PC) which increased their options to include interactive manipulation and 3-D anaglyphic views.

Parisian Urban Development Unit (APUR), **The Pont Royal bridge, study of the routing of the road along the right bank of the Seine**, 1972
Software: 3D Balsa.

This is one of the first computer-generated images, produced using photogrammetric cross-sections and tracings drawn with a light pen (cryptograph). The aim was to create a three-dimensional mathematical database that would make it possible to view major development projects in situ. The 3-D program meant that the image could be visualized from any angle.

This view represents the Voie Georges-Pompidou, built on the Right Bank of the Seine to help traffic flow more freely (resolution of the Paris City Council, 1966).

Model of the Île de la Cité, using the 'cardboard relief' method, 1977
Cardboard model.

This experiment was carried out to see what could be produced using 3-D data. The pieces of cardboard were assembled to reconstruct volume.

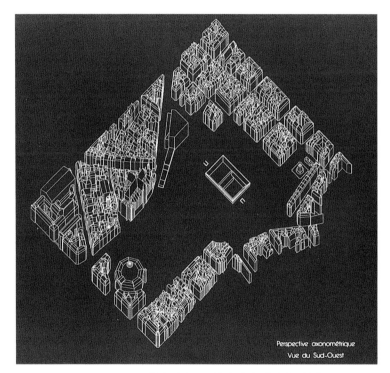

Perspective axonométrique
Vue du Sud-Ouest

National Geographic Institution (IGN), **Les Halles**,
January 1979
Software: Trapu system, developed at the IGN
by Yves Egels.

The first application of the Trapu system in Paris involved
the Les Halles district. It was used to evaluate Ricardo
Bofill's project for the development of the Rue de Turbigo.
The project was subsequently rejected.

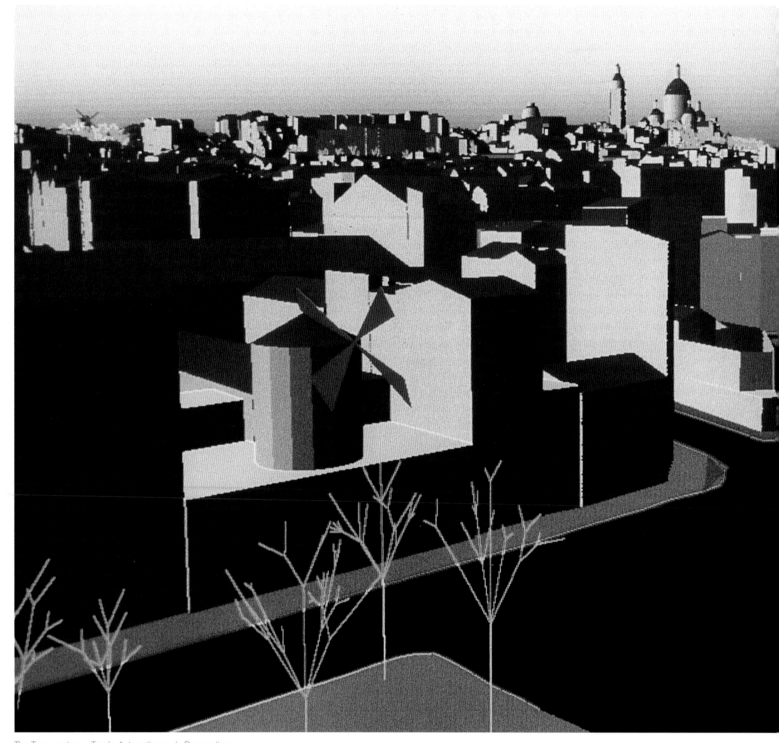

The Trapu system – Tracés Automatiques de Perspectives
Urbaines (automatic layouts of urban perspectives) – was the
result of the National Geographic Institution's desire to have
at its disposal an efficient tool based on photogrammetric
principles. Today, research is focusing on the development
of a system for the automatic recognition of structural
frameworks on aerial photographs. The last aerial survey
of Paris was carried out in 1999.

To create the impression of a three-dimensional image,
the new 'Poivilliers E' system makes it possible to visualize
this data with liquid-crystal glasses on an ordinary PC.

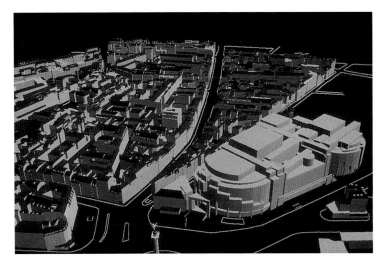

National Geographic Institution (IGN), **The Faubourg
Saint-Antoine district**, 1988
Software: Trapu system, developed at the IGN
by Yves Egels.

This computer model was created to study urban
development.

National Geographic Institution (IGN), for the Regional
Department for the Cultural Development of the
Île-de-France, **General view of Montmartre and
close-up of the Moulin Rouge** (opposite), 1993
Software: Trapu system, developed at the IGN
by Yves Egels.

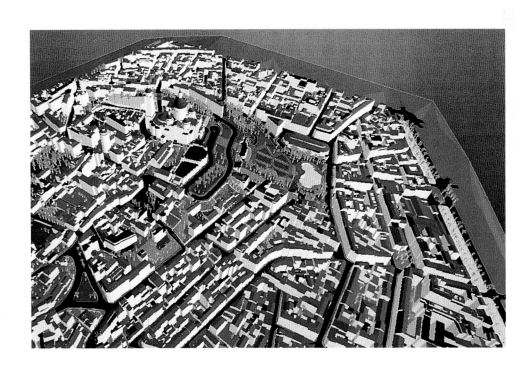

206

Centre de Recherche en Architecture et Ingénierie,
with EDF (Electricité de France), **Lighting project
for the Cour Carrée of the Louvre Museum**, 1992
Software: Phostère, Soisic laser sensor.

This image was created to study the lighting for the
Cour Carrée of the Louvre Museum.

**The Cour Carrée of the Louvre, photographed after
the new lighting was installed**, 1993

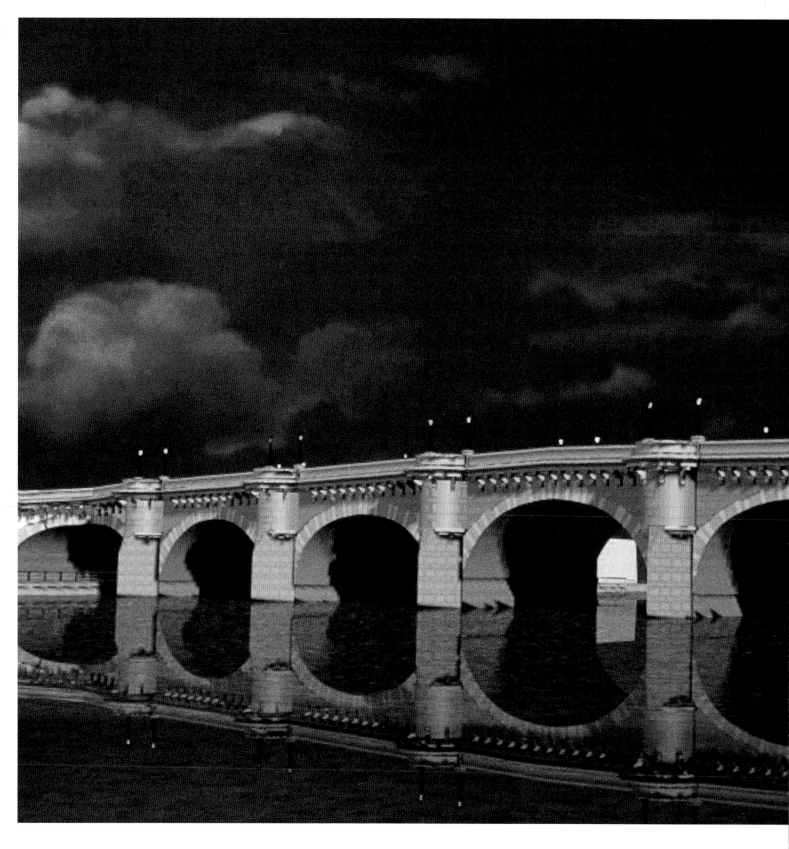

Centre de Recherche en Architecture et Ingénierie,
with EDF (French Electricity), for the City of Paris,
**Simulation of lighting for the Pont-Neuf, Pont
au Change and Pont Louis-Philippe bridges**, 1993–96
Software: Phostère, Soisic laser sensor.

The new lighting on these Paris bridges was inaugurated
on 23 November 1999.

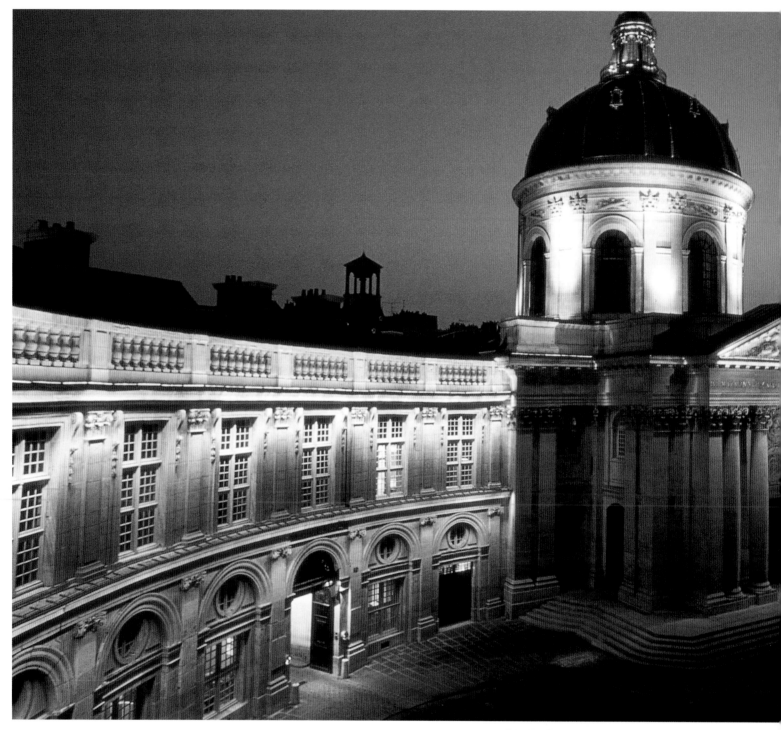

Didier Bur, for the National Centre for Scientific Research
(CNRS), **The Institut de France**, 1996–97
(project revised in 1999)
Software: Arc+ 3D, Animation Candela.

In 1995, to commemorate the bicentenary of the Institut
de France (the seat of the five French Académies), the
institute's stonework was re-dressed and its façade re-lit.
A computer model of the façade was created by a team
from the Architecture and Engineering Research Unit of the
National Centre for Scientific Research (CNRS) to determine
the position of the new lighting. This 3-D model made
it possible to create a computer-graphics image of the
building in real time. Above, a colour photograph of the
façade with the new lighting.

Dino Pesci/L'Autre Image, **Utopian view of Paris**, 2000
Software: Allias, Maya.

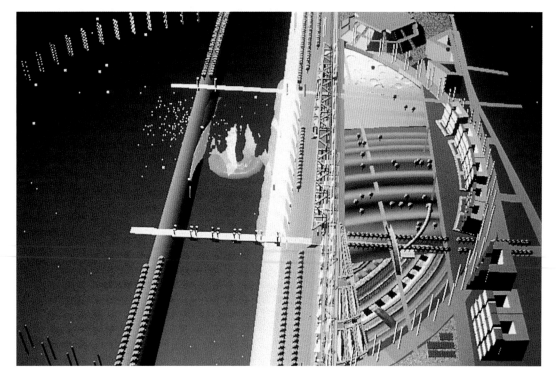

Elise Glodek and Sabine Porada, for the architect Alain Sarfati and the Parks and Gardens Department of the City of Paris, **Development project for the Parc de Bercy**, 1985
Software: Eskis.

Alain Sarfati was one of the first architects to use 3-D computer images for a competition entry: 'The main problem was one of design. How do you create the impression that the garden would be a metaphor for the ocean, and convey the idea that the undulation, which on a 1/1000 drawing only measured 2 mm, would in reality be quite significant and extremely effective? It was to answer these two questions that I used digital images, not so much to represent reality as to go beyond it, to transcend it and get closer to the reality of the anticipated emotion.'

The Parc de Bercy, which covers an area of 13.5 hectares, is one of the new Parisian gardens. It was built partly on the site of the old Bercy warehouses that were once the centre of the wines and spirits trade. This themed garden, which in the end was designed by Bernhard Huet and Marylène Ferrand, Bernard Leroy and Jean-Pierre Feugas, was completed in September 1997.

Parisian Urban Development Unit (APUR), **Project under consideration for the Austerlitz district**, 1996 and 1998
Software: Macro Mind Accelerator Acrobat.

In the mid-1980s an area of 130 hectares on the banks of the Seine became the focus for a development scheme that extended from the Gare d'Austerlitz to the Boulevard Masséna. It is the largest urban development scheme undertaken in the city since the work carried out by Georges Eugène Haussmann (1809–1891) between 1853 and 1870. The Bibliothèque Nationale de France was opened on the site in 1995.

Stereo-reality and other dimensions

Odile Fillion

Medialab, Éric Morvan, for the Parisian Urban Development Unit (APUR), **'Mise en Seine'**, 1990
Software: Explore Silicon, Wave.

This short computer animation, originally 33 seconds, and now 1 minute 26 seconds long, consists of a low-flying journey along the surface of the Seine. In 1981 the French government initiated a series of major development schemes designed to boost the economy and modernize the city's infrastructure.

There is something that has far-reaching implications, that raises the question of a stereo-reality, a new dimension, a new mass that would not be created, as in stereophony, by the distribution of low and high notes, but by the conjunction of low notes, in the Aristotelian sense of bodies, of real 3-D space, and of virtual space, as represented by the high notes. The formation of this stereo-reality implies a new dimension, a new type of perspective, which would replace the way real space was perceived in the quattrocento.
Paul Virilio

The first computer-generated images created in the 1970s were greeted with huge enthusiasm. The Imagina festivals, organized annually in Monaco since 1982 and providing a round-up of the latest developments in digital imaging, became exciting events: computer animations lasting several seconds, like the famous teapots and the leapfrogging Luxo desk lamps by American animation director John Lasseter, caused a sensation. The armed forces as well as the film, advertising and video games industries were the first to realize the potential of these new so-called simulated images, made possible by improvements in computer performance. The first so-called 'virtual reality' environments, which could be viewed through special headsets, made their appearance.

This historic development was largely ignored by architects. The use of 3-D images in visual representations, whether architectural or urban, remained very much the exception until the late 1980s. Only research centres like the CIMA (Centre de Recherche d'Informatique et de Méthodologie en Architecture), set up in France in 1971 by Jean Zeitoun, or the INA (Institut National de l'Audiovisuel), which has very little contact with the world of business, showed any interest. As a result, when film-maker Jacques Barsac incorporated a simulation of the Voisin city plan in Paris in a perspective view of the capital for his film on Le Corbusier, or when, in the late 1980s, a simulation of the housing programme being built by the young architect Jean Nouvel in Nîmes was developed as part of the construction plan implemented by the Ministry for Town Planning and Housing, these images were being used largely for effect rather than as standard practice. It was felt at the time that the quality of the visual representations produced by this technology, which was not only unwieldy, expensive and slow but had to be calculated by computer specialists in huge data processing centres, was less than satisfactory. With schematic forms and minimal textural effects, digital images were still very poor. However, technology progressed at the furious pace of what is known as Moore's Law, a theory put forward in 1965 and never disputed, which states that the amount of data storage held by a microchip will double every eighteen months, increasing computer performance and causing demand to spiral. This steady growth led to the widespread appearance of personal computers in the workplace in the late 1980s and these inevitably ended up in architectural practices, where they were used for drawing up plans as a potential replacement for the traditional 'rapido', a design tool of the 1970s which had in turn replaced the old drawing pen. The computer was therefore not much in demand for 3-D reproductions and computer animations at first. Rather unimaginatively, the architects also confined themselves to using dedicated software. The leading software product used by French architects

214

up plans, even perspectives, was Autocad, virtually unknown in the United States, which used FormZed almost exclusively. These functional software programmes were particularly useful for creating hyper-realistic perspective views in saturated colours, which rapidly became commercial 'conventions' and pseudo-criteria for professionalism.

Computer animation and the simulation of movement made it possible to 'navigate' around prospective constructed spaces, but changes were slow to be implemented because it took a relatively long time to calculate the images, and the budgets needed were substantial. As a result, various extremely realistic high-quality simulations appeared for one-off events like the Olympic Games in Barcelona or, in France, for the last of François Mitterrand's 'grands projets', particularly the Bibliothèque Nationale de France. In the early 1990s some superb computer-generated simulations were designed for major facilities like the airports at Roissy, the Météor metro stations, and the competition for the Millau viaduct…

However, fascination with these projects was short-lived; exceptions soon lost their novelty and the pioneering achievements once showcased at Imagina rapidly became the accepted norm as computer hardware proliferated, software programmes improved and computer performance increased. Computer-generated images and 3-D computer animations today are no longer a source of amazement to children who have grown up with video games and can swiftly and expertly find their way around a games console, or to adults who have been swamped with the same images by dint of advertising, cinematographic special effects and the Internet.

A student of architecture now finds it fairly easy to produce animations lasting one or several minutes on a school PC and most architectural projects, whether prestigious or not, involve this type of representation and simulation: hypothetical constructs designed

Artefactory, for the architect Jean Nouvel,
Musée des Arts Premiers, view of the garden near the Seine, 1999
Software: Archicad, Rhinocéros, 3D Studio, Photoshop.

The Musée des Arts Premiers, due to open in 2004, will bring together the collections of the Musée des Arts d'Afrique et d'Océanie (1931) and the Musée de l'Homme (1937). The new museum will house 260,000 objects and 200,000 audio, photographic and film records. The building, designed by the architect Jean Nouvel, will be built along the Seine, on the Quai Branly, at the centre of a plot surrounded by Haussmann-style apartment blocks. A garden of approximately two hectares will be created by the landscape designer Gilles Clément.

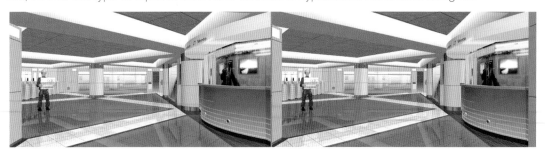

to be visited like a video game, seductive tools with no real appeal, a code created by pixels which has begun to pall. If an architectural centre were to initiate the systematic collection of these run-of-the-mill computer-generated architectural projects, it would become an interesting observatory of the 'invisible city' that has been designed by this unimaginative and conventional era in the sincere belief that it was being modern. By swapping the 'rapido' for the computer, the analog image for the digital image, architects simply did not realize that they were changing the nature of the image, even the nature of space, and that it would have been better to invent something new rather than mimic an outdated vocabulary with a virtual 'rapido'.

By using the computer like a traditional architectural tool, without acknowledging the fact that the computer was actually becoming a universal tool used by all professions, and without noting, incidentally, the advent in France in 1988 of the Internet, the architects mismanaged their entrance into the cyber-world.

This is because, according to Paul Virilio and his concept of 'stereo-reality', the dimension occupied by these computer-generated images exists somewhere other than in the three dimensions they suggest. When looking at these images displayed on screen or printed in a catalogue, it is possible to forget that these are not ordinary images, that they have been processed and, being digital, cannot be regarded as primary 'images'. They are simulations of images, generated by the skilful assembly of pixels, bits, electronic impulses and elements that are inert but capable of rearrangement and reactivity: programmes run by algorithms are sometimes concealed behind each pixel just waiting to react on the computer screen to generate new spaces. The creation of these new interactive spaces, invented by computer processes and contained within the aperture of a screen, has redefined the field of architecture in the 1990s.

Outside its traditional subject field, outside its real physical 'terrain', virtual

Jean-Marc Bernadello and Guy Outier/RATP,
The new 'Météor' metro line, 1998
Software: Explore Silicon.

A new metro line was opened in July 1999, the first since 1935. The eight-kilometre line is entirely automated and provides a high-speed link between the key points of the French capital: 40 km/hour compared with 25 km/hour for the standard metro.

architecture, which has appeared in the last ten years, claims to give architecture a new role in a modern information-based society. The American architect, theoretician and mathematician Marcos Novak, one of the pioneers of virtual architecture, has undoubtedly provided the best definition of these new types of space, these liquid architectures, these 'transArchitectures'. These new places, which can only be viewed through the intermediary of a screen, are completely devoid of essentials or of any code peculiar to the real world. These spaces have no weight, adhere to no stylistic code and conform to no structural or building requirements since they obey other laws. Boundless, recalculated and reconfigured by the constant activity of genetic algorithms, they derive more from mathematics and artificial life than from the architectural apparel they don to help us gain access to virtual worlds.

No one today, given the recent growth of the Internet, would deny the rapid establishment of this stereo-real world described by Paul Virilio, who situates the

Jean-Charles Cholet, for the architect Christian de Portzamparc and the Paris Chamber of Commerce and Industry, **Extension for the Palais des Congrès, Porte Maillot**, 1994
Software: 3D Turbo, Stratavision.

Here, the architect has created a new façade and an extension (4,000 sq m) for the existing building. The complex was opened in October 1999.

Canal⁺ Multimédia, **Le Deuxième Monde (The Second Dimension)**, 2000
Software: Blaxxon-Viewer.

Canal⁺ was the first European media company to open a 3-D 'virtual community' website in 1997–98. As they connect, subscribers can create 'avatars', real or imaginary figures who walk through certain districts of Paris, for example the Place des Vosges, the Louvre, the Tuileries, the Place de la Concorde and the Champs-Élysées.

individual midway between two worlds, the real world and a world which is a complete digital structure, yet no less present. This new state is also described by various science-fiction authors: William Gibson in the 1980s in his cult book *Neuromancer*, Neal Stephenson in *Snow Crash* or Maurice Dantec in *Les Racines du Mal*, as well as by the makers of films like *Matrix*, *Existenz*, *Nirvana*, etc. 'With the appearance of virtual worlds,' wrote Philippe Quéau, 'the image left the screen and became a "place" in its own right where we can move around, meet other people, make ourselves comfortable, place our marker, where we can end up spending most of our professional life and leisure time. The "real" world, where we eat and sleep, may then become a sort of home base to which we must return from time to time to feed, before heading back onto the virtual networks of telecommuting and cyberspace communities.' And the confusion will inevitably be greater and greater as the illusion of space becomes more and more perfect.

We navigate through virtual 3-D space where we are surrounded by ersatz architecture. Like our grandfathers, who built the first cars to look like carriages, and the first aeroplanes to look like birds, our first virtual worlds, shopping centres, meeting

216

places and discussion forums often resemble the real world. Paris was therefore the model for the 'Paris' of 'Deuxième Monde' ('Second Dimension'), a digital universe launched perhaps somewhat prematurely by the television channel Canal⁺ in 1997, which intended to create a parallel virtual community. The Cryo design team used computer-generated images to reconstruct the centre of Paris and each of them, by connecting to the network and, by taking on the personality of an 'avatar', a digital entity they created to represent themselves in this other place, was able to visit the capital, go shopping and rent an apartment that they decorated to their taste and used to entertain friends.

Due to a lack of Web users, 'Deuxième Monde' was not initially as successful as had been hoped. However, the idea had taken root and since then, new virtual worlds, chat rooms, shopping centres and game sites are being created every day with architectural

Thierry Deschaumes, for the architects A.C.D. Girardet & Associés, for the French Tennis Federation, **Project for the renovation of the Roland Garros stadium**, 1998 Software: Archicad version 6.5.

These images were created for the renovation of the Roland Garros stadium to be carried out between 2000 and 2002.

structures. The technology is improving daily. Virtual worlds make it possible to travel through computer-generated universes, imaginary spaces, with live cameras and webcams, and are becoming the arena for continuous graphic inventions. Leading financial institutions, the first ones to realize the potential of the telephone in the nineteenth century, were also the pioneers and the first real users and creators of these virtual spaces. In winter 1998 Nasdaq in New York inaugurated the first navigable three-dimensional stock exchange for its employees. A great deal of money was invested in the project so that employees could navigate from their computer screen, fly like birds through 'the computer-generated space of the virtual trading floor', passing from one room to another, from one screen to another, clicking on an icon to have immediate access to international money-market quotations, or a historical review of a price, while simultaneously being linked to televisions all over the planet. This world premiere probably also marked the first time in the world that a group of architects, the New York company Asymptote, had been given a real commission to build an operational virtual world. Within several weeks, Asymptote was commissioned by the Guggenheim Museum to design another virtual structure, that of the Guggenheim Virtual Museum, which was to accommodate the works of artists working with new technology. This would be the Guggenheim of the twenty-first century, said its sponsors.

Faced with the speed of these developments, the computer screen seems quite archaic and perhaps unsuitable for navigating these limitless spaces full of images; it is almost certainly a temporary interface which will one day be succeeded by other types of representation that might include holographic systems, ghostly environments, and image-filled bubbles floating around us.

The best way of exploring these three-dimensional digital universes or of immersing ourselves in images with today's technology is to use virtual reality headsets or to try out the 'Cave'. The principle of the Cave was invented in Chicago in the late 1980s. It is a cube, a room several metres square, its walls composed of screens and itself standing in an area twice as large, allowing the simultaneous and coordinated overhead projection of computer-generated images calculated in real time. The visitor inside the room is equipped with sensors and stereoscopic glasses and uses movement or a video-game joystick to emit interactive signals that activate real-time computer-generated images that are projected on the surrounding screens. Initially designed for the purpose of scientific research, the Cave is the best possible way of simulating virtual architecture. This fascinating invention has become the key attraction at new media design centres like the Ars Electronica Center in Linz or the ICC in Tokyo. Immersed in images, the visitor finally understands the powerful fascination exercised by these worlds.

Jakob and Mac Farlane, for S.N.C. Costes and
the Georges Pompidou Centre, **The Georges
Pompidou Centre, plans for the fifth-floor
restaurant area**, 1998
Software: 3D Studio.

The architects Bernard Reichen & Philippe Robert, for the
City of Paris, **Bercy-Tolbiac footbridge**, 1998
Software: 3D Turbo.

The scheme was submitted for a competition but was
not chosen.

The steadily growing popularity of electronic shopping is likely to bring about a commensurate growth in the application of architecture in virtual space in the near future. Moving with the times, architects will naturally become hybrids, qualified to practise both aspects of their profession, building for one or other world by request and with predictable areas of interaction.

As a result, if virtual shopping centres entirely or partially replace real shopping centres, architects will have to build virtual shopping centres while at the same time drastically altering 'terrestrial' shopping areas, which would have to be adapted for new uses. If virtual universities built on the Internet destabilize the system of further education, it will be necessary to rehabilitate the real universities by redefining the teacher's role, etc. For a time, therefore, the architects' work will entail adapting both worlds in line with their respective and inextricably linked changes.

Nothing in fact heralds these forthcoming developments better than the extensive worldwide use – still in its primitive form – of the mobile phone, an ordinary object that seems to have been tamed and domesticated. Its mass distribution is gently changing our perception of space, unreservedly extending and merging the respective boundaries of private and public spheres that are losing their distinctive identities, even their purpose. When phones become, as is already the case, electronic diaries, computers, cameras, modems, MP3 players, is there a point in building company headquarters and office buildings if everyone can organize their workload from the local café or the beach?

Industry as a whole is now focusing on the development of extremely miniaturized objects that weigh only several grams and yet are powerful enough to incorporate entire virtual worlds. Three prototypes of glasses with integrated displays developed by IBM are currently being piloted throughout the world. The lenses of these glasses, which are in every respect identical to a pair of ordinary glasses, have an inbuilt display that is superimposed on the wearer's vision of the real world. The pocket microcomputer with its mini-keyboard provides fingertip technology. At the same time, wearable computers, 'intelligent' clothes, are beginning to appear at American IT conferences, consolidating a trend which is encouraging us to replace the physical world and therefore our traditional concept of space, with a world or a bubble of information, a new dimension superimposed on the changing face of the real world.

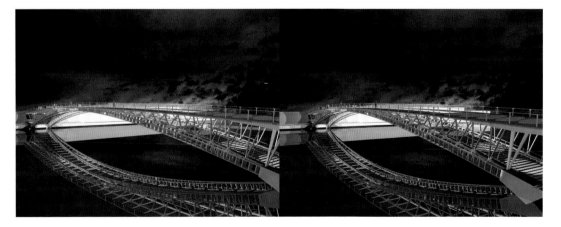

Vincent Dominguez, for the architect Marc Mimram and the French Ministries of Culture and Infrastructure, **Solferino footbridge**, 1992
Software: 3D Studio.

The Solferino footbridge links the Tuileries gardens with the Left Bank of the River Seine, near the Musée d'Orsay. It replaced a temporary bridge built in 1961, on the site of the old Pont de Solferino bridge, destroyed in 1992. The 900-ton steel bridge – 140 metres long and 11–15 metres wide – consists of a single arch which links the lower and upper quays by means of the two walkways built into the framework. It was the last bridge built across the Seine in Paris.

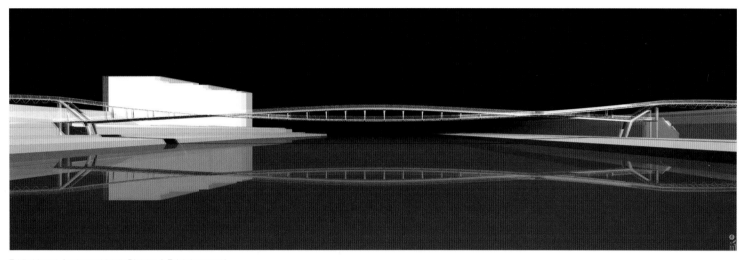

Eddie Young, for the architects Dietmer & Feichtinger and
the City of Paris, **The Bercy-Tolbiac footbridge**, 1998
Software: 3D Turbo.

The Bercy-Tolbiac footbridge is the thirty-eighth and last
bridge currently being built across the widest part of the
Seine. It should be completed by the end of 2002.

220

Louis Mariani and the students of the Ecole d'Architecture
de la Villette/French Ministry of Culture, **The Trocadéro
and the Eiffel Tower**, 1994–2000
Software: Archicad 12.

The students of the school of architecture created computer
models of a number of Parisian buildings using the building
records and original plans.

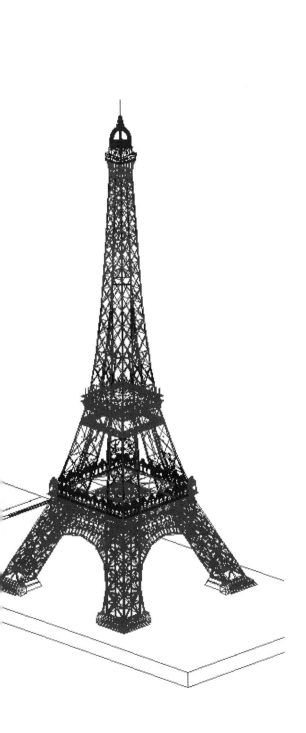

Nadir Tazdaït, for the Georges Pompidou Centre,
**Virtual visit to the Georges Pompidou
Centre**, 1998
Software: Silicon Graphics transcribed onto PC,
computer-graphics image in real time with figures
incorporated by Nemo.

In 1996, just before its temporary closure,
the Georges Pompidou Centre (Centre
National d'Art et de Culture Georges Pompidou)
was welcoming seven million visitors a year.
Following a major project to redefine its spaces,
this unusual building in the heart of Paris
was extensively renovated and reopened
on 1 January 2000.

Studio Gui, **'The little boat', a virtual walk through Paris**, 2000
Software: Alias Studio, Maya 2000.

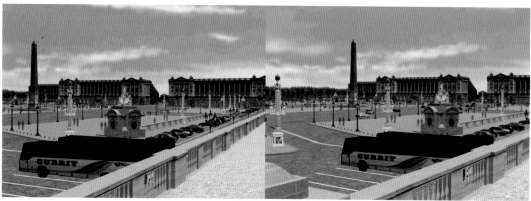

Anne-Marie Duguet

Moving around an image, giving it volume, being at the heart of the representation, seeing a moving scene in three dimensions; today computer techniques and languages enable us to fulfill all of these ambitions, or at least facilitate their realization. For almost twenty years the convergence of three-dimensional synthetic images and interactivity has made it possible to reach a new – and eminently contradictory – stage of perception, in which our experience of the virtual world coexists, and must continually negotiate, with our experience of the material world. In the calculated spaces of virtual reality, movement is fluid and light, varying in speed and direction, passing through unresisting architecture in its own time. Visitors to these spaces meet with different physical laws, while remaining subject to those that govern their own reality.

With these new means of exploring the virtual world, the image recedes in favour of the whole scene and the realism of representation matters less than the realism of the experience.

The 'depth' of three dimensions

To synthesize an object digitally is to describe it in terms accessible to and by a computer and, if desired, in its three dimensions, whatever the chosen modelling principle (polygonal mesh, fractals, particle system, etc.). The interactive mode then allows it to be visualized from every aspect. The operator has the impression of moving around the object, although in fact the object is simply being shown from several different points of view. It exists in a space of data, a virtual scene in which perspective, when it is present, is continually and immediately recalculated (in 'real time'), depending on the position adopted by the observer.

It is the mobility of our vision of the scene – the possibility of moving through it in any direction, of passing behind and between objects – that confirms our impression of their volume and of the three-dimensionality of the space, even though we are still seeing them on a screen. This is more than simply depth of field, or the 'thickness' of some electronic images made using superimpositions and embedding. There are no holes in the surface of the plane, but there is empty space between the elements. For what is being described is primarily a set of relationships, of spaces 'between', an interplay of simulated distances which enables us to move around and identify phenomena in all their diversity.

In his interactive installation *Legible City* (1988–91), Jeffrey Shaw takes his visitors on a bicycle ride through a series of cities (New York, Amsterdam, Karlsruhe). Visitors sit in front of a screen on which symbolic virtual architecture is projected and, by pedalling, move around in all directions between or through the rows of 'letter-buildings', all of which are texts, stories to explore. In this way visitors can create their own individual readings of the space in which they move around.

These virtual spaces can be hypersensitive and react strongly to the activity of their viewer-operators, who must themselves then adapt to the machine's capacity for calculation and understand the pace of the dialogue and the consequences of their actions. Interactivity is without doubt a primary parameter in the creation of the effect of proximity of such worlds.

Oktal, for the City of Paris and the Parisian Urban Development Unit (APUR), **Redevelopment of the Place de la Concorde in Paris**, 1998 and 1999 Software: Simteam.

A computer model of the existing square was created and two alternatives studied to determine the pedestrian zones. The project is under consideration. Oktal and Renault Design are currently working on a 3-D real-time visualization project that will make it possible to incorporate virtual vehicles into a reconstruction of Paris.

226

The experience of relief in three-dimensional virtual environments

The perception of three dimensions should not, however, be confused with the impression of depth or volume. Three-dimensionality requires different mechanisms in order to be perceived, such as the wearing of stereoscopic goggles, which are today increasingly associated with the exploration of three-dimensional artificial realities. It is almost certainly in virtual environments that this experience of seeing in three dimensions is the most striking and poses the most radical questions about representation. These mechanisms aim to create a feeling of immersion, either through projecting images on a very large scale or by filling the spectator's visual field using a juxtaposition of screens (on the model of 1950s Cinerama, for example), and are as varied as the prostheses and interfaces used to access synthetic spaces. The visitor's perceptive experience depends very precisely on the choice of mechanism. Wearing a helmet or visualization goggles and stereo headphones can certainly give us the impression of being in the scene, but the rest of the body, which is often covered in further prostheses, is rendered an impotent slave of sight and hearing, subject to a more brutal disassociation from the physical reality in which it exists.

One of the most advanced mechanisms, involving both stereoscopy and the real-time calculation of complex 3-D images, is the Cave Automatic Virtual Environment.[1] On entering this cube – particularly when there are back projections on all six sides at once[2] – visitors have the sense of being plunged into the scene. The metaphor of immersion, though now worn and limited, is still appropriate to describe the kind of weightlessness that comes over them in this extremely fluid space.

Here we should consider three parameters that influence seeing in three dimensions in the Cave: the scene is all around us; the scene is moving; transformations of the scene result from the visitor's actions.

Visitors are no longer face to face with the representation; instead they share the space with it. They are literally pulled 'into' the scene. The frame is gone, all defining edges have disappeared and the projected images link up seamlessly, creating a continuous all-round space of representation. However, it is also the task of stereoscopic vision to remove that other border created by the surface of the screen. Once this 'fourth wall' has fallen there is nothing separating 'images' from bodies.

At this point we could say that the visitor's body acts as a screen, but one which casts no shadow behind it. It does not interrupt the representation, which flows past it in any direction from all sides. In using a control (joystick or other kind of sensor), visitors no longer simply propel themselves through the space, as they might be carried through it by an amusement park ride. Here the perceptive experience is different from that provided by viewing of a fixed image stereoscopically from the front. Not only do three-dimensional elements – signs, objects and architecture – which float through the entire space of the Cave, seem to move towards visitors; they also pass through them, hitting them as a projectile hits its target. Rather than the eyes 'falling on' the image, the image itself touches the observer's whole body. The reflexes of visitors, who step back, protect themselves and cry out, attest to the fact that this is a real multi-sensory kinaesthetic experience. It is the very strong 'feeling of presence' that reinforces the 'impression of reality' given by the world that the visitor is exploring; the realism of this world, no matter how meticulously textured, marbled and rich in detail it may be, is no longer as important as the realism of its effects on the senses, of the experience itself.

While the closed nature of the system and the scale of the projected images are essential to the production of this illusion, the distribution of sound within the space also makes an important contribution. All-enveloping and multidirectional, it also responds quickly to the visitor's slightest movement. Here the elements of sound and vision are of the same nature. The image takes on the physical quality of the sound, it spreads beyond the frame, becoming a field.

Distance, which constitutes the representation itself, is taken to the point of disappearance to enhance the 'heightened' perception of volume and relief. But just when things seem so present as to be palpable, they lack substance. They are only light – pure transparencies – and this lack of consistency betrays their source and reveals their artifice.

Maurice Benayoun is one of the few artists to have used the Cave system (although it is not yet available in France), freeing it from its status as a fairground attraction offering virtual tours round archaeological sites. In the course of the photo safari to the land of

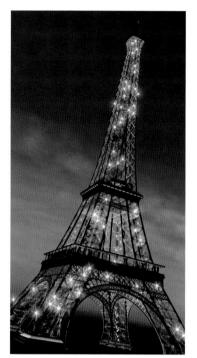

Trimaran, for the Operating Company of the Eiffel Tower,
Eiffel Tower 2000, 1993–2000
Software: Arc+, Maya.

The first 3-D computer-generated images of the Eiffel Tower were presented in the Canadian computer-graphics film *Vol de Rêve* (Dream Flight) (1982), produced by Philippe Bergeron. The database featured here was developed using Gustave Eiffel's original plans. Computer models of all the different components used to build the Tower were created and then assembled. The complete model was then revised according to the present state of the structure. This database is currently being used to produce a 3-D film on the Eiffel Tower.

Groupe Seca, **Computer model of a Parisian dugout**, 2000
Soisic-type laser.

Dugouts dating from 4,500 BC were discovered during the Bercy excavations in 1991 and 1992. A 3-D computer model of one of the dugouts was created with a view to manipulating it on the screen of an interactive terminal. The readings for each point were recorded by laser so as to form a scatter of points from which a computer model was produced and then reprocessed into a synthesized image.

Maurice Benayoun/Z.A. Production, **World Skin**, 1998
Software: Silicon Graphics.

war offered by *Worldskin* (1997), tourist visitors take 'photographs' of media images that are cut out and analysed in the virtual space through which they move. With each shot they 'efface' the fragment of history they have photographed. The camera is no more innocent than a gun and responds to the procession of victims, ruins and soldiers' silhouettes that assail it from all sides. The power of Maurice Benayoun's work lies in the way that it catches the major parameters of these synthetic environments in a network of metaphors into which he introduces a few humorous paradoxes: photographing virtual elements, digging a tunnel through the intangibility of digital images (*Le Tunnel sous l'Atlantique* [*Tunnel under the Atlantic*] 1995), making communication all the more uncertain because it uses all the technical means at its disposal (*Crossing Talks*, 1999).

The principle of stereoscopy allows a synthetic scene to be perceived fully in its three dimensions, as described or generated by a computer programme. In his earliest experiments with virtual projection in the late 1970s, Jeffrey Shaw developed a system of visualization making it possible to see a cube in 3-D using a computer-generated stereoscopic image which, by a process of mirroring, could be superimposed on the viewer's own surroundings. Seeing the three dimensions of a space takes us a step further in our experience of virtual reality. For exploration of that reality is still new and seeking to develop beyond the escalating effects fostered by the entertainment industry. These systems must continually be re-evaluated to enable them to do more than simply surprise our senses; in this way they will avoid relegation to a place in the history of novelties.

1. Cf. description in Odile Fillion's article.
2. As, for example in the Cave at the Royal Institute of Technology in Stockholm.

J.M.G. Graphic's/Centre for International Cooperation in the
Field of Agronomic Research for Development, for the Parks
and Gardens Department of the City of Paris, **Computer
model of the Dessous-des-Berges garden**, 2000
Software: Computer Modelling Unit for Landscaping
Development (AMAP).

In 1978 the agronomist and mathematician Philippe
de Reffye developed a project based on computer
simulations of plant growth. Current research is trying
to take account of the external factors that influence plant
development. Among other things, the software makes
it possible to develop simulations of urban development.
Here, the relief and blocks of stone of the little
Dessous-de-Berges garden, created in 1999, evoke
a mountain landscape. A computer-graphics image
will make it possible to visualize its development over
the next few years.

French Electricity (EDF) and Vision Plus,
for the 'Friends of Bagatelle' association, **The Château
de Bagatelle in the Bois de Boulogne**, 1998
Software: Explore Silicon, Wave.

This folly, a small chateau built for social events and
entertainments, was constructed in the eighteenth
century for the Comte d'Artois (brother of the future
Charles X) in only two months. Alterations carried out in
the nineteenth century included raising the first floor and
making the bay windows larger. The computer model
shows it here in its original state.

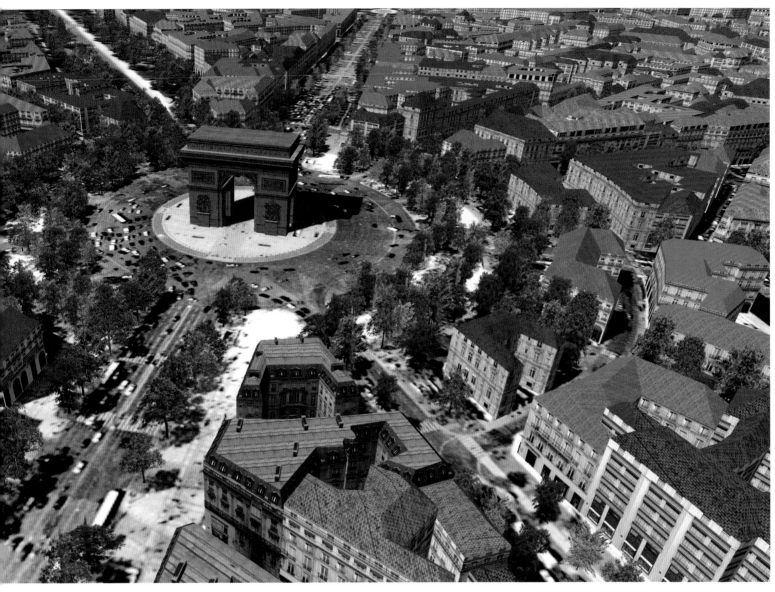

Ondim/Archi Video, for French Télécom, **Virtual walk round the Arc de Triomphe, computer model of the Étoile district**, 1999
Software: Fast Bielder, Animak, World Toolkit.

232

Gérard Perron, **Virtual tour of the Musée Carnavalet**,
2000
Software: Quick Time VR.

Images from an animated anaglyphic tour of the building
and rooms of the Musée Carnavalet.

234 Artists and contemporary art

Françoise Reynaud

Patrick Bailly-Maître-Grand

Born: Paris, 1945
Lives in Strasbourg; French

Œil de Mouche (Eye of a Fly), 2000
Installation: series of transparent globes filled with water
(63 globes 12 cm in diameter and 1 globe 16 cm
in diameter); overall height 120 x 130 cm, Plexiglas,
water and wood.

Coll. Patrick Bailly-Maître-Grand.

Patrick Bailly-Maître-Grand's project for the gardens
of the Musée Carnavalet provides a fitting introduction
to the phenomenon of three-dimensional vision. The
installation stands in the middle archway of the central
gallery. The series of globes evokes the multifaceted eye
of a fly after which the work is named, as well as Gabriel
Lippmann's remarkable invention of 'photographie intégrale'
(1908). Looking south through the biggest globe, the busy
Rue des Francs-Bourgeois can be seen through the
Arc de Nazareth, a sixteenth-century architectural element
from the Palais de Justice on the Île de la Cité. Facing north,
the other side of the central gallery is dominated by the
'Renommée' ('Fame') statue standing in the garden, a replica
of which is located at the top of the pillar in the Place
du Châtelet. The statue was created by Boizot in 1806 to
commemorate the victories of Napoleon. Its silhouette can
be seen, inverted, 63 times through the series of 63 globes.

'What if we had three eyes! Or eight, or twenty! What
do flies see with a hundred or so pupils around their head?
It would be like trying to listen to – and enjoy – all the one
hundred or so compact discs in your collection at the same
time. In simple terms, an eye is rather like a transparent
marble that projects a tiny image onto the back of the
crystalline lens, which the brain then sorts out into
a coherent vision of reality.

'Let's try an experiment. Supposing I construct
a network of lots of closely set crystalline globes, placed
side by side like a sort of optical stained-glass window,
in which each globe produces its own image of the
surrounding landscape, an image that is almost identical
to the one produced by its neighbour. What would we see
through it with our own two eyes? A window for flies?'
(P. Bailly-Maître-Grand, March 2000).

Since 1992, the artist has been experimenting with
the inverted image produced by an aquarium filled with
water and placed in front of a landscape ('Arrêt sur Viaduc',
'La Défense' and the installation at Pontault-Combault).
The glass globes extend the field of vision, while each globe
transmits a perspective which assumes an abstract form.
A network of glass balls placed in front of a landscape
prevents the observer from seeing in three dimensions.
It raises the issue of optical phenomena and the systems
invented to restore the impression of space and depth.

Sylvie Blocher

Born: Alsace
Lives in Saint-Denis, near Paris; French

Rue des Dames, self-portrait, 1992
Plastic Lestrade Stereoscope 7 x 12 x 7.5 cm;
stereogram in colour, recentred transparencies 24 x 36 cm.

Coll. Sylvie Blocher.

Silver stereoscopes on stems, stereoscopes stuck onto
panels to form tableaux, viewers placed at regular intervals
on the floor and walls, and telescopes made up the 180
holes through which to view the exhibition 'Mise à vue',
a presentation by Sylvie Blocher at the Abbaye Saint-André
de Meymac in 1993. It represented the last work of one
of her artistic methods, developed between 1984 and 1991,
'to try and see the world'. During this period, the artist made
extensive use of the Lestrade (or Simplex) international
catalogue, as well as her own stereoscopic images.

Sylvie Blocher has collected optical devices since
she was a child. They enabled her to see the world 'as little
luminous three-dimensional scenes of life'. But it wasn't just
the represented scenes that led the little girl to dream of the
world beyond; the illuminated transparency of the
stereoscopic views evoked the light at the end of a tunnel.
Today she makes films, creates installations and speaks with
emotion about her childhood love of stereoscopes.

The red stereoscope invites you to look into it and
discover a landscape but, as you do so, you meet the clear
wide eyes of the artist staring back at you with an attentive
and curious expression and just a hint of a smile. A dialogue
of exchanged looks is established: but what have we come
to see? Who captures our own gaze as we look through the
lenses of the stereoscope?

236

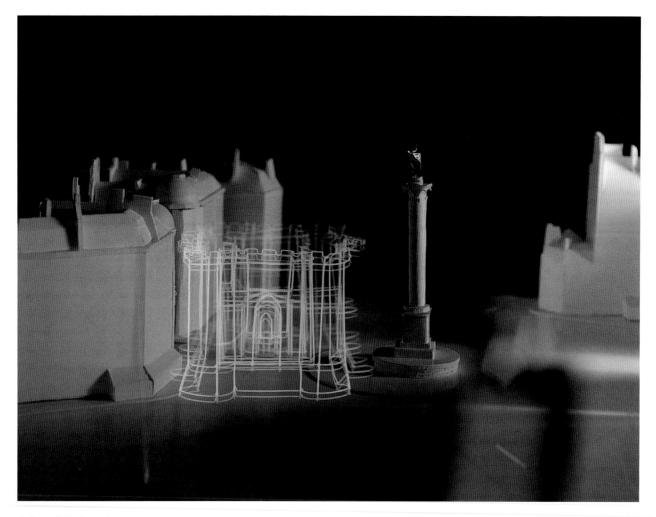

Gérard Boisard

Born: Paris, 1938
Lives in Ivry-sur-Seine, near Paris; French

Le Fantôme de la Bastille
(The Phantom of the Bastille), 1989–2000
Installation: metal model, painted wire, semi-transparent
mirror, lighting in black light; 170 x 100 x 120 cm.

Coll. Gérard Boisard.

Since the development of synthesized images, the sculptor
Gérard Boisard, who trained as an architect and engraver,
has created works inspired by their power to fascinate and
their ability to create the impression of a three-dimensional
shape evolving in space 'by itself'. His revolving pseudo-
virtual coffee pot (1988), his info-sculpted hat 'En attendant
Gouraud' ('Waiting for Gouraud') (1992) and his
reconstruction of a guardroom in the Bastille (1989) gave
him the idea of constructing a scale outline of the mediaeval
fortress – using a metallic, telegraphic and luminescent
framework – on the very spot where it would have stood
if it hadn't been demolished during the French Revolution
in 1789. Since the life-size project is 'virtual', the artist
modelled it by reducing today's Place de la Bastille and
giving the historic fortress an outline in green-tinted wire,
which is then transferred to its former site by an optical
illusion. Holography? Laser beam? Viewers cannot be sure
of anything as they look through a semi-transparent mirror
and see an impalpable weightless shape outlined in the
centre of the model.

Blanca Casas-Brullet

Born: Mataro (Spain), 1973
Has lived in Paris since 1998; Spanish

The work of Blanca Casas-Brullet, which today focuses
on the fragmentation and juxtaposition of parts of the body
photographed in action, is derived from the medical uses
of the laser and scanner. The cruciform series of profiles
of the face and head of a person – in 'Images
qui se croi(s)ent' it is the same young woman who is
photographed and whose skull is scanned – evoke some
of the historic moments in three-dimensional photography.
But this is pure coincidence. The artist was unaware of the
different forms of photosculpture developed in the late
nineteenth and early twentieth century by François Willème
and Claudius Givaudan, and of Louis Lumière's
'photostéréosynthèse'. Over the years, the processes have
coincided, in spite of the different preoccupations of each
period and the individuals concerned. The phenomenon
is truly amazing to observe, and attests to a fascinating
continuity in the fields of human thought and creativity.

Images qui se croi(s)ent (cruciform images), 1998
16 photographic prints, gelatin silver:
11.5 x 11.5 cm; 1 vertical print: 207 x 13.3 cm.

Coll. Blanca Casas-Brullet.

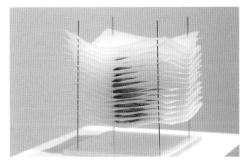

Reconstruction, 1997
16 sheets of Japan paper, alugraphic printing,
Plexiglas and metallic stems; 25 x 22 x 22 cm.

Coll. Blanca Casas-Brullet.

238

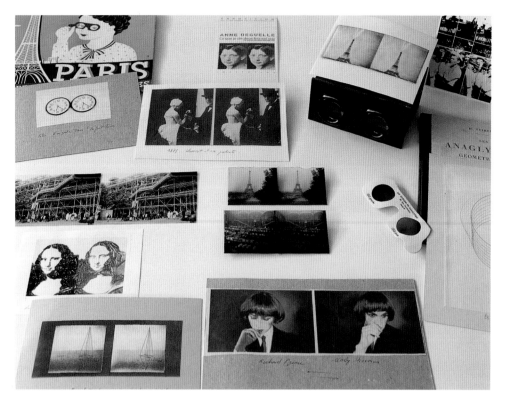

Fragments of a collection, **'Stereoscopic Images, Double Vision and Other Double Images'**, 1996–2000
Installation: photographs, stereoscope, publications;
100 x 70 x 140 cm.

*Coll. Anne Deguelle, with the exception of 'Is-Is' by
James Lee Byars, Coll. Neues Museum, Weserburg, Bremen.*

Anne Deguelle

Born: Paris, 1943
Lives in Paris; French

For many years, the visual artist, painter and photographer Anne Deguelle has been interested in stereoscopy and the phenomenon of double vision. She collects, creates and, on this occasion, has gathered together a collection of works centred around an old stereoscope, rather like a cabinet of curiosities.

The collection includes the work of other artists – James Lee Byars's 'Is-Is' (1993), printed on gold paper, Andy Warhol's 'Rain and Flowers' (1970), a 3-D Xograph – as well as examples of her own work based on double imagery: 'Diplopie-coup de foudre' (1996), 'Diplopie-Centre Georges Pompidou' (1996) and 'Diplopies-de ma fenêtre en 4D' (1993–2000).

Old stereoscopic views on glass – 'Grand Palais, le Salon de l'agriculture', 'La tour Eiffel' and 'Patinage au bois de Boulogne' (4 views) – and on paper – 'Palais de l'industrie' (2 views), 'Les deux amis' and 'Alpinisme à Chamonix' (2 views) – add the collector's touch.

Reproductions highlight the preoccupations of various periods: 'The Cholmondeley Sisters' (anonymous, 1600), 'Charcot et une patiente' (anonymous, stereoscopic view, c. 1900), Marcel Duchamp's 'Roue de bicyclette' (1913) and 'Stéréoscopie à la main' (1918), René Magritte's 'Portrait de Paul Nougé' (1927), Andy Warhol's 'Silver Marlon' (1963), Alighiero e Boetti's 'Jumeaux' (1968), Joseph Beuys's 'Zeige deine Wunde' (1974), Jean-Olivier Hucleux's 'Les jumelles' (1978), Richard Prince and Cindy Sherman's 'Portrait' (1980), Felix Gonzales-Torres's 'Perfect Lovers' (1987), Bernard Pifaretti's 'Crayon' (1988), Anne Deguelle's 'Double-portrait' (1997) and Vik Muniz's 'Double Mona Lisa' (1999).

Books, press cuttings and invitation cards complete the installation: Vuibert's *Les anaglyphes* (1912); *La sculpture au musée du Louvre* and *Paris en relief*, anaglyphic publications from the 1930s; and *Stereogram* (1994).

François Delebecque

Born: La Baule, 1955
Lives in Malakoff, near Paris; French

Le vol de la tour Eiffel
(The Theft of the Eiffel Tower), 1999
2 digital sepia prints on film, glass, soft oxidized steel,
Plexiglas, rubber; porthole window: 22 x 22 x 20 cm;
overall height 160 cm.

Coll. François Delebecque.

Since 1986, François Delebecque has been creating hybrid three-dimensional subjects in which superimposed images printed on film – creating an evocatively transparent effect of lightness and depth – are set into metallic structures that form a porthole window, cage or even a moving chariot. The theme of the chariot as the vehicle of images has pervaded the artist's work since 1990 and provided the title of a short film produced in 1998. In 'Le vol de la tour Eiffel' two small figures covered in leaves are trying to spirit away the Eiffel Tower by camouflaging it with foliage. According to the artist, the three-dimensional effect is merely 'a gentle illusion of space more or less accentuated by the juxtaposition of images'. In this respect, although he did not know it at the outset, his work coincided with the process known as 'photostéréosynthèse' developed by Louis Lumière. Spiriting away the Eiffel Tower, the largest monument in Paris, in a small porthole window made of a material that is reminiscent of the metal from which the tower is constructed, is a delightful jibe at those who built it (1887–89), digitized it, illuminated it or used it for publicity purposes, as an egg-timer or some other kind of tourist gadget.

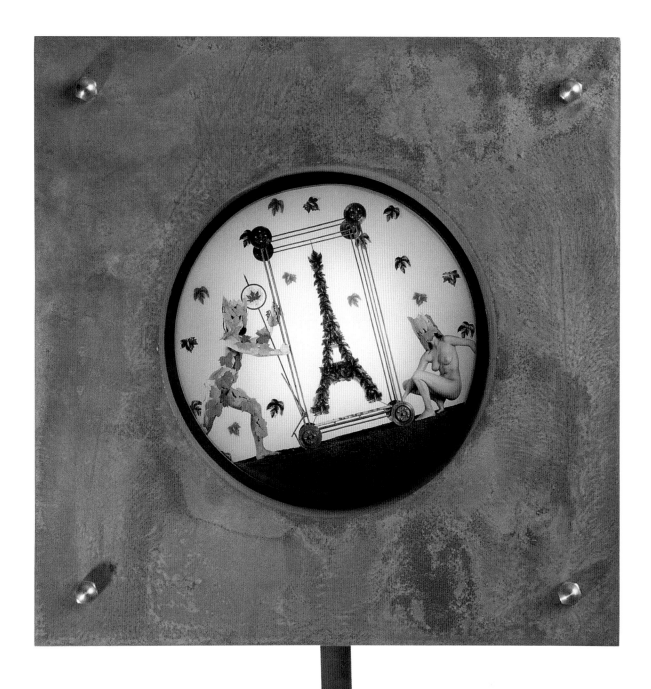

240

Alain Dufour

Born: Les Ageux (Oise), 1943
Lives in Boulogne-Billancourt, near Paris; French

Since 1988, this biologist, qualified pharmacist, collector
of cameras and talented amateur photographer has taken
a series of wide-format views, especially of Paris. In 1998,
after meeting people who were involved in producing
anaglyphs, in a photographic print laboratory, Alain Dufour
became passionately interested in three-dimensional views.
He periodically improves his equipment and adds to the
list of high viewpoints from where he photographs some
classic views. He also likes to photograph typically Parisian
monuments and recently renovated sites. The development
of an ingenious device has enabled him to record
successfully the hustle and bustle of public places, which
would be impossible without a perfectly simultaneous
technique for taking shots.

Bassin du Trocadéro and the Eiffel Tower, 29 August 1999
Countdown minus 156 displayed on the Eiffel Tower

Panoramic views (140°), taken with 2 coupled Kodak
Panoram no. 4 cameras (1900–05), scanning optics;
2 large-format colour transparencies; each image
6 x 29.5 cm.

Coll. Alain Dufour.

Parc André-Citroën, 29 August 1999
With the Fortis Balloon, view towards the Seine

242

HUES VIEWS COMPANY
Copyright 1991 Síochain Hughes

Underground & Underground Studios
Tunnel Series
Metro, Paris

Síochain Hughes

Born: Dublin (Ireland), 1961
Lives in Bloomfield, New Jersey (USA);
Irish/American

Paris Metro, 1991
Stereoscopic view in black and white, gelatin silver print 8.2 x 15.5 cm; mount 10.1 x 18.4 cm.

Coll. Síochain Hughes.

Drawing her inspiration from American commercial series such as those by Underwood & Underwood or Keystone, Síochain Hughes has arbitrarily created the Hues Views Company which offers a series of urban themes: 'Deutsche Bahn Series', 'Berlin 1994 Series', 'Berlin S-Bahn Series', 'Tunnel Series: Paris Metro; London Underground; New York City Subway' and 'Paris, France'. In 'Paris Metro', the view is taken from the elevated railway of Line 6. The stereoscopic effect is enhanced by the mirror placed on the line.

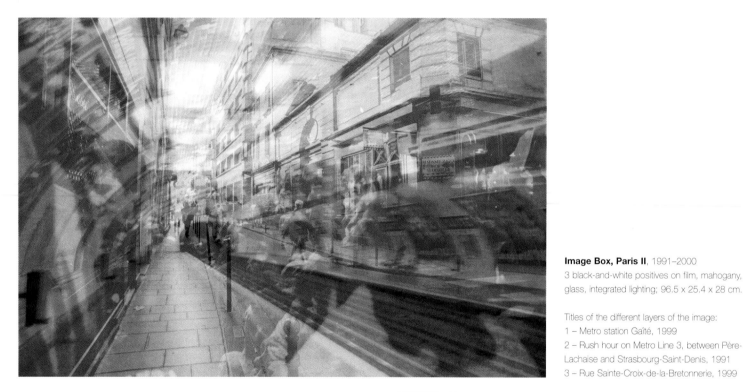

Image Box, Paris II, 1991–2000
3 black-and-white positives on film, mahogany, glass, integrated lighting; 96.5 x 25.4 x 28 cm.

Titles of the different layers of the image:
1 – Metro station Gaîté, 1999
2 – Rush hour on Metro Line 3, between Père-Lachaise and Strasbourg-Saint-Denis, 1991
3 – Rue Sainte-Croix-de-la-Bretonnerie, 1999

Coll. Síochain Hughes.

Since 1991, Síochain Hughes has been interested in many kinds of three-dimensional techniques: stereoscopy, anaglyphs, etc. In 1997, she exhibited works at the Galerie Jean-Pierre Lambert in Paris. These combined the composition and the transparency of images printed on film, as in the technique of 'photostéréosynthèse', of which she was then unaware. The superimposed images (between three and four different layers) are incorporated into elegant elements of light-coloured wood. Metro tunnels, stations, airports and a variety of urban settings create an impression of density which evokes the city 'tempo' particularly well, whether in a sort of table-top, as in this instance, or in convex or concave corner cupboards hung on the wall.

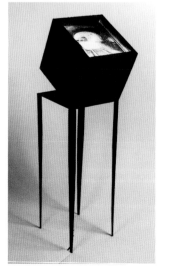

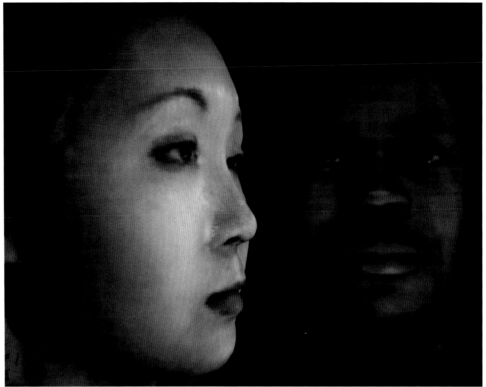

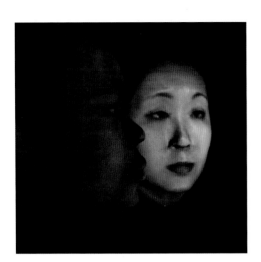

Catherine Ikam

Born: Paris
Lives in Paris; French

and **Louis Fléri**

Born: Casablanca (Morocco)
Lives in Paris; French

Scène virtuelle (Virtual Scene), 1998–2000
Project for a video installation: digital modelling, 3-D
rendering and animation; Umatic PAL source, from a digital
master, transmission via a monitor or by projection;
liquid-crystal glasses.

Coll. Catherine Ikam and Louis Fléri.

Catherine Ikam is a visual artist who, since 1990, has
been working on interactive virtual reality with Louis Fléri.
Since 1980, her work has focused on the concept of
identity and appearance in the electronic age. The face is,
for her, a 'place of disorientation'. 'L'autre' (1992), a mask
alternately sad and smiling depending on the position of
the observer equipped with the appropriate electronic tool –

as it was admired at Jouy-en-Josas at the Fondation
Cartier, near Paris – is entirely designed in three dimensions.
In the room where 'Elle' (1999) was placed in the Maison
Européene de la Photographie, a laser analysed the
positions of the spectators and let the piece evolve in
response to their movements. An impassive female face
with slanting eyes leans forwards, leans backwards, is
transformed into a pseudoscopic image; she blinks her
eyes, moves more quickly or slowly depending on where
the visitor or visitors are standing. This work, like the first,
could be presented in 3-D, all the necessary information
being present in the database.

'What interests me about virtual reality is fulfilling the
role of a sculptor; sculpting spaces which are constantly
changing,' Catherine Ikam says. 'Scène virtuelle' places
together two models, digitalized from real faces, who
otherwise had never met: an Asian female face and a black
male face, symbols of the cosmopolitan nature of our urban
society. The work pursues the artist's attempt to discover
the meaning of the relationships between the real and the
artificial, human and model, presence and absence.

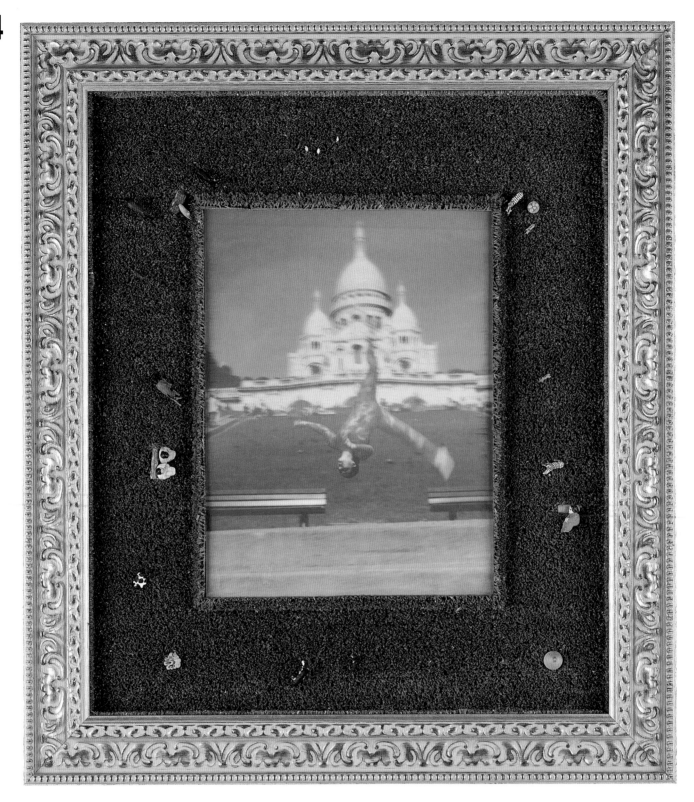

Kamran Kavoussi

Born: Teheran, 1960
Lives in Paris; Iranian

**Le Tire-Bouchon du Sacré-Cœur
(The Acrobat of the Sacré-Cœur)**, 1993
Lenticular image in colour, print from the 3dX Laboratory
(USA); image: 35.5 x 27.5 cm; frame: 69.5 x 61.5 cm.

Coll. Kamran Kavoussi.

Kamran Kavoussi has been living in Paris since 1980.
About ten years ago, using a four-lens Nimslo bought from
a camera fair, he began to take three-dimensional shots of
the street artists, dancers, actors, musicians, mime artists
and acrobats in the streets of the French capital whom he
had previously photographed in black and white.

Retranscribing a split second of their performance into
lenticular images, Karoussi gives the scene a dreamlike
setting, reworked in the style of a three-dimensional Persian
miniature – with little figurines made of all sorts of materials
arranged in the round. This technique allowed the artist
to create a universe of luminous magic and vibrant colours
where kitsch touches upon the poetic and the tender.

Martha Laugs

Born: Stolberg (Germany), 1935
Lives in Raeren (Belgium); German

Since 1989, Martha Laugs, a visual artist who combines all kinds of techniques and subjects, has been using stereoscopy as an integral part of her sculptures. Her work is punctuated by pairs or trios of views, for which no device is ever provided to enable the observer to see them in three dimensions – Martha Laugs has no difficulty using cross-viewing (by squinting) to fuse her pairs of images. One of her works is humorously entitled: 'Use your left eye to see the right sight' (1990). Observers are left to work it out for themselves and, if they don't succeed, they can always contemplate each separate element. The significance of these elements in relation to the overall subject is sufficiently intriguing and interesting in its own right.

In this work, the small figure (around the height of a man) looking through binoculars at the arch from the square in front of La Défense (as publicity for a fast-food restaurant) can be seen in three dimensions by parallel viewing or cross-viewing, since three different points of view are presented. Although the work appears to be addressing the problem of the place of human beings in relation to monumental architecture, it also raises the issue of the communication networks that underpin our cities and the means at our disposal to apprehend them.

Martha Laugs spent the summer of 1998 taking three-dimensional photographs of the fittings and furniture of the Paris Metro, in the corridors and areas surrounding the stations. She isolated them in her shots in order to determine their structure and typology, rather like ready-mades, and then grouped them together in series. The result is an inventory of ageless forms that appear to have been untouched by the passing decades, in spite of the continual comings and goings of millions of passengers.

Metro, 1998
Stereoscopic view in colour, based on 2 colour negatives
24 x 36 cm.

Coll. Martha Laugs.

La Défense-Bellevue, 1997
Sculpture, metal, concrete, 3 transparencies;
175 x 60 x 40 cm.

Coll. Martha Laugs.

246

Marie-Hélène Le Ny

Born: Vitré, 1963
Lives in Paris; French

Vincennes, 2000
Plexiglas, wood and 5 prints on transparent film;
16.5 x 24.5 x 6.3 cm.

Lac de Vincennes, 2000
Plexiglas, wood and 5 prints on transparent film;
13 x 18 x 6 cm.

Coll. Marie-Hélène Le Ny.

In the series that she calls 'Passing through Appearances',
Marie-Hélène Le Ny evokes the technique
of 'photostéréosynthèse' by using the vibration
of transparency. 'In the city, life is like a film that is being
fast-forwarded. The crowds, the movement, the lights, the
speed and the noise merge into inextricable kaleidoscopic
images with unpredictable trajectories.' In these works,
Marie-Hélène Le Ny – a city dweller who is fascinated
by the social implications of urban phenomena – was
inspired by the process developed by Louis Lumière.
She has attempted 'to redistribute space, as [she] likes,
to those who have passed through it, by mixing up
trajectories, provoking encounters and creating layers
which are so thin and permeable in relation to each other
that the immobile space and structures assume density
and presence, creating a striking contrast to the translucent
quality of the movement of the passing figures.' In this way,
the artist populates her scenes with human and animal
figures which invest them simultaneously with luminosity,
density and translucence.

Bruce McKaig

Born: Goldsboro, North Carolina (USA), 1959
Has lived and is at present living in Paris, after long periods spent in other European countries, South America, India and the United States; American

Bruce McKaig has been working with stereoscopy since 1986. In Latin America he took three-dimensional photographs using such rudimentary methods as photograms and pinhole photography. Living in Paris since 1993, he has become interested in more classic photography using a camera. Nevertheless, the themes which he explored remained surreal: somewhat bizarre street scenes, abandoned objects, stuffed animals in a museum, shop windows, merry-go-rounds . . . His preferred motifs were linked to subjects that were manipulated, their uses transformed.

These black-and-white prints are delicately tinted with watercolours in such a perfect manner that the three-dimensional images can always be easily seen and are not, as often happens, marred by irregularities. For the viewing of these images, which the artist considers one-off works, he has constructed stereoscopes in accordance with the Wheatstone principle, with inlays of precious wood. The entire creation process is very slow and painstaking, and sometimes the artist chooses to revive earlier images with colour. Today, alongside his extremely varied photographic work, which has always focused on the exploration of unusual devices, Bruce McKaig deals in his work with stereoscopy, pursuing new themes relating to daily life (for example, portraits of his friends) and the more architectural aspects of Paris.

Second-hand market, Avenue de Laumière, 1995
2 black-and-white gelatin silver prints tinted with watercolours by Dominique Taupin; each image 15.2 x 14.4 cm, each mount 18 x 16 cm.

Coll. Musée Carnavalet.

Stereoscope with mirrors, 1995–96
Zebras and giraffes at the Museum of Natural History, 1994
Wheatstone stereoscope, mahogany, exotic woods; 19 x 28 x 17 cm.
2 black-and-white gelatin silver prints tinted with watercolours by Dominique Taupin; each image 14 x 13.1 cm, each mount 18 x 16 cm.

Coll. Musée Carnavalet.

Mannequins, Boulevard Magenta, 1994–95
2 black-and-white gelatin silver prints tinted with watercolours by Dominique Taupin; each image 13.9 x 12.9 cm, each mount 18 x 16 cm.

Coll. Musée Carnavalet.

248

RUE DU DÉPART
QUAI DU POINT-DU-JOUR
AVENUE DU COQ
HAMEAU LA FONTAINE
RUE DE LA POMPE
RUE DE LA GOUTTE-D'OR
RUE DU SOLEIL
RUE DU JOUR
PORTE DES LILAS
RUE CAMPAGNE PREMIÈRE
RUE DU BOCAGE
GALERIE DES CHAMPS
RUE DU MOULIN-DES-PRÉS
PASSAGE DES HAIES
RUE DU BUIS
RUE DES ALOUETTES
RUE BOIS-LE-VENT
COUR DU BEL-AIR
IMPASSE DES JARDINIERS
PASSAGE BONNE-GRAINE
RUE DE LA PÉPINIÈRE
QUAI-AUX-FLEURS
RUE PAPILLON
RUE DES ROSIERS
SQUARE DES MIMOSAS

RUE JASMIN
RUE DES GLAÏEULS
COUR DU PANIER FLEURI
JARDIN DES PLANTES
AVENUE BOSQUET
IMPASSE HAUTEFEUILLE
PLACE DU TERTRE
RUE DU RENARD
RUE CHAPON
RUE POUSSIN
RUE DES CANETTES
COUR DES FERMES
IMPASSE DU BOEUF
RUE DU PAS-DE-LA-MULE
RUE DE L'ABREUVOIR
RUE DE LA GRANGE-AUX-BELLES
RUE DES LISERONS
JARDIN DES MÛRIERS
RUE DES MARAÎCHERS
RUE DU PONT-AUX-CHOUX
PASSAGE DES EAUX-VIVES
RUE DU CHAT-QUI-PÊCHE
FAUBOURG POISSONNIÈRE
RUE DE L'HIRONDELLE
RUE DES QUATRE-VENTS

PASSAGE DES PANORAMAS
RUE DU DESSOUS-DES-BERGES
RUE DES FONDS-VERTS
RUE DES PÂTURES
RUE PASTOURELLE
CITÉ BERGÈRE
RUE MOUTON-DUVERNET
PLACE PASDELOUP
ALLÉE DES BROUILLARDS
CITÉ HIVER
RUE DE L'ARBRE-SEC
RUE DU ROCHER
RUE LEPIC
PASSAGE DES ÉPINETTES
AVENUE DES PEUPLIERS
RUE DU REPOS
ALLÉE DU LAC
RUE DU CYGNE
VILLA HAUTERIVE
CITÉ HÉRON
RUE DE LA SABLIÈRE
VILLA DES FALAISES
SQUARE LA BRUYÈRE
RUE SERPENTE
SENTIER DES MERISIERS

RUE DES JONQUILLES
RUE CHAMPFLEURY
VOIE DES CHARMILLES
PASSAGE DU PETIT-CERF
IMPASSE DE LA MARE
PASSAGE DU PONT-AUX-BICHES
RUE DU GRAND-VENEUR
RUE DE LA FAISANDERIE
RUE DU FAUCONNIER
RUE DE LA BUTTE-AUX-CAILLES
SQUARE ORTOLAN
AVENUE DES CHASSEURS
RUE BEAUTREILLIS
RUE DE LA CAVALERIE
RUE DES BOIS
RUE DES FOUGÈRES
IMPASSE CORNEILLE
RUE DE LA LUNE
COUR DE L'ÉTOILE D'OR / RUE
DE L'ÉTOILE
RUE DU VIEUX-COLOMBIER
RUE DE LA GRANDE-CHAUMIÈRE
RUE DE L'ARRIVÉE
**(cube n° 1 / 0° at 60° from the
angle of vision of the hologram)**

PLACE BIENVENÜE
PASSAGE DE L'ASILE
RUE MADEMOISELLE
RUE DU REGARD
RUE CHARLES LAMOUREUX
RUE DÉSIRÉE
RUE DE L'ESPÉRANCE
RUE GALANDE
PASSAGE DES SOUPIRS
PLACE DE LA RÉSISTANCE
IMPASSE DES SOUHAITS
RUE DES VERTUS
RUE DE LA FIDÉLITÉ
IMPASSE DE LA DÉFENSE
RUE DU RETRAIT
RUE DES SOLITAIRES
RUE GÎT-LE-COEUR
RUE DE LA FOLIE-MÉRICOURT
RUE DES MESSAGERIES
CITÉ DU RENDEZ-VOUS
CITÉ BEAUREPAIRE
RUE BEAUREGARD
CITÉ BIENAIMÉ
IMPASSE DE LA GAÎTÉ
PASSAGE DU DÉSIR

RUE DES RECULETTES
RUE DES ENVIERGES
SQUARE DE L'UNION
IMPASSE MONPLAISIR
PLACE DES VICTOIRES
RUE DE PARADIS
RUE DE LA FÉLICITÉ
IMPASSE DE LA LOI
RUE DE L'ÉGLISE
BOULEVARD DU TEMPLE
RUE MADAME
RUE MONSIEUR
RUE DES MARMOUSETS
RUE ROSA BONHEUR
RUE DE L'HARMONIE
RUE DES BONS-VIVANTS
IMPASSE DE LA CONFIANCE
VILLA DE LA RENAISSANCE
RUE DES QUATRE-FILS
IMPASSE DE LA SANTÉ
PASSAGE DES DEUX-SOEURS
COUR DES TROIS-FRÈRES
IMPASSE DES DEUX-COUSINS
PLACE DE LA RÉUNION
PASSAGE DU MARCHÉ
RUE DES HALLES
RUE DES MEUNIERS
RUE DE LA HUCHETTE
RUE DU FOUR
RUE DES BOULANGERS
RUE DU PRESSOIR
PASSAGE DE LA PETITE BOUCHERIE
RUE DE LA GLACIÈRE
RUE SAULNIER
PASSAGE POTIER
RUE TISSERAND
RUE DES LAVANDIÈRES STE OPPORTUNE
PASSAGE DES LINGÈRES
RUE DE L'ÉCHAUDÉ
SQUARE DES CARDEURS
RUE DE LA CORDERIE
RUE DES TANNERIES
RUE DE LA PARCHEMINERIE
QUAI DE LA MÉGISSERIE
PASSAGE DES TAILLANDIERS
RUE DE LA COUTELLERIE
RUE DES CISEAUX
RUE CHAUDRON
RUE DU FER-À-MOULIN
PASSAGE TENAILLE
PASSAGE DE LA FONDERIE
RUE DES FORGES
RUE DE LA FERRONNERIE
IMPASSE DES CARRIÈRES
JARDIN DES TUILLERIES
RUE DE LA BRIQUETERIE
RUE DE LA BÛCHERIE
RUE DE LA VERRERIE
PASSAGE DES FOURS-À-CHAUX
RUE DES CHAUFOURNIERS
RUE DU PLÂTRE
RUE DES DÉCHARGEURS
RUE DES CHANTIERS
PORT DE L'ARSENAL
RUE DE L'AQUEDUC
RUE DU CHÂTEAU-D'EAU
VILLA DES ENTREPRENEURS
COUR DES FABRIQUES
PASSAGE DE L'INDUSTRIE
PLACE DU COMMERCE
PONT DES ARTS
IMPASSE DES PEINTRES
RUE DES ARTISTES
RUE DE L'EXPOSITION
RUE DE LA MONNAIE
QUAI DE L'HORLOGE
RUE DES FRANCS-BOURGEOIS
RUE RICHOMME
RUE DU TRÉSOR
RUE DE LA CLÉ
RUE DE LA BANQUE
RUE DU CHÂTEAU-DES-RENTIERS
IMPASSE DU CRÉDIT LYONNAIS
RUE DE LA GRANDE TRUANDERIE
PASSAGE DE LA VÉRITÉ
VILLA MODERNE
PASSAGE DU PROGRÈS
CITÉ DE L'AVENIR
**(cube N°2 / 60° at 120° from the angle
of vision of the hologram)**

Hélène Mugot

Born: Bougie (Algeria), 1953
Lives in Gentilly, near Paris; French

Tableaux parisiens (Parisian Scenes), 2000
Project for a digital reflection hologram presenting 2 virtual
images in turn (120 x 120 cm, in 4 sections 60 x 60 cm).
Typography: Bodoni Roman. Software: 3D Studio Max;
transfer of files via the Internet at the Zebra-Imaging
holographic laboratory (Austin, Texas); in association with
Metafort d'Aubervilliers and assisted by Sébastien Dabadie.

Coll. Hélène Mugot.

'In the beginning was the Word . . . ' As in some of her
other recent works – 'Le pouvoir du Monde' (1996),
'Le centre du Monde' (1998) and 'Le Banquet' (1999) –
the artist uses words, the names of things instead of their
image, in an attempt to reinvest the word and the meaning
with their original power. By using the word 'Light' – one
of the first words mentioned in the Bible's Book of Genesis
– God created Light. In the same way, the magic formulae
of names and terms enable images that are richer in
meaning, denser and more creative, to rise to the surface
of the individual or collective memory.

To materialize this rather more metaphysical approach
and avoid adding another type of image to an already
saturated contemporary environment, Hélène Mugot
chose holography – writing with light – to illustrate the
concept of Paris: 'Ville-Lumière' ('City of Light'). She takes
the observer on a charming and appealing journey through
Paris, as street names evolve in space, behind
and in front of the holographic plate. All the colours of
the rainbow are used to concretize, in thirty or so shades,
the light radiating into the field of vision. Elegant lettering –
reminiscent of the beautiful Didot printing on the old street
plaques of the city – stands out in three dimensions
in a sort of logical and well-ordered ballet.

The names of streets, quays, bridges, avenues,
passageways, culs-de-sac, courtyards, squares and
gardens follow one after the other, pass each other and
form, via two virtual cubes which are only visible in
succession, two conceptual promenades, each with its own
particular atmosphere. One begins with blue, while the other
ends with red, the two colours of Paris. The first promenade
belongs to the bucolic world of a golden age and evokes a
rural Paris of yesteryear that smelt sweetly of the changing
seasons. The second, which begins with 'love at first sight',
draws us into the pleasures and torments of life, love and
work: the history of mankind since time immemorial. But
after paradise lost comes the eternal city: Paris regained.

250

Alain Paiement

Born: Montreal, 1960
Lives in Montreal and Brussels; Canadian

Diamant (Diamond), 1999–2000

View of Paris from the top of the scaffolding of the Georges
Pompidou Centre during renovations for the year 2000.
Mobile photographic sculpture, complete panoramic view,
horizontal and vertical (360°), reworked digitally.
Laminated digital prints arranged on a framework, aluminium
gyroscopic to ensure the mobility of the work in relation
to itself; 250 x 300 cm.

Coll. Alain Paiement.

Alain Paiement, who has moved away from abstract painting
to work on architecture and urban development through the
media of photography and sculpture, is interested in the
overall perception of a subject and ways of transcribing it
in its totality. By means of a very particular form of geodesy,
bringing together photographic optics and a process of
digital synthesis, he simultaneously reconstructs space and
volume. 'Mapping', in the broad sense of the term, enables
him to construct a three-dimensional image from multiple
photographs. This image creates the impression that the
scene or landscape has been turned inside out like a glove,
in a mental reconstruction which forces the spectator to
spin round on himself, through the abstraction of his
imagination and his inventive memory. According to Guy
Bellevance, photography is one of the 'most characteristic
fragments' of the urban landscape ('Mentalité Urbaine,
Mentalité Photographique', *La Recherche Photographique*,
no. 17, p. 15). 'Diamant' is like a giant photographic
fragment, a diamond from the heart of Paris, crystallizing
a specific moment in the city's history.

Alain Paiement took up a position on a level with
the top floor of the Georges Pompidou Centre and near
the south corner of the building, on scaffolding that ran
parallel to that of the façade and supported the giant
publicity hoarding for Swatch (designed to conceal the
renovation works). Today, the position that gave him an
unrivalled view of the renovation work and the Parisian
landscape is a completely empty space. Equipped with
a Hasselblad Super Wide Camera (6 x 6 non-reflex camera
with a Zeiss Biogon lens), having ingeniously transformed
the tripod to make it gyroscopic and able to turn in all
directions, the artist spent an entire day in mid-June 1999
taking photographs that he later extended and adapted –
one per facet – to form the shape of a diamond, the
polyhedron that symbolizes perfection and eternity, after
which the work is named.

Before the invention of photography, the first
images seen through the stereoscope were polyhedrons
(such as the geometric figures of the nineteenth-century
French optician Louis Jules Duboscq, printed on a black
background). For Alain Paiement, 'Diamant' not only pays
homage to 'Conical Intersect' (1975) by Gordon Matta-Clark
(1943–78) – a conceptual piece made when the Pompidou
Centre was first being built – but is also a culmination of
the series of giant polyhedrons that he has created featuring
French, American and Canadian architecture since 1986.
Within the context of the 'Paris en 3D' exhibition, this
photographic sculpture raises the issue of an image
with volume.

Alain Paiement's previous works on Paris: 'Mapping
Continuum (Bourse de Paris)' (1991–94), the 'Amphithéâtre
Bachelard' (1986-–88), and the 'Grand amphithéâtre' (1988)
at the Sorbonne University.

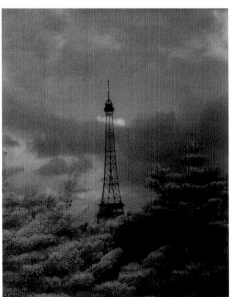

Guillaume Paris

Born: Abidjan (Ivory Coast), 1966
Lives in Paris; French

The Eiffel Tower, 1998
The Cemetary at Montparnasse, 1999
Lenticular photographs from 4 colour negatives; each print
8.9 x 11.4 cm.

Coll. Guillaume Paris.

Guillaume Paris is a visual artist who is carrying out
a number of projects in various fields. Some, such as his
remarkable study of commercial packaging designs inspired
by the great themes of the history of art, have social
connotations. Each study is based on the identification
of the specific characteristics of the medium used.

Equipped first with a Nishika and then a four-lens
Nimslo, the artist has been taking three-dimensional
photographs since 1990. He has chosen themes
for which this technique is most frequently used at both
amateur and commercial level – picturesque and religious
scenes, flowers and plants – and has managed to avoid
the more banal and kitsch subjects. Flights of pigeons,
chairs in Parisian public gardens, tombs decorated
with real and artificial flowers, monuments and events.
He recreates a contemplative world inspired by the
relationship between the shimmering colours on the
different grounds of the image.

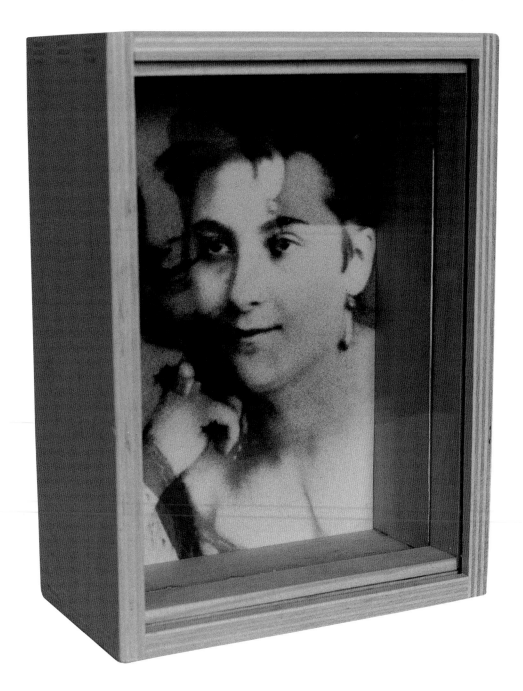

Catherine Poncin

Born: Dijon, 1953
Lives in Montreuil, near Paris; French

L'instant aveugle (The Blind Moment), 1994–2000
From a series of six portraits of actresses, gelatin silver print, wood, 2 pieces of glass; 11 x 15.5 x 6 cm.

Coll. Catherine Poncin/Galerie Les Filles du Calvaire.

Since the 1980s, Catherine Poncin's technique of reinterpreting old photographs has led her to establish a dialogue with time and presence, a study of memory. By means of subtle découpages, recentring and repetition, she redefines fragments of images found by chance or in thematic collections, emphasizing attitudes and atmosphere, moments and emotions. She found the stereoscopic portraits of Parisian actresses during the

Second Empire – preserved in the collections of the Musée Carnavalet – all the more fascinating since the faces and silhouettes of these women, now forgotten, show them at the height of their careers, in the two slightly different poses required for the photographic stereoscopic technique. In 'L'instant aveugle', the artist is referring to the 'blind moment' that the observer cannot see through the binocular viewer. The moment at which the two images are superimposed by the stereoscope, a sort of space into which forms and aspirations topple. Superimposition is here treated as a subjective proposal. The reference to illusion is developed not by 'three-dimensional form', but by 'three-dimensional time'. Two pieces of glass, one tinted an almost imperceptible pink – a reference to the anaglyph, another stereoscopic technique – provide double protection for each work, set within its frame.

Jacques Robin

Born: Geneva, 1964
Lives in Meinier (Switzerland); Swiss

Jacques Robin is a sculptor whose work incorporates fixed and moving images to create a wide range of visual effects. For the 'Paris en 3D' exhibit he has developed two machines that will take visitors on a walk through Paris.

An appearing and disappearing object interacts with a photograph seen in relief and is superimposed upon the images through semi-transparent mirrors. These photographs are fixed to drums that visitors can turn for themselves using a wheel linked to an ingenious mechanism. The three-dimensional image is obtained by means of the two angled mirrors, in accordance with the principle of the Wheatstone stereoscope. In addition to the fascination of the three-dimensional images – in this instance wide-format images over which the viewer's gaze can wander – there is the surprise of discovering a hidden object and the added pleasure of actively participating in the process.

In 'Jeux de balle', a ball leaves the hands of a little girl in the Place des Vosges and bounces into different parts of Paris: first along the Left Bank of the Seine, where the riverboats are moored in the port of Montebello, then near the Conservatoire des Arts et Métiers on the Rue Reaumur, and finally to the exit of the steps of a public car park on the Rue Saint-Martin. The little ball, which is lit up to draw the viewer's eye from one scene to the next, bounces and turns behind the 'peephole' mirror.

'Jeux de masques' goes even further in the field of optical devices by taking the bronzes of Aristide Maillol (1861–1944) as a departure point for a reflection on sculpture and architecture. The viewer can see through part of a statue to the walls of the Louvre, which overlooks the gardens adorned since the 1960s with these nudes (donated by Dina Vierny). 'Île-de-France', 'La baigneuse' and 'Vénus' turn on the drum. At the same time, the missing part of the body can be seen lit from the inside, which creates a dilemma in the viewer's mind: is he or she looking at the hidden nude or architecture revealed?

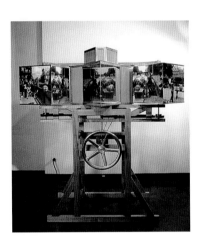

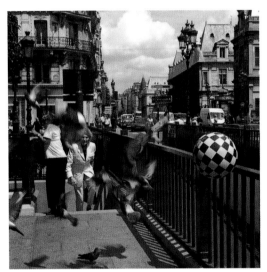

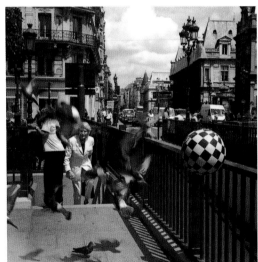

Jeux de balle à Paris (Ball games in Paris), 1999
8 gelatin silver prints, two-way semi-transparent mirrors, wood, galvanized steel, aluminium, transmission devices, dynamo, lamp, miniature ball; 155 x 181.5 x 93.5 cm.

Coll. Jacques Robin.

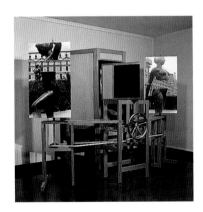

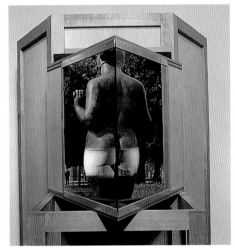

**Jeux de masques au Carrousel
(Masked games at the Carrousel)**, 1999–2000
6 digitally reworked gelatin silver prints, two-way semi-transparent mirrors, wood, galvanized steel, aluminium, transmission devices, dynamo, 3 lamps, plaster-cast torso; 210 x 280 x 180 cm.

Coll. Jacques Robin.

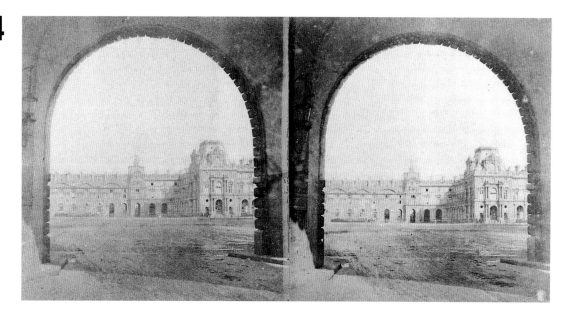

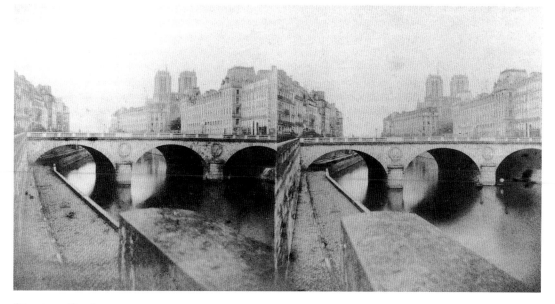

Stephen Sack

Born: Plainfield, New Jersey (USA), 1955
Lives in Brussels; American

The Louvre, 1999
Gelatin silver print; 90 x 180 cm.

Île de la Cité, 1999
Gelatin silver print; 90 x 180 cm.

Coll. Stephen Sack.

Within the context of his work on ancient documents (portraits on tombs, coins, engravings by Buffon), to which he always gives an unusual interpretation (as if he had an 'inner vision' of things), Stephen Sack decided to rephotograph nineteenth-century stereoscopic images. He presents them as a series of panoramic landscapes, which he called 'Landscapes' (1995–99) and in which he abandons the concept of three dimensions in favour of the formal aspect of the overall composition.

After looking at thousands of images, Stephen Sack chose those that remained imprinted on his memory because there were unusual marks on them – this one could have been from a huge fire – or because they depicted a monumental bridge or endless arcades, double churches or a pair of columns. Such places, ones that we know well but can never identify, come back to us every so often in our dreams.

The 'Landscapes' series leads us to experience a fourth dimension, perceived as an echo that becomes flattened, but continues to reverberate since it immediately reflects the memory that we construct of a place. Places no longer look the same and could be anywhere: Paris has been transformed.

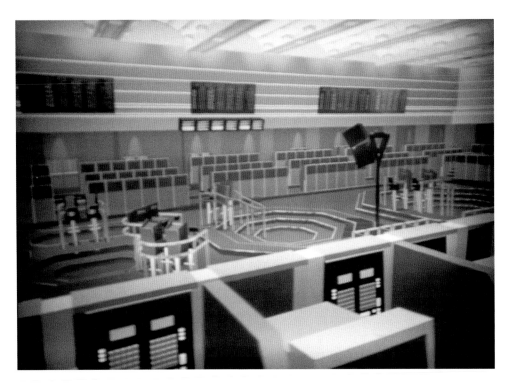

Ellen Sandor

Born: New York, 1942
Lives in Chicago; American
In association with Stephan Meyers and Janine Fron,
(art)ⁿ Laboratory.

The Matif (virtual stock-exchange), 1994

Virtural Reality still 'PHSCologram' synthesized image,
line screen photograph, computer interleaved Cibachrome
and Kodalith colour films, backlit Plexiglas; 30 x 40 in
(76.2 x 101.7 cm).
Virtual reality obtained by Scott Kinsey, Steven Meier and
Dave Ivey, Space Management Programs, using the Matif
S.A.'s file (1994) to transform the Paris Stock Exchange
into a virtual market; with the collaboration of the Electronic
Visualization Laboratory of the University of Illinois, Chicago.

Coll. Ellen Sandor.

Ellen Sandor, a sculptor by training, was one of the first
artists to work on the images that were the forerunners
of virtual reality, beginning in 1983 in the United States.
In the same year she founded the '(art)ⁿ Laboratory', which
brings together artists and the creators of numerous three-
dimensional images at Northwestern University in Evanston,
near Chicago. Many collaborations with the world
of science also take place there. The name of the technique
'PHSCologram' was invented by Ellen Sandor and
combines the initials of photography, holography, sculpture,
and the 'C' from computer. The term is a reference to both
the means by which these images, which are at first
generated – and embedded – by computer, are put into
relief and to the effect of depth perceived by the viewer.

This virtual reality image, created using a line screen,
represents the replacement of the traditional trading pit used
by the stockbrokers of the Paris Stock Exchange with a
new system of computer screens that makes it possible
to carry out electronic transactions. The database for this
virtual architecture of the Matif (Marché à Terme International
de France) was provided by a French company. Thus,
in 1994, the entire field of three-dimensional creation got
off to an early start, as much in the realm of architecture as
in that of science or economics. But unlike most such
works, this one involved the actual visualization of a three-
dimensional image, achieved by means of a unique process
that is still kept a closely guarded secret.

Jacques Simonetti

Born: Meknès (Morocco), 1941
Lives in Nancy; French

Atelier de Vavin no. 2, 1999
Attaché case, metal, glass, plastic, 4 photographs;
39 x 28 x 10 cm when closed; 39 x 55 x 21 cm
when open.

Coll. Jacques Simonetti.

This unrivalled inventor, fascinated by the phenomena
of the transmission of images, is always ready to create
new devices and experiment with all the possibilities of light.
The artist works with different materials, especially metal, to
produce optical illusions and unexpected effects in space.

First known for his astonishing anaglyphs 'Des Poissons
dans les Murs' ('Fish in the Walls'), created from
photographs of cracks in the walls of buildings in the
city of Nancy, Jacques Simonetti has proposed a work
of an eminently conceptual nature, whose link with Paris
is truly virtual. An incomprehensible phenomenon is seen
through anaglyphic glasses (located in a second attaché
case that accompanies the first). Impalpable forms appear,
floating in the air on the interior face of the lid. If set on
the right track, some people can figure out the connection
between stereoscopic photographs and the luminous
reflections captured on metal plates arranged on the
bottom of the case.

Dagmar Sippel

Born: Schmalmstadt (Germany), 1961
Has lived in Paris since 1987; German

**L'autoportrait photographique en 3D
(3-D photographic self-portrait)**, 1992–98
Series of images, lenticular photographs, colour prints from
4 negatives, on opaque or translucent photographic paper;
24 x 18 or 62 x 51 cm.

Coll. Dagmar Sippel.

Dagmar Sippel got the idea of creating three-dimensional
self-portraits (of which she has done around sixty) in Paris
when she found a damaged but repairable 1970s Nimslo
camera (with four lenses) in a flea market. She attached
to it a 6-metre-long wire shutter release and a 10-second
self-timer so that she could stage her own shots. After
Frankfurt, London, and Rome, Dagmar Sippel uses Paris
as her scenery. The monuments, gardens, streets, and
squares of the city become pretexts for her sometimes
fantastic simulations. She places herself in situations that
are humorous (as a chic or slightly vulgar tour guide), wild
(stealing the Mona Lisa and sneaking past the Pyramid
of the Louvre, armed with a pistol) and delightful (as
a mermaid in front of the Bassin de la Villette and Marilyn
Monroe at Les Halles). Amazingly enough, the artist works
entirely alone and no one tries to interrupt her.

Since 1981 Dagmar Sippel's artistic process has
been that of a photographer and a model at the same time.
Unlike a Cindy Sherman, she takes advantage of references
to the modern world to emphasize individual attempts
at social integration and the professional adaptations that
most of us make. The artist seeks – by playing with her
successive incarnations – as much to demonstrate that
all of the different aspects of each person's personality have
an ever-renewable authenticity, as to prove the liberating
value of an attitude that does not allow her to take herself
too seriously.

258

Michael Snow

Born: Toronto, 1929
Lives in Toronto; Canadian

Egg, 1985
Transmission hologram: 60 x 50 cm; metal frame;
base with a cast-iron frying pan: 112 x 63 x 40 cm.

*Coll. Fonds National d'Art Contemporain, Ministère
de la Culture et de la Communication, catalogue no. 96,177.*

Type-Writer, 1985
Transmission hologram: 60 x 50 cm; base with a typewriter:
112 x 63 x 40 cm.

Coll. Michael Snow.

Maura Seated, 1985
Transmission hologram: 60 x 50 cm; wooden frame;
wooden base: 11 x 66 x 142 cm; mirror: 14 x 41 cm
and Plexiglas sides: 67 x 59 x 89 cm.

Coll. Michael Snow.

The painter, sculptor, film-maker, photographer and
musician Michael Snow had never experimented with
the technique of holography when, in 1984, he was asked
to create holograms for Expo 86 in Vancouver. At its height
at the time in North America and especially in Europe,
holography was especially well suited to his artistic method,
which addresses the problems of perception and the
means of achieving or avoiding it. He took up the challenge
and created a hundred or so pieces, fifty of which were
displayed. To create some of these images, he needed
to travel to the Musée de l'Holographie in Paris, which
opened in 1980 and was equipped with a pulse laser,
an indispensable piece of equipment for creating portraits
or scenes using real people (with standard lasers it is only
possible to produce a hologram of elements made from
extremely stable materials, the most widely found type
of hologram).

The holograms from the Parisian series on the one
hand illustrate the possibility of producing a three-
dimensional recording of an action within time and, on the
other, develop the confrontation between the real and the
virtual, the tangible and the intangible. 'Egg', one of the best
known of these works, shows the artist in the process
of cracking an egg, with viscous matter suspended virtually
in the air, ready to fall into a real frying pan placed beneath
the image. Some of the portraits are of members of the staff
of the Musée de l'Holographie or of Parisians, such as
'Type-Writer', which shows Guy Fihman, another
holographic artist and film maker. Michael Snow posed
him as a journalist hurriedly writing an article, exhaling the
suspended smoke of his cigarette, while his hands are busy
typing on a typewriter which is actually placed beneath the
hologram. Another piece, 'Maura Seated', records not
an action but a thought. At first we see only the Plexiglas
structure, a sort of abstract sculpture. But as we approach
we notice the hologram, placed horizontally, showing,
as if we were looking at her from above her shoulders,
a woman looking at herself in a mirror which she holds
on her knees. She seems virtually to fill the interior of the
Plexiglas stand. Acting, creating, and reflecting: three
moments that symbolize existence and artistic creation.

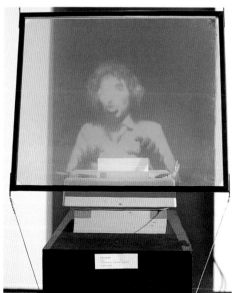

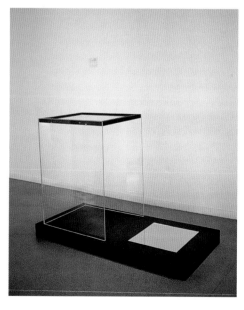

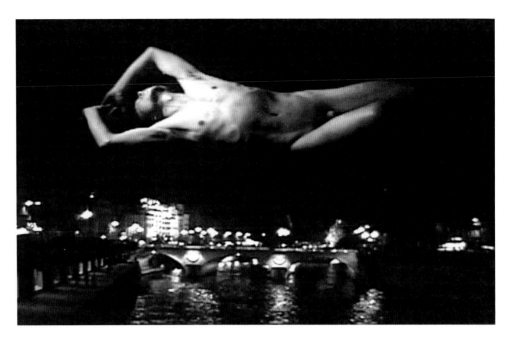

Aiyoung Yun

Born Seoul, 1964
Has lived in Paris since 1989; Korean

Abyss, 2000
3-D video installation with liquid-crystal glasses and sound;
basin, video monitor, VCR; 70 x 150 cm.

Coll. Aiyoung Yun.

A three-dimensional human form evolves in the darkness
above Paris and the waters of the River Seine, the 'symbol
of a certain obsessive desire to escape from enclosed
spaces'. The installation maintains the continuity of the work
of the artist and her partner, Cho. They have both (under
the name Cho & Yun) often expressed the movements
of the consciousness in response to the limitations
of existence and the material world. The soul, regarded
as evolving around each individual being, is represented
by a body or face floating in space and time.

'Time Cube' (1998), a 3-D video installation viewed through
glasses, symbolized the insatiable quest for human
happiness. 'Abyss' was created by Yun working on her own
and reflects her perception of herself as the eternal
stranger: a stranger in the city where she has chosen to
live, but also a stranger now in the city where she was born,
a feeling of which she is very much aware each time she
returns there.

The city has rarely been featured in the symbolic
themes of Cho & Yun. The young woman therefore
approaches the theme in this work from an entirely personal
point of view. The figure rises and falls, unable to gain
access anywhere; it floats and remains external, in an
original and subjective Parisian composition.

260 Fernand Zacot

Born: Cairo (Egypt), 1950
Lives in Paris; French

When Fernand Zacot was caught taking photographs with a stereoscopic camera in the Rue du Faubourg-Saint-Antoine in 1995, he revealed that he was a keen collector of views on glass and stereoscopes dating from 1900–30. Since childhood, this graphic artist and designer-illustrator for the press has collected, exchanged and sold plates, keeping the most beautiful examples for a time before starting to collect a new series. But above all, he designs the most beautiful and originally shaped stereoscopic viewers, which are carved from exotic woods and which have the feel of a fine maritime instrument. With artist Alphonsine David and the writer Jean-Pierre Dufreigne, he has also created a series of elegant book-objects entitled *Paris et son double (Paris and her Double)*. These single editions have twenty of his contemporary views and a stereoscope incorporated into the binding.

Fernand Zacot began to take stereoscopic photographs in 1994, going in search of scenes of everyday life, street events in the working-class districts of Paris, trades from bygone days or that are fast disappearing, performances, fashion shows, and the humour – or poetry – of certain situations typical of Parisian life. One of the new themes in which he is currently interested is the world of Marcel Proust.

Paris et son double (Paris and her Double), 1997
Art binding; text by Jean-Pierre Dufreigne,
binding by Alphonsine David; 31 x 24 x 7 cm.

Coll. Fernand Zacot.

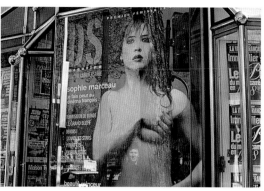
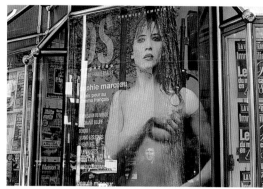

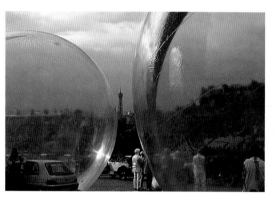
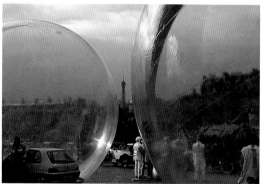

Paris, 1998
Stereoscopic views, 4 colour transparencies
24 x 36 mm.

Coll. Fernand Zacot.

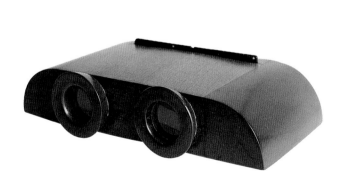

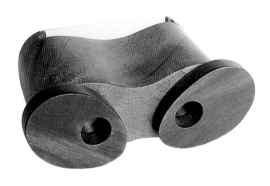

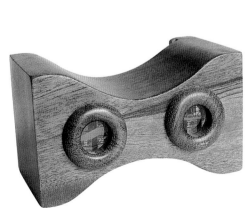

Stereoscopes, 1998–99
Exotic woods, different dimensions, for transparencies:
4.1 x 10.1 cm.

Coll. Fernand Zacot.

262 Autostereograms

Camouflaged stereograms

Camouflaged stereograms first appeared as curiosities around 1920, but their development did not really begin until 1960, with the work of Béla Julesz. They consist of two images representing a form that is impossible to distinguish when each image is viewed separately. It appears only when stereoscopic vision is used, and the two images are compared.

Autostereograms or SIRDS

SIRDS (single image random dot stereograms) developed out of camouflaged stereograms, but consist of what appears to be a single image that is in fact made up of several images combined into one. Since 1992 many SIRDS have been published across the world and millions of people have discovered the power of stereoscopic sight naturally, without the use of an instrument. A SIRD is constructed by sliding one of the images of a camouflaged stereogram behind the other, and modifying their texture so that they can be perfectly superimposed. In this way, the two images become one. The camouflage and repetition are a result of the way the image is constructed. For example, a flower bed can hide the three-dimensional form of a cat. However, this cat does not have the usual fur, but looks as though it is covered in flowers.

These images can be seen using either cross-viewing (where the person crosses his or her eyes slightly) or parallel viewing (where the eyes have the same distance between them as they do when looking into the distance). The camouflaged forms will be seen either receding into the image or projecting from it, depending on the viewing method used[1].

Olivier Lapidus, **Dress made with autostereogram fabric**, 1994

Coll. Olivier Lapidus.

From the spring/summer collection, 1995.

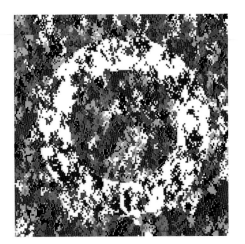
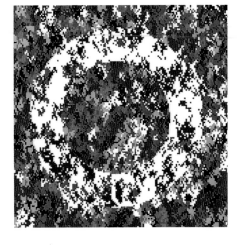

Jacques Ninio, **Camouflaged stereograms**

When the two images are fused by stereoscopic vision, with parallel viewing the ring will be seen on top of the background, and with cross-viewing it will appear underneath the background. When both the ring and the background are shown with the same pattern (below), the ring is visible on neither the left- nor the right-hand image; it only appears when stereoscopic vision is used.

Jacques Ninio, **SIRDS**

The ring of the image on the left-hand page is shown here in a three-strip autostereogram. In the top image, the two rings to be fused can be made out against the background. In this kind of representation they may be hard to see stereoscopically. In the bottom image, the rings and the background have the same pattern. When viewed stereoscopically, it is relatively easy to see one ring either on top of or beneath the background.

1. Bibliography
B. Julesz, *Foundations of Cyclopean Perception*, University of Chicago Press, Chicago, Ill., 1971.
J. Ninio, *Stéréomagie*, Seuil, Paris, 1994.
I. Sakane, 'The Random-Dot Stereogram and its Contemporary Significance: New Directions in Perceptual Art', in *Stereogram*, Boxtree, London, 1994, pp. 73–82.
A. Schilling, *Binocularis*, Galerie Ariadne, New York, 1975.
C. W. Tyler and M. B. Clarke, *The Autostereogram*, SPIE Proceedings, 1990, 1256, pp. 182–97.

264 Stereoscopy and aerial views

Pierre d'Espezel, Roger Schall, *Paris en relief, histoire de Paris des origines à nos jours* **(A 3-D history of Paris from its origins to the present day)**, 1945

Coll. Roxane Debuisson.

Hardback book written by Pierre d'Espezel, containing a folding metal stereoscope and 100 stereoscopic photographs by Roger Schall. 500 copies of the book were published by Chanteclerc.

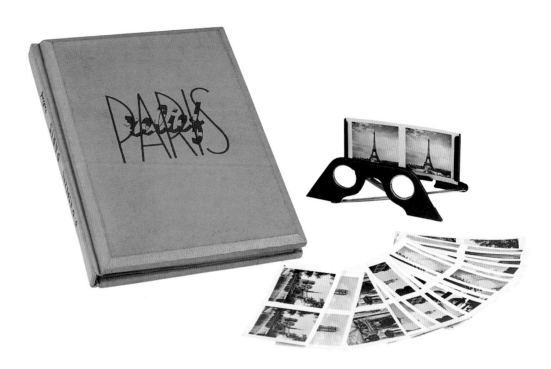

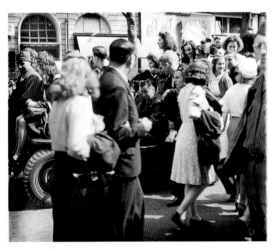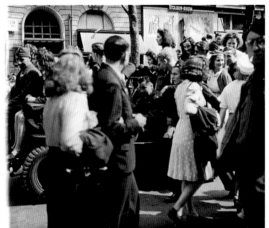

Lucien Raynaud (b. 1909), **Liberation of Paris, American jeep**, August 1944
Stereoscopic view, toned gelatin silver on glass; 6 x 13 cm.

Coll. Lucien Raynaud.

La Stéréochromie, **The Romo**, 1955
Plastic and metal; 11.0 x 9.0 x 6.5 cm.

Coll. Christian Kempf.

In 1946 Robert Mousillat founded La Stéréochromie
in the Rue du Bouloi. From there, the company moved
to the Rue Coquillère and is today based in the Rue de la
Faisanderie. The stereoscope pictured here was the first
produced by the company and sold thousands of copies.

The Loreo

Camera for taking stereoscopic views on flexible film
for printing on paper, 1995
Anthony Lo, inventor and manufacturer, Hong Kong
International patents
Moulded plastic; 8 x 15 x 5 cm.
Wide-angle f11/28 mm lenses
55 mm stereoscopic base
Diaphragm with 2 aperture settings (f/11 and f/16)
Shutter speed 1/100th second

Coll. Jacques Périn.

The Loreo is the modern symbol of the perennial interest
in stereoscopic photography. Invented in 1988 by the
engineer Anthony Lo, the camera meets the modern criteria
for taking instant, easy and inexpensive stereoscopic
photographic prints.

It takes standard 35 mm colour or black-and-white
negative film cassettes. The optical unit consists of a
system of mirrors that reflect the two crossed and directly
inverted images onto the two lenses, and then onto the film.
Standard developing and printing produces photographs
(9 x 13 cm and 10 x 15 cm) that can be viewed
immediately using the stereoscope supplied with the
camera. This original device, distributed widely in Asia,
the USA and Europe, has proved extremely popular with
enthusiasts. **Jacques Périn**

266

National Geographic Institute (IGN), **Centre of Paris**, 1949
Stereoscopic view, modern prints; each print (detail):
11.5 x 16.5 cm.

Coll. Institut Géographique National.

These images form part of the first survey of the Paris region
(Versailles-Lagny) using stereoscopic aerial photography.

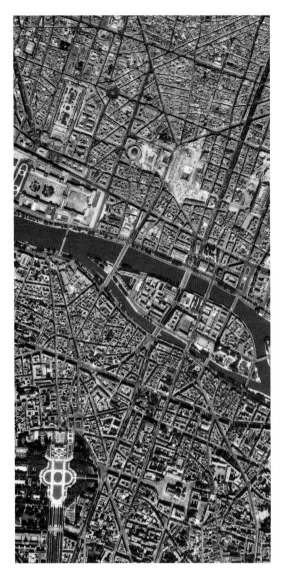 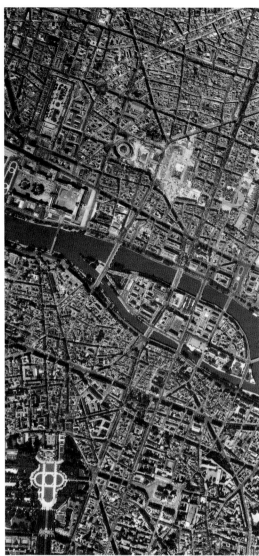

National Geographic Institute (IGN), **Centre of Paris**, 1978
Stereoscopic view, modern prints; each print (detail):
23 x 23 cm.

Coll. Institut Géographique National.

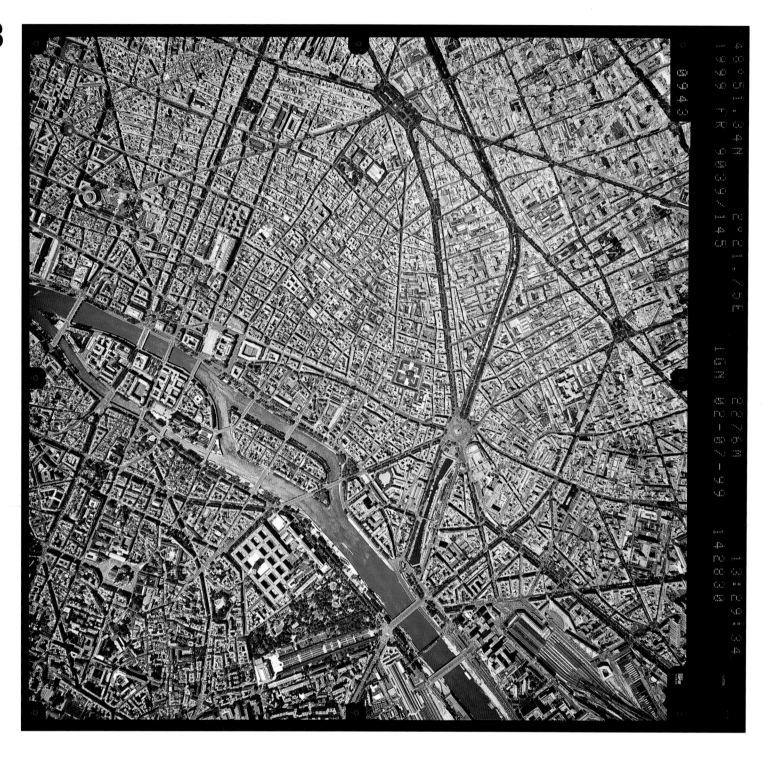

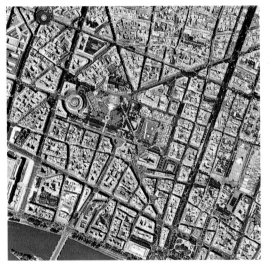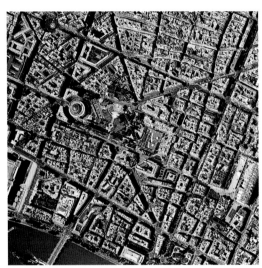

National Geographic Institute (IGN), **Centre of Paris**, 1999
Stereoscopic view, modern prints; each print (detail):
23 x 23 cm.

Coll. Institut Géographique National.

The centre of Paris has been extensively developed
over the past thirty years. To remedy traffic congestion,
Les Halles, the market that provided the city's fresh meat,
fruit and vegetables, was transferred to Rungis, a few
miles south of the capital. Since 1971 the old ironwork
pavilions built by Baltard have been demolished and the
resulting hole in the urban landscape filled by a shopping
centre and an RER (regional express network) station.
The Georges Pompidou Centre was built during the
same period and new pedestrian precincts were created.

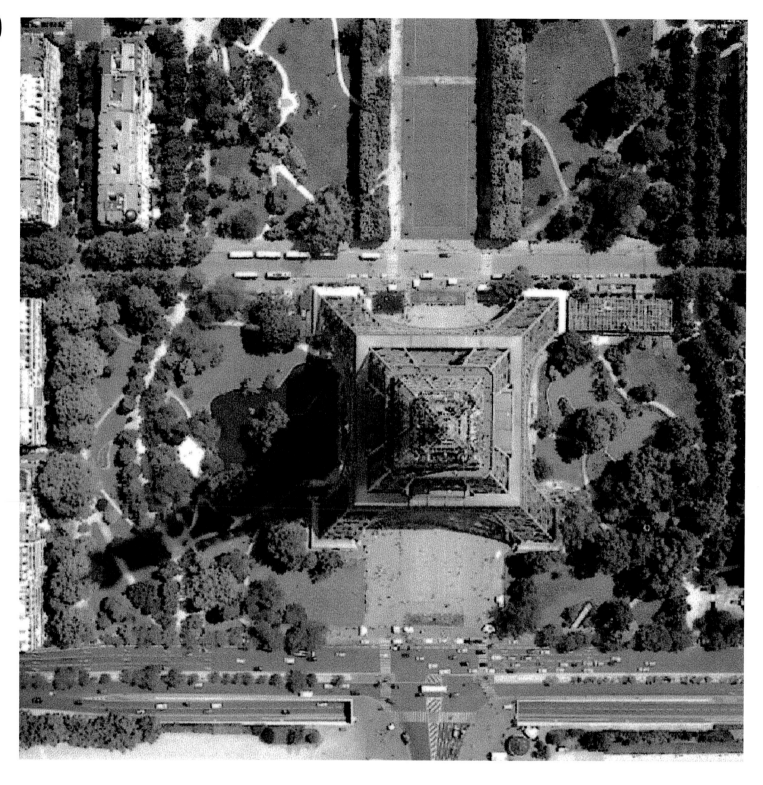

Marcel Guinard, Police Department,
The Tour Montparnasse, 1999
Stereoscopic view, colour prints; 6 x 6 cm.

Coll. Préfecture de Police.

The much-criticized Tour Montparnasse was
the first Parisian skyscraper. It was built by the
architects Eugène Baudoin, Urbain Cassan,
Louis le Hoyn de Marien and Jean Saubat as
part of the project for the redevelopment of the
Maine-Montparnasse district between 1950
and 1990. The original plans, approved in
1958, envisaged a huge rectangular block,
150 metres wide and 100 metres long. Today,
however, an ovoid structure with a concrete
framework dominates the Gare Montparnasse
from a height of 210 metres. The station has
been recently altered to improve its TGV
(high-speed train) facilities.

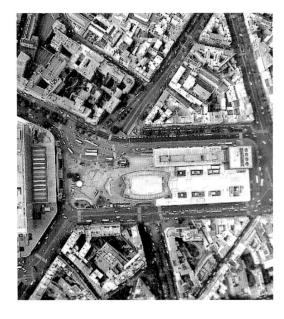
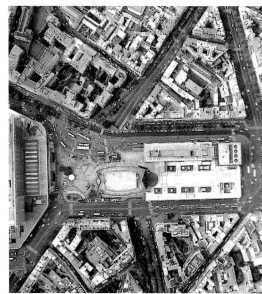

Marcel Guinard, Police Department,
The Bibliothèque Nationale de France,
1999
Stereoscopic view, colour prints; 6 x 6 cm.

Coll. Préfecture de Police.

In 1989 the architect Dominique Perrault
won the design competition for the new
Bibliothèque Nationale. Four towers stand
like open books at the four corners of the
compass and mark the boundary of a central
garden. Each tower has its own theme:
numbers to the south-east (Tour des Nombres),
time to the north-west (Tour du Temps), law
to the north-east (Tour des Lois) and literature
to the south-west (Tour des Lettres).

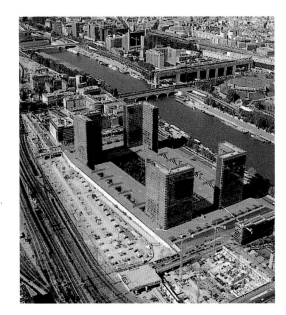
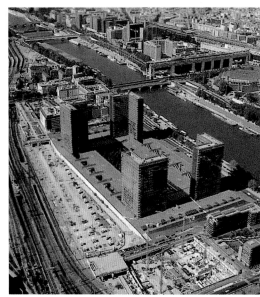

Marcel Guinard, Police Department,
The Eiffel Tower, 1999
Stereoscopic view, colour prints; 6 x 6 cm.

Coll. Préfecture de Police.

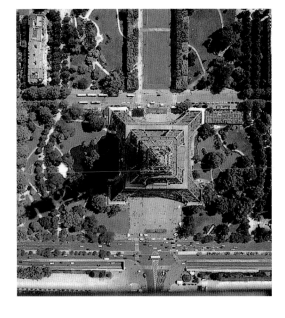
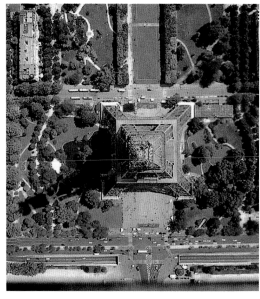

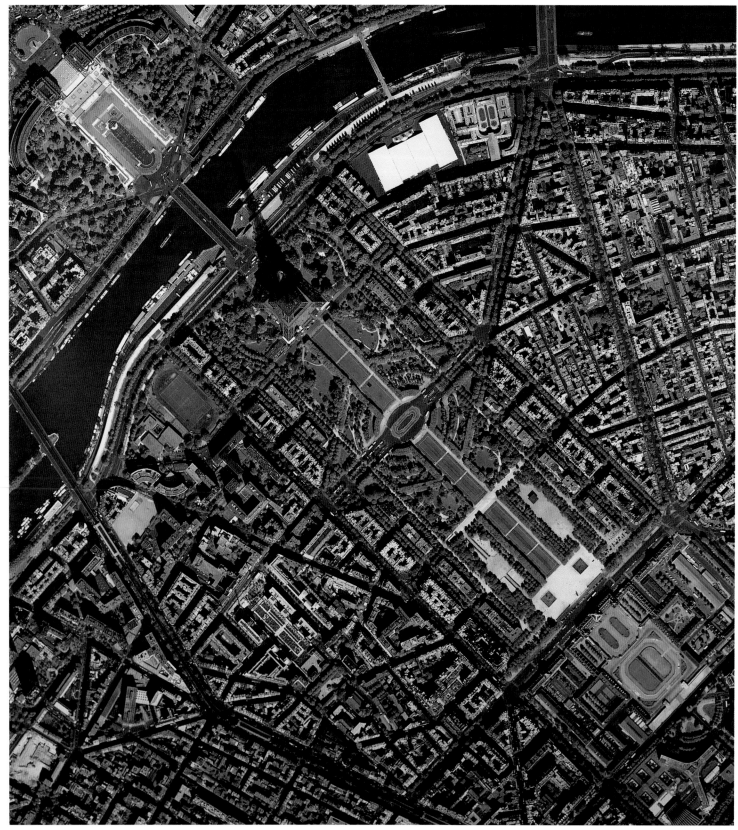

Istar, **Aerial view of the Trocadéro, Eiffel Tower and Champ-de-Mars**, 1999
Orthoscopic image produced using digital images taken from an altitude of 6,000 metres (resolution 50 cm/pixel) with a DLR digital imaging sensor.

Coll. Istar.

This type of image, patented by the Istar company under the name 'hypsoimage', is the result of 'pixel-by-pixel' processing. Each point of the image was corrected using data from a digital model of the city produced by combining six different views.

The optical discrepancies due to perspective were corrected so that the view is exactly perpendicular to the ground and the façades of the buildings are never visible.

The subsequent colorimetric processing of the image makes it possible to restore its relief, with the warmest colours indicating the highest points, and the coldest colours indicating the lowest points. The image can be seen in three-dimensions with the ChromaDepth glasses, which are equipped with filters that separate the different wavelengths of the colours.

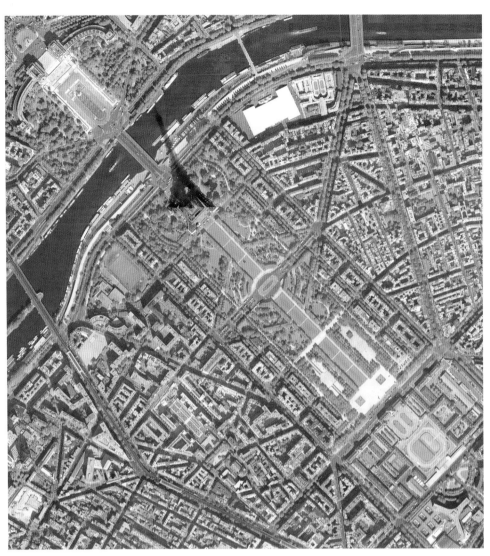

Istar, **Aerial view of the Trocadéro, Eiffel Tower
and Champ-de-Mars**, 1999
Image before the colorimetric processing used to create
the 3-D image.

Coll. Istar.

274

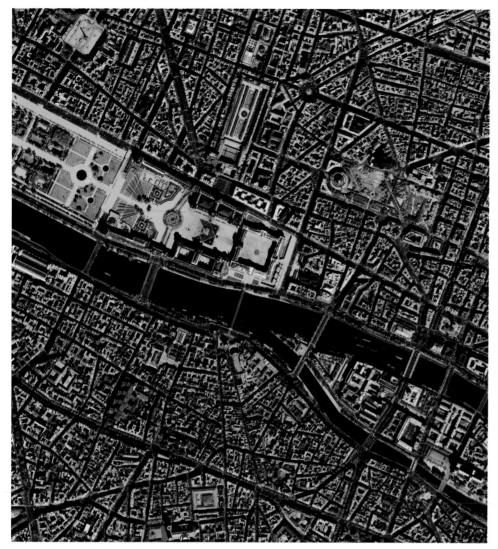

Istar, **Aerial view of the Louvre Museum
and centre of Paris**, 1999
Orthoscopic image produced using digital images taken
from an altitude of 6,000 metres (resolution 50 cm/pixel)
with a DLR digital imaging sensor.

Coll. Istar.

In 1839, the year in which the invention of photography
was announced in Paris, the city still had the boundaries
established during the Ancien Régime (along the lines
of the main boulevards).

In 1860 new boundaries – which still exist today –
were established. The idea of a three-dimensional plan
is an old one and, for centuries, draughtsmen, engravers
and publishers have tried to create a bird's-eye view
of buildings in three dimensions. The most successful
of these plans was the one produced by Turgot in 1739.

Here (opposite), a plan produced during the Romantic
period (but which looks remarkably modern) uses a sort
of 'honeycomb' technique to create a three-dimensional
effect. Today, aerial photography and digital imagery make
it possible to create a different and possibly more realistic
three-dimensional impression. Viewing these images
through CnromaDepth filters, which give each eye a
different view, creates an impression of depth.

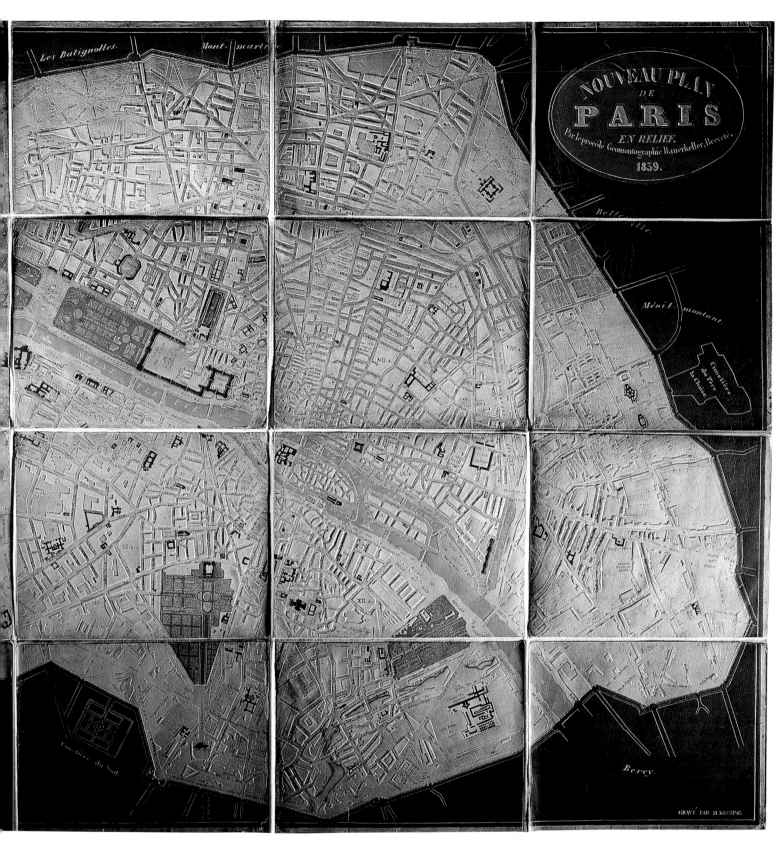

New three-dimensional plan of Paris, 1839
Printed plan, slightly embossed, process patented
under the name 'géomontographie Bauerkeller',
engraved by H. Kissing; 54.5 x 68.5 cm.

Coll. Roxane Debuisson.

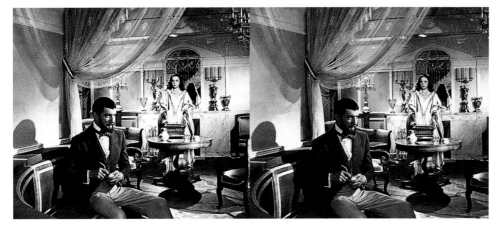

Anonymous, **Filming of *Les Enfants du paradis***,
1943–45
Stereoscopic view, gelatin silver on glass; 5.9 x 12.9 cm.

Coll. Cinémathèque Française, Collection des Appareils.

The well-known film by Marcel Carné and Jacques Prévert
was the largest French production during the Occupation.
This image is one of a series of ten views.

Jerzy Kular and José Xavier, ExMachina, **Image from the
film *1789***, 1989
Ten-minute 35 mm film produced for the bicentenary of the
French Revolution, with two-and three-dimensional images
of Paris.

**The Nimslo 3840, a six-lens camera
for lenticular images**, 1965
39.0 x 13.0 x 7.5 cm.

Coll. Musée Français de la Photographie, Bièvres, catalogue no. 99.10128.

Prototype for the camera brought onto the market in c. 1970.

Chronology
1940-2000

1940 German troops enter Paris.

1941 The United States enters the war.

1942 *In May, Maurice Bonnet opens his portrait studio,
La Relièphographie, on the Champs-Élysées.*

1943 Marcel Carné's film, *Les Enfants du paradis*.

1944 Paris is liberated in August.

1945 *François Savoye presents his 3D line screen
cyclostereoscopic cinema screen, a system that did not
require special glasses, at Luna Park.*
Women are given the vote for the first time, in elections
for the Constituent Assembly.

1946 Formation of the Fourth Republic.
Ration coupons are abolished.
Renault launches the 4CV car.

1947 The Polaroid camera is launched on the market.
Jacques Tati's film, *Jour de fête*.
Vincent Auriol is elected President of the Republic.

1948 *Dennis Gabor invents the principle of holography.*
Citroën launches the 2CV car.

1949 *Maurice Bonnet is working for the Ministry
of Defence (3D lenticular images for cartography
and aerial photography).
The IGN (National Geographic Institute) produces
aerial stereoscopic views covering the whole of Paris
for the first time.*
Simone de Beauvoir, *The Second Sex*.
Edith Piaf sings in the music halls.

1950 The Magnum agency opens in Paris,
three years after it was founded in New York.
Introduction of the minimum wage in France.

1951 The Marthe Richard law is passed,
outlawing brothels.

1952 Georges Brassens begins his career.

1954 Outbreak of the Algerian War.
The population of Paris is 2,850,189.

1956 Claude Autant-Lara's film, *La Traversée de Paris*.
Third-class rail travel is abolished.

1957 Creation of the EEC (European Economic
Community).

1958 Formation of the Fifth Republic, investiture
of Général de Gaulle.

1959 André Malraux becomes Minister of Cultural Affairs.
Jean-Luc Godard's film, *Á bout de souffle*.
Raymond Queneau, *Zazie dans le métro*.

1960 Invention of the laser.
The 'new franc' is introduced.
Manifesto of the 'new realists': Tinguely, César,
Niki de Saint-Phalle.

1961 *Creation of Maurice Bonnet's lenticular film laboratory at the C.N.R.S. (National Scientific Research Centre).*
Demonstration by Algerians is brutally repressed by Parisian police.

1962 End of the Algerian War.
Statutory paid holidays extended to four weeks per year.
Agnès Varda's film, *Cléo de 5 à 7*.
François Truffaut's film, *Jules et Jim*.

1963 *First laser hologram of a 3-D object.*
Alain Robbe-Grillet, *Pour un nouveau roman*.
Opening of the Maison de la Radio on 14 December.
Jacques Brel is a great hit in concert at the Olympia.

1964 First colour television broadcast in France.

1965 Courrèges introduces the miniskirt, revolutionizing the world of fashion.

1966 *Creation of the company Relieforama, which sells images created using Bonnet's lenticular process for advertising purposes.*

1967 Tower blocks constructed on the Quai de Grenelle.

1968 General strike in May, uniting students and workers.
Paco Rabanne introduces figure-hugging fashions, Pierre Cardin presents thermoformed garments.

1969 Les Halles are transferred to Rungis; the old buildings by Baltard will be demolished.
De Gaulle steps down and is replaced by Georges Pompidou.
The first section of the RER (Réseau express régional) rail system is opened.

1971 *The first computer images of Parisian buildings (predecessors of 3D images, representing objects via line drawings).*

1972 *Creation of the Trapu system (Tracé Automatiques de Perspectives Urbaines [automatic 3-D urban layouts]).*

1973 The Tour Maine-Montparnasse skyscraper is opened on 13 September.

1974 Following the death of Georges Pompidou, Valéry Giscard d'Estaing is elected President on 2 April.
The abattoirs of La Villette are closed.

1975 *Presentation of F. Olivier's fashion holograms in a window on the Champs-Élysées.*
The Simone Veil law, authorizing voluntary termination of pregnancy, is introduced on 17 January.
Divorce by mutual consent is introduced.

1976 *Creation of a large-size hologram of the Venus de Milo.*

1977 Inauguration of the Centre national d'art et de culture, the Pompidou Centre, on 31 January.
Jacques Chirac is elected mayor of Paris on 25 March: he is the capital's first mayor since Jules Ferry in 1870–71.
Disco fever reaches its height.

1978 *Hologram of a metro carriage, the 'Sprague', exhibited at Châtelet metro station.*
Georges Pérec, *La Vie mode d'emploi*.

1979 Inauguration of the Forum des Halles, built on the site of the former Les Halles market.

1980 *The Musée de l'Holographie opens on 20 March, in the Les Halles district.*
Unisex fashions and bell-bottomed trousers.

1981 TGV (high-speed trains) are introduced on the Paris–Lyon line.
François Mitterand is elected and launches an ambitious construction and development plan for the Paris region.
The death penalty is abolished.
Creation of the Centre national de la photographie.
Introduction of the Minitel system.

1982 *Hologram of a model of the Parc de la Villette, a cultural and leisure centre under construction in northern Paris.*

1983 *Creation of the Atelier holographique de Paris.*

1984 Inauguration of the first buildings in the Parc de la Villette.

1985 *Exhibition of 145 holograms at the Palais de la Découverte.*
Canadian artist Michael Snow creates holograms in Paris.
A wave of bomb attacks start, continuing into 1986.
Christo wraps up the Pont-Neuf bridge on 26 August.

1986 Inauguration of the Musée d'Orsay, housed in the former Gare d'Orsay train station.

1987 New lighting for the Eiffel Tower.
The Institut du Monde Arabe, designed by Jean Nouvel and Architecture Studio, opens its doors.
Regulation is introduced for independent radio stations, which have been broadcasting since 1981, greatly enriching the diversity of radio programmes on offer.
Comedian Coluche introduces the 'Restaurants du cœur' (soup kitchens for the poor).

1988 The Vidéothèque de Paris, in the Forum des Halles, opens on 7 February.
Inauguration of the glass pyramid entrance to the Louvre, designed by I.M. Pei, on 4 March.

1989 *Ex Machina produce the film* 1789, *computer-generated imaging.*
Celebrations for the bicentenary of the Revolution.
Opening of the new Opéra-Bastille, designed by Carlos Ott, and of the Grande Arche de la Défense, designed by Johan Otto von Spreckelsen.
New building for the Ministry of Finance, designed by Paul Chemetov and Borja Huidobro.

1990 The population of Paris is 2,154,678.

1991 *Closure of Maurice Bonnet's lenticular film laboratory.*

1992 *A holographic band is incorporated into the French 50-franc banknote.*
The Romanesque Abbey of Cluny in Burgundy, destroyed during the Revolution and recreated in model form in 1990, is put on public display in a film composed of synthetic images, produced by ENSAM (higher college of arts, crafts and trades) in collaboration with IBM.
Opening of the Parc André-Citroën in September.
New lighting for the Cour Carré of the Louvre Museum.

1993 *Autostereograms or* Magic Eye *images are all the rage in France.*
Inauguration of the Richelieu wing of the Louvre on 18 November. The 'Bains Deligny', a floating swimming pool on the Seine built in 1796, sinks on 8 July.

1994 Inauguration of the Cartier foundation's building dedicated to contemporary art, designed by Jean Nouvel.
Reopening of the main gallery of the Museum of Natural History, closed since 1965.

1995 *Designer Olivier Lapidus's holographic suit, part of the spring collection.*
Opening of the Cité de la Musique, designed by Christian de Portzamparc.
Bomb attack in the Saint-Michel RER station on 26 July.
Jacques Chirac is elected President.

1996 Opening of the Maison européenne de la photographie.

1997 *Launch of the virtual game '2e monde' by Canal+.*
Opening of the new Bibliothèque Nationale de France, designed by Dominique Perrault.
Diana, Princess of Wales, dies in a car accident in the Pont de l'Alma tunnel on 31 August.
The Catholic church organizes an international youth festival in Paris during August.

1998 Football World Cup in Paris.

1999 The 'Pacte civil de solidarité' (Civil Solidarity Pact) is passed on 13 October.
At the end of December, France is shaken by violent storms, which damage a number of listed buildings and bring down thousands of trees in Paris.
Millennium celebrations, with fireworks at the Eiffel Tower, on 31 December.

2000 The Pompidou Centre reopens after restoration work on 1 January.

Sources and bibliography

The titles listed here are arranged under the headings (given in alphabetical order) of the different techniques of 3-D photography and, under each heading, in chronological order of publication of each author's works. The list is far from exhaustive, but gives the most important reference works and documents (some of which are unpublished), including those quoted in this book.

Abbreviations:

B.S.F.P.: Bulletin de la Société Française de Photographie
C.R.A.S.: Comptes rendus de l'Académie des Sciences
S.F.P.: Société Française de Photographie

Anaglyphs

Almeida (Joseph Charles d'), 'Nouvel appareil stéréoscopique', *C.R.A.S.*, 12 July 1858, vol. 47, pp. 61–63 [reprinted in the *B.S.F.P.*, 1858, pp. 260–61].
Les Anaglyphes géométriques, Librairie Vuibert, Paris, 1912.
Clerc (L.P.), 'Les divers procédés de projection stéréoscopique', *B.S.F.P.*, 1924, pp. 145–52 [pp. 147–50 on anaglyphs].
Ducos du Hauron (Louis), 'Estampes, photographies et tableaux stéréoscopiques produisant leur effet en plein jour sans l'aide du stéréoscope', patent no. 216,465, 15 September 1891 [first French patent for anaglyphs].
Ducos du Hauron (L.), *L'Art des Anaglyphes*, paper presented to the S.F.P., Mustapha Printers, A. Cougnard, Mustapha, Algiers, 1893 [reprinted in the *B.S.F.P.*, 1893, pp. 621–25].
Ducos du Hauron (L.), 'Production des phototypes pour l'anaglyphie polychrome (stéréochromie)', *B.S.F.P.*, 1896, pp. 473–81.
Fouché (Edmond), 'Nouveau procédé de stéréoscopie', patent no. 225,696, 16 November 1892 [first French patent for anaglyphic projection].
Gimpel (Léon), 'Les anaglyphes sur autochromes', *B.S.F.P.*, 1911, pp. 211–12.
Gimpel (L.) and Touchet (Emile), 'Procédé de projection en relief utilisant les clichés stéréoscopiques ordinaires', patent no. 576,046, 21 January 1924 [anaglyphic projector].
Gimpel (L.) and Touchet (E.), 'La vision en relief par les anaglyphes', *L'Illustration*, 26 January 1924, pp. 81–84 [anaglyphic illustrations].
Gimpel (L.), *Quarante ans de reportages photographiques, vol. 1, 1897–1932*, February 1944 [unpublished manuscript, coll. S.F.P.; illustrated with anaglyphs].
Gussalli (L.), 'Nouveau procédé de stéréoscopie directe', *B.S.F.P.*, 1923, pp. 261–68 [Method for viewing anaglyphs directly using lenticular film].
Halluin (Dr M. d'), *Le Relief stéréoscopique par les anaglyphes*, coll. Bibliothèque de la Photo-Revue, Charles Mendel, Paris, 1912 [medical anaglyphs, glasses].
Lumière (Louis), 'Écrans colorés pour projections stéréoscopiques', *C.R.A.S.*, vol. 200, 25 February 1935, pp. 701–4.
Mareschal (G.), 'Projections stéréoscopiques', *La Nature*, no. 917, 27 December 1890, pp. 49–50 [Molteni's stereoscopic projections].
Molteni (Alfred), letter to Etienne Jules Marey, 5 December 1890, published in T. Lefebvre, J. Malthête, L. Mannoni, *Lettres d'Etienne Jules Marey à Georges Demenÿ 1880–1894*, Association Française de Recherche sur l'Histoire du Cinéma-BiFi, Paris, 2000, pp. 495–96.
'M. Molteni adresse un extrait de l'ouvrage de M. Figuier…', *B.S.F.P.*, 1890, pp. 200–1.
'M. Molteni a repris également et d'une façon très

complète la projection de vues stéréoscopiques…', *B.S.F.P.*, 1892, p. 302.

Musée de l'Homme en relief par les anaglyphes. Muséum national d'histoire naturelle. Laboratoire d'ethnologie des hommes actuels et des hommes fossiles, Les Éditions en anaglyphes, Paris, no date [1937 or later].

'Nos nouveaux anaglyphes', *L'Illustration*, 28 June 1924, pp. 610–14 [anaglyphic illustrations].

Nus académiques dans la nature en relief par les anaglyphes, Les Éditions en anaglyphes, Paris, no date [after 1937].

Paris en relief par les anaglyphes, Les Éditions en anaglyphes, Paris, no date; two albums (first and second series) [c. 1937].

Paris Match, 'Spécial Relief. Que la France est belle! Les magnifiques paysages de la route du Tour', 5 July 1983.

Paris Match, 'Spécial Relief. Les plus beaux paysages de France', 30 December 1983.

Parville (Henri de), 'Les anaglyphes', *La Science illustrée*, 28 April 1894, vol. 13, no. 335, pp. 343–44.

Rollmann (Wilhelm), 'Zwei neue stereoskopische Methoden', *Poggendorf's Annalen (Annalen der Physik und Chemie)*, vol. XC (vol. 166), 1853.

Rollmann (W.), 'Réclamation de priorité pour une certaine disposition d'appareils stéréoscopiques. Lettre de M. Rollmann à M. Pouillet', *C.R.A.S.*, vol. 47, 1858, p. 337 [reprinted in the *B.S.F.P.*, 1858, p. 262].

La Sculpture au musée du Louvre en relief par les anaglyphes, Les Éditions en anaglyphes, Paris, no date [c. 1937].

Vidal (Léon), 'Vision avec le relief d'épreuves stéréoscopiques projetées', *Le Moniteur de la photographie*, 1890, pp. 106–7 [Molteni's stereoscopic projections].

Vues plastographiques du monde, series I, part 7, *Une tournée à Paris*, no publisher or date [album of anaglyphs published in Germany showing Paris, c. 1905].

Zoo de Paris en relief par les anaglyphes, Les Éditions en anaglyphes, Paris, no date; two albums (first and second series) [c. 1937].

Holography

Very little has been written on the history of holography in Paris. One good work of reference is:

Saxby (Graham), *Holograms: How to Make and Display Them*, Focal Press, UK, 1980

Duve (Thierry de), 'Michael Snow. Still life in 8 calls, 1985', *Passages de l'image*, Éditions du Centre Pompidou, Paris, 1990, pp. 177–79 [exhibition catalogue].

Photosculpture

Cardin (Pierre Arthur Camille), 'Photo-sculpture', patent no. 370,820, 15 September 1906; certificate of addition no. 8177, 10 September 1907.

Cardin (P.A.C.), 'La photosculpture (procédé de M.P.A. Cardin)', *B.S.F.P.*, 1908, pp. 59–62.

Cardin (P.A.C.), 'La photosculpture', *B.S.F.P.*, 1910, pp. 307–11.

'M. C. Cardin a fait hommage du buste en plâtre…', *B.S.F.P.*, 1908, p. 30.

'M. Cardin a fait don d'un exemplaire du buste…', *B.S.F.P.*, 1910, p. 222.

'[Don] par M. Cardin d'un exemplaire en plâtre du buste…', *B.S.F.P.*, 1913.

[Cardin (P.A.C.)], 'Formation d'une association en participation pour l'exploitation des brevets de Photosculpture de M. Cardin', no publisher or date [c. 1912; typewritten, unpublished, coll. S.F.P.].

Claudet (Antoine François Jean), 'Procédé de photo-sculpture', patent no. 65,834, 13 January 1865.

Claudet (A.F.J.), 'Description de la photoplastigraphie, nouveau procédé de photosculpture', *B.S.F.P.*, 1865, pp. 99–107.

Claudet (A.F.J.), 'Photosculpture. Photoplastigraphie – nouveau procédé de photosculpture inventé par M. A. Claudet', edition bound with other articles by the S.F.P., no date [c. 1866], pp. 15–17.

Clerc (L.P.), 'La Photostérie de MM. Lernac et Cⁱᵉ', *B.S.F.P.*, 1899, pp. 131–33 [obtaining relief by photochemical reaction].

Cromer (Gabriel), 'Histoire de la photographie et de ses précurseurs enseignée par l'image et l'objet d'époque. Deuxième exposition: François Willème, inventeur de la photosculpture', *B.S.F.P.*, 1924, pp. 134–45.

Drost (Wolfgang), 'La photosculpture, entre art industriel et artisanat. La réussite de François Willème (1830–1905)', *Gazette des beaux-arts*, October 1985, vol. 106, no. 1401, pp. 113–29.

'Exposition rétrospective du Centenaire de la photographie', *B.S.F.P.*, 1925, pp. 283 ff. [description of works exhibited at the S.F.P.].

Gall (Jean-Luc), *La 'Sculpture photographique' de François Willème (1830–1905): éclipse d'une invention au XIXᵉ siècle*, unpublished D.E.A. dissertation, École des hautes études en sciences sociales, 1996.

Gall (J.-L.), 'La photosculpture de François Willème', *Études photographiques*, no. 3, November 1997, pp. 62–83.

Gautier (Théophile), 'Photosculpture', *Le Moniteur universel*, 4 January 1864 [Willème process].

Givaudan (Claudius), 'Procédé de reproductions plastiques de sujets en relief', patent no. 573,998, 30 November 1923.

Givaudan (C.), 'Appareil de photostéréotomie pour reproductions plastiques', patent no. 592,163, 1 December 1923.

Givaudan (C.), 'Photosculpture et photostéréotomie (procédés C. Givaudan)', *B.S.F.P.*, 1926, pp. 197–202.

Héliécourt (René d'), *La Photographie en relief ou la Photo-sculpture et ses principales applications*, Charles Mendel, Paris, 1898 [obtaining relief by photochemical reaction].

Hémardinquer (P.), 'Un système de sculpture cinématographique', *B.S.F.P.*, 1934, pp. 234–35. Extract from *La Nature*, July 1934.

Lazard, 'Photosculpture', *B.S.F.P.*, 1887, pp. 186–87 [Lazard process].

Lécuyer (Raymond), *Histoire de la photographie*, Baschet & Cⁱᵉ, Paris, 1945, pp. 275, 281–84.

Marion, 'Obtention des reliefs par des procédés photographiques', *B.S.F.P.*, 1900, pp. 313–20.

Moigno (François Napoléon Marie), 'Photo-sculpture', *Cosmos*, 17 May 1861, pp. 547–50 [Willème process].

Mougin (Auguste), 'Nouveau procédé de photosculpture', patent no. 194,735, 12 December 1888.

Saint-Victor (Paul de), 'La photosculpture', *La Presse*, 15 January 1866 [Willème process].

Sobieszek (Robert A.), 'Sculpture as the Sum of its Profiles: François Willème and Photosculpture in France, 1859–68', *The Art Bulletin*, December 1980, vol. 62, no. 4, pp. 617–30.

Tranchant (L.), *La Photosculpture pour tous*, coll. Bibliothèque de la Photo-Revue, Charles Mendel, Paris, no date [c. 1906; obtaining relief by photochemical reaction].

Willème (François), 'Procédé de photo-sculpture', patent no. 46,358, 14 August 1860 (additions in 1861, 1863 and 1864).

'M. Willème donne la description d'une application nouvelle de la photographie à la sculpture qu'il désigne sous le nom de photosculpture', *B.S.F.P.*, 1861, pp. 150–51.

Photostéréosynthèse

Coustet (Ernest), *La Photographie stéréoscopique en noir et en couleurs*, Charles Mendel, Paris, no date [1930s], pp. 217–24.

'Exposition rétrospective du Centenaire de la photographie', *B.S.F.P.*, 1925, p. 303 [description of works exhibited at the S.F.P.].

Hémardinquer (P.), *Le Cinématographe sonore et la Projection en relief*, Léon Eyrolles, Paris, 1935, pp. 292–95.

Lécuyer (Raymond), *Histoire de la photographie*, Baschet & Cⁱᵉ, Paris, 1945, pp. 289 and 292.

Lumière (Louis), 'Procédé de stéréo-synthèse photographique par stratification', patent no. 523,962, 21 January 1920.

Lumière (L.), 'Représentation photographique d'un solide dans l'espace. Photo-stéréo-synthèse', *C.R.A.S.*, 8 November 1920, vol. 171, pp. 891–96 [reprinted in the *B.S.F.P.*, 1920, pp. 262–67].

Lumière (L.), 'Représentation photographique d'un solide dans l'espace. Photo-stéréo-synthèse', no publisher, no date [typewritten document held by the Institut Lumière; the beginning is identical to the text in the C.R.A.S., but the end gives more detail on the exposure, with photographs of the camera and of the six plates that make up one work].

Line screen systems and lenticular screen systems

Berthier (A.), 'Images stéréoscopiques de grand format', *Cosmos*, no. 591, May 1896, pp. 227–33 [line screen systems].

Berthon (Rodolphe), 'Méthode de photographie et de projection donnant l'illusion du relief, également applicable aux projections en couleurs', patent no. 430,600, 13 August 1910 [lenticular screen systems].

Bessière, Gustave (Société d'exploitation des brevets et procédés), 'Procédé et dispositifs pour l'obtention d'images photographiques stéréoscopiques', patent no. 590,853, 20 February 1924 [line screen systems, cinema].

Bessière, Gustave (Société d'exploitation des brevets et procédés), 'Procédé pour obtenir des images photographiques donnant l'illusion du relief', patent no. 618,880, 20 November 1925 [line screen systems, cinema].

Bessière (G.), 'Sur une méthode péristéréoscopique', *B.S.F.P.*, 1926, pp. 43, 49–54.

Boistesselin (Henry du), 'Moyen nouveau pour l'obtention d'images cinématographiques visibles directement sans projection et application desdites images', patent no. 404,972, 7 July 1909 [line-screen system animated scenes].

Bonnet (Maurice) et Gandillon (H.), 'Procédé pour l'obtention de plaques photographiques donnant le relief', patent no. 774,145, 5 June 1934.

[Bonnet (M.)]/*La Relièphographie*, 'Procédé et appareils pour l'obtention de photographies donnant l'impression du relief', patent no. 833,891, 2 July 1937.

[Bonnet (M.)], document describing the period 1936–39 and the beginnings of the company *La Relièphographie*, no author, title or date [typewritten, unpublished, coll. Michèle Bonnet].

[Bonnet (M.)]/*La Relièphographie*, 'Dispositif optique, applicable en particulier à la photographie en relief', patent no. 943,083, 13 June 1941 [technique in which the camera moves in an arc of a circle; this idea is also developed in patents no. 943,084 and 943,086].

[Bonnet (M.)]/*La Relièphographie*, 'Dispositif pour l'obtention de photographies en relief, de leurs agrandissements et réductions, particulièrement applicable à la macrophotographie', patent no. 943,601, 13 October 1941.

[Bonnet (M.)]/*La Relièphographie*, 'Dispositif pour l'obtention d'enregistrements photographiques à éléments d'image ponctuels', patent no. 944,249, 1942 [line screen systems].

Bonnet (M.), 'La photographie en relief', Cours-conférences du Centre de perfectionnement technique, no. 770, Maison de la Chimie, Paris, April 1942.

[Bonnet (M.)]/*La Relièphographie*, 'Support d'émulsion pour images photographiques tramées ou à éléments microscopiques', patent no. 944,603, 12 December 1942 [images sur papier collé sur verre ou sur verre avec vernis opaque].

[Bonnet (M.)]/La Relièphographie, 'Appareil de photographie en relief, utilisable pour réduire ou agrandir des positifs, ou pour la prise de négatifs', patent no. 944,258, 15 December 1943 [multi-lens camera and printer-reproducer].

[Bonnet (M.)]/La Relièphographie, 'Combinaison d'un objectif et d'un sélecteur lenticulaire, pour l'enregistrement et la restitution d'images photographiques, en particulier d'images multiples sur cliché unique', patent no. 944,261, 31 March 1944.

Bonnet (M.), 'Le cinéma en relief', lecture given on 21 March 1945 at the Conservatoire des Arts et Métiers, *Bulletin officiel de la Commission supérieure technique*, October 1945, pp. 45–64.

[Bonnet (M.)]/La Relièphographie, 'Appareil de photographie en relief instantanée, à distances variables', patent no. 945,440, 1 June 1945 [camera with horizontal row of lenses and mirrors].

[Bonnet (M.)]/La Relièphographie, 'Appareil statique pour la photographie en relief, permettant l'instantané', patent no. 968,293, 15 May 1946 [camera with a large horizontal lens and a series of 'inversing optical devices for the fragmented inversion of the image'; this principle was developed in patents no. 968,294, 968,295 and 968,299].

Bonnet (Michèle), *Entrelacs biographiques. Maurice Bonnet et la photographie en relief*, Master's dissertation unpublished, Université de Toulouse-le Mirail, 1996 [by Maurice Bonnet's daughter].

Bouillot (René), 'Avec l'Alioscopie, la télévision en relief sans lunettes semble au point!', *Vidéo Broadcast*, June 1997, pp. 86–93 [Pierre Allio's lenticular screen process for television].

'M. Callier a fait don de trois épreuves…', *B.S.F.P.*, 1910, pp. 350–51 [line screen systems].

Chéron (Louis Camille Daniel André), 'Procédé de photographie en relief et à aspects changeants, sans appareil stéréoscopique', patent no. 443,216, 1 May 1912 [line screen systems and lenticular screen systems].

Clerc (L.P.), 'Plaques autostéréoscopiques de M. E. Estanave donnant par vision directe l'effet stéréoscopique', *B.S.F.P.*, 1909, pp. 105–07.

Closets (François de), 'La radiographie en relief', *Science et Avenir*, 1972, pp. 62–68 [work of Bonnet and others].

Cousin (E.), 'Prix de l'Exposition de 1889: rapport', *B.S.F.P.*, 1932, pp. 218–21 [work of Estanave].

Estanave (Eugène Pierre), 'Dispositif de stéréophotographie et de stéréoscopie à l'aide des réseaux', patent no. 371,487, 24 January 1906 (and certificates of addition no. 7,518 in 1906 et no. 8,860 in 1908).

Estanave (E.P.), 'Le relief stéréoscopique en projection par les réseaux lignés', *C.R.A.S.*, 29 October 1906, vol. 143, pp. 644–47.

Estanave (E.P.), 'Stéréophotographie par le procédé des réseaux', *B.S.F.P.*, 1906, pp. 226–30.

Estanave (E.P.), 'Images à aspect changeant par l'écran de projection à réseaux lignés', *C.R.A.S.*, 24 February 1908, vol. 146, pp. 391–92.

Estanave (E.P.), 'Relief stéréoscopique en projection. Images à aspect changeant par l'écran stéréoscope', *B.S.F.P.*, 1908, pp. 209–13.

Estanave (E.P.), 'Plaque photographique pour relief à vision directe ou plaque autostéréoscopique', patent no. 392,871, 1 August 1908 (and certificates of addition no. 12,164 and no. 12,366 in 1910).

Estanave (E.P.), 'Plaque à réseaux lignés donnant le relief stéréoscopique à vision directe', *C.R.A.S.*, 25 January 1909, vol. 148, pp. 224–26.

Estanave (E.P.), 'Obtention simultanée du relief stéréoscopique et de l'aspect changeant dans l'image photographique', *C.R.A.S.*, 14 March 1910, vol. 150, pp. 683–85 [summary in the *B.S.F.P.*, 1910, p. 171].

'M. Estanave a fait don de trois épreuves…', *B.S.F.P.*, 1910, pp. 350–51.

Estanave (E.P.), 'Contribution à la réalisation de la photographie intégrale', *C.R.A.S.*, 27 April 1925, vol. 180, pp. 1255–57.

Estanave (E.P.), *Relief photographique à vision directe. Photographies animées et autres applications des réseaux lignés ou quadrillés*, F. Meiller, Vitry-sur-Seine, 1930.

Estanave (E.P.), 'Nouvelle contribution à la photographie intégrale', *C.R.A.S.*, 3 March 1930, vol. 190, p. 584.

Estanave (E.P.), 'Photographies intégrales obtenues sans objectifs', *C.R.A.S.*, 16 June 1930, vol. 190, pp. 1405–06 [reprinted in the *B.S.F.P.*, 1930, pp. 222–24].

'Exposition rétrospective du Centenaire de la photographie', *B.S.F.P.*, 1925, pp. 303–04 [exhibition of Estanave's work at the S.F.P.].

Hémardinquer (P.), *Le Cinématographe sonore et la Projection en relief*, Léon Eyrolles, Paris, 1935, pp. 295–303, 312–19 [screen systems for projections and images on fixed media].

Hémardinquer (P.), 'Les films photographiques composites à images multiples et leurs applications', *Le Photographe*, 20 July–5 August 1962.

Hémardinquer (P.), 'La photographie industrielle en relief ou xographie', *Le Photographe*, no. 1109, 1966.

Hess (Walter), 'Images stéréoscopiques à effet direct avec procédé et dispositif pour leur production', patent no. 444,578, 4 June 1912 [lenticular screen system].

Ives (Frederic E.), 'A Novel Stereogram', *The Journal of the Franklin Institute*, January 1902, pp. 51–52 [line screen systems; report in the *B.S.F.P.*, 1902, p. 487].

Karampournis (Roger), untitled document (series of 47 'Notes de synthése'), written from 8 April 1966 to 28 July 1967 [typewritten document describing the beginnings of the *Relieforama* company; unpublished, author's collection].

Lassus Saint-Geniès (Anne Henri Jacques de), 'Procédé et appareils pour l'obtention de photographies en relief et facultativement en couleurs', patent no. 634,973, 25 September 1926.

Lassus Saint-Geniès (A.H.J. de), 'Sur une solution partielle de la photographie intégrale', *B.S.F.P.*, 1934, pp. 205–18.

Lécuyer (Raymond), *Histoire de la photographie*, Baschet & Cie, Paris, 1945, pp. 289 and 290.

Lippmann (Gabriel), 'Épreuves réversibles. Photographies intégrales', *C.R.A.S.*, 2 March 1908, vol. 146, pp. 446–51 [reprinted in the *B.S.F.P.*, 1908, pp. 161–67].

Lorenzini (Frédéric), 'Entrez dans la 3e dimension!', *Science et Avenir*, April 1994, pp. 58–61 [3-D lenticular screen television, Pierre Allio process].

Lumière (Louis), 'Dispositif permettant la réalisation de la photographie intégrale de Lippmann', patent no. 633,689, 6 September 1926.

'La photographie en relief est trouvée! Je sais tout interview le professeur Lippmann', *Je sais tout*, fourth year, first half-yearly edition, IV-43, 1908, pp. 545–48 ['photographie intégrale'].

Prépognot & Cie, 'Appareil pour projections stéréoscopiques', patent no. 449,856, 4 January 1912 [screen with line screen for 3-D projections and cinema].

'Rapport de la commission chargée de proposer pour l'année 1908 la répartition des subventions', *C.R.A.S.*, 29 June 1908, vol. 146, p. 1434 [grant for Estanave's work].

'Rapport de la commission chargée de proposer pour l'année 1908 la répartition des subventions du fonds Bonaparte', *C.R.A.S.*, 7 December 1908, vol. 147, p. 1211 [grant for Estanave's work].

'Rapport de la commission chargée de proposer pour l'année 1909 la répartition des subventions du fonds Bonaparte', *C.R.A.S.*, 28 June 1909, vol. 148, pp. 1802–3 [grant for Estanave's work].

Violle (Louis Jules Gabriel), 'La stéréoscopie sans stéréoscope', *C.R.A.S.*, 24 October 1904, vol. 139, pp. 621–22 [presentation of F. Ives's line screen images].

Watteville (C. de) et Wallon (E.), 'Commémoration de l'œuvre de Gabriel Lippmann (1845–1921)', *B.S.F.P.*, 1921, pp. 328–41 [pp. 336–38 on 'photographie intégrale'].

Stereoscopy

The publications on stereoscopy are too numerous to list here. The footnotes given at the end of each essay in this book will give some idea of the variety of sources that may be of use to the historian. The following recent studies and catalogues of contemporary art exhibitions are of particular interest for Paris.

Buerger (Janet E.), *French Daguerreotypes*, University of Chicago Press, Chicago, 1989 [catalogue of the collection of daguerreotypes – many of them stereoscopic – of George Eastman House, Rochester, NY].

Cahen (Olivier), *L'Image en relief. De la photographie stéréoscopique à la vidéo 3D*, Masson, Paris, 1989 [principles and history of stereoscopy].

Darrah (William C.), *The World of Stereographs*, W.C. Darrah, Gettysburg, Penn., 1977 [a classic work, with a section on stereoscopy in France].

'Le relief au cinéma', supplement to the magazine *1895*, October 1997.

McCauley (Elizabeth Anne), *Industrial Madness. Commercial Photography in Paris 1848–1871*, Yale University Press, New Haven, Conn., 1994.

Ninio (Jacques), *Stéréomagie*, Seuil, Paris, 1994 [principles of stereoscopy, autostereograms and stereograms in the style of Bela Julesz].

Pellerin (Denis), *La Photographie stéréoscopique sous le Second Empire*, Bibliothèque Nationale de France, Paris, 1995 [Bibliothèque Nationale de France collection; dictionary of photographers].

Périn (Jacques), *Jules Richard et la magie du relief*, vol. 1, Cyclope, Paris, 1993, vol. 2, Prodiex, Paris, 1997.

Richard (Pierre-Marc), 'La vie en relief. Les séductions de la stéréoscopie', chapter 9 of Michel Frizot (ed.), *Nouvelle histoire de la photographie*, Bordas, Paris, 1994, pp. 174–83.

Sack (Stephen), *La Mémoire chromosomique. Stephen Sack, travaux photographiques 1983–1997*, Château-Musée, Dieppe, 1997 [exhibition catalogue].

Secrets de la 3e dimension, Gallimard Jeunesse/Paris-Musées, Paris, 1999 [children's book].

Sugiyama (Makoto), 3D Museum, Shogakukan, Tokyo, 1995 [famous paintings numerically treated to create stereoscopic views].

Sylvie Blocher, Centre d'Art Contemporain, Abbey of Saint-André, Meymac, 1993 [exhibition catalogue].

Vasselin (Séverine), *La Maison Bruguière*, unpublished memoir, École Nationale Supérieure Louis Lumière, 1997.

Wing (Paul), *Stereoscopes: The First One Hundred Years*, Transition Publishing, Nashua, N.H., 1996.

3-D

There is no work which specifically places the techniques of 3-D within a Parisian context.

Canredon (Alain) and Gros (Jacques), *Recherche sur un système de graphisme automatique appliqué à la conception d'architecture et d'urbanisme*, Atelier Parisien d'Urbanisme/Secrétariat d'Etat à la Culture, Paris, no date [c. 1973].

Ikam (Catherine) and Fléri (Louis), *Portraits. Réel/virtuel*, Paris Audiovisuel/Maison Européenne de la Photographie, Paris, 1999 [exhibition catalogue].

Author biographies

Clément Chéroux is a photography historian and a member of the board of directors of the Société Française de Photographie and the scientific committee of the Musée Nicéphore Niepce. He is sub-editor of the journal *Études Photographiques* and has published a number of articles on photography as well as *L'Experience Photographique d'August Strindberg* (1994).

Hubert Damisch is an art historian and until 1999 he was head of studies at the *École des Hautes Études en Sciences Sociales* (School of Advanced Studies in Sociology). His publications include *Théorie du nuage* (1972), *L'Origine de la perspective* (1987) and *Le Jugement de Pâris* (1993).

Anne-Marie Duguet lectures in visual arts and art sciences at the University of Paris I. She is head of the Centre de Recherches d'Esthétique du Cinéma and des Arts Audiovisuels (Research Centre for Aesthetics in the Cinema and Audiovisual Arts), and the 'Anarchive' CD-Rom collection. She writes about video, television and new media, and has published *Vidéo, la mémoire au poing* (1981) and *Jean-Christophe Averty* (1991). She took part in *Paysages virtuels* (1988) and the monograph dedicated to Jeffrey Shaw, *From Expanded Cinema to Virtual Reality* (1997).

Odile Fillion is a journalist and film-maker who is particularly interested in the relationship between architecture and the development of new technologies. She was the driving force behind the 'Transarchitectures' exhibitions (on virtual architecture), and has made two videos devoted to the synthetized images used by architects: *Espace = Écran* (1996) and *Columbia Paperless Studio* (1998).

Jean-Marc Fournier is a doctor of science who has taken an active interest in holography since 1969. With Gilbert Tribillon, he produced the Venus de Milo hologram (1976). Since 1982 he has been head of the optics laboratory at the Rowland Institute for Science, in Cambridge, USA. He is a member of the American, European and French optics societies, the Imaging Science and Technology Society and the SPIE (Society for Optical Engineering).

Michel Frizot is a head of research at the CNRS (French Centre for Scientific Research) and the Centre de Recherches sur les Arts et le Langage (Research Centre for the Arts and Language), and fellow of the École des Hautes Études en Sciences Sociales (School of Advanced Studies in Social Science). He specializes in the epistemology of photographic images, procedures and techniques. His publications include *Histoire de voir* (1989) and he has edited the *Nouvelle histoire de la photographie* (1994).

Laurent Mannoni is head of the camera collection of the Cinémathèque Française and the Centre National de la Cinématographie. He has written a number of works, including *Le grand art de la lumière et de l'ombre* (1994) and *Étienne Jules Marey, la mémoire de l'oeil* (1999).

Anne McCauley lectures on the history of art at the University of Massachusetts, Boston, USA. She has published numerous works on the history of photography, in particular on Disdéri (1985), *Industrial Madness, Commercial Photography in Paris, 1848-1871* (1994) on the Parisienne studios, and is currently preparing a study of the career of Edouard Steichen in France.

Jacques Ninio is a biologist and a head of research at the CNRS (French Centre for Scientific Research). His interest in 3-D images dates from 1976 and he produces stereoscopic images, camouflaged stereograms and autostereograms. He has published *L'Empire des sens* (1989) and *Stéréomagie* (1994).

Denis Pellerin has specialized in stereoscopic photography for the last ten years. He has written a great many articles in French and English on the subject and three works to accompany exhibitions: *La photographie stéréoscopique sous le Second Empire* (1995), *Les Frères Gaudin, pionniers de la photographie* (1997), *La Bretagne en relief. Premiers voyages photographiques en Bretagne* (2000).

Jacques Périn, a specialist in the history of photographic techniques, makes films on 3-D and its various procedures. He creates educational tools and publications on vision (photography and cinema), gives discussion-lectures and is a consultant for museums in France and other countries. He is the author of *Jules Richard et la magie du relief* (2 vols., 1993/1996).

Françoise Reynaud is a curator at the Musée Carnavalet and has been head of the photographic collections since 1980. She has organized a number of exhibitions and overseen the publication of the exhibition catalogues, including *Eugène Atget, intérieurs parisiens* (1982), *Ilse Bing* (1987), *Paris et le daguerréotype* (1989), *Le Paris de Boubat* (1990), *Portraits d'une capitale de Daguerre à William Klein* (1992) and *Les voitures d'Atget* (1992).

Philippe Sorel is a curator at the Musée Carnavalet and has been head of sculpture since 1982. More recently, he became deputy curator at the Musée Bourdelle. He has published a catalogue raisonné on the sculptures and caricatures of Dantan (1986/1989).

Catherine Tambrun has been an active member of the Musée Carnavalet's department of photographic collections since 1986. She has been involved in the organization of a number of exhibitions and the publication of the exhibition catalogues. She is currently responsible for compiling a database of the museum's collections that will eventually be accessible on-line via an interactive web site.

Kim Timby is an anthropologist and a photography historian. She has worked with the Musée Carnavalet's department of photographic collections since 1994. Her publications include the children's treasury *Secrets de la 3ᵉ dimension* (1999) and an article on the history of line-screen photography in the journal *Études photographiques*, n° 9 (2000).

Key to captions and illustrations

The information given with illustrations was compiled by the exhibition organizers and is generally presented in the following order:

1 - **The name of the author**: this may be the creator, the implementer, the inventor of the technique, the distributor or the printer. If relevant, the name of the company responsible for the creation or distribution of the work is featured in this part of the caption. If appropriate, the name of the sponsor of the work follows that of the author.

2 - The **title** (or description) of the work, in bold type, is followed by the date of its creation. Inverted commas indicate an old, original title.

3 - A **technical description** of the work which may indicate the materials and, in general terms, the medium used for the photographic image. With computer-generated images, which are copies (or scans) of screens and have no tangible support, the name(s) of the software used to create them is given. If they were produced using a laser, this is also indicated.

4 - Certain **inscriptions** of historical interest have been transcribed in inverted commas and translated from the language of origin; spelling, italics, capital letters and errors have been reproduced. The / symbol indicates the start of a new line. The inscriptions transcribed are on the front of the work, unless otherwise stated.

5 - **Dimensions** are given in centimetres and refer to the height, width and depth of the work, in that order.

6 - The name of the **collection** is given in italics and followed by a catalogue number where one exists.

7 - Where possible, an historical or **documentary** note on the work follows the technical details.

3-D Vision

The stereoscope

The stereoscope accompanying the book will make it easier to view the stereoscopic images in 3-D. To use it, you must first of all fold it and insert the flaps in the slots near the lenses. The base must also be folded back so that it can stand on the pages of the book. Take the time to position the stereoscope exactly below each stereoscopic view by placing it in the centre of the two images forming the view. It should be parallel to the base of each image. The images should be extremely well lit and the light distributed evenly over the page.

Everyone's vision is different and the distance required between the eyes and the lenses of the stereoscope will vary from person to person: short-sighted people will have their eyes very close to the lenses, while long-sighted people will need a longer distance between their eyes and the lenses. If you usually wear glasses, it is advisable to keep them on since it is important that the images are clear.

When you first look at a 3-D image, the time required to see it in three dimensions can vary from a few seconds to a few minutes, depending on the individual. Once you have successfully viewed a stereoscopic image in three dimensions, the other images will become increasingly easy to see in 3-D. Some stereoscopic views are easier to see than others, so begin by practising with several images.

Old views sometimes contain defects. The aim of this book is to reproduce them as they are without readjusting them or touching them up. In some cases the mounts have been removed to make it easier to see the image in 3-D.

3-D vision without a stereoscope

With patience and a little practice, all stereoscopic images can be viewed without a stereoscope, using parallel vision. Start by looking at the images as if you were trying to see an object in the far distance, through the sheet of paper. By looking at the image on the left with the left eye and the image on the right with the right eye, you can in fact see the view in 3-D. By squinting, which some people find much easier, you obtain a reversed, or pseudoscopic, relief since the left eye sees the right-eye image and the right eye sees the left-eye image. The section on autostereograms in Chapter 3 explains this exercise.

Images viewed with anaglyphic glasses

Red and green filters make it possible to view a number of anaglyphic images reproduced in this book. They can be identified by their bicoloured and slightly blurred appearance which is the result of the slight discrepancy between the two images which are printed together (they do not all have perfect 3-D, however, because of the difference in the quality of the original images). It is important to hold the filters the right way round (the red filter on the right and the green on the left) since, if the colours are reversed, this will produce a 'pseudoscopic effect', i.e. the relief will be inverted and the foreground will appear as the background.

The ChromaDepth 3-D glasses

The transparent filters of this device react differently to shades of red and orange, and blue and green. NB: if the filters are reversed, this will produce what is known as a 'pseudoscopic' effect, i.e. the relief will be inverted and the foreground will appear as the background. The glasses are to be used to look at the aerial views of Paris (pp. 272-275).

Stereoscopic reconstruction of non-stereoscopic images

The stereoscopic technique has sometimes been used to view non-stereoscopic 3-D images in three-dimensions (see line screens, lenticular screens, holography and 3-D computer-generated images). Two images taken from a slightly different angle are placed side by side so that is possible to view them with a stereoscope.

Glossary

This glossary presents a selection of terms relating to three-dimensional photographic techniques. The words in italics can be found under a separate heading.

Alternating images A method of presenting *stereoscopic views*. The right- and left-eye images are shown successively in such a way that each eye sees one image only. To achieve this, shutter glasses or some other kind of device, cover the eyes alternately and in synchronization with the presentation of the images. See also *liquid-crystal glasses*.

Anaglyph A *stereoscopic view* in which the two images are superposed and differently coloured to produce an image that can be seen in three dimensions with bicoloured glasses. The technique was named for the first time in 1893 by the French physicist and inventor Louis Ducos du Hauron (1837–1920) to refer to printed images. Previously, anaglyphs had always been projected and were simply called 'stereoscopic projections'.

Autostereogram Usually created on a computer, this type of image consists of several vertical sections, which are almost identical (like the two images of a stereogram) but which contain slight discrepancies. When this composite image is viewed using *parallel viewing* or *cross-viewing*, it appears as a three-dimensional image. Also sometimes called a *Magic Eye* image, in English as well as French.

Autostereoscopic (image or plate) Term sometimes used in French to describe a *line screen* system image produced on a single plate of glass with the photographic emulsion on one side and the screen on the other. It was named by Estanave, who invented this improvement to the process (1908). By extension, the term is sometimes used to refer to images that can be seen directly in three dimensions.

Cross-viewing or cross-eyed viewing A viewing technique for 3-D images in which the lines of sight of the two eyes aim and focus at a point in front of the images' surface; the lines of sight cross in front of the images. See also *parallel viewing*.

Dioramic See *tissue view*.

Holmes-Bates stereoscope See '*Stéréoscope mexicain*'

Hologram A photographic support – glass or film – that has recorded the interference of light waves. These 'interferences' are a microscopic optical phenomenon produced when the wavefront reflected by an object meets a 'reference' (or neutral) wavefront. As they meet, some of the light waves interfere negatively and produce dark areas (absence of light), while others interfere positively and produce light areas (presence of light). The image created by these interferences is recorded and creates a hologram.

Holographic stereogram A *hologram* that synthesizes several dozen photographic, video or digital images to create a three-dimensional animated image.

Holography The process of recording a reflected optical wavefront off the surface of an object that, upon reconstruction, yields a high-fidelity three-dimensional image containing all the spatial information of the object recorded. See also *hologram*.

Hyperstereoscopy A stereoscopic effect in which the relief is accentuated in relation to the 'normal' vision of the subject. Hyperstereoscopy is used in particular for photographing distant objects.

Lenticular screen A plastic screen consisting of a series of round or longitudinal lenses, used to create and visualize three-dimensional images without spectacles or any other kind of instrument. See also *olostereogram*, *'photographie intégrale'*, *xography*.

Lenticular stereoscope The most widely used type of stereoscope. It is fitted with two lenses or prisms and is sometimes called a *refracting stereoscope*.

Line screen A screen composed of a series of fine lines that are alternatively opaque and transparent, used to create and visualize three-dimensional images without spectacles or any other kind of instrument. See also *autostereoscopic plate, parallax panoramagram, parallax stereogram*.

Liquid-crystal glasses Spectacles that become opaque and then transparent under the effect of low-level electric tension creating a shutter effect. This system is synchronized with the images that alternate on a computer or projection screen. See *alternating images*.

Magic Eye See *autostereogram*.

Mirror stereoscope The oldest type of *stereoscope* in existence. It functions by using mirrors to direct each eye to the image intended for it, and was invented by the English physicist Charles Wheatstone (1802–75).

Olostereogram A term used in the 1930s by the French inventor Lassus Saint-Geniès to describe his lenticular or line screen photographs.

Panoptic See *tissue view*.

Parallax The apparent displacement of a viewed object due to the observer's change of position.

Parallax panoramagram The inventor Herbert Ives used this term to describe his *line screen* photographs that incorporated more than two images.

Parallax stereogram A term used historically for a *line screen* photograph incorporating two images. The term was invented in 1902 by the American photographer and inventor Frederic Eugene Ives (1856–1937) and often used in French as 'stéréogramme à parallaxe' or 'parallax stéréogramme'.

Parallel viewing A viewing technique for 3-D images in which the lines of sight of the two eyes aim to meet at a point beyond the image surface; the lines of sight are parallel. See also *cross-viewing*.

Photogrammetry The technique used to determine the dimensions of objects photographed from different angles. *Stereoscopic views* are placed in an instrument that is able to compare the distances between different coordinates expressed as x, y and z.

'Photographie intégrale' A type of 3-D photography using a *lenticular screen* composed of spherical lenses. The name of the technique is derived from the fact that the image records a change in perspective both vertically and horizontally. The system was devised and named by the French scientist Gabriel Lippmann in 1908.

Photosculpture The term used to describe sculptural techniques executed more or less automatically involving the translation of camera images into solid three-dimensional representations of the subject.

'Photostereosynthèse' The superposition of glass plates representing the same subject photographed using different levels of focus. The technique was invented and named by the French inventor Louis Lumière (1864–1948) in 1920.

Polarization A means of orienting the vibrations of the individual waves making up light rays. For stereoscopic views the two images are projected with different polarizing filters and then viewed through spectacles fitted with the same filters. See also *vectograph*.

Pseudoscopic image The reverse 'inside-out' image seen when the left image is seen with the right eye and the right image with the left eye. The background appears on the foreground and the concave becomes convex. The opposite to *stereoscopy*.

Reflecting stereoscope See *mirror stereoscope*.

Reflection hologram A type of hologram where the reconstruction beam is on the same side of the hologram as the viewer.

Refracting stereoscope See *lenticular stereoscope*.

Stereocomparator A type of apparatus for measuring distances using stereoscopic views. See *photogrammetry*.

Stereogram A commonly used term for a *stereoscopic view*.

Stereographoscope An instrument combining lenses for stereoscopic views and a large lens for viewing ordinary images.

Stereoscope The generic term used to describe an instrument that makes it possible to see the effect of *stereoscopic views* by focusing each eye on the individual image intended for it.

'Stéréoscope américain' Term used historically in France for a multiple-view *stereoscope* with images mounted on an endless chain.

'Stéréoscope classeur' French term used to describe a *stereoscope* fitted with grooved trays containing a series of views on glass.

'Stéréoscope mexicain' French term for a *stereoscope* fitted with a handle and consisting, on the one hand, of lenses with a mask to protect the viewer's eyes from the light and, on the other, a sliding support for a *stereoscopic view*. Known in the USA as the *Holmes-Bates stereoscope*.

Stereoscopic camera A camera with two lenses used for the simultaneous recording of the two images of a *stereoscopic view*.

Stereoscopic projection See *alternating images*, *anaglyph*, *liquid-crystal glasses* and *polarization*.

Stereoscopic view An image produced using the technique of *stereoscopy*. A stereoscopic view is also known as a *stereogram*, a stereo pair, stereoscopic photograph, etc.

Stereoscopy A technique by which a pair of two-dimensional images produce a three-dimensional impression. Each image represents the same scene viewed from two slightly different angles. For the scene to be viewed in three dimensions each eye must only see the individual image intended for it. See *stereoscopic view*.

Transmission hologram A hologram that must be backlit for the image to be viewed. This technique makes it possible to produce large-format holograms with particularly deep images.

Tissue view A *stereoscopic view* on paper (usually albumen) that can be viewed alternately frontlit and backlit, and which has been retouched, coloured, ornamented with openwork and / or reinforced on the back with translucent coloured strips and coloured paper. In the nineteenth century it was referred to in French as a 'dioramic' or 'panoptic' image.

Transposition When a *stereoscopic view* is taken with most binocular cameras, the views are inverted in relation to reality. To view the final image with most *stereoscopes*, it is necessary to transpose, or exchange, the right- and left-eye images.

Vectograph A polarized *stereoscopic view* fixed onto a support (not projected) and viewed in three dimensions with polarizing filters. See also *polarization*.

Virtual image When describing a *hologram*, the image is said to be virtual if it appears behind the frame formed by the support.

Virtual reality A computer system that is able to reconstruct three-dimensional interactive images.

Xography Historically, an industrial method for producing *lenticular screen* images. The images were printed.

284

Index

Page numbers given in *italics* indicate illustrations.

Images visible in 3-D with the anaglyphic glasses: 14, 122, 125-126, 129-133, 212, 219, 240-241, 256.

Images visible in 3-D with ChromaDepth glasses (cut the glasses in two at the centre and place each filter against the respective eye, keeping both eyes open): 272, 274

Images visible in 3-D with the stereoscope: *12, 15, 18-20, 32-34, 46, 49, 52-53, 55-56, 59-60, 62-70, 72-74, 76-77, 98, 102, 110, 113-114, 116, 119, 155, 157, 166, 187, 190, 199, 211, 214-216, 218, 222-224, 235, 242, 245, 247, 253, 261-262, 264, 266-267, 269, 271, 276*

Group entries for the following terms: Advertisements, Avenues, Boulevards, Bridges, Cameras, Churches, Embankments, Footbridges, Fountains, Gardens, Stations, Museums, Parisian Life, Parks, Reviews, Squares, Street names, Transport.

A Académie des Sciences, 13, 102, 103, 145, 153, 167, 171, 210; *123, 210-211*
Adamson, Robert (1821-1848), 45; *44*
Advertising, 101, 103, 122-124, 141, 160-161, 172, 183, 186, 213-214, 277; *14, 22, 30-31, 84, 124-129, 134-135, 137, 183, 187, 265*
Advertisements (3-D) for:
 Castellane, 183; *183*
 Laboratoires Bottu, 122; *126-129*
 Laboratoires Midy, 122; *134-135*
 Pierre Cardin, *187*
 Poupina, *14*
 Rivoire and Carret, 122, 124; *124-125*
 Suralo, *186*
Aerial photography, 173, 204, 266, 276; *266-274*
Aléthoscope, 142
Alexandre, *see* Valtier, Alexandre
Allio, Pierre, 280
Almeida, Joseph Charles d', 103, 121, 140, 278
Alphand, Jean Charles (1817-1891), 49
Alternating images, 103, 121, 141, 161, 164, 282; *141, 164; see also* Glasses: liquid-crystal
Amateur photography, 47; *see also* Stéréo-Club Français
Anaglyphs, 13-14, 95, 102-103, 121-135, 140-144, 161, 163, 167, 200, 240, 252, 256, 281-282, 278-279; *120-135, 232-233, 256*
 albums of, 14, 122, 131, 133; *14, 122, 130-131, 133*
 viewing glasses, *123*
Anaglyphic projector, for stereoscopic views, 167
Anderton, John, 141-142, 163
Animated images:
 line screen or lenticular images, 14, 154, 157, 173-175, 179, 279-280; *14, 156-157, 174-175, 179*
 stereoscopic images, 26, 137-143, 161, 163-164, 167; *136-143, 161, 181*
 3-D images, 123, 137-144, 163, 167, 276, 278-280; *123, 143*

A-P Holographie, 196; *196*
APUR, Atelier Parisien d'Urbanisme (Parisian Urban Development Unit), 200, 212, 277, 280; *200-201, 212-213, 224*
Arago, François (1786-1853), 46, 48; *38*
Arc de Triomphe, 14, 45, 53, 55, 103, 110, 196; *13, 43, 45, 53, 55, 69, 189, 231*
Archaeology, 226, 277
Archi Vidéo, *231*
Artefactory, *214*
Artist, *70*
Artois, Étienne d', 164
Astronomy, 121, 122, 173; *15, 26*
Atelier holographique de Paris, 197, 277
Austerlitz, 212; *212*
Auteuil, 49, 103
Autochrome, 39, 108, 116, 121-122, 167, 278; *120, 122, 150*
Automatic camera (Bertsch's), *101*
Autostereogram, 262-263, 277, 280, 282; *20, 262-263*
Autostereoscopic plate, 154, 280, 282
Avenues, 248-249
 Avenue Daumesnil, 51
 Avenue de l'Étoile, *see Wagram*
 Avenue Foch, 53, 103; *53*
 Avenue d'Iéna, *55*
 Avenue de l'Impératrice, *see Foch*
 Avenue de Laumière, *247*
 Avenue Ledru-Rollin, *166*
 Avenue Montaigne, 72
 Avenue de l'Observatoire, 65
 Avenue de l'Opéra, 49, 103
 Avenue Wagram, 82, 103; *82*
 Avenue Winston-Churchill, 72

B Babbage, Charles, 44
Badin, Régis, 164
Bagatelle, Château de, 230; *230*
Bailly-Maître-Grand, Patrick (b. 1945), 234; *234*
Bal Bullier, 65; *65*
Balsa, 200-201
Baltard, Victor (1805-1874), 50, 102, 269
Barricade, 74, 77; *76-77*
Bastille, 236; *236, 276; see also* Place
Bastin, F., 146
Bates, Joseph L., 101
Batignolles, 49, 93
Baudelaire, Charles (1821-1867), 37, 46, 103
Baudoin, Eugène, 271
Bayard, Hippolyte (1801-1887), 44, 102
Beaubourg, *see* Georges Pompidou Centre
Bécaud, Gilbert (b. 1927), 183
Beckers, Louis, 160
Becquerel, Antoine César (1788-1878), 46
Belgrand, Eugène (1810-1878), 49
Belleville, 49, 93, 103; *200*
Belloc, Joseph Auguste (1805-1868), 91, 93; *92-93*
Belloni, Giorgio, 163
Benayoun, Maurice, 226-227; *227*
Benoist, Philippe, 138, 142
Bercy, 49, 212, 226; *212*
Bernardello, Jean-Marc, *214*
Bernicard, Ernest, 164
Berry, Kelley & Chadwick, *13*
Berthier, A., 153, 166, 279
Berthon, Rodolphe, 163, 279
Bertrand, Alexandre Pierre (1822-after 1868), 91, 94
Bertsch, Nicolas Auguste (?-1871), 101, 164; *101*
Bessière, Gustave, 164, 279; *164*
Bibliothèque Nationale de France, 214,

277; *212, 271*
Bièvre, 60; *60-61*
Billon-Daguerre, *see* Cordier, Alfred François
Binger, Maurice, 164
Bioscope, 137-138; *136-137*
Biot, Jean Baptiste (1774-1862), 46
Blanchère, Henri de la (1821-1880), 45
Bloch, E., 39; *39*
Blocher, Sylvie, 235, 280; *235*
Block, Adolphe (1829-after 1915), 161; *37*
Boilly, Louis-Léopold, *23*
Bois:
 de Boulogne, 49, 53, 102, 103, 140, 230; *116-117, 230*
 de Vincennes, 49, 167; *246*
Boisard, Gérard (b. 1938), 236; *236*
Boistesselin, Henry du, 279
Bonelli, Gaetano, 138-139
Bonnet,
 Alain, *183, 184*
 André, 154; *183, 184*
 Claude Joseph (1786-1867), *89*
 Françoise, *177*
 J., *184*
 Jeanne, *174-175*
 Liliane, *170*
 Maurice Georges Quentin (1907-1994), 32, 154, 167, 171-174, 179-180, 184, 187, 276, 277, 279-280, 282-283; *154, 170-177, 179-181, 184, 190-191; see also* Reliéphographie, La
Bouchard, Désiré, 163
Boulevards, 47, 49, 52, 102, 248-249, 274; *52*
 Boulevard Bonne-Nouvelle, 94
 Boulevard des Capucines, 103
 Boulevard des Italiens, 72; *72*
 Boulevard Magenta, *247*
 Boulevard Malesherbes, 103
 Boulevard Richard-Lenoir, 51; *268*
 Boulevard Saint-Michel, *51*
 Boulevard de Sébastopol, 49, 52, 103; *52*
'Bouquin', stereoscopic camera, *39*
Bourgeois, *70*
Bourse (Paris Stock Exchange), 255; *255*
Braquehais, Auguste Bruno (1823-1875), 92
Brassens, Georges (1921-1981), 183; *183*
Braun, Adolphe (1812-1877), 51
Brewster, Sir David (1781-1868), 26, 44-46, 48, 100, 102, 143; *26, 44*
Bridges, 56; *52, 266-269; see also* Footbridges
 Pont Alexandre III, 167
 Pont de l'Alma, 72
 Pont des Arts, *52, 54-55*
 Pont d'Austerlitz, 60
 Pont du Carrousel, *22*
 Pont au Change, 103, 209; *52, 209*
 Pont de la Concorde, 72
 Pont d'Iéna, 73
 Pont Louis-Philippe, 51, 209; *49, 51, 209*
 Pont Neuf, 208-209, 277; *28, 53, 208-209*
 Pont Royal, *201*
 Pont de Solférino, 50, 218; *50, 57, 218*
Briggs, Charlie, 164
Brin, Arthur, 164
Brisson, François Charles (1815-after 1864), 51
Bruguière, 31, 48, 276, 280; *30-31*
Building works, 49-52, 103, 213-214; *49-50, 52*
Bull, Lucien, 142

Bull, Lucien, 142
Bullier, François (1796-1869), 65; *65*
Bünzli, René, 138-140, 142; *139*
Bur, Didier, *210-211*
Buttes-Chaumont (Park), 51, 103, 167; *51*

C Cabinet of Curiosities, 238
Cagneaux, Émile, *107*
Cameras:
 automatic (Bertsch's), *101*
 'Bouquin', stereoscopic camera, *39*
 'Chambre a tiroir', *100*
 Duplex stereoscopic camera, 163; *163*
 for photosculpture, 84, 151,
 279; *151*
 for 'photostéréosynthèse', 145-146,
 279; *146*
 for lenticular images, 172, 184, 244,
 251, 257, 276, 279; *172-173, 184,
 276*
 Leroy 'stereo-panoramique' camera,
 165
 Loreo, 265; *265*
 Richard stereoscopic
 cinematographic camera, the, *143*
 Romo, 48, 265, 276; *265*
 'Stéréopanoramique', 116, 162,
 165; *165*
 Stereoscopic, 26, 31, 33, 45, 48,
 100-102, 116, 159-161, 163, 165-
 166, 265, 282; *22, 39, 100-101, 109,
 161, 163, 165, 265*
Canal⸱, 216, 277; *215*
Canal Saint-Martin, 51
Cantoni, Mario, 164
Cardin, Pierre, 277; *187*
Cardin, Pierre Arthur Camille, 83, 150,
 279; *150*
Carlet, Gaston, 139
Carné, Marcel, 276
Carpentier, Jules (1851-1921), 149; *149*
Cartoon strip, 122; *122*
 Mighty Mouse, 122; *122*
Casas Brullet, Blanca (b. 1973),
 237; *237*
Casenave, J.-F., *23*
Cassan, Urbain, 271
Caussignac, Jean-Marie, 195
Cave, the, 216-217, 226
Chaillot hill, 55; *55*; see also Trocadéro
'Chambre à tiroir', camera, 100
Champ-de-Mars, 55, 73, 103, 112-113,
 167; *55, 113, 272-273; see
 also* Eiffel Tower
Champs-Élysées, 47, 50, 66, 172,
 194-195, 215, 276, 277; *13, 66,
 172, 177*
Chapelle, La, 49
Chapus, Noël Paul (1832-after 1874), *51*
Charcot, Jean Martin (1825-93), 110; *110*
Charonne, 49
Chenevée, Philippe, 164
Chéron, Louis Camille, 163, 280
Chérubin d'Orléans, *17*
Chevalier, Charles, 100; *43-44, 100*
Chevojon, *177*
Cholet, Jean-Charles, *215*
Christakis, Anne-Marie, 196
ChromaDepth, 272, 281; *272, 274*
Chronophotograph, 139, 166
Church, 66; see also Notre-Dame,
 Sacré-Cœur, Sainte-Chapelle;
 Notre-Dame-de-Lorette, 69
 Saint-Augustin, 103, 200
 Saint-Eustache, 133
 Saint-Gervais, 52, 124
CIMA, Centre de recherche d'informatique
 et de méthodologie en architecture,
 213

Cinema, 27, 37, 116, 119, 149, 163,
 166-167, 189, 213-214, 276, 279;
 119, 276
CinemaScope, 141
Cinerama, 226, 141
Cirque d'Hiver, 102
Cité des sciences et de l'industrie,
 277; *196*
Claparède, *16*
Claudet, Antoine François Jean
 (1797-1867), 48, 83-84,
 138, 142, 279
Clément, Gilles, 214
Clémentel, Étienne, 39
Clésinger, Jean Baptiste, known
 as Auguste (1814-1883), 82, 83
Closerie des Lilas, see Bal Bullier
Clouzard, Jacques Atahanase Joseph
 (1820-after 1875), 160
CNRS, Centre national de la recherche
 scientifique (National Centre for
 Scientific Research), 14, 172, 206,
 210, 277; *206, 208-211*
Colardeau, Louis Joseph Emmanuel,
 32-34, 164
Collen, Henry, 44, 48
Collins, Jonathan, 197
Colombier, Henry Louis, 93
Colonne Vendôme, see Place Vendôme
Colour, see Colour photography, Coloured
 stereoscopic views
Colour photography, early, 13, 26, 102,
 108, 132, 162-164, 167; *30*
Coloured stereoscopic tissue view, 47, 63,
 102, 160, 283; *15, 37, 63-67,74, 160*
Commune, The, 47, 74-79, 91, 95, 103,
 110, 166; *74-79*
Computer-generated images, 200-201,
 220, 226, 236, *277; 201, 220-221*
Conservatoire des Arts et Métiers,
 139; *253*
Continsouza, Victor, 138, 140, 142; *139*
Cook, Henry, 138-139
Copyright, 68, *102*
Cordier, Alfred François, known
 as Billon-Daguerre, 91, 95
Corot, Jean-Baptiste Camille (1796-1875),
 102; *102*
Cosmos, Le, see Reviews
Cotton, Aimé (1869-1951), 193
Courbet, Gustave, 72, 74, 95
Courchant, Jacques Albert de, 160
Courrier, 95
Cours-la-Reine, 113
Cresson, Lucien, 113, 166
Cromer, Gabriel (1873-1934), 26, 80-81,
 83, 279
Cross viewing, 18, 20, 245, 262,
 281,283
Cyclostereoscope, 276

D Daguerre, Jacques Louis Mandé
 (1787-1851), 25, 44, 63, 102
Daguerreotype, 25-27, 49, 65, 72, 94,
 100, 102, 103, 137, 160, 280; *26-27,
 38, 43, 46, 59, 90, 92, 96-99*
Damoy, Julien, 101, 109
Dancer, Joseph Benjamin, 164
Dantan the Younger (1800-1869), 82; *39*
Darnay, 92
David, Alphonsine, 260
David, André, 138, 142
David, G., 164
Davioud, Gabriel (1823-1881), 49, 51, 103
Défense, La, 195, 245, 277
Deguelle, Anne (b. 1943), 238; *238*
Delebecque, François (b. 1955),
 239; *239*
Demenÿ, Georges (1850-1917), 139-140

Demesse, Marie Léopold, 93, 95
Deneux, Henri, 200
Denisyuk, Youri, 193-194
Desavary, Charles, *102*
Descartes, 17-18, 25
Deschaumes, Thierry, *216*
Desjardins, 72
Deslys, Gaby (1881-1920), 119; *119*
Dessoye, 94
Deuxième Monde (The Second
 Dimension), 215-216, 277; *215*
Diableries, 47, 102, 103; 37, *102*
Dietmer and Feichtinger, *219*
Diagrams:
 Lenticular screen, *171, 173*
 Line screen, *153*
 'Photographie intégrale', *171*
 Sight, *18, 33-34, 36*
Digital stereoscopic image, 108; *18, 20,
 262*
Diorama, 63, 160
Disdéri, André Eugène Adolphe
 (1819-1889), 82, 102, 164; *59*
Discs, 137-138; *136-137*
Doisneau, Robert (1912-1994), 13; *12*
Dominguez, Vincent, *218*
Drouin, F., *107*
Duboscq, Louis Jules (1817-1886), 45-46,
 48, 100, 102, 103, 121, 137-138,
 142, 160; *100, 136-137, see also*
 Duboscq and Soleil, Duboscq
 stereoscope
Duboscq and Soleil, 100; *26*
Duboscq stereoscope, *100*
Ducos du Hauron, Louis (1837-1920),
 103, 121, 122, 132, 138-140, 142,
 162-163, 166, 278, 282; *132*
Dufour, Alain (b. 1943), 240; *240-241*
Dufreigne, Jean-Pierre, 260-261
Du Mont, Henry Désiré, 138, 142
Duplex (stereoscopic camera), 163; *163*

E École d'architecture de la Villette, 221;
 220-221
École polytechnique, 200
EDF, Électricité de France
 (French Electricity), 206-211, 230
Edison, Thomas Alva (1847-1931), 139
Eiffel, Gustave (1832-1923), 112, 226;
 see also Eiffel Tower
Eiffel Tower, 55, 112, 166-167, 197,
 226, 239, *277; 112-113, 122, 188,
 190-191, 197, 221, 226, 239-240,
 251, 257, 270-273*
ELD, 48
Electricity, 103, 113, 154, 164; *164; see
 also* lighting
Ellie, Raoul, *34.*
Embankments, 55-56, 248-249; *56-57*
 Quai Branly, 214; *see also* Musée
 des Arts premiers
 Quai des Célestins, *56*
 Quai des Grands-Augustins, *53*
 Quai de Grenelle, 277
 Quai de l'Horloge, 100
 Quai du Louvre, 167; *54-55, 74*
 Quai d'Orsay, 103
 Quai des Tuileries, 56-57; *74*
Enfants du paradis, Les, 276; *276*
Épiscope, 47
Estanave, Eugène Pierre (1867-after
 1936), 35, 153-155, 157, 163, 167,
 171-2, 280, 282; *152-153, 155-157,
 171*
Euclid, 17
Eugénie de Montijo (1826-1920), 59, 102;
 59, 85
ExMachina, *276*

F Faraday, Michael (1791-1867), 138
Farlane, Jakob and Marc, 217
Fashion, 15, 67, 94, 102-103, 119, 167,
 194, 197, 217, 277; *59, 67, 71, 95,
 102, 116, 119, 186-187, 195,197,
 247, 262*
Faubourg Saint-Antoine, *205*
Favre, Claude Louis (1835-after 1882),
 see Lachenal and Favre
Featherstone, Willard Bradford, 163
Félix Potin, 101
Ferrier, Claude Marie (1811-1889), 45;
 45, 137; see also Ferrier and Soulier
Ferrier and Soulier, 49, 52; *49-53, 55-57*
Figuier, Louis, 31, 46, 48; *33*
File BB3, 91-95; *91-95*
FFilm gaufré, 278, *282; see also* lenticular
 screen
Fizeau, Armand Hippolyte Louis
 (1819-1896), 48
Fléri, Louis, 243, 280; *243*
Folies-Bergères, 123
Footbridge, *see also* Bridges: Pont
 des Arts
 Passerelle Bercy-Tolbiac, 217, 219;
 217-219
 Passerelle de la Cité, 51; *51*
 Passerelle de Solférino, 218, 277;
Fouché, Edmond, 163-164, 278
Fountains:
 Fontaine du Châtelet, 53; *53*
 Fontaine du Louvre, 223
 Fontaine du parc André-Citroën, *240*
 Fontaine Saint-Michel, 51, 103; *51*
 Fontaine du Trocadéro, 190-191, *220,
 240-241*
Fouquet, Jean-Baptiste, 162; *162.*
Fournier, Jean Marc, 195; *195, 199*
French Telecom, *231*
Franco-Prussian War, 47, 73-74, 103
French Ministry of Culture, *218, 220-221*
Friese-Greene, William (1855-1921), 140
Fronty, 103
Furne, Charles Paul (1824-1875), *see*
 Furne and Tournier
Furne and Tournier, 46, 70-71, 138,
 142, 164

G Gabor, Denis (1900-1979), 193, 276
Gadault, Louis Stanislas, 160
Galerie des Machines, 112
Garbouleau, Paul, 164
Gardens and parks:
 Jardin du Dessous-des-Berges, 229;
 228-229
 Jardin du Musée des Arts Premiers,
 214; *214*
 Jardin des Tuileries, 76; *76*
Garnier, Charles (1825-1898), 103, 110
Gastain, 91
Gauchet, Pascal, 197
Gaudin, Jacques Charles Emmanel
 (1825-1905), *64-65*
Gaudin, Marc Antoine (1804-1880), 44,
 45, 48, 94
Gaudin, Pierre Ignace Alexis (1816-1894),
 37, 46, 48
Gaumont (Studios), 116, 122-124, 141-
 142, 162, 164, 167; *124*
G.C., 79; *74-76*
Gelatin silver bromide process, 107,
 161, 166
Genre scenes, 46, 66-67; *27, 63, 64,
 66-67, 70, 71*
Gentil-Descarrières, Adolphe Félix, 91, 93,
 95, 160; *160*
Geometric figure, 44, 46, 137, 139, 194,
 227, 250, 279; *18, 46, 262-263*
Georges Pompidou Centre, 196, 197,

222, 250, 268-269, 277; *217, 222, 250, 267-269*
Gérard, Louis Joseph Auguste, 160; *160*
Germain, Louis, 92
Gimpel, Léon (1878-1948), 121-122, 124, 167, 278; *120, 122, 124-127*
Girardet & Associés, *216*
Givaudan, Claudius (1872-1945), 84, 144-145, 150-151, 167, 279; *144, 151*
Glasses:
 anaglyphic, 14, 122, 123, 140, 281, 282; *120-123*
 ChromaDepth, 272
 liquid-crystal, 204, 216, 226, 259, 283
 polarizing, 141, 143, 283; *141, 143; see also* Polarization
 with integrated displays, 217; *see also* Virtual reality headset
 with shutters, 141, 164; *141, 164*
Glodek, Élise, *212*
Godefroy, Henri, *114-115*
Godet, Prosper Bernard, 160
Gougin, 94
Gouin, Alexis (1799-1855), 94
Grand Palais, 113, 167
Grande Chartreuse dance hall, *see* Bal Bullier
Graphoscope, *see* Stereographoscope
Gréco, Juliette (b. 1927), 183; *184-185*
Grégory, Bernhard, *163*
Grenelle, 49
Grivolas, Claude Agricol Louis, 140-141
Gros, Antoine, 95
Groult, Georges, 164
Groupe Seca, *226*
Guidoni, Jean, 198
Guimard, Hector (1867-1942), 114, 167, 196; *196*
Guinard, Marcel, *270-271*

H Habert, Louis Alfred (1824-1893), *37*
Half-lens, 44, 48; *see also* Lenticular screen, Line screen
Halles, Les, 50, 102, 196, 200, 268, 277; *50, 114, 203, 266, 267, 268, 274*
Hanau, Eugène, *163*
Haussmann, Georges Eugène (1809-1891), 49, 52, 102
Helmholtz, Hermann von (1821-1894), 17, 21
Hennetier, Pierre Adolphe, 102
Herriot, Édouard (1872-1957), 151; *151*
Hesekiel, Adolf, 164
Hess, Walter, 163, 171, 280
Higelin, Jacques, 198
Hill and Barratt, 83
Hill, David Octavius (1802-1870), *44*
Hittorf, Jakob Ignaz (1792-1867), 53, 102
Holmes-Bates stereoscope, *101*
Holmes, Oliver Wendell (1809-1894), 15, 27, 29, 101
Hologram, 13, 142, 193-199, 236, 249, 258, 276-277, 279, 282-283; *192, 195-199, 258*
 reflection, 282
 stereographic, 198, 282; *196, 198*
 transmission, 283; *192, 195-197, 199, 258*
Hologramme Industries, 197
Holography, *see* Hologram
Holo-Laser, 195, 197, 199; *197, 199*
Hospital, *135*
Hôtel de Ville, 46, 52, 74, 79, 103, 166; *52, 68, 79*
House in Paris, A, 70; *70-71*
Hoyn de Marien, Louis le, 271
Hughes, Síocháin (b. 1961), 242; *242*

Hugo, Victor (1802-1885), 110, 166; *110*
Hyperstereoscopy, 283
Hypnotism, 26-27

I Iconoscope, 142
Identity card, 73
Idjiez, Benjamin Victor, 164
IGN, Institut Géographique National (National Geographic Institution), 200, 204, 266, 276; *202-205, 266-269*
Ikam, Catherine, 243, 280; *243*
Île:
 de la Cité, 49, 51-52, 56; *28, 202, 254*
 Saint-Louis, 49, 51, 56; *49, 268*
Ilegal copies, 47, 193, 277
L'Illustration, see Reviews
Imax, 141
INA, Institut National de l'Audiovisuel, 213
Installation, 234-238, 243, 250, 258-259
Institut de France, 210; *52, 54-55, 210-211*
Interiors, 46, 70, 82; *70-73, 77-78, 82, 128-129, 152*
Internet, 214-216
Intini, Paul, *28*
Italian Campaign, 50
Istar, 272; *272-274*
Ives, Frédéric Eugène (1856-1937), 153, 280, 283
Ives, Herbert, 283

J Jakob and MacFarlane, *217*
Jenkins, Charles Francis, 140, 142
Jeune, Gilles, 82, 84-85, 89
J.M.G. Graphics, 229; *228-229*
Jouvin, Hippolyte (1825-after 1887), 68-69, 103; *68*
Jouvin, Léon, 93
Jugnot, Gérard (b. 1951), 198; *198*
Julesz, Béla, 262
Jundzill, Adam, 138, 142

K 'Kalloscop' stereoscope, *163*
Kanolt, Clarence Whitney, 171
Karampournis, Roger, 280
Kastler, Alfred (1902-1984), 194
Kavoussi, Kamran (b. 1960), 244; *244*
Keller-Dorian, 163
Kepler, Johannes, 17
Kinimoscope, 138
Kitsch, 244
Knapp Nettel, 116
Kodachrome, 108
Kossonis, Miltiade, 142
Kreinitz, 94
Kular, Jerzy, *276*

L Lacan, Ernest, 94
Lachenal and Favre, *73*
Lacroix, Joseph, 92
Lamiche, François Benjamin, 94
Land, Edwin Herbert, 143, 167
Lanier, A., *22*
Lapidus, Olivier, 197, 277; *197, 262*
Larauza, Adolphe Guillaume, *162*
Lartigue, Jacques Henri (1894-1986), 116; *116-117, 119*
Laser, 193, 194, 196, 206, 208-209, 226, 258, 277; *226*
Lassus Saint-Geniès, Jacques de, 280, 283
Laugs, Martha (b. 1935), 245; *245*
Laussedat, Aimé, 200
Le Corbusier (1887-1965), 213
Lefort, Pierre Henri Amand (1804-1880), 66, 160; *63, 66-67*
Legendre, Ernest (1834- ?), *38, 64-66*
Leith, Emmeth, 193-194

Lenoir, Albert (1801-1891), 50
Lenticular:
 camera for *172*
 image, 13-14, 23, 32, 163, 171-190, 244, 251, 257, 276, 277, 279-280, 283; *14, 170, 173-183, 185-191, 244, 257*
 screen, 171, 173, 283; *171, 173; see also* 'Photographie intégrale'
 with superimposed horizontal and vertical screens, 179, 279; *179*
Line-screen systems, 153, 283; *153*
 image, 13, 142, 153-157, 163-164, 166-167, 255, 276, 279-280, 283; *152-157, 255*
 with superimposed horizontal and vertical screens, 154, 157, 167, 174, 279; *156-157, 174-175*
Le Ny, Marie-Hélène (b. 1963), 246; *246*
Léon & Lévy, 48, 103, 109; *74,114, 159*
Léon, Moïse (1812- ?), *see* Léon & Lévy
Leonardo da Vinci, 17, 38
Lepage, 92, 94
Lernac, 83, 279
Leroy, Lucien, 165; *165*
Leroy 'stereo-panoramique' camera, *165*
Lestrade, 31, 48, 235; *235*
Leventhal, J. F., 141
Lévy, Isaac (Jules) (1833- ?), *see* Léon & Lévy
Liberation of Paris, The, 264, 276
Lighting, of monuments, 206, 209-210, 277; *206-211, 226*
Lihou, Benjamin, 107, 108; *107*
Lion, Moïse, 160
Lippmann, Gabriel (1845-1921), 153, 155, 163, 166-167, 171, 193, 234, 280; *see also* 'Photographie intégrale'
Locomotion, 139; *139*
Londe, Albert (1858-1917), 107
Loreo (camera), 265; *265*
Loudon, 44
Louvre, 74, 76, 103, 122-123, 206, 215, 277; *74, 132, 206-207, 215, 223, 254, 266-267, 274*
 Pyramid, 277; *223*
Lumière, La, see Reviews
Lumière,
 Auguste (1862-1954), 144, 146; *145-147*
 Louis (1864-1948), 123, 141, 144-146, 166-167, 246, 278-280; *123, 144-; see also* 'Photostéréosynthèse'
 Yvonne (1907-1993), 149; *149*
Luna Park, 167, 276

M Macaire, Louis Cyrus, 164
Macroscopy, 172, 173, 279
Magic Eye, 283
Magic lantern, *23*
Maine-Montparnasse, 271
Malacrida (photographer), 94
Marey, Étienne Jules (1830-1904), 140, 142, 146, 278; *139*
Mariani, Louis, 220-221
Marinier, Jules Alexandre Édouard (1823-after 1896), 102; *38, 102*
Marion, 83, 279
Markets, *see also* Les Halles
 Marché des Innocents, *50*
 Marché Sainte-Catherine, 200
Marlet, Jean Henri, *23*
Marville, Charles (1816-1878?), 84
Marylin, *192*
Massage School for the Blind, *126-127*
Masters, Frederick William, 164
Mattey, A., 119; *119*

Mattey stereoscope, *119*
Maury, 141
Maximoff, Alexandre Théodorovitch, 164
Mayer and Pierson, 59, 103; *58-59*
Mayo, 47
Mazzero, François, 196, 197
McKaig, Bruce (b. 1959), 247; *247*
Megascope, 48, 121, 123
Métro, *see* Transport
Metro Goldwyn Mayer (MGM), 141
Microphotograph 27, 95, 146, 173; *see also* Stanhope
Microscope, 25-27, 29, 100, 193
Millerand, Alexandre (1859-1943), 149, 167; *149*
Millet, Désiré François (1828-after 1868), 94
Mimram, Marc, *218*
Mirror:
 in photographs, 258; *27, 96-98, 245*
 in stereoscopic devices, 63, 139-140, 162; *140, 162*
Mitaine, 94
Moëssard, Paul, 163
Moigno, François Napoléon Marie (1804-1884), 35, 44-46, 48, 100, 279
Molteni, Alfred (1837-1907), 121, 122, 140, 278; *121*
Montmartre, 49-51, 103, 200; *50, 68, 189, 205*
Montparnasse, 124, 166, 271, 277; *271*
Montparnasse Cemetery, *251*
Moreau, Jean-François, 196
Moree, Sam, 197
Morin, 82
Morny, duc Charles de (1811-1865), 86; *86*
Mortier, Paul, 141-142
Morvan, Éric, 213
Moulin, Félix Jacques Antoine (1802-after 1875), 39, 91; *39*
Mounts for stereoscopic views, 47, 63; *13, 26-27, 37, 50, 55, 59-60, 64-67, 70-71, 73-74, 76-77, 79, 102, 110, 114*
Mugot, Hélène (b. 1953), 249; *248-249*
Multi-lens camera (for lenticular images), 172; *172, 276*
Multiple stereoscope *159, 164*
Museums
 Musée des Arts Premiers, 214; *214*
 Musée Carnavalet, 166; *232-234*
 Musée Grévin, 194
 Musée de l'Holographie, 193, 196, 258, 277; *196, 198*
 Musée de l'Homme, 122
 Musée d'Orsay, 277
Museum of Natural History, 277; *247*
Mutoscope, 140, 163, 167

N Nachet, Camille, 162
Nadar, Félix (1820-1910), 82, 102, 103; *47*
Napoléon III, Louis Napoléon Bonaparte (1808-1873), 49, 52, 59, 72-73, 86, 93, 102, 103, 110; *58-59, 85*
Nimslo, 244, 251, 257, 276; *276*
Ninio, Jacques, *262-263*
Norling, J. A., 141
Notre-Dame, 103, 196, 200; *180*
Nouvel, Jean, 214; *214*
Novak, Marcos, 215
Nudes, *91-94, 97-98, 131, 187*

O Oktal, 225; *224*
Olivier, Frank, 194, 277; *195*
'Olostéréogramme', 283
Omnibus, *see* Transport
Omnimax, 141

Omniscope, 138
Ondim, *231*
O.P. 3000, 173, 184; *184*
Opera, see Stereoscopic views
Opéra Bastille, 277
Opéra Garnier, 103, 196, 200, 277; *28, 196*
Optical illusion, 14, 18, 23-29, 31-35, 38-39, 94, 253; *16, 34*
Outier, Guy, *214*

P Paiement, Alain (b. 1960), 250; *250*
Pailleux, Stanislas Théodore, 159-160; *159*
Palais de la Découverte, 194, 196, 277
Palais de l'Électricité, *113*
Palais de l'Industrie, 72, 82; *72*
Palais de Justice, 103
Panorama, 23-24, 27, 49, 116, 162, 165, 226, 240-241, 250; *165*; see also CinemaScope and Cinerama
Panthéon, 110, 200
Pantograph, 81-83; *82-83*
Parallax, 283
 panoramagram, 283
 stereogram, 153, 283
Parallel viewing, 18, 20, 245, 262, 281, 283
Paris,
 aerial views, *266-274*
 city boundaries (1860), 49-51, 102, 103, 274; *50-51*
 industry, 56-57, 60, 72
 map of, 274; *50-51, 275*
Paris Chamber of Commerce and Industry, 215
Paris City Transport Authority (RATP), 199; *214*; see also Transport
Paris, Guillaume (b. 1966), 251; *251*
Paris-Stéréo, 116
Parisian life, scenes of
 Acrobat, 244; *244*
 Actor/Actress, 198, 252; *198, 252*
 Animals, 139, 152-154, 248-249; *14-15, 155, 162, 247*
 Arrest, 27, 91-95; *108*
 Aviation, 116, 167; *116*
 Balloon, 253; *240-241, 253, 261*
 Baths, 55, 161, 277; *54-55*
 Bicycle, 107, 116; *109, 116*
 Boats, 55-57, 73, 113; *54-55, 188, 223*
 Bouquiniste (book stall), 53; *53*
 Carnival, *15*
 Carriage accident, 15
 Casino de Paris, 123; *119*
 Comet (of 1858), 15
 Concierge, *70*
 Department stores, 66, 102, 107
 Festival, *68*; see also Carnival
 Games, 46, 213-217, 277
 Hotel, 161
 Restaurant, *70, 217*
 Second-hand market, *247*
 Traffic, *13*
 Washhouse, 54-55, 92; *64*
 Wedding, *166*
Park, see also Buttes-Chaumont, Gardens
 Parc André-Citroën, *240-241*
 Parc de Bercy, 212; *212*
 Parc des Princes, 116; *116*
 Parc de la Villette, 196, 277; *196*
Passage de la Bouteille, *114-115*
Passy, 49
Patent, 48, 62, 84, 100-103, 121, 123, 132, 137-138, 140-143, 149-151, 155, 157-167, 172-4, 179, 180, 278-280; *82, 150, 159-164, 272*
Pathé, 140-141, 164
Peep-show, 24, 25, 27-29; *28, 196*

Pei, I. M., 277
Penne, Joseph, 92-93
Perrault, Dominique, 271, 277
Perron, Gérard, *232-233*
Perspective projection, *34*
Pesic, Dino, 212
Petit Palais, 113, 167
Petit, Pierre (1832-1909), 82, 91-92
Petitpierre-Pellion, Louis Fleurus Gustave, 164
Phenakistoscope, 37-38, 137-138
Photobioscope, 138-139
Photo-club, 107; see also Stéréo-Club Français
Photogrammetry, 200-201, 204, 283
Photographic studio, 46, 66-67, 82, 93, 172, 177, 184, 196
'Photographie intégrale', 144, 152, 163, 167, 171, 234, 280, 283; *171*
Photoplastigraphy, 83
Photosculpture, 80-89, 103, 144-145, 150-151, 162, 167, 279, 283; *80-89, 144, 150-151*
 using the bichromated gelatin process, 83, 279
'Photostéréosynthèse', 145-149, 151, 167, 237, 239, 242, 246, 279, 283; *145-149*
'Photostérie' (process), 83
Physionotrace, 81
Piccoli, Michel (b. 1925), 183
Picot, Eugène, 95
Pictet, Lucien, 164
Pigalle, 187; *187*
Pigueron, Francis, 117
Pius IX (1792-1878), 84; *84*
Plateau, Joseph (1801-1883), 137-8, 142
Plaut, Henri Charles (1819-after 1870), 91, 94
Polarization, 108, 122, 141-142, 166-167, 283; *141, 143*
Polaroid, 143, 276; *197*
'Polyorama Panoptique', 63, 160; *25*
Poncin, Catherine (b. 1953), 252; *252*
Porada, Sabine, *212*
Pornographic images, 27, 91-95, 119, 187; *27, 90-99, 118, 128-131, 187*
Porte Maillot, 113, 196, 215, 277; *215*
Portrait, 45, 48, 59, 93, 94, 103, 146, 149-152, 154, 172, 173, 177, 183-184, 187, 192-194, 198, 237, 252; *12, 26, 43-44, 58-59, 65, 102, 144-152, 154, 156-157, 170, 172-179,182, 184-185, 187, 190, 195, 198, 237, 252, 258*; see also Photosculpture
Portzamparc, Christian de, 215, 277; *215*
Postcard, 47, 95, 109, 162, 167, 173, 188-189; *109, 114, 188-189*
Poster, 22, 84
Poterne des Peupliers, *61*
Potschke, 83
Pouillet, Claude, 46
Praxinoscope, 140, 142; *140*
Préfecture de police, *270-271*
Prépognot & Cie, 280
Prévert, Jacques (1900-1977), 276
Prism, 46-48
Prison, 93, 94; see also Arrest
Pseudoscope, 48
Pseudoscopy, 19, 43 (converse image), 48, 281, 283
Puccini, Giacomo (1858-1924), 196; *196*

Q Quarries, 51, 103
Quartier de l'Horloge, 196, 200
Quinet, Alexandre Marie (1810-after 1863), 48, 91, 93, 100, 102, 160; *161*
Quinetoscope, 48, 100, 102, 161; *161*

R Rail, see *Transport*
Rateau, Auguste, 141-142
Raudnitz, Jules (1815-after 1872), 91, 94
Raynaud, Lucien, *264*
Realism, 32, 81, 83-84, 112, 225-226
Reconstituted views
 of the Paris Commune, the, 74
 of the Paris Opera, 38, 46; *38*
 of paintings, 46, 160, 280
 of the theatre, 38, 46-47, 102
Reffye, Philippe de, *229; 228-229*
Reflection, 256; *256, 261*; see also Mirror
Regnault, Henri (1810-1878), 46
Reichen, Bernard, *217*
Relieforama, 172, 183, 187, 277; *14, 183, 186-187*; see also Karampournis, Roger
Reliéphographie, La, 154, 171-172, 177, 279-280; *154, 170, 172, 174-177, 180*
Renault, 225
République, 79
Retournat, Charles, 160
Reviews:
 Actu, 173
 Bulletin du Stéréo-Club Français, 108, 109; *106*
 Ça m'intéresse, 123
 Le Cosmos, 48
 Le Déshabillé au stéréoscope, 95; *95*
 L'Illustration, 48, 122, 123, 167, 278-279
 La Lumière, 37, 46, 48, 95; *36*
 Paris-Match, 123, 279
 Petit journal pour rire, 10, 47
 Science et vie junior, 123
 Stéréo-Nu, 95
 Le Stéréoscope, 39, 103
Reynaud binocular praxinoscope, the, *140*
Reynaud, Émile (1844-1918), 140-142; *140*
Richard, Jules (1848-1930), 122, 143, 162, 164-166, 280; *33, 143, 165*
Richard polarized light projector, the, *143*
Richard stereoscopic cinematographic camera, the, *143*
Rideau, 94
Ritcher, Eve, 197
Robert, Jean-Baptiste, 158
Robert, Philippe, *217*
Robin, Jacques (b. 1964), 253; *253*
Roland Garros, stadium, 216; *216*
Rollmann, Wilhelm (1821-?), 102, 121, 279
Romo (camera), 48, 265, 276; *265*
Roy, Georges, 150
Rude, François (1784-1855), 14, 42, 45

S Sack, Stephen (b. 1955), 254, 280; *254*
Sacré-Coeur, basilica, 103; *244*
Sainte-Chapelle, 200
Sandor, Ellen (b. 1942), 255; *255*
Sandoz, Charles Auguste, 164
Sarfati, Alain, 212; *212*
Sarret, Michel, 14, 183, *186-187*
Satire, 27, 67, 70, 102, 124; *10, 27, 37, 47, 67, 70-71, 102, 125*
Saubat, Jean, 271
Saugrin, Louis François, 62, 160, 164
Savart, Félix (1791-1841), 46
Savoye, François, 276
Scanner, 237
Schall, Roger (1904-1995), *264*
Schenck, August Friedriech (1828-1901), 45, 48
Schiertz, Jules Gustave, 164
Schönewald, Emil, 164
Scientific photography, 14, 110-111, 121, 139-140, 155, 160, 278; *110-111, 139, 155*

Sculpture, 14, 37, 45, 47, 48, 81-82, 102, 137-139, 162, 237, 251, 253; *37-39, 42, 45 73, 132, 253; see also* Photosculpture, Venus de Milo
Second Empire, 13-15, 26-28,42-103, 121, 137-139, 158-161, 252; *15, 25-27, 37-39, 42-102, 136-137, 158-162, 252*
Seine, River, 49, 50, 55-56, 166-167, 200, 213, 271; *52-57, 74, 166, 213, 254, 259;* see also the Bièvre banks of, 200-201; *201*
Selector, 171; see Lenticular screen systems
Self-portrait, 45, 80, 190, 235, 257; *43, 152, 190, 235, 257*
Selke, Willy, 151, 164
Sellers, Coleman, 138, 142
Senate, 46
Serres, 94
1789, 276; *276*
Shaw, Jeffrey, 227
Shutter, 100-101, 138-141, 158-159, 161, 165, 172; *139, 163, 257*
Siès, Victor Pierre, 161, 164; 161
Simonetti, Jacques (b. 1941), 256; *256*
Simplex, see Lestrade
Singer, 198, 183, 276; *182, 184-185*
Sippel, Dagmar (b. 1961), 257; *257*
SIRDS (single image random dot stereogram), 262-263; *262-263*
Snow, Michael (b. 1929), 196, 258, 277, 279; *258*
Société Française de Photographie, 81, 107, 108, 138, 140, 150
Société Industrielle de Photographie (SIP), *15*
Société Nouvelle d'Exploitation de la Tour Eiffel, 226
Söderbaum, Karl Richard, 164
Soleil, Jean-Baptiste François (1798-1878), 45-46, 94; see also Duboscq and Soleil
Soulier, Charles, 160; see also Ferrier and Soulier
Souparis, Hughes, 197
Speisser, Auguste (1836-after 1865), 91, 93
Spido-Gaumont, 116
Squares
 Place de la Bastille, 51, 236; *76, 236, 268*
 Place du Châtelet, 51-53, 103; *51-53*
 Place de la Concorde, 14, 77, 215, 225; *69, 224*
 Place de l'Étoile, see Arc de Triomphe
 Place d'Orléans, 39; *39*
 Place du Palais-Royal, 114; *114*
 Place Saint-Pierre, 68
 Place du Tertre, 189
 Place Vendôme, 74, 103; *74-75, 77, 274*
 Place des Vosges, 200, 215, 253, 268
Stanhope, 27, 95
Stations, 66
 Gare d'Austerlitz, 212
 Gare de l'Est, 51, 102, 103; *51*
 Gare de Lyon, 200
 Gare Montparnasse, 50, 102, 271; *50, 271*
 Gare du Nord, 103
 Gare Saint-Lazare, 50, 103; *50*
'Stéréochromie', 265, 276; *265*
'Stéréoclic', *31*
Stéréo-Club Français, 107-109, 162, 167; *106-108*
 membership card, *108*
Stereocomparator, 283
'Stéréodrome' stereoscope, 123

Stereocomparator, 283
'Stéréodrome' stereoscope, 123
Stéréofilm Bruguière, 31; see
 also Bruguière
Stereogram, 283; see Stereoscopic view
 camouflaged, 21, 262, 280; 262
 holographic, 198, 282; 196, 198
 parallax, 153, 283
Stereoscope, 17-18, 26-27, 31, 37-39,
 43-44, 47, 48, 121, 159
 'américain' (multiple-view), 160, 164,
 283; 164
 children's, 25
 'classeur' (with grooved tray), 162,
 166
 coin-operated, 161; 163
 Duboscq, 100
 film viewer for, 139
 for animated images, 137-140, 163,
 167; 139, 161
 glasses for, 141
 glass plates for, 108
 hand-held, 17-18, 27, 44-48, 62-63,
 100, 102, 137, 160-161, 167, 235,
 260, 264-265, 276, 283; 10, 25-27,
 31, 36, 37, 47, 62, 65, 109, 137,
 160-161, 235, 261, 264-264
 in the form of a book, 39; 39
 in the shape of a chalet, 158, 160;
 158
 'Kalloscop', 163
 'mexicain' or Holmes-Bates
 stereoscope with mirrors, 101,
 283; 101
 Mattey's, 119
 multiple view, 103, 119, 123, 159-161,
 164, 166, 283; 119, 159, 163-164
 'Stereo-Carte', 109
 with mirrors, 44, 47, 48, 101, 164,
 247, 253, 283; 44, 101, 247, 253
Stereoscope workshop, 62
Stereographoscope, 103, 161-162,
 283; 162
Stereoscopic acuity test, 32
Stereoscopic cinematographic camera,
 138-141, 143, 163; 143
Stereoscopic images,
 daguerrotype, 26
 drawings, 18, 31, 43-46; 25, 36
 lithograph, 45-46, 48; 25, 46
 prints, 33
 sale of, 27, 38, 45, 47-48, 68,
 91-95, 102
 travel, 28, 46
Stereoscopic plate, 33, 162; 163
Stereoscopic views
 anaglyphic projector for, 167
 box for, 38
 coloured, 27, 32, 47-48, 63, 74,
 91, 93-94, 102, 247; 15, 25-27, 37,
 50-51, 55, 58-59, 63-67, 90, 92-93,
 95-99, 160-161, 247
 instantaneous, 15, 47, 68, 72, 153;
 73, 84
 mounts for, 47, 63; 13, 26-27, 37,
 50, 55, 59-60, 64-67, 70-71, 73-74,
 76-77, 79, 102, 110, 114
 production of, 47, 62, 91, 94
 sales album, 45, 68; 68-69
Stereoscopy,
 publications on, 107, 260, 264; 107,
 260, 264
 definition of, 283
Still-life, 24, 27; 24, 46
Street names, 248-249
 Rue Bergère, 106
 Rue du Bouloi, 265
 Rue Cadet, 93
 Rue du Caire, 112

Rue de Castiglione, 77
Rue de Clichy, 108
Rue Coquillière, 265
Rue des Dames, 235
Rue d'Enfer, 50
Rue de la Faisanderie, 265
Rue du Faubourg-Saint-Martin, 66
Rue de Lancry, 93
Rue Mélingue, 33
Rue Montorgueil, 114-115
Rue des Nations, 73
Rue de Paradis, 82
Rue de Paris, 93
Rue de la Perle, 46
Rue de Presbourg, 194-195
Rue de Rennes, 50
Rue de Rivoli, 50, 77; 50
Rue de Rome, 50
Rue Saint-Antoine, 50, 200
Rue Saint-Georges, 122
Rue Soufflot, 110; 110
Rue Tourlaque, 154
Rue de Turbigo, 203
Studio Gui, 223
Sueur, 150

T Taber Bas-Relief Syndicate, 162; 162
Talbot, William Henry Fox (1800-1877), 44,
 48, 102
Talbotype, stereoscopic, 48
Tannery, 60; 60
Tazdaït, Nadir, 222
Telephone, 166; 128
Television, 14, 27, 122, 142-3, 195, 280
Thiébault, Pierre Eugène (1825-after 1874),
 91
Thiers, Adophe (1797-1877), 49, 74, 103
This, 160
Thompson, Warren, 59; 59
3-D; see Virtual reality
3-D cinema, 123, 137-144, 163, 167, 276,
 278-280; 123, 143
3-D images:
 development of, 13-14, 23-28, 37
 the industry, 13, 27, 47, 56, 60-61, 91,
 160, 164, 193, 197
3-D projection, 109, 121, 132, 161, 163;
 see also 3-D cinema
 anaglyphic, 103, 121, 122, 123,
 140-141, 143, 163, 167, 278;
 121, 123
 polarized, 108, 122, 143, 163,
 166-167; 141, 143
 stereoscopes for viewing, 163
 using alternating images, 103, 121,
 161, 163-164; 141, 164
 using line-screens, 154, 280
Touchet, Émile, 122
Toulon, Pierre Marie Gabriel, 164
Tour Montparnasse, 271, 277; 271
Tourism, 15
Tournier, Henry Alexis Omer (1835-after
 1866), see Furne and Tournier
Townsend, Elizabeth Edith, 164
Trades, 51, 70, 73, 79, 91, 92, 95, 108,
 160; 22, 63-64, 70-71, 126-127
Transport:
 automobile, 225; 117, 224, 264
 horse-drawn carriage, 13, 15, 133
 metro/RER, 50, 113-114, 167,
 194-195, 199, 214, 242, 245, 269,
 277; 114, 196, 199, 214, 242, 245
 omnibus, 167; 13, 67
 rail, 49-51, 113, 271, 277; see
 also Stations
 river, 56-57; see also Boat
 road, 196, 224, 269; 13, 15, 50-51,
 72, 201
Transposition, 283

Trapu system, 200, 203-205
Tribillon, Gilbert, 195, 197; 195, 197, 199
Tribillon, Jean-Louis, 195, 197; 197
Tribunal de commerce, 52; 52
Trimaran, 226
Trocadéro, 73, 103, 240-241; 112-113,
 122, 190-191, 220, 272-273
Trompe-l'œil, 24, 26-28; 28
Tuileries, The, 46, 50, 74, 76, 102-103;
 56-57, 76-77, 253
Tyler, Douglas, 197
Typewriter, 73, 161; 258

U Underwood & Underwood, 114
Upatnieks, Juris, 193
Utopia, 139, 142; 212

V Valtier, Alexandre, known as Alexandre
 (1802-after 1869), 37
Varley, Frederick Henry, 140, 142
Vaugirard, 49
Vectograph, 167, 283
Venus de Milo, 195; 195
Verascope, 165-166; 33, 165
Victoria (1819-1901), Queen, 45, 48, 72,
 100, 103
Video, 259
Viel, 72
View-Master, 167
Villette, La, 49, 103, 124, 197, 200,
 277; 196
Vincennes Zoo, 122; 14
Virtual reality, 13-14, 23, 27, 39, 200-231,
 243, 255, 276-277, 280, 283;
 200-231, 243, 255, 276
Virtual reality headset, 23, 213, 216
Vision binocular, 11, 17-21, 26, 31,
 38, 43, 281; 17, 36
Vision Plus, 230
Voie Georges-Pompidou, 201; 201

W Weinberg, Boris, 164
Wheatstone, Charles (1802-1875), 17-18,
 43-45, 47-48, 102, 137; 43-44;
 see also Stereoscope, with
 mirrors
Willème, François (1830-1905), 80-89,
 103, 150, 279; 80- 89
World Fair:
 of 1851 (London), 31, 45, 72,
 100, 102
 of 1855 (Paris), 13, 46, 72, 103;
 72, 102
 of 1867 (Paris), 47, 73, 82, 103;
 37, 73
 of 1878 (Paris), 73, 103
 of 1889 (Paris), 112, 166; 112-113
 of 1900 (Paris), 13, 47, 113, 114, 167;
 113
 of 1970 (Osaka), 183
Worldskin, 227
World War I, 47, 108,167
World War II, 47, 108, 264, 276

X Xavier, José, 276
Xography, 280, 283
X-ray, 155, 162, 164, 166,
 280; 155

Y Young, Eddie, 219
Yun, Aiyoung (b. 1964), 259; 259

Z Zacot, Fernand (b. 1950), 260; 260-261
Zeiss, Carl, 162
Zootrope, 138-139

First published in 2000 by
Booth-Clibborn Editions
12 Percy Street
London W1T 1DW
www.booth-clibborn.com

©Booth-Clibborn 2000
©Paris-Musées 2000

Design: David Hillman and
Deborah Osborne for Pentagram, assisted
by Owen Peyton-Jones
Editorial for Paris-Musées:
Florence Jakubowicz, Sandrine Bailly,
Joseph Jacquet
Editorial for Musée Carnavalet:
Françoise Reynaud, Catherine Tambrun,
Kim Timby and Gilles Menegaux
Editorial for Booth-Clibborn Editions:
Denny Hemming, Hazel Curties
English translation by Wendy Allatson,
Susan Mackervoy, Sue Rose, Trista Selous
and Sue Holmes for Ros Schwartz
Translations, London

Lenticular image on front cover by
Patrick Garret, printed by Imprimerie SMIC,
Montbrison
Anaglyphic glasses supplied by 3-D
Images Ltd, London
Stereoscopic glasses © Simon Rouse,
Pentagram; produced by
Empire Graphics Ltd.
ChromaDepth glasses donated by Istar,
France

A catalogue record for this book
is available from the publisher.

ISBN 1-86154-162-7
Printed by Toppan, Hong Kong

Editorial Acknowledgments

The dates of the nineteenth-century
photographers were established by
Denis Pellerin
The descriptions of the instruments
and stereoscopes were written by
Jacques Périn: pp. 100-102, 119, 140,
143, 165 and 265
The instructions on how to make a
hologram were written by Pascal Gauchet
and Dominique Sevray: p.194
Most of the captions and commentaries
on the images were researched and written
by Catherine Tambrun and Kim Timby.

Photographic acknowledgments

Reproduction copyright:

© Atelier parisien diurbanisme: p. 200 (above), 201, 202, 203, 204, 205
© Atelier de restauration et de conservation des photographies de la Ville de Paris: p. 113 (below), 166 (above) Rémi Briant, 33, 65 (left), 182, 185 Daniel Lifermann
© Patrick Bailly-Maître-Grand: p. 234
© Bibliothèque municipale de Lyon: p. 147, 149 (left and below)
© Bibliothèque nationale, Paris: p. 37 (above), 51 (no. 12, 14), 92 (above right), 93 (above centre), 95, 102 (centre and below)
© Sylvie Blocher: p. 235 (above)
© C.N.R.S UMR MAP Le CRAI/ Culture: p. 210, 211
© Blanca Casas Brullet: p. 237
© Centre de liimage, administration publique des Hôpitaux de Paris: p. 110 (above), 111
© Clément Chéroux: p. 108 (below), 109 (all three above)
© Cinémathèque française, collection des appareils: p. 72 (below), 112, 113 (above), 139 (above), 158, 276 (above)
© Anne Deguelle: p. 238
© Jacques Delamarre: p. 166 (below)
© François Delebecque: p. 239
© Robert Doisneau, Agence Rapho, Paris: p. 12
© Alain Dufour: p. 240-241
© Fondation Electricité de France: p. 207
© Jean-Marc Fournier: p. 195
© Michel Frizot: p. 30, 32, 33 (above and below), 34 (below)
© Pascal Gauchet, Paris-Musées, 2000: p. 197 (above), 199
© Courtesy George Eastman House: p. 26, 43, 80, 81, 83 (above)
© Síochián Hughes: p. 242
© Initial groupe lumière/photo ExMachina: p. 276 (centre)
© Institut géographique national, Paris: p. 266, 267, 268, 269
© The J.Paul Getty Museum, Los Angeles: p. 44 (below), 72 (above)
© Lapidus Haute Couture/DR: p. 197 (below), 262 (above)
© J. H.Lartigue, ministère de la Culture, France/A.A.J.H.L.: p. 116, 117, 119 (above)
© Martha Laugs: p. 245 (below)
© Marie-Hélène Le Ny: p. 246
© Karin Maucotel, Paris-Musées, 2000: p. 10, 14, 15 (centre), 17, 24 (centre and below), 26 (below), 27 (above and below), 28 (below), 31, 32 (centre and below), 34, 36, 37 (centre), 39, 42, 44 (above) 45, 46, 47, 49, 50 (no. 1, 2, 3, 4, 5, 7), 51 (no. 8, 9, 10, 11, 13), 52, 53, 54, 55 (above and centre), 56, 57, 58, 59 (above and centre), 60, 61, 63, 64, 66, 67, 68, 69, 70, 71, 73 (below), 77 (below), 82, 83 (below), 84, 85, 86, 87, 88, 89, 91, 92 (left and below), 93 (below), 94, 100, 101, 102 (above), 107 (above), 108 (above), 109 (centre and below), 118, 119 (below), 120, 121, 122, 123, 124, 125, 126, 127, 128, 129, 130, 131, 132, 133, 134, 135, 137, 138, 139 (below), 143, 144, 145, 146, 149, 150 (below right), 151, 152, 153, 154, 155, 156, 157, 159, 160, 161, 162, 163, 164, 165, 170-181, 183, 184, 186-191, 200 (below), 235 (below), 236, 244, 245 (above), 247, 251, 254, 256, 264 (above), 265, 275 (right), 276 (below)

© Musée Archéologique National, Naples, Alix Barbet: p. 24 (above)
© Musée de l'holographie/Bernard, Paris: p. 192, 196, 198
© Musée de la publicité, Paris: p. 22, 140
© Musée français de la photographie, Bièvres: p. 149 (right)
© Musée des arts et métiers, Paris: p. 140
© Jacques Ninio: p. 16, 18, 19, 20, 262 (below), 263
© Alain Paiement: p. 250
© Denis Pellerin: p. 10
© La photothèque EDF, Jean-Marc Charles, p. 210
© Photothèque des musées de la Ville de Paris: p. 23 (above), 82 Irène Andréani; p. 50 (no. 6), 55 (below), 73 (above), 78, 79, 113, 166 Lyliane Degrâces; p. 23 (below), 74 (above), 75, 76, 77 (above), 114 (below), 115, Philippe Joffre; p. 110 (below), Philippe Ladet; p. 28 (above), 65 (right) Daniel Lifermann
© Catherine Poncin: p. 252
© Préfecture de police/ Marcel Guinard: p. 270, 271
© Lucien Raynaud : p. 264 (below)
© Réunion de musées nationaux, H. Lewandowski, Paris: p. 59 (below), 90, 96, 97, 98, 99
© Jacques Robin: p. 253
© Stephen Sack: p. 254
© Ellen Sandor: p. 255
© Jacques Simonetti: p. 256
© Dagmar Sippel: p. 257
© Michael Snow: p. 258
© Société Française de Photographie, Alexandre Grégoire, Paris: p. 15 (above), 107 (below), 150 (above and left)
© Stéréo-club français: p. 106, 108 (centre)
© Catherine Tambrun: p. 141
© Tex Treadwell: p. 26
© Université de Gand, Belgique: p. 136
© Harry Ransom Humanities Research Center, The University of Texas at Austin: p. 15 (below), 114 (centre)
© Wim Van Keulen: p. 13, 25, 27 (centre), 62, 74 (below)
© Christophe Walter, Paris-Musées, 1998: p. 148, 200
© Fernand Zacot: p. 260, 261

Authorship copyright:

© Agence Mimram/Vincent Dominguez/ministères de la Culture et de l'Équipement: p. 218
© AP-Holographie: p. 196
© Atelier Jean Nouvel/Artefactory: p. 214 (above)
© Atelier parisien d'urbanisme: p. 200, 201, 202, 212 (centre), 213
© Atelier Portzamparc/Jean-Charles Cholet: p. 215 (above)
© Patrick Bailly-Maître-Grand: p. 234
© Maurice Benayoun/Z.A Production: p. 227
© Sylvie Blocher: p. 235
© Gérard Boisard: p. 236
© André et Alain Bonnet: p. 184
© J. Bonnet: p. 182, 184, 185
© Michèle Bonnet archives: p. 154, 170, 174, 173, 175, 176, 177, 179, 180, 181, 190, 191
© C.N.R.S UMR MAP Le CRAI/Culture: p. 210, 211
© Emile Cagneaux: p. 107
© Canal+ multimédia: p. 215 (below)
© Blanca Casas Brullet: p. 237
© Chevojon: p. 177
© Lucien Cresson: p. 113, 166
© Anne Deguelle: p. 238
© Jacques Delamarre: p. 166 (below)
© François Delebecque: p. 239
© Robert Doisneau/Agence Rapho, Paris: p. 12
© Alain Dufour: p. 240, 241
© Ecole d'architecture de la Villette/Louis Mariani and students: p. 220, 221
© Eugène Estanave: p. 153, 155, 156, 157, 177
© Louis Fléri: p. 243
© Fondation Electricité de France/C.N.R.S UMR MAP Le CRAI/Culture: p. 206, 207, 208, 209, 230
© Fondation Roland Garros/Girardet et Deschaumes: p. 216
© Jean-Marc Fournier, Gilbert Tribillon: p. 195
© Jean-Marc Fournier, Gilbert et Jean-Louis Tribillon: p.197, 199
© Léon Gimpel: p. 120, 122, 124, 126, 127
© Claudius Givaudan: p. 144, 151, 158
© Groupe Seca: p. 226 (below)
© Síocháin Hughes: p. 242
© Initial groupe lumière/photo ExMachina/Jerzy Kular, José Xavier: p. 276 (centre)
© Institut géographique national, Paris: p. 203, 204, 205, 266, 267, 268, 269
© Paul Intini: p. 28
© Istar Imagerie HRSC© DLR: p. 272, 273, 274 (left)
© J.H.Lartigue, ministère de la culture, France/A.A.J.H.L.: p. 116, 117, 119 (above)
© J.M.G.Graphics: p. 228, 229
© Kamran Kavoussi: p. 244
© A. Lanier : p. 22
© Lapidus Haute couture/DR: p. 197 (below), 262 (above)
© Martha Laugs: p. 243; Catherine Ikam: p243; © ADAGP, 2000
© Marie-Hélène Le Ny: p. 246
© Louis Lumière/famille Lumière: p. 145 (above and below), 146
© Louis Lumière/famille Lumière, collection Bibliothèque municipale de Lyon: p. 147, 147 (above) 149 (below)
© Louis Lumière/famille Lumière, collection Joachim Bonnemaison: p. 148

© Louis Lumière/famille Lumière, collection musée français de la photographie, Bièvres: p. 149 (centre)
© Bruce McKaig: p. 247
© Medialab/Éric Morvan: p. 213
© Hélène Mugot: p. 248, 249
© Musée de l'holographie/Bernard, Paris: p. 192, 196, 198
© Jacques Ninio: p. 16, 18, 19, 20, 262 (below), 263
© Ondim/Archi.Vidéo/France Télécom: p. 231
© Alain Paiement: p. 250
© Guillaume Paris: p. 251
© Gérard Perron: p. 232, 233
© Dino Pesic/L'autre image: p. 212 (above)
© Catherine Poncin: p. 252
© Préfecture de police/Marcel Guinard: p. 270, 271
© Lucien Raynaud: p. 264 (below)
© Régie autonome des transports parisiens/Jean-Marc Bernardello, Guy Outhier: p. 214 (below)
© Régie autonome des transports parisiens/AP Holographie Gilbert and Jean-Louis Tribillon: p. 199
© Reichen and Robert/Ville de Paris: p. 217 (below)
© Jacques Robin: p. 253
© S.A.R.L Jakob et Mac Farlane: p. 217 (above)
© Stephen†Sack: p. 254
© Ellen Sandor: p. 255
© Alain Sarfati/Élise Glodek/Sabine Porada/Ville de Paris: p. 212 (centre)
© Michel Sarret /Relieforama: p. 183, 186, 187
© Jacques Simonetti: p. 256
© Dagmar Sippel: p. 257
© Michael Snow: p. 258
© Société Oktal/AP.U.R./Ville de Paris: p. 224
© Société Trimaran/Société nouvelle d'exploitation de la Tour Eiffel: p. 226 (above)
© Studio Gui: p. 223
© Nadir Tazdaït/Centre Georges Pompidou: p. 222
© H. William: p. 13
© Eddie Young/Dietmer Feichtinger/Ville de Paris: p. 219
© Aiyoung Yun: p. 259
© Fernand Zacot: p. 260, 261

The publishers have taken every effort to trace copyright holders. Should there be any omission, the appropriate acknowledgement will be made in any subsequent edition.